the Terracotta Warriors

the Terracotta Warriors

EXPLORING THE MOST INTRIGUING
PUZZLE IN CHINESE HISTORY

Edward Burman

PEGASUS BOOKS
NEW YORK LONDON

THE TERRACOTTA WARRIORS

Pegasus Books Ltd
148 West 37th Street, 13th Floor
New York, NY 10018

ISBN: 978-1-68177-796-2

10 9 8 7 6 5 4 3 2 1

Printed in the United States of America
Distributed by W. W. Norton & Company, Inc.

CONTENTS

LIST OF ILLUSTRATIONS

Section 1

1. Mausoleum, 1914 (Musée Guimet)
2. Mausoleum, 2013
3. First excavation of Pit 1, 1974 (Zhang Tian Zhu © Emperor Qin Shihung's Mausoleum Site Museum)
4. Preliminary cleaning of first warriors (Zhang Tian Zhu © Qin Shihung's Mausoleum Site Museum)
5. Later work in Pit 1, 1978 (Zhang Tian Zhu © Qin Shihung's Mausoleum Site Museum)
6. Exterior of the original museum
7. Interior of Pit 1 today (Zhang Tian Zhu © Qin Shihung's Mausoleum Site Museum)
8. Pit 2, March 2017
9. Early restored warriors in Pit 1
10. Charioteer in Pit 1
11. Warrior close-ups before advanced pigment protection
12. Warrior close-ups with some pigment protection
13. Terracotta *qun* (Shaanxi History Museum)
14. Bronze vessels
15. Excavated tomb of Duke Jing at his capital, Yong
16. Covered pit at Yong awaiting excavation
17. Cedar beams from the coffin of Duke Jing
18. Tomb of Duke Jing, bronze junction bracket (Shaanxi History Museum)
19. Replica reception room for Duke Jing
20. Miniature gold woodpecker (Shaanxi History Museum)
21. Miniature gold monster (Shaanxi History Museum)
22. Tile end with deer pattern (Shaanxi History Museum)
23. Bell from Taigong Temple (Baoji Bronzeware Museum)
24. Eroded ancient Great Wall near Yulin, northern Shaanxi

NOTE ON THE TEXT

Like most authors writing about China today, I've used the pinyin system of romanization of Chinese words. To make things easier for the general reader and to be consistent between text and quotes I've usually modernized, that is changed to pinyin, the place names and other names in early texts while giving the older Wade–Giles name in brackets or notes. Very occasionally, as in the case of the Qin capitals, I've added the Chinese name in brackets for clarity since a Chinese reader might not recognize some of the lesser-known places or books from the romanized form; old maps use very different forms of the names, and often those names have changed completely. There are several variant spellings of the name Qin, such as Ch'in or Chhin in English, Ts'in in French (in Biot and Chavannes, for example) and Zin in Italian. Again, for consistency and clarity I have always used the form Qin even in quotations where others are used. There have also been many variants of the city name Xi'an during its long history, including Fenghao, Chang'an, Daxing, Fengyuan and Xi-Jing, and other spellings in European languages, for example, Hsien, Sian, Sianfu, Sigan Fu. I have used Xi'an throughout to avoid confusion. The unique French system of romanization used by Chavannes – P'ong-tch'eng for Pengcheng, for example – makes reading hard for those used to pinyin, or not used to Chinese names. Once again, for clarity and consistency I have modified the French names even in the quotations (references to the original are always given).

Since most of the events recounted here took place in the pre-Christian era, dates have been given throughout the text without the indicators BC or BCE to make it easier on the eye. The few dates later than the birth of Christ are given as AD, with the exception of obviously modern years from the nineteenth and twentieth centuries.

I've also followed convention on one potentially confusing matter. One of the seven major Warring States, an important neighbour of the Qin from the time when the older Jin territory was split into three, was that of the kings of Hann. But these Han had nothing whatsoever to do with the more famous and later Han dynasty which succeeded the Qin, so this book always uses the form Hann for the small ancient state and Han for the imperial dynasty to avoid misunderstandings.

There is also some possible ambiguity concerning the use of the words tomb and mausoleum and what is now sometimes referred to as a mausoleum complex which includes the terracotta warriors. For clarity, this book will use the following forms: Mausoleum Precinct (in the sense of a cathedral precinct), comprising the tomb, burial chamber, funerary mound, and the area within the Inner Wall; the Area Immediately Surrounding the Mausoleum Precinct, inside and around the Outer Wall; the Terracotta Warriors (which form a distinct entity 1.5 kilometres east of the mausoleum); and the capitalized form Mausoleum to include the entire area planned by the First Emperor for his afterlife.

My debt to scholarly authors is clear from the Bibliography, and, having been introduced to French sinology through a study of the exploits of Victor Segalen in China for a documentary film, I would like to add that I make no excuse for using the very old work of Édouard Biot (1803–40), and that of Segalen's teacher at the Collège de France, Édouard Chavannes (1865–1918), both profound scholars of classical Chinese whose detailed notes often provide significant insights (the same is true of James Legge's notes to his nineteenth-century translations of the Confucian texts). Chavannes actually visited the location in 1907 without knowing it, and inspired Segalen to take his famous photograph of the site seven years later – following indications from his mentor's translation of the Han historian Sima Qian, whose work is the primary source of information about the Qin. The letters between Chavannes and Segalen make fascinating reading on the mausoleum. All quotations concerning the Qin from Sima Qian have been translated/adapted by me from the relevant

chapters of Chavannes' work, *Les Mémoires historiques*, published in French in five volumes between 1895 and 1905, except a few from Burton Watson's modern translation, in particular from chapters on the Han dynasty which were not translated by Chavannes (*Records of the Grand Historian, Han Dynasty I* and *Han Dynasty II*, 1993). I have also consulted, but not quoted from, the multi-author translation edited by William H. Nienhauser, in particular volume I, *The Basic Annals of Pre-Han China* (1994), dedicated to Chavannes, and volume II, *The Basic Annals of Han China* (2002), dedicated to Burton Watson.

The objective has always been to provide a clearly comprehensible English version. Translations of passages from Chinese scholarly reports have been privately made for my personal use, and any uncertainties discussed with the authors when possible. Translations from other languages are my own.

INTRODUCTION:
LEGENDS AND THE 1974 DISCOVERY

The existence of a mausoleum built for Qin Shihuang, who is better known outside China as the First Emperor, has been recognized since fairly soon after his death over 2,200 years ago. For the story of its construction was related in a celebrated chronicle of ancient Chinese history, whose title is usually translated into English as *Records of the Grand Historian* or *Records of the Scribe*, written on bamboo strips by the Grand Historian (also known as Grand Astrologer) at the court of Emperor Wu of the Han dynasty, Sima Qian (145–86). He described the process as follows:

> From the beginning of his reign Shihuang had Mount Li built and shaped. Then, when he had united the whole empire in his hands, he had seven hundred thousand workers transferred there. They dug down until they reached the water level and poured in bronze to make the sarcophagus.[1] They made replicas of palaces and government buildings, and wonderful utensils, jewels and rare objects were brought and buried there to fill the tomb. Experts were ordered to build specially set-up crossbows to fire arrows at anyone who tried to break into the tomb.[2]

But the precise location of the funerary mound and its underground tomb were unknown to the ancient Chinese because it had been deliberately hidden. Unlike mausoleums designed to be admired from afar, such as the Taj Mahal in Agra or the Panthéon in Paris, this product of the long-term labours of such a vast workforce was always intended to be made invisible after the burial. Once the thousands of artefacts and treasures which would enable the Emperor to continue his terrestrial life into eternity had been placed in the

tomb, the artisans and craftsmen who had completed the task (see Chapter 7) were to be locked inside to die with him. Trees and bushes were then planted over the site so that it would resemble another mountain in an already mountainous landscape.

Legends and rumours abounded through the centuries; some local villagers may have known or guessed what it was, but failed to imagine its significance in a landscape dotted with funeral mounds, imperial tombs and ancient ruins. The exact location was identified and roughly surveyed in the Ming period, around the time of the Italian Renaissance, and it was photographed by two foreign travellers just over a century ago; but meaningful knowledge dates only from the 1960s. Superstition and fear – and the presence of mercury, known from Sima Qian's account and to be discussed later – seem to have provided immunity through the centuries from the grave-robbers and dealers who ransacked other tombs.

This is remarkable in itself, and already poses difficult questions and mysteries to resolve, but it refers only to the *tomb*. What is truly astonishing is the fact that the existence nearby of an army consisting of thousands of terracotta figures intended to protect the emperor and his tomb was totally unknown to the local people and even to a well-informed chronicler like Sima Qian, or to his father Sima Tan, whom he succeeded as Grand Historian. Sima Tan began the *Records* and had been born within living memory of the sepulture. There had never been the slightest hint in surviving documents or books. It was, literally, unimaginable until 1974 and still astounds in its dimensions and complexity. There is nothing quite like it in the world.

In fact the entire story of the Emperor and his Mausoleum is one of History, Mystery and Discovery, three elements which provide the structure of this book. *History*: the chronicles and annals of Chinese history help us to outline the straightforward historical record; this provides the basic starting point of the story. *Mystery*: since the emperor's death there have been several mysteries, including the character of the emperor himself, the deliberately disguised location of the tomb, its real purpose and more recently

the uncertain role of the terracotta warriors. *Discovery*: in the past this was serendipitous, as in the 1974 discovery of the warriors, but today it has become systematic and adopts advanced archaeological and scientific techniques which fill out the History and build on the Mystery.

One of the foreigners mentioned above, the French poet, novelist, sinologist and doctor Victor Segalen, was not the first to photograph the tumulus but he is the only one to have recorded his 'discovery'. His photos, taken with equipment provided by Kodak for an official mission sponsored by the Ministry of Education in Paris, were also of better quality.[3] Segalen recounts how on 15 February 1914 he arrived in the nearby town of Lintong in search of Tang dynasty tumuli – supported by his mentor, Chavannes, and the latter's own mentor, Henri Cordier, a professor at the École Spéciale des Langues Orientales. Chatting to some old local men one evening, he was told about another much larger funerary mound nearby. One of the villagers mentioned the name of Qin Shihuang. It sounded implausible to Segalen and his companions, since as far as they knew the First Emperor had been buried closer to Xi'an, and it was thought likely that his tomb had long since been violated and eliminated like hundreds of others which once lined the roads of north-western China. In the later formal report on the mission, he explains further that they were sure they were being duped, for such deceptions were common.[4]

But when he and his companions approached the large tumulus from the north, doubt dissipated. As dusk began to fall, they saw a chain of violet-tinted mountains which appeared in front of them with regularly spaced natural buttresses like masonry shoulders. There, Segalen wrote the next evening in a letter to his wife, at the foot of the mountain range, was 'another mountain, isolated, ash-white, with such a regular, deliberate and orderly shape that there could be no doubt'.[5] It corresponded perfectly to the three layers or terraces mentioned in ancient texts by Sima Qian. Ironically, it is more like the original now than it was in Segalen's time, since in recent years trees have been replanted over the mausoleum. In its nude form, he intuitively compared it to the Great Pyramid at

Giza, and on 3 March took an excellent photograph which has since provided a key visual reference to archaeologists. The original glass plate is in the Musée Guimet in Paris, but a copy may be seen in the Mausoleum Site Museum and in many books on the First Emperor. Yet neither Segalen nor the archaeologists who built on his early exploration could imagine the riches which lay beneath the earth over a much wider area than that of the tomb itself.

So we can imagine the astonishment – and fear – felt by superstitious villagers nearby when, in 1974, the first of the warriors came to light.

This part of the story is well known, and has been repeated by guides in one form or another to the ninety million Chinese and fifteen million foreign visitors who have made the pilgrimage to Lintong since the first museum housing the warriors was opened in 1979. In the midst of a drought in March 1974, which threatened that year's income from fruit-farming, six brothers named Wang who owned the orchard under which the pits then lay hidden decided to dig a new well. Just one metre down they reached something solid which they assumed to be an old brick kiln, but after a few days they had dug a broad deep hole. Then, to their surprise, fragments of pottery began to emerge as they worked, and, quite suddenly, a terracotta head whose eyes and appearance frightened them. When clay limbs, entire torsos and bronze arrowheads were revealed, they realized they were finding ancient relics such as other farmers and grave-robbers had come across closer to the mausoleum in earlier decades. Their first thought was to make some quick money by selling their finds to collectors or recycling the metal as scrap. They could have no idea of the scale of what still lay underground. The spot where the brothers dug down and made their first discovery is still shown to visitors by guides in Pit 1 today.*

The finds were so numerous that word rapidly spread through nearby villages and soon reached the ear of Zhao Kangmin, the curator of a small museum in Lintong. He had himself found three

* Illustration 3 on List of Illustrations, p.ix.

figures of crossbow archers a few years earlier, and when he visited the site of the discoveries he recognized that the bricks and other objects were from the Qin period. He took some of the finds to his museum to begin some simple cleaning and restoration; he also located and bought back metal objects which had been sold for scrap. No one else guessed their real potential value. Credulous villagers were worried in case these finds should bring disaster or just bad luck on them; some believed they were figures of demons or deities linked to sickness and epidemics, and they even burned incense to protect themselves. There were also other kinds of fear. Zhao himself was concerned that so soon after the Cultural Revolution, one of whose tenets was to eradicate ancient imperial relics, the newly discovered objects would be destroyed by nervous officials as so many had been in the previous decade.

At first, the news spread no further.

Then a Beijing-based journalist, Lin Anwen, happened to hear about the discovery while visiting his family in the Lintong area. He visited Zhao's museum, listened to his story and studied the artefacts. On returning to Beijing, he wrote a 1,000-word report for an official journal which was published in June 1974.[6] This report spurred interest at the highest levels, and the excitement is palpable in the rapid sequence of events at a time when communications and travel were much slower than today: within days it was seen by Li Xiannian, vice-premier of the State Council and also by the minister of the State Administration of Cultural Heritage; on 6 July the director of Cultural Heritage flew to Xi'an in person to investigate; on 15 July the Shaanxi Institute of Archaeology in Xi'an dispatched a team to evaluate the site.

The next part of the story is less well known in its details. Three archaeologists set off on the open back of a bull-nosed Jiefang CA-30 military lorry, known as a Liberation Truck, with one canvas bag each and a mosquito net. They had been ordered to visit the site, measure its extent and then write a report for the government in Beijing. The future museum director Yuan Zhongyi, who was part of this group, recalls that they expected to be away for a week

and thus took very few supplies.[7] They slept under a tree beside the site, protected by the mosquito net, and ate their meals in a different farmer's home each day, paying thirty *mao* in cash (ten *mao*, or *jiao* = 1 *yuan*) and also giving them a *ban jin* coupon (with which they could get an extra pork ration of a quarter of a kilo). Their primary task was to calculate the size of the pit, so they began from the well-hole and worked outwards; at the same time, they selected two large baskets of terracotta fragments from a pile of apparent rubbish and began to study them. On 2 August, still at the site, they began to drill exploratory bore-holes while the expanding pit continued to astonish them by its contents. The then 42-year-old Yuan already had a reputation for 'lucky' finds: his previous task had been a dig in San Yuan, north of Xi'an, at the seventh-century AD tomb of the uncle of Li Shimin (the future Tang emperor Taizong), where he had found the first-known surviving Tang murals – now in the Shaanxi History Museum. Hard work under the hot summer sun was relieved by a series of magnificent surprises. That August, they found the first bronze sword, its blade still gleaming in the absence of rust. Then, in September, after twenty or so warriors had emerged, Yuan expressed a wish that they should find a horse: two days later, the first terracotta horse emerged from the dig, and in the evening they celebrated with *baijou*, the Chinese liquor. But it was not until March 1975, after innumerable trips out to the site, now taking two-and-a-half hours by bike without the privilege of a truck which urgency had conferred, that they were able to report the exact scale of the pit, measured as 230 by 62 metres.

A year after initial work had hinted at the wealth of Pit 1 with the discovery of the bronze sword and terracotta horse, it was decided that a museum should be built. But as work on the new structure began in May 1976 two further sites, now known as Pit 2 and Pit 3, were discovered beside the original one, together with the unfinished and never used Pit 4. Yuan Zhongyi's task stretched from a week to three decades of digging, analysis, research and publication, lasting until his retirement in 2003. Today in his mid-eighties, he is still honorary director of the Mausoleum Site Museum and respected as the doyen of 'warrior studies'. Under his guidance, the accretion

of knowledge has been constant, and his major publications on the tomb and the terracotta army are the most complete and authoritative sources of information, though never translated into any foreign language because they are highly technical (his most recent summa on the warriors, published in 2014, runs to nearly 600 pages of dense text with dozens of sketches of archaeological detail).[8] Soundings and digs continued over the years in the wider area around the mausoleum site under a growing team, with surprising results and discoveries which continue to emerge. The total area involved has been thought for some time to be around fifty-six square kilometres, but as we shall see towards the end of this book is likely to have been nearly twice as large as that – spun outwards like a spiral from the original well-hole.

Traditional archaeological techniques have been augmented in recent years by scientific analysis, and by methods which were unavailable forty years ago, together with important international collaborative projects. Magnetic scans of the area made in 2005, for example, allowed a more precise map of the site and its buildings to be made, and indicated the presence of a large number of metal objects and coins. Metallurgical studies on unearthed weapons and objects have also provided fascinating information, as has research into colours and pigments used to decorate the warriors. In the summer of 2009 a third series of excavations began at Pit 1 (following those of 1974 and 1985, which identified Pits 1, 2 and 3) and lasted until 2011. Significant new finds include over a hundred terracotta warriors and horses, two sets of chariots and large quantities of weaponry. Some of these newly discovered figures are high-ranking officers, with more elaborate decorations on tunics and weapons; new techniques have allowed the preservation of a larger amount of colour, including flesh colours on the faces and painted eyelashes. Preliminary details were reported in 2015, and a full study is due to be published. In March 2015, promising new excavations also began in Pit 2.

Over the period from 1999 to 2012 a series of other excavations took place in the area closer to the mausoleum. Archaeologists found near the burial mound the remains of what was then thought to be

an imperial palace but is now believed to be the prayer halls and reception halls for the afterlife, comprising eighteen courtyard-style houses with one main building at the centre. The remains of subsidiary pits, walls, gates, stone roads and brickwork have provided a clear idea of the layout and construction. The Qin development of the ancient idea of a mausoleum with a garden or precinct around it involved a symbolic representation of the capital city for the afterlife, which as we will see formed the template for such structures under the Han and future dynasties. The preliminary results of this more recent work will be discussed in Part III of this book.

At the same time, knowledge of the Qin has been enhanced by numerous parallel discoveries concerning their rivals in the Warring States period and near-contemporary tombs of the early Han emperors who succeeded them. Other spectacular discoveries, well known to sinologists and specialist historians but not to the average visitor, have furnished significant insights into the workings of the empire. One important example was the discovery, a year after that of the warriors, of 1,155 bamboo strips bearing texts which provide information about laws, administration and religious and everyday life during the First Emperor's lifetime. They were found at Shuihudi, in Yunmeng County, Hubei Province, where in 210 the emperor himself travelled and made sacrifices, and many artefacts are on display in the Hubei Provincial Museum in Wuhan. These ancient texts are difficult to read and interpret even for Chinese scholars, but following their publication in specialized journals a selection was translated and published in English by the Dutch sinologist A. F. P. Hulsewé in 1985 as *Remnants of Ch'in Law*. Since then, other caches of documents have been unearthed: in 1989 in Longgang (also Yunmeng County), in 1993 in Jingzhou, Hubei Province, and in 2002 and 2005 at Liye, Longshan County, Hunan Province, of which the first publication of one of five projected volumes was made in Chinese in 2012.[9] New information has also appeared in the form of inscriptions on bronze vessels and steles, and by means of new disciplines such as geo-archaeology, the study of DNA from human bones, and advanced techniques of digital analysis.

These new sources, and sometimes almost monthly announcements

of new tombs and related discoveries, are likely to be augmented by further revelations for many years to come and to offer an ever clearer overview of the Mausoleum and its Terracotta Army. This book is based on information available up to mid-2017.

I : HISTORY

1

WARRIOR CHU

Legend has it that each of the 2,000 warriors so far unearthed bears distinctive features. Certainly there are many facial types, reflecting the ethnic differences between warriors from the extreme north-west, the centre of China, the north-east and the regions of the south – the areas of the six Warring States (the Qin themselves were the seventh) which were subsumed into the new empire. Let us take one warrior at random and assume for a moment that this is a realistic portrait of a soldier in the armies of Qin Shihuang.[1]

Who is this battle-worn warrior?

His clothing and hairstyle show him to be of Chu origins, especially the knot on the right side of his head, but his battle experience was Qin. His imagined life will serve as a basis for understanding the terracotta army. We shall call him Warrior Chu.

He was born in 264 in the city of Ying, on the banks of the Yangtze River west of Wuhan, and very close to the Qin lands and Sichuan. At the time of his birth the Chu state was ruled by King Qingxiang, a powerful monarch whose reign lasted from 298 to 263. His kingdom was one of the seven Warring States, and included most of modern Hubei and Hunan provinces based on the rivers Yangtze and Han – the latter a tributary of the Yangtze which rises in the south-west of Shaanxi. The Chu had long been the main rivals of the Qin and the king's father King Huai had been held hostage by the Qin, and died in captivity in 299. They might well have produced the first emperor in the person of one of Qingxiang's descendants had they not been subjugated by the Qin.

In their perpetual search for new recruits, the Qin conscripted

boys from their own and neighbouring lands, especially places like Ying close to their own territory. Thus Warrior Chu was press-ganged into the Qin army at the age of fourteen in 250.[2] All men between seventeen and sixty were legally recruitable, but boys of fourteen to sixteen often slipped through the net – and perhaps lied about their age. He looked older, and was five centimetres taller than the minimum recruitment height of 1.77 metres, toughened by years of hoeing and ploughing. The next thirty years of Warrior Chu's life were to be spent on the march, on guard duty, in the saddle and in battle as the Qin consolidated their power. Together with other boy recruits, he was taken north deep into Shaanxi for military training. In 248 the sixteen-year-old warrior was assigned as weapon-carrier to a crossbow archer on a mission to provide back-up for an attack on the Zhao city of Taiyuan, across the Yellow River to the north-east of Xianyang. The following year he was wounded in the leg, and joined a general retreat back into the Qin lands.

Most of the next decade he spent on guard duties along the already existing stretches of the Great Wall across the Ordos Desert, with brief spells of combat against the Zhao, so that in the year 238 when Zheng, as the First Emperor was then known, was enthroned as king of Qin he was an experienced and hardened soldier in his late twenties.

Then military duties and marches escalated as King Zheng implemented what was known as his Thirty-Six Stratagems for annexing the other six Warring States, the essential strategy being to create alliances with the most distant of them while attacking those nearest to his own lands (see Figure 1). Ten years of almost constant combat were to follow for Warrior Chu and his comrades-in-arms as the king sought first to conquer his close neighbours the Hann and the Zhao. For now, the policy was to block the Wei and the Chu, and make an alliance with the more distant Yan and Qi, both located on the eastern coast.

In 236, Warrior Chu marched with the troops of one of the four greatest generals of the Qin, Wang Jian, into Zhao territory, where they captured nine cities in a series of fierce battles which severely weakened the enemy forces. It was not all combat, for General Wang

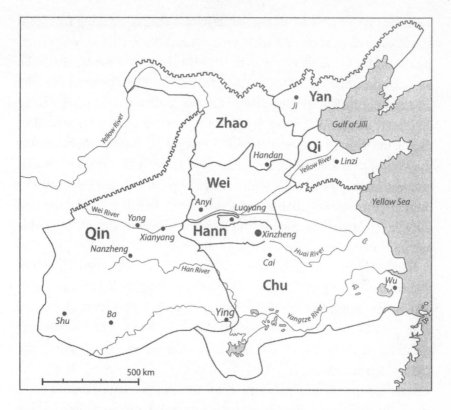

Figure 1. The lands of Qin and the other six major Warring States, c.300 BC

was an excellent and innovative leader of men. Like Napoleon 2,000 years later, he understood that infantry marched on their stomachs, and fed them well after allowing them the unusual luxury of washing after military action. This exceptional leader of men also ate with his soldiers, and encouraged them to indulge in their favourite forms of relaxation, which included martial sports such as stone-throwing, weightlifting and high-jumping. It was training as fun, creating a strong *esprit de corps*.

Warrior Chu relished the feeling of strength and superiority in this army, and marched with the certainty of companionship and trust in his fellow warriors which derived from years on the road together, tricky river crossings, the horseplay between warriors, the camaraderie, bustle and odours of campsites, close-fought battles

and the joys of post-victory celebrations. We may imagine this solid footsoldier as he marched once more against the Zhao two years later, again under General Wang Jian, who this time commanded a force of 600,000 men. The Qin army defeated the Zhao general Hu Zhe in a crucial battle in Pingyang, near Handan – where King Zheng had been born. Following the victory, Warrior Chu participated in the beheading of 100,000 captured troops. In their enthusiasm for the victory he vied with his colleagues to see who could sever the greatest number of heads with a single sword stroke. The army was then free to march further east into Zhao territory and take two further strongholds, paving the way for ultimate victory over this key and persistent enemy a few years later.

Warrior Chu marched eastwards once again under the minister of the interior, Teng, as the army fought its way into the lands of Hann which lay along the southern bank of the Yellow River. The Hann state was the smallest of the six other major Warring States, but was strategically vital because it offered a channel eastwards along the Yellow River into the heart of Wei and Chu, and beyond that to the coastal plains. In 230 the army took the state's capital, Zheng,[3] and the following year King An of Hann surrendered his kingdom to the Qin. It was the first of the six states to fall definitively, but the others fell in rapid succession over the next decade.

Years of marches and battle had taken their toll on Warrior Chu. Now in his mid-forties, after again being wounded in the leg at Zheng and receiving a dagger slice to his lower cheek which left his lower lip drooping slightly to the right, he was allowed to travel back to the capital at Xianyang on convalescence at the main imperial barracks situated south of the River Wei. Given good food and rest, and with his strong natural physique, he recovered quickly. It was time to take a wife, and he found a young servant girl from Chu who worked in the private household of Wang Jian. With permission from his general, he set up home in a zone reserved for married quarters on the western edge of the barracks near the River Feng. He was made a troop commander; with his experience and knowledge, and the prestige derived from fighting under General Wang, he became an

excellent instructor for new conscripts. But as we can imagine from the powerful set of his shoulders and the stubborn determination evident in his face, he desired to return to the life he had known for thirty years.

He was to participate as a commander in later campaigns.

In 226 he joined the army of Wang Jian once again as it prepared for a major offensive against the Yan, the northernmost of the six enemy states. King Xi of Yan had sought alliances with tribes to the north of his lands, but his son Prince Dan rashly undermined these plans by sending an assassin disguised as an envoy to murder King Zheng. The assassination attempt failed, and only spurred the king of Qin to send his general into Yan lands to conquer their capital, Ji, which stood in what is today the north-eastern part of Beijing. The capital was taken and the Yan army destroyed. In a token gesture, King Xi himself ordered the execution of his son Prince Dan and sent his severed head to the Qin as a mark of penitence.

On the second campaign, Warrior Chu returned to the now-forgotten land of his birth. It began with a preliminary tactical move, in which he did not take part, led by Wang Jian's son, who took a dozen or so cities along the northern frontier of Chu. Then in 224 there was a disagreement between Wang Jian and his fellow general Li Xin over the number of men required for a final assault: the former went for 600,000, while the lower number of 200,000 proposed by Li Xin was for obvious reasons accepted by King Zheng. Disgusted, Wang Jian went into voluntary retirement, claiming to be ill. But when Li Xin failed and lost large numbers of men, the king sent for his most successful general and offered the forces he had required in the first place. Given his long-term loyalty to Wang, Warrior Chu joined this new campaign, which resulted in the definitive conquest of Chu the following year.

Now fifty-four, exhausted and battle-worn, he stares out with a certain contempt on his lips. He's seen and survived everything that life could throw at him. His experience made him an exemplary model as a member of the secret army being created to defend Qin Shihuang's mausoleum, since his life story encapsulated the recent

past. The strength, confidence and fatalism of the ancient Chinese warrior are palpable in his expression. With a million solid men like this, for such was the size of his army, it is easier to understand how the First Emperor was able to overcome his six adversaries in the quest for absolute domination.

2

THE ANCESTORS OF QIN SHIHUANG

The Qin had long dreamed of unification, for their eventual empire was not created by one man as is often assumed. It was the result of a centuries-long process involving the ancestors of Qin Shihuang – the dukes and later kings of the state of Qin – as well as the success of his own military campaigns.

When the house of Zhou overthrew the Shang dynasty at the end of the second millennium BC, around 1046,[1] the newly conquered lands were assigned to family members, to allies in the campaign and to some of the old Shang aristocratic families whose support was vital for continuity. Three centuries later, during what is known as the Spring and Autumn period (which lasted from 771 to 475), when the Qin began to build power after the Zhou had retreated eastwards, there were around 170 independent states – some of them tiny, no more than a single city with its surrounding valley. Between then and the third century, during the Warring States period (from 475 to 221), by a sequence of conquests, attrition and annexation in which the Qin were heavily involved, the number of feudal territories was reduced to seven major states: the Qi, the Chu, the Yan, the Hann, the Zhao, the Wei and the Qin themselves.[2] The city states and smaller political entities could no longer defend themselves as marauding armies grew in size from thousands of men to hundreds of thousands, although some nonetheless managed to survive. When, in 260, the Qin finally defeated the last of their rivals, the Zhao, at the decisive battle of Changping, 400,000 men are said to have died.[3]

According to family tradition, the Qin were descended from a

certain Zhuanxu, a grandson of Huangdi, one of the five mythical founders of Chinese culture better known to us by his popular name as the Yellow Emperor. This legendary or semi-legendary figure was said to have lived in the middle of the third millennium and has often been credited as the originator of the centralized state, and as the inventor of key elements of Chinese culture such as traditional medicine and the lunar calendar. Sima Qian describes the Yellow Emperor as follows in the opening words of his *Records*: 'From his birth he had supernatural powers; from childhood he could talk; from his youth, his virtue was always expressed promptly; as an adolescent, he was good and perspicacious; as a man, he had an open intelligence.'[4] There could be no more prestigious lineage. So it was also natural that his name should later be incorporated into the First Emperor's formal name, Qin Shi*huangdi*, as we shall see later. In reality, the Qin probably originated in Gansu during the transition from Shang to Zhou.[5]

Sima Qian provides an insight into the skills which promoted their rise to power when he observes that two distant ancestors, a certain Boyi and the later Feizi, were expert horse breeders who both increased the number of horses available for their royal patron's army. This underlines the perennial importance of warhorses in Chinese history, since many enemies were expert horsemen from the northern steppes and the vast dimensions of China required horses for rapid transport and military deployment as well as for battle. It is no coincidence that expert horsemen, both as sword-bearing cavalry and as archers firing from the saddle – such as the Mongols and the Manchu – dominated China for much of its history. Sima Qian quotes the words of King Xiao of Zhou, who ruled between 891 and the 870s: 'In the past, Boyi supervised the raising of animals for Emperor Shun, and they grew greatly in number. That is why he was given a fief and the family name Ying. Now his descendant [that is, Feizi] is doing the same with my horses. I shall give him land in Qin, so that he becomes a vassal of mine.'[6] He ordered that the horse trainer should then be called Qin Ying, and that sacrifices should be made to the Ying family at their new home in Qin, which today is

known as Zhangjiachuan, in Gansu. Horses, warfare and sacrifice were in their DNA.

In 822, Zhuang, a great-great-grandson of Feizi, built his capital at a city called Quanqiu (or Xiquangqiu) in south-western Gansu – not far from Qin. This is now known as Lixian, close to the border with Shaanxi. It stands over a strategically important valley from which two tributaries almost connect the river systems of the Yellow River and Yangtze River – the River Ji which flows north into the former, and the River Xi Han which flows south into the latter. It is an extraordinary place from the standpoint of historical geography. Just to the east of Lixian the Qinling Mountains rise and separate the course of the River Wei, which flows north into the Yellow River, from the tributaries of the River Han and the River Jialing which flow south into the Yangtze River. The symbolic importance of the site is striking. For in the upper Han valley the lands of the Qin and Chu touch, together with those of the smaller states of Ba and Shu further down in Sichuan, which the Qin eventually conquered; later, the Chu came up from the eastern plains along the Han through Ankang and Hanzhong, while the Qin travelled down along the Wei and Yellow rivers through Xi'an and Luoyang towards the coast.

The Lixian area has only recently been studied in a systematic way by archaeologists, with as many as forty early Qin settlements including three walled cities being identified between 2004 and 2008, and further excavations carried out in 2010–11. Two discoveries of particular interest in the context of this book concern a sacrificial pit at a site called Dabuzishan, near Lixian: the tomb of a Qin 'regional ruler' which is eighty-eight metres long with two ramps aligned on an east–west axis, and which includes a musical-instrument pit and four pits for human sacrifice; and another tomb 110 metres long with east and west ramps. These already huge structures with several burial pits around them pre-date Qin Shihuang's tomb by 600 years.[7] From this base in Lixian, the Qin gradually moved eastwards, occupying a series of nine successive capitals.[8] The first duke, whose name was Xiang, initiated this sequence when in 776 he moved the capital from Lixian to Qian (汧) in Shaanxi, today identifiable as Longxian. It was a momentous shift. (See Figure 2.)

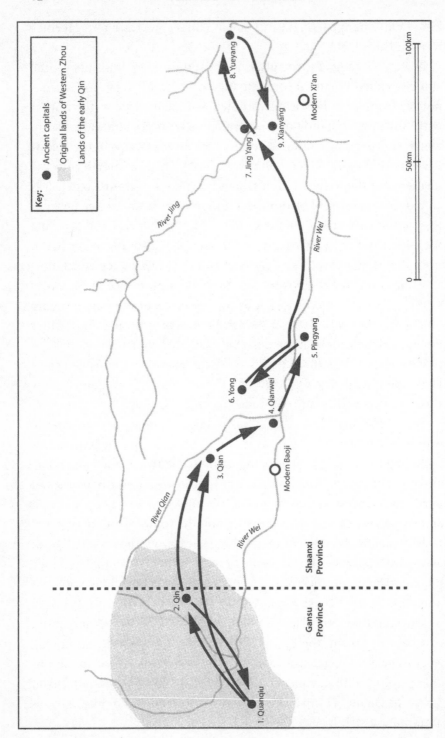

Figure 2. The Qin migration route from Gansu to Xianyang, with the nine capitals numbered in sequence

For centuries, the capital of the Zhou dynasty had been in Shaanxi to the west of the present city of Xi'an and comprised two walled settlements on opposite banks of the River Feng, a tributary flowing north into the River Wei very close to the site of the future Qin imperial capital at Xianyang (whose modern tower-blocks are visible from the confluence). One was called Feng, on the western side, and the other Hao; together they were known as Fenghao. But in the 770s the Zhou came under pressure from barbarian raiders known as the Rong and also from their own vassal states, and in 771 moved their capital eastwards to a site near modern Luoyang on the Yellow River, now in Henan Province. This was a key moment in Chinese history – and in the history of the Qin.

When the Zhou moved eastwards, they charged the Qin with guarding their western frontier and formally granted the rank of duke to Xiang (his father Zhuang became known as duke posthumously).[9] With the Zhou kings now residing 500 kilometres away to the east, the Qin found themselves in prime position to take advantage of a virtual power vacuum west of the Yellow River. In fact Xiang's son and heir Duke Wen was one of the great warriors of early Qin history and took full advantage of his freedom to act autonomously. He ruled for fifty years, from 765 to 716, outliving his own son, and left his grandson Xian a much larger territory by defeating the same Rong barbarians who had attacked the Zhou. During his long rule, he moved the Qin capital back to Quanqiu (犬丘) in present-day Li County in Gansu, and then again in 762 to a site near the confluence of the River Wei and its tributary the River Qian.

In 714 the Qin moved eastwards into the province of Shaanxi, when Duke Xian, grandson of the warrior Duke Wen, created a new capital at Pingyang (平陽) on the south bank of the River Wei just east of modern Baoji, in a district today called Meixian.

This was a key site in terms of north–south communication and conquest. The Wei valley and often arid Shaanxi in the north were separated from fertile and luxuriant Sichuan by two east–west mountain ranges, the Qinling Mountains and the Daba Mountains; between them lies the valley of the River Han which later lent its name to a great dynasty and to the Chinese people – who refer to

themselves as *hanren* ('han people', or 'han nationality'). Later, the Qin were to conquer Sichuan, but for the present they were subjected to marauding attacks by the Shu people who travelled north from that province into their territory. One of the main routes for the Shu was to follow the River Bao, a tributary of the Han, up to its source and to the watershed of the Qinling Mountains near Mount Taibai, which is 3,767 metres high. Crossing a series of high passes, they could then descend by following the steep valley of a mountain torrent known as the Xie down to the point at which it flowed into the River Wei at Meixian. This route later became known as the Baoye Road (褒斜道). A British consular officer who followed it from south to north in 1917 wrote a detailed account of his journey, of stiff climbs, precipitous ravines and walking or riding over eleven passes with snow on the mountains even in May.[10] His exhausted party was relieved to reach the plains beside the River Wei, while those earlier Shu raiders had then been required to fight.

Such military harassment ensured that Pingyang was a short-lived capital of which little remains. But it was nonetheless an important site, for excavations there in 1987 unearthed numerous bronze items and a set of *zhong* ritual bells which may have belonged to Xian's son, Duke Wu. These bells bear an inscription which asserts that the Qin had inherited from the Zhou the Mandate of Heaven, a key step on the way to a unified empire. It states unequivocally that 'The Duke of Qin says: my foremost ancestor has received the Mandate of Heaven, was rewarded with a residence and has received his state.'[11] We will examine the doctrine of the Mandate of Heaven when we turn to the story of Qin Shihuang in Chapter 3.

In 677, Wu's younger brother and successor Duke De moved the capital across the river and up to higher ground at Yong (雍) in modern Fengxiang County, also today a district of Baoji.[12] The new site offered more space for building, and was well watered in addition to being safer; another attraction for people obsessed with ancestry was that it had once been the site of a Shang dynasty city. It was to remain the Qin capital for three centuries, until 349, and was the site of their first monumental tombs. Yong is the only one of the earlier capitals which may be compared to Xianyang: firstly, because

it survived longer than all the others (the next two longest were used for only fifty-five and forty-six years respectively, and Qian for just ten years); secondly, because it was the only one with a tomb complex which could serve as a model for the final great Qin monument at Lintong. Sections of the external wall of the city are still visible, although little within remains above ground.

Yong was also the site of a compelling prophecy. Sima Qian tells us that when Duke De was preparing to take up residence there, he performed sacrifices with 300 sets of animals at the Altar of Yu.[13] Once again, ancestry and ancient myth were paramount, for Yu the Great – who is credited with inventing flood control – was the founder of the Xia dynasty which pre-dated the Shang and Zhou, and could therefore be seen as an excellent role model. The chronicler describes this semi-legendary figure as follows: 'Yu was an active, helpful, capable and diligent man, whose virtuous conduct was not enough for him to avoid eventual punishment. His kindness made him worthy of affection; his word was to be believed . . . He was absolutely tireless and very majestic, taking care of both the whole and the details.'[14] Duke De also performed divination rites with tortoise shells at the Dazheng Palace to decide whether he should live there, and among other things was informed that in future times his descendants *would water their horses in the Yellow River*.[15] Given the links through the Shang and their predecessors the Xia to Yu the Great, such a prophecy was not to be taken lightly. Qin was then still a small state, but, as Confucius remarked, 'its resolution was great' and although it ruled over what was in some eyes a semi-barbaric outer region, its conduct was 'just and correct'.[16] Its reputation was growing, together with a sense of predestination.

Now the Qin began to emulate the great dynasties of the past. Sacrifice and divination were closely linked in rites that followed those of the Shang, who sacrificed hundreds of horses for their royal tombs, while the use of tortoise shells for divination was standard Zhou practice, also inherited from the Shang. An ancient document informs us that the first ruler of the Zhou used them to identify the site for his capital at Hao:

He who took the omens was the King Wu,
He took up his residence in the capital [called] Hao;
It was the tortoise [shell] oracle which decided the matter.[17]

In fact, Yong was laid out according to the stipulations of the Rites of Zhou (an official manual outlining the departments, roles and duties of the government administration). Excavations in the 1980s and 1990s discovered walls running 3,300 metres north–south and 3,200 metres east–west, as the Qin used the presence of rivers and natural topography to create a strong capital. Xu Weimin, who worked at this site, describes the city as a milestone in Qin history which marks their real rise to power over four centuries (and fourteen generations) before the time of Qin Shihuang.[18] A recent article on the city layout, published in 2013, supports this view. A total area of eleven square kilometres contained numerous gates, eight main roads, ducal palaces and temples. The three-arched city gates were eight to ten metres wide, with a main entrance and two smaller side entrances, and the rammed-earth structures, built by forcing earth between wooden planks, were up to fifteen metres in height – especially the north wall, where attacks were most likely.[19] Gates so enormous seem at first sight an exaggeration in such an era. But they also had what Paul Wheatley calls a 'cosmo-magical' significance: 'The city gates, where power generated at the axis mundi linking earth to the underworld and to heaven flowed out from the confines of the ceremonial complex towards the cardinal points of the compass, possessed a heightened symbolic significance...'[20] They were presumably also important when grand ceremonies involving sacrifice took place, for processions and to facilitate entry to the city for the large numbers of people coming in from the surrounding countryside.

It was known for centuries that the Qin continued the ancient Shang dynasty practice of human sacrifice, in which some close kin or officials offered themselves, as attested by the interment of whole bodies in royal tombs around the principal coffin, and others such as prisoners or captured enemies were killed, as attested by frequent burials in which the victims had been beheaded. The presence of

those who had been companions in real life was believed to preserve the status of the deceased in the afterlife.[21] Such sacrificial victims sometimes numbered in the hundreds, and even a smaller tomb of a queen such as the well-known one of the Shang queen Fu Hao in Anyang, in Henan Province, had the bodies of sixteen servants or slaves arranged around her coffin.[22]

In the first case that Sima Qian mentions of Qin sacrificial burials, sixty-six people were buried with Duke Wu in 678; he uses the ambiguous phrase 'those who follow the dead' – ambiguous because it is not always clear whether the following was voluntary or enforced. In the case of Duke Mu, who died in 621 after thirty-nine years of rule, 177 people were interred with him – or 'followed' him – including three members of his government from a prominent family who were probably required to commit ritual suicide.[23] Their death became a cause célèbre as the result of a famously sad poem in the classic *Book of Odes* (also known as the *Book of Songs*) which laments their death, and which we will discuss below.

A chance discovery analogous in time and mode to that of the terracotta warriors revolutionized our knowledge of this practice. In 1976 the late Han Wei, then director of the Shaanxi Institute of Archaeology, was probing for remains of the city of Yong when he met a farmer called Jin Sizhi who told him that while digging on his land for building clay his shovel had hit something very hard which made further work impossible. Han Wei excavated the site and found a huge and remarkable tomb, of which much remained even though it had been ransacked during the Han dynasty, and later during the Song dynasty. The tomb was positively identified as that of Duke Jing (ruled 576–537) from an inscription on one of thirty-three stone instruments known as the *qin*, which were placed in the tomb for musical rituals and entertainment in the afterlife. The inscription, now in the Mausoleum Site Museum, states that the Zhou rulers had approved the status of Duke Jing. He was yet another long-lived and successful Qin ruler who built on the successes of the forty-year rule of his grandfather Duke Mu.

Music was a fundamental part of all ritual and ceremony in Zhou times, as we shall see in the Epilogue in the ritual for an imperial

burial. The opening verses of a poem from the *Book of Odes* evoke the performance of rites concerning an ancestor in the theatrical setting of an ancestral temple, the wooden music frames supporting the bronze bells:

> See the blind musicians here!
> Sightless all, the men appear,
> In the temple-court of Zhou.
> All is ready for them now.
>
> Stand the music frames around,
> On whose posts rich plumes abound,
> While their face-boards, edged like teeth,
> Show the drums that hang beneath.
> Sounding-stones and hand-drums there
> In the concert part shall bear.[24]

The poem provides a vivid glimpse into an ancient ceremony, with its drums, and stones and flutes enrapturing the participants – and we might imagine spectators beyond the inner family circle also enjoying the music.

Some of these ceremonies must have been spectacular, with several hundred cattle, sheep and pigs being slaughtered even when humans were not involved. At a contemporary sacrificial site fifteen kilometres to the south-east of Yong with the ominous-sounding name Blood Pool, first located by Han Wei, new evidence has recently emerged. An interview posted online in April 2017 by the National Museum of China provided some initial detail, based on the excavation to date of 2,000 square metres out of a total of over 400 hectares covering a landscaped area with two mountain peaks and several terraced lower hills.[25] The largest of three pits here is lined with wooden boards, and the presence of model chariots – made of wood but with some bronze components – and model crossbows together with bronze arrowheads anticipates the contents of the First Emperor's mausoleum. Two other pits have yielded further chariots and hundreds of funerary objects.

The interview offers a fascinating outline of the preparations for a major sacrifice in the Blood Pool based on literary evidence, including the *Zhou li*. Once every three years an emperor would attend in person, and on such occasions work would begin several months in advance. First the animals to be sacrificed were selected from the farm management bureau and given to the office responsible for organizing the ceremony. Rare birds were also provided in order to enhance the prestige of an imperial ceremony. The Qin emperor sailed up the Wei River from Xianyang, and the later Han emperors from their new capital of Chang'an on the south bank, and then rode in a carriage from the river to Yong. Both during the journey and after arrival there were moments of ritual fasting at prescribed temples in spiritual preparation for the event. On the appointed day, the emperor would lead his ministers and other court officials through a series of prayers and sacrifices, with slaughter of the animals and ceremonial burning of the bodies. Each phase of the ritual was accompanied by precisely regulated music and singing.

According to the *Zhou li*, the funerals and burials of members of the reigning family were conducted by a group of senior court officials such as the burial officer (who decided the correct place and carried out the necessary planning with the appropriate sacrifices), the prefect of the tombs and the director of funerals (who was also responsible for the ceremonies at aristocratic funerals). In the case of a royal burial, the burial officer arranged for princes of the family to be buried in front of the royal tomb, with ministers behind disposed according to their rank; the size and height of funerary mounds and the number of trees planted above them were also carefully graduated, in this case according to the rank of the deceased.[26]

We may assume that the Qin ceremonies followed Zhou practice at this time, and employed the standard layout which had evolved with that dynasty: a ramp led down to a deep trench on an east–west axis in which the funerary chamber lay with the coffin at its centre; around this were arranged the subsidiary tombs of officials, and sometimes of slaves and personal servants. When the work was completed, and the incumbent buried, the whole area was refilled with earth up to surface level.

In the case of the tomb of Duke Jing at Yong, the funerary chamber was 24.5 metres underground. As prescribed, around it, on a slightly higher level, were placed seventy-two coffins of officials close to the duke who were required to commit suicide to join him in the afterlife; beyond them were smaller coffins of a further ninety-four men, artisans, musicians and instrument-makers.* Nearby there were also twenty coffins of labourers who had worked on the tomb, just like those at the First Emperor's mausoleum (already in 537!). Altogether, this means that 186 people committed suicide or – more likely – were killed to 'follow' the duke. The coffins themselves were made of massive cedar beams. Those used in the duke's coffin were 7.2 metres long and 21 centimetres square in cross section, hewn from trunks with knives since they possessed no adequate saws. Knife marks may be clearly seen on the beams displayed at the museum of the Yong site.[27] They were connected with dowels, and then the joints were strengthened by elaborate bronze 'cages' or brackets which also provided support for ninety-degree angles at the corners.†

The director of the museum at the site, Jing Hongwei, believes that the dimensions and perfection of these massive beams marks the rise to real power of the Qin family. For such work, he reasons, implied a huge workforce for the timber felling by axe, for transport to the site and for cutting to shape, comparable in proportion to that of the duke's famous descendant fourteen generations later.[28]

So this mausoleum can be read as a preliminary study for its more famous successor at Lintong, developing the model of earlier tombs in Gansu to create a monumental structure which is already larger than the imperial tombs of the Zhou. It thus symbolizes the ambitions of the Qin at a very early stage. In fact there were deeply felt links between the First Emperor and his ancestors at Yong. Sima Qian tells us that in the fourth month of the year 238 King Zheng, the 22-year-old future emperor, spent a night there when he 'took the cap of manhood and wore a sword on his girdle'.[29] This refers to the 'capping' ceremony which took place at the door of the Hall

* Illustration 15 on List of Illustrations, p.ix.
† Illustrations 17 and 18 on List of Illustrations, p.ix.

of the Ancestors on a carefully chosen auspicious day, akin to the ceremony of being girded with the belt of knighthood in later European tradition. As one modern scholar of these rituals has written: 'Early Chinese feudalism was based primarily on ties of kinship; punishment was often meted out to entire families rather than individuals; and ancestor worship was the major focus of religious life. As a result, the careful definition of family roles and transitions was fundamental to the organization of society.'[30] The ancestors always had to be 'present' at such moments.

The capping was perhaps the key moment in a man's life.[31] For after this ceremony a man was thought to be ready to govern other men, and in Zheng's case the formal regency of Lü Buwei came to an end. According to one ancient text, 'it was on this account that the sage kings attached such an importance to the ceremony, and therefore it was said, that in capping we have the introduction to all the ceremonial usages, and that it is the most important of the festive services.'[32] The temple, ancestral hall and tombs of Yong created the tradition for his family and informed Qin Shihuang's own actions. That he should travel to Yong for his own capping ceremony emphasizes the city's key role in Qin history, and his personal deference towards the rites and customs.

In the first year of his rule, Duke Xian of Qin (384–362) moved the capital further east to Yueyang, which was situated on a fluvial plain about twenty kilometres from Yanliang – today the seat of one of the nine districts of Xi'an, north-east of the modern city. One of the reasons for the move seems to have been to station his armies closer to the Hann, Wei and Zhao who had been encroaching on the former Qin territory. Yueyang was just a five- or six-day march from the Yellow River. From Sima Qian we learn that the city was walled in that first year,[33] and that the duke was then thinking of a move further east to the natural border formed by the broad river. But his son, Duke Xiao (361–338), succeeded in bringing much of the lost land back under Qin control without such a move. The exact site of Yueyang was unknown for centuries, until it was located in 1964 by archaeologists who identified walls indicating an urban area of around two square kilometres. Further work was carried out in

1980–1, and detailed excavations were started in April 2013 with a view to tracing the complete walls. The city has been found to be larger than previously thought, rectangular in plan, with north–south walls 2,500 metres long, and east–west walls of 1,900 metres. There were three main east–west streets as wide as fifteen metres, leading to three gates in each direction, while the other walls were provided with two gates. As in Yong, the gates were wide for a fairly small city at around six metres. The existence of three possible sets of walls has been explained by the presence of several rivers and ancient canals, suggesting that floods and shifting river courses necessitated frequent changes to the original plan.[34] This may also be why the capital was moved to a safer site on higher ground at Xianyang after only thirty-five years, just as convenient riverside Pingyang had given way to the safer and more practical Yong.

The site is still being excavated. It was announced in January 2017 that a large underground room and a very rare fireplace had been found, suggesting that the ruined buildings above were of some importance. Such a basement was usually associated with a royal owner, and the experts who made the discovery have suggested that it was a storage room for concubines.[35] Perhaps these would have been the concubines of a member of the Qin imperial family, although the exact date of these features is as yet unknown.

For the Qin, the final momentous shift came in the twelfth year of Duke Xiao's reign, when he moved the capital slightly to the west from Yueyang to Xianyang, across the River Wei from what was later Xi'an – and just north of the old Zhou capital of Fenghao. Existing towns and villages were incorporated into a single and much-expanded city, to which nearby people were forced to move. New and larger palaces were constructed, with vast reception halls, and what Sima Qian calls two towers were specially prepared for the display of imperial edicts. In fact the phrase used, Jique (冀阙) or Ji Gate Towers, means something closer to palace halls, and *ji* also has the secondary meaning of 'tall and imposing'.[36] So they were more than simple towers. In anticipation of Qin Shihuang, and another indication of how he simply followed and built on the foundations of his ancestors, one new edict affixed to these towers decreed that

the measures of length, weight and volume should be the same throughout the kingdom. As if in recognition of this new power, the Zhou emperor now elevated Duke Xiao to the dignity of *pa* (伯), the third highest imperial rank, and named him the supreme chief of the princelings (秦) and an imperial 'uncle' – the highest rank to which a person not of imperial birth could attain. In 341, the other ducal rulers travelled to pay homage to Duke Xiao at his new city. In the words of the late nineteenth-century Jesuit sinologist Albert Tschepe, the fact that only he had been accorded such an honour by the emperor indicated that 'while the man with the poetic title of emperor resided in Luoyang, real authority rested with Duke Xiao in Xianyang'.[37] The Qin were already set on the path towards imperial rule a century before the First Emperor himself was born.

This progress was enhanced when the new duke took as his political and strategic adviser the shrewd and skilful statesman usually known as Lord Shang (390–338). Shang had been born in the rival state of Wei, where he served at the court of King Hui (370–319), but later his ambition took him to the stronger state of Qin when he learned that Duke Xiao was seeking new advisers in Yueyang. Gifted with an eye for the main chance, he sensed that there would be greater opportunities as the Qin achieved the domination he foresaw. Shang had studied criminal law as a young man, and his expert administration of the law and its punishments served as the basis of his success and made him a key figure in Qin history. We know more about his life and work than about those of most other statesmen of the time thanks to a chapter of Sima Qian's *Records* dedicated to his life, and to the survival of the even more detailed *Book of Lord Shang* which made him a byword for his severity; both were translated into English in the twentieth century, the latter by the great Dutch sinologist J. J. L. Duyvendak in an edition of 1928 with a long and excellent introduction. Lord Shang brought brigands and surviving independent feudal cities and clans under centralized control, and broke up the traditional structure of noble families to create a meritocratic hierarchy of officials. He introduced the policy of dividing the entire population into groups of five or ten families, thus providing a measure of social control through denunciation

and joint responsibility for offences – so that if one person committed a crime, the whole family would be punished. But together with these severe measures he encouraged agriculture and weaving, introduced individual land tenure and insisted on the importance of bringing wasteland under the plough. He understood very well that 'the means, whereby a country is made prosperous, are agriculture and war'.[38] This is why an introductory paragraph on law in his *Book* is followed by another entitled 'An order to cultivate waste lands', with an emphasis on ways of encouraging or forcing the inhabitants to grow more food, especially grain.

Lord Shang first worked on his reforms in Yueyang, then later in Xianyang when the Qin moved once again to build their final capital. In some ways, his assertions – and style of argument – resemble a Machiavelli *ante litteram*, for example when he writes: 'If the people are stronger than the government, the state is weak; if the government is stronger than the people, the army is strong.'[39] The latter case also provides a safe environment in which agriculture and wealth may be stimulated. Tradition and most later books have it that the punishments devised by Lord Shang were issued with a severity that has rarely been equalled, that in some ways he was a monster. Yet, obviously, he was a man of his time. One of the most interesting commentators on events during the Warring States period is Han Fei (c. 280–233), a political philosopher who has also been compared to Machiavelli for his shrewd observations on statecraft, and who had been a student of the Confucian scholar Xunzi (310–235). In his book the *Hanfeizi*, or 'Master Han Fei', previously rendered as Han Fei Tzu, he recounts a curious episode which illustrates an utterly different moral code to that of our times as far as punishment is concerned:

Once in by-gone days, Marquis Zhao of Hann was drunk and fell into a nap. The crown-keeper, seeing the ruler exposed to cold, put a coat over him. When the Marquis awoke, he was glad and asked the attendants, 'Who put more clothes on my body?' 'The crown-keeper did,' they replied. Then the Marquis found the coat-keeper guilty and put the crown-keeper to death. He punished the coat-keeper for the neglect of his duty, and the

crown-keeper for the overriding of his post. Not that the Marquis was not afraid of catching cold but that he thought their trespassing the assigned duties was worse than his catching cold.[40]

There were indeed severe forms of punishment, from execution by beheading to castration, and the bastinado was regularly used during questioning. One often cited and drastic measure was the cutting in half at the waist of those who failed to report a crime. Han Fei reminds us of the importance of punishment in the eyes of a sophisticated Confucian: 'The means whereby the intelligent ruler controls his ministers are two handles only. The two handles are chastisement and commendation. What are meant by chastisement and commendation? To inflict death or torture upon culprits, is called chastisement; to bestow encouragements or rewards on men of merit, is called commendation.'[41] Moreover, some of the lesser punishments were fundamentally important to the system. For example, the category of hard-labour convicts who were assigned to wall-building activities was essential for the extensive building projects of the Qin.

In 1975, a fragmentary set of laws and regulations written on more than a thousand bamboo strips was discovered in Hubei Province in the tomb of a third-century prefectural clerk named Xi. They revealed a previously unimaginable attention to detail and administrative efficiency in such matters as the numbers of calves and lambs born each year, the deaths of horses, transactions in foodstuffs and salaries. For example, oxen were regularly measured and once a year subjected to a meticulous evaluation, after which the overseer of agriculture was rewarded or punished: the reward might be a bottle of wine and some dried meat, but if 'the oxen have been used in agricultural work and they have decreased in girth, the person in charge is bastinadoed with ten strokes for each inch'.[42] In contrast to such severity, the texts also demonstrate, in answers to questions submitted to the authorities, considerable leniency and understanding both of criminal acts and of the people who commit them. They were translated into English by another eminent Dutch sinologist (and student of Duyvendak), who comments in his introductory

remarks on the extreme care taken in the investigation of criminal suits. The description of the detective work involved in building a case seems strikingly modern, such as detailed evidence reports on a highway murder concerning the location of the body, the fatal wounds, clothing and even precise measurementof the distance from the corpse at which its shoes were found.[43] Further brief examples offer insights into the Qin legal system and the equally modern-sounding use of precedents in the determination of guilt:

> When a thief-catcher pursues and arrests a malefactor, the malefactor beats the thief-catcher and kills him. Question: is the killer to be considered as having killed a person with murderous (intent) or as having killed him in a fight? It is killing a person in a fight, but the Precedents of the Court consider it is murderous (intent).[44]
>
> It happens that a person is murderously killed or wounded on the road, (but) the bystanders do not help him. If (they are) within one hundred paces this is comparable to the suburbs and warrants a fine of two suits of armour.[45]

These 'working instructions', as we might call them, provide a different view of the Qin laws as established by Shang and continued into the reign of King Zheng – from whose time the bamboo strips are thought to date although the rules are themselves older. The very fact that provincial bureaucrats were able to ask for clarification about the laws and precedents is striking, as is the fact that officials who refused to answer their questions could themselves be punished. The thinking behind this is interesting, for 'the clerks clearly knowing that the people know the laws, they will not dare to treat people contrary to the law, nor will the people dare to violate the law'.[46] This is a sophisticated and balanced view for the fourth century BC.

Administrative reforms and emphasis on the legal system developed by Shang enabled the Qin to become a formidable military power – and construction empire – with centralized control superior to that of its rivals, favouring philosophical reasoning which entailed

the use of law, the manipulation of statecraft and the exercise of political power.

In the year 350, an order was affixed to the Ji Gate Towers in Xian-yang 'forbidding fathers and sons, elder and younger brothers from living together in the same house. The small cities, the villages and towns were to be combined into districts, *xian*, over which he placed officials called prefects, *ling*, and assistants, *cheng*, with altogether thirty-one districts... In order to obtain arable land he opened up a longitudinal and horizontal path and the border country, and the *fu* and *shui* taxes were equalized; he [Shang] standardized weights, skills, and measures of quantity and length... After five years the people of Qin were rich and strong.'[47] Thus many of the measures which Qin Shihuang 'introduced' over a century later were already present in Shang's writings, and indicate that his own administrative excellence had a gestation as long as the Qin conquest of their rival states. They were also long-lasting, since Shang's *xian* (县) survives today as a descriptive term for a district and as a part of many place names.

Indeed, such measures were already implicit in the writings of Confucius a century before that, for the philosopher's ambition had been to re-establish political harmony after the disintegration of the relatively unified Zhou state, and also to unite the Warring States. His emphasis on morality, social relationships and justice was driven by a desire to create a single polity, and his works were intended to enhance the virtues of Chinese traditions and beliefs within such unification. At a time of political chaos and constant war between the many small states, Confucius yearned for what he perceived as the ancient order which could bring back an era of peace and pros-perity. Unfortunately his wish to become a political decision-maker remained unfulfilled, but his thoughts evolved and became widely known through the classic texts compiled by his followers just as the Qin were beginning their rise to power. Mencius, for example, a student of the grandson of Confucius, recounted a conversation with one of their neighbours, King Hui of Wei, during a visit in the year 319: 'Abruptly he asked me, "How can the empire be settled?" I replied, "It will be settled by being united under one sway."'[48] Other

prominent followers, such as Han Fei, became direct advisers to the Qin. The means changed as Confucian ideals were modified in favour of Shang's legalistic approach to government, but the desire for peace which would follow unification ran parallel to his thoughts.

Unification was already in the air, and from around the same period informed the ambitions of the Qin.

3

FROM PROVINCIAL KINGS TO UNIVERSAL EMPEROR

King Huiwen (338–311), the son of Duke Xiao, was the first of the Qin to assume a royal title – a powerful symbolic statement of consolidated power. As the grandson of Xian, the son of Xiao and the great-great-grandfather of Qin Shihuang, he occupies a pivotal role in the story of the Ying/Qin family by linking ducal past and imperial future.

He was an excellent military leader who greatly expanded Qin territory and provided the base for later conquests by introducing new military techniques and tactics. It is known, for example, that the first mounted archers in Chinese history were the nomadic peoples known as the Hu.[1] During the Warring States period, this expression was used as a generic term for all nomads but gradually became identified with the Xiongnu, who were a constant threat in the north for the Qin and later for the Han dynasty.[2] In his history of the Han, Sima Qian devotes a long chapter to his 'Account of the Xiongnu'.[3] It is also well known that the Zhao learned from the Hu the practice of shooting from the saddle. Their ruler Wu Ling (325–298) introduced nomadic tactics to his army; changing traditional customs, it was said that he 'wore the costume of the Hu, and trained cavalry and archers'.[4] This meant wearing loose breeches, which were more suitable for shifting the body in the saddle and shooting from horseback. Li Mu, a Zhao general considered one of the greatest of all Warring States commanders, not only trained his men in riding and archery but also began the use of signal towers to send orders rapidly over great distances. In King Huiwen's time, these practices were adopted by the Qin and used for the first time

in a successful campaign beyond traditional Qin lands, when in 316 they annexed Sichuan to the south. The natural wealth and resources of that province made it an attractive target.

Anticipating his great-great-grandson's military strategy, Huiwen used a 500-kilometre road he had built two years previously to drive the Qin army directly into Sichuan.[5] He had tried various stratagems to gain access to Sichuan, for example seeking to exploit the supposed avarice and lust of the ruler King Kaiming XII of Shu by sending concubines as gifts. Then he settled on a more complex plan. This entailed the creation of five stone cattle, or oxen, who had lumps of gold hidden under their tails to give the impression that they always excreted precious metal. The story goes that the gullible Kaiming believed this and built a road through the mountains to Hanzhong strong enough for these miraculous animals to be delivered to him. When the road was completed, instead of sending the precious stone cattle, the Qin army invaded his lands along what became known as the Jinniu Road (金牛道), or 'Golden Ox Road', and took his capital.[6] It was probably the first of several 'plank roads' built along sheer cliffs high above mountain torrents and waterfalls on the major north–south routes, constructed by driving timber brackets into the rock-face, sometimes using fire to crack the rock. These plank roads were used until recent times, and some restored sections may still be seen south of Hanzhong – as well as a reconstruction of the entire route in the city's rarely visited but interesting museum.

The new royal highway ran to the west of the road that the marauding Shu had taken to Meixian, but was much longer because it had a southern extension over the Daba Mountains south of the River Han: the first part, the Chencang Road (陈仓道), passed over the Qinling Mountains from Baoji, to the west of Meixian but still on the River Wei; the second part, the 'Golden Ox Road' proper,[7] passed over the Daba Mountains and through the treacherous pass and gorges of Jianmen Guan down to the Shu capital – which had recently been moved by Kaiming and renamed Chengdu. The Tang dynasty poet Li Bai (also known in English as Li Po) was not exaggerating when

he composed the refrain for his poem about the road, here in Arthur Waley's 1919 translation:

> It would be easier to climb to Heaven than to walk the Sichuan Road; and those who hear the tale of it turn pale with fear.[8]

By means of this extraordinary feat of engineering, and the courage of an army taking a perilous route along what Waley translates as 'sky ladders', Huiwen and the Qin came to control the southern states of Shu and Ba. The picturesque name of a later road, which links the Chencang and Baoye roads, the Lianyu or 'Linking-Cloud Trestle Road' (连云道), renders the idea behind Li Bai's fears; this expression is also used sometimes for the whole of the first section instead of just the Chencang Road. The achievement was strategically of immense historical importance. In the words of an expert on the Chu, 'there is no doubt that the single most significant event in the balance of power in Warring States times was the Qin conquest of Sichuan (Ba and Shu) in 316'.[9] It could only portend a major struggle between Qin and Chu, whose lands lay to the east of Sichuan, and was thus an important military milestone in the rise of the Qin. It also resulted in the death of King Kaiming in battle as he attempted to resist the Qin advance in northern Sichuan.[10] The Shu capital of Chengdu, which previously only had a wooden palisade, was now walled and reconfigured as a larger Qin city; according to one ancient source it was laid out as a reduced version of Xianyang.[11] Now a fertile area known to the ancient Chinese as 'Heaven's storehouse' could provide sufficient grain for the Qin armies. The success of this conquest was largely due to the construction of the road south from Baoji.

A few decades later, the well-organized and efficiently administered Qin state was admired by Xunzi, who visited around 264 and first commented on the excellent topographical features which helped it to become independent: 'Its defences at the border barriers have a natural strength of position. Its topographical features are inherently advantageous. Its mountains, forests, streams, and valleys are magnificent. The benefits of its natural resources are

manifold. Such are the inherent strengths of its topography.'[12] Xunzi also praised the people as clean and not frivolous, obedient to the authorities, dignified in their behaviour and serious at their work. These factors, he concluded, together with excellence of administration, were behind the success of the Qin rulers over the past four generations. It must be said, however, that Sima Qian disagreed with the notion that the geographical configuration had made their success possible. He wrote in his introduction to a chronological table of the other six kingdoms that it 'seemed more a matter of being helped by Heaven'.[13]

One of King Huiwen's first actions on ascending the throne was to dispose of Lord Shang. As the statesman Su Qin argues to the king in the *Records of the Warring States*, 'when the great ministers are too important the state is in danger. When those in attendance are too intimate one's person is in danger. Now the women and children of Qin all talk of the prince of Shang's laws.'[14] In truth, Shang could hardly have expected to survive the death of his patron, Duke Xiao. He was formally accused by Huiwen of fomenting rebellion, but was actually punished in revenge for actions he had taken against the new king when his father was still alive. He was executed by the brutal system of dismemberment, with chariots pulling him apart. Altogether nine members of his family were executed, due to the severity of the laws he himself had devised and implemented – hoist by his own petard.

From the new capital, King Huiwen waged almost constant war against the other states with a ferocity which made Shang's laws seem humane by comparison. According to the numbers supplied by Sima Qian, in the twenty-seven years of his reign, from 337 to 310, Huiwen's generals captured dozens of cities from Qin enemies and beheaded hundreds of thousands of defeated troops: 80,000 after a battle with the Wei, 82,000 after a war against the combined forces of Hann, Zhao, Wei and Yan, 10,000 after a battle with the Hann and a further 80,000 after victory against the Chu. While these figures may be exaggerated, there were many other battles between these major campaigns, and the total – whether real or imagined – gives

some idea of the determination and military force of the Qin during Huiwen's reign.

In addition, there was another fascinating aspect of his rule, for he took as his wife a woman of Chu origin who was to have a huge impact on the Qin story. This woman, whose personal name was Mi, belonged to the princely house of Chu. In fact the Chinese historian Chen Jingyuan argues strongly that the concept of the Mausoleum and Terracotta Warriors derives from this influential ancestor usually known as the Dowager Queen Xuan (or Queen Mother), but also as Lady Mi. He puts forward, Luther-like, sixty-three theses to sustain his argument. On most counts, his theories are dismissed by archaeologists as eccentric, but in this respect he may have a valid point.[15]

This extraordinary lady, a precursor of the Dowager Empress Cixi in the nineteenth century, entered the court as a concubine and, as often happened with favourite concubines, then became King Huiwen's second wife. Given her evident ambition, she certainly would have dreamed of her son as the progenitor of a great and long-lived dynasty worthy of such a memorial.

One sign of the ruthlessness with which Lady Mi pursued her ambitions came when she seduced the ruler of the Yiqu, a half-nomadic half-pastoral people who lived to the north of the River Jing, a tributary of the Wei, within the area of the great northern loop of the Yellow River known as Hetao. It seems to have been a fairly long affair, since she bore him two sons. But later she murdered her lover and arranged for a Qin army to conquer his lands; thus a woman of Chu origins married into the Qin managed to bring to them the lands of another people who had long troubled them along their northern frontier. Whether seducing the Yiqu ruler was real or elaborated later to defile the memory of the Qin, she also had a reputation for licentiousness. Once, as recounted in the *Records of the Warring States*, she employed the following provocative example in the course of a discussion after Huiwen's death: 'When I served our former king, if he put his leg across my body I would object, saying it was uncomfortable, but when he laid his whole body upon me I did not find it heavy. Why was this? Because I felt the former act held little benefit.'[16] She became known as the Dowager Queen when

her eldest son Zhaoxiang, then seventeen, became king on the death of his elder but childless half-brother King Wu due to the political skills and conniving of her own half-brother Wei Ran.

She then acted as regent for three years until Zhaoxiang reached 'the cap of manhood'. Wei Ran and her full brother Mi Rong were excellent and loyal military commanders, while her two younger sons were keen to defeat machinations by their older half-brothers who supported King Wu. It is obvious from historical accounts that the real founders of the dynastic power which led to the final unification of China were Queen Xuan and her clique made up of what were known as the 'Four Nobles', namely her brothers and her sons.

Her son King Zhaoxiang brought stability at least in part because he reigned for fifty-seven years (307–250). It was his aggressive territorial expansion, planned and executed with the aid of his mother, uncles and brothers, which made the Qin the dominant force in the decades before the future emperor's accession as King Zheng. As soon as Zhaoxiang became king, he made his uncle Wei Ran a general and charged him with the defence of the capital at Xianyang. Later, he served as prime minister for three separate terms, and became known to history as the Marquis of Rang. For after fifteen years as military commander and prime minister he was rewarded with the rank of marquis and given lands in Henan at Rang, whence the title, and also in Tao, in neighbouring Shandong.[17] He personally led an attack on the state of Wei, and captured sixty cities there. His role in suppressing the Wei, Zhao and Hann was fundamental to Qin success. In 274, he led another attack against the Wei which resulted in a huge victory, with the chroniclers recording the beheading of 40,000 captured soldiers, and in the following year together with the great general Bai Qi he destroyed the joint forces of the Wei and the Zhao in a ferocious battle at Huayang, in Henan,[18] this time cutting off the heads of 100,000 troops and taking several key cities. It is said that like many successful generals and ministers in history he, together with his sister, became so powerful and wealthy that his enemies within the court conspired against him. He was eventually forced to retire to his lands in Tao, but had already played a fundamental role in Qin history given that after a long period at the helm of the

kingdom the road to unification was prepared. Sima Qian tells us explicitly that that expansion of Qin territories was possible thanks to the Marquis of Rang,[19] which also means at least implicitly thanks to his sister. His success was also that of King Zhaoxiang, who at the end of his long reign was a mature and powerful king well on the way to establishing a single empire.

In fact Zhaoxiang once attempted to create a twin empire – to resolve the conflicts of the Warring States and create a stable and well-organized society. In the nineteenth year of his reign, 'the king took the title of Emperor of the West, and [the king of] Qi proclaimed himself Emperor of the East'.[20] However, after a few months both renounced their titles. It seems that they soon understood that the title of *di*, emperor, was meaningless if held by two people at the same time because unlike a Roman emperor his Chinese equivalent would *by definition* rule over 'all under heaven'. There was thus a logical contradiction involved in the concept of twin emperors. But the attempt to overcome it shows that in 288, nearly seventy years before Qin Shihuang's eventual success, his great-grandfather had already sought a similar unification.

This is significant because there were very direct links between Zhaoxiang and Zheng, the future Qin Shihuang. Zhaoxiang's son Zhaowen died just three days after his coronation, and *his* successor Zhuangxiang, the emperor's father, ruled for only three years;[21] thus there was first of all a virtual continuity of policy, since the two intermediate kings had no time to stamp their own authority on the kingdom before Zheng himself became king just three years after Zhaoxiang's death. More importantly, we may assume that the future emperor knew and was inspired by King Zhaoxiang, because he was already nine years old when his great-grandfather died. Given the extreme veneration for his ancestors, could there be a more important one than a great-grandfather he had known personally and who may have spoken to the young boy of his imperial ambitions?

There are even hints that these ambitions actually dated back to the time of Zhaoxiang's own father, King Huiwen, and thus to the ambitious Lady Mi – as she then was. In the *Records of the Warring*

States, there is a remarkable prophecy made by the king's strategic counsellor Su Qin, who addressed his master in these words:

> Your Majesty's State, in the west, has the produce of Ba, Shu, and Hanzhong,[22] on the North it has the use of the badgers of Hu and the horses of Tai,[23] on the South there are the borderlands of Mount Wu and Qianzhong,[24] and on the East the strongholds of Xiao and Xian.[25] The cultivated ground is rich and choice. The people are numerous and wealthy. Of war-chariots there are 10,000. Of warriors impetuous in attack there are a million. Of fertile country there are 1000 *li*. The stores are abundant. The configuration of the land is advantageous. It is what is called a Celestial Treasury, the most powerful State under heaven. With Your Majesty's ability, the multitude of your offices and people, the readiness for use of your chariots and cavalry, and their instruction in military tactics, you may annex the feudal States, absorb all under heaven, and rule with the title of Emperor.[26]

King Huiwen replied modestly that 'I have heard that (a bird) which is not fully fledged cannot fly high...'[27] But the seed was sown, and his wife was to persist with this vision as Queen Dowager well beyond his lifetime until a fully fledged bird arose from within the family.

Such prognostications persisted. There is another story from the *Records*, described in a volume of selections from that book as a 'romance', in which Huiwen's prime minister and strategist Zhang Yi – an opponent of the ideas of Su Qin – explains to the king of Chu that 'the only reason Qin has not sent her troops beyond Han-ku Pass these fifteen years past is because she has been secretly planning how to devour the empire'.[28] The *Annals* of Lü Buwei also recount a story from the time of Zhaoxiang in which the following sentence occurs: 'There is the opinion that the king of Qin will be the master of emperors and kings.'[29] It is true that this compilation dates from the time of the young King Zheng himself, but the scholars who wrote it were quoting and drawing on earlier sources. Dreams and rumours had circulated for centuries.

The idea of unification and empire returned again in the mind of

Qin Shihuang's father King Zhuangxiang. Li Si, the future minister in the First Emperor's government, was contemplating his next move after finishing his studies with Xunzi,[30] and knew that with the rivalry between the Warrior States coming to a head there would soon be plenty of opportunities for employment. Although he was a native of Chu, having been born in Shangcai in the south of Henan Province,[31] he believed that the current king of Chu would not be an ideal employer in terms of advancement. Hawking his intellectual wares around as Lord Shang had done earlier, he decided to approach the Qin precisely because he had heard that Zhuangxiang wished 'to swallow up the world, to call himself emperor and rule it'.[32] This rumoured ambition was not fulfilled for the king soon died, but the episode provides an interesting insight into the historical mindset of the Qin family.

Such failed attempts, together with the forecasts recorded nearly a century before Qin Shihuang's birth, indicate for how long the dream of a unified state had been nourished by the Qin – at least since the time of his great and much admired ancestor Duke Jing.

In 259, the future emperor was born far from the traditional Qin lands in Handan, then the capital of the Zhao kingdom and now in the modern province of Hebei. This town, today an anonymous industrial centre, stands at a strategic site on the main route from Beijing to Xi'an, about halfway between the two cities, at a point where the key ancient provinces of Hebei, Shandong, Henan and Shanxi meet. The family was living there because of an alliance between the houses of Qin and Zhao negotiated by King Zhaoxiang, which required the presence of his grandson Prince Yiren (later King Zhuangxiang) – father of the newborn child – as a hostage to guarantee its success. He was born therefore as a hostage to internecine war, within the lands of an enemy state, a circumstance which must have sharpened not only his awareness of his future role but also his ambitions. He was then known as Zhao Zheng, putting together his family name Zhao with the month of his birth, Zhengyue (正月), the first month of the traditional calendar, used as a personal name.

It was at this time that the family came under the influence of

the wealthy merchant Lü Buwei, whose concubine, known as Zhao Ji, Prince Yiren had taken as wife (her surname Zhao was taken from the state in which she lived, and had no connection to the Qin clan name Zhao). Lü Buwei was by all accounts a unique man, who rose from being a successful merchant in Handan to become first regent and then chancellor to an emperor – comparable to a European figure like Cosimo de' Medici in this shift from mercantile and financial success to genuine political power. He was certainly a man with clear ambition if a story from the *Records of the Warring States* is to be believed. Having met Prince Yiren, he went to his own father and had this conversation:

'What is the yield of ploughing the fields?'
'Tenfold.'
'What is the profit on pearls and jade?'
'A hundredfold.'
'What is the profit of setting the ruler of a State upon his
　　throne?'
'It cannot be counted.'[33]

But he was a shrewd statesman as well as a go-getter. His *Annals*, compiled for him in 239 from ancient texts and wisdoms by leading scholars, provide a comprehensive philosophy of government offering insights into the later administration of an emperor who was in effect his protégé. It is a compendium of wisdom with anecdotes and sayings from the Yellow Emperor, the Daoist writings and Confucius among others. Lü Buwei was quick to seize his chance when Prince Yiren arrived as a hostage in Handan. Recognizing that Yiren had legitimate claim to the throne of Qin but was being held back by intrigues at court, he facilitated his emergence as heir to the throne by travelling to Qin and using his wealth for some astute bribery. Thus he established himself as a vital part of the court-in-waiting, and when Zhao Zheng was born became the boy's tutor and mentor. The *Annals* provide us with a unique insight into the intellectual atmosphere of the court, with its emphasis on almanacs and ritual, in which the future emperor grew to maturity.

It is often said that Lü might have been the real father of the future emperor, but most historians now believe that that story was a later addition by a Confucian scholar intended to slander the reputation of the First Emperor in the eyes of the Han. The late Derk Bodde, a reliable and conscientious historian of ancient China and the translator of several chapters from the *Records*, dismissed the story as 'definitely untrustworthy' in the conclusion to his study of Lü's biography.[34]

When, in 250, Prince Yiren became King Zhuangxiang, Lü Buwei moved to Xianyang, became his chancellor and was ennobled as a marquis. In the words of the late John Knoblock, the American translator of the *Annals*, Lü now became 'the de facto ruler of Qin'.[35] Some modern Chinese authors, such as Yang Kuan in his 1956 biography *Qin Shihuang*, accord even greater importance in the process of unification to Lü than to the emperor himself.[36] In fact, Lü oversaw the period in which the Qin conquered their six neighbouring states and were enabled to complete the unification of China, and he took an active part in military campaigns. In 246, at the end of his father's three-year reign as Zhuangxiang, the young boy became King Zheng of Qin under the regency of Lü Buwei. The latter's *Annals* may be read as a kind of training manual for the future emperor, who must have studied them attentively.

The early chapters illustrate the importance of ancestry and historical precedent by constant reference to the dukes and kings of Zhou and the Warring States, emphasizing the way in which the young emperor was imbued with a sense of history and his role as the Son of Heaven – as we will see when we look at the historical precedents for Qin Shihuang's mausoleum and terracotta army. The broad duties of a ruler are made clear, for example in the emphasis on efficient administration in land management that many would do well to follow today. Predictable events such as spring flooding were prepared for by ordering the director of works to make thorough inspections of the walled cities, including the capital, and also to visit plains and fields which might be subject to flooding. His staff should make tours of inspection, and also check dams, dykes and ditches and repair where necessary, ensuring that there would be

no potential blockages. Even roads were to be checked so that there would be no obstacle when the rains came.[37] Such attention to detail is laudable and extremely practical. Other chapters deal with ethical matters such as filial piety, being a good ruler and conduct and strategy in war, and provide an essential philosophy of government for centralized control. We might imagine the boy-king discussing the ideas with his mentor, absorbing the importance of attention to detail.

Wei Liao, a respected military strategist, author of a military manual and an acute observer, provided a brief but intriguing portrait of Zheng before he became emperor, which Sima Qian quotes: 'The King of Qin has a large nose, broad eyes, and the chest of a bird of prey; he has a voice like a jackal; he's not very kind to others, with the heart of a tiger or wolf. When he finds himself in a difficult situation it's easy for him to be humble to others, but when he achieves his aim he will just as easily devour men.'[38] This description rings true when we consider the ruthlessness with which he murdered rivals and overcame coups against him in the early years of his rule – including an attempt to take power by his half-brother Zhao Chengjiao. The discipline and bloodthirstiness of his army were legendary, with a few hundred heads cut off here and a few thousand there as he fought each of the rival states. He also survived two assassination attempts, and seems to have been personally fearless. One story relates how he once walked through the streets of Xianyang during the night, incognito and with a very small retinue of four guards.

The meticulous attention to detail which went into the running of the first empire was already discernible in the young king's military expeditions against his enemies, based on the acceptance of discipline. All the authors of the seven military classics of ancient China stress the importance of discipline and organization for success in war. As the author on strategy Wu Qi wrote around the year 400 of earlier generations of his family, 'Qin's character is strong, the land treacherous, and the government severe. Their rewards and punishments are believed in, the people never yield but instead are all fiery and contentious.'[39] In similar vein, Xunzi recounts how during his visit to Xianyang he saw government officials 'sternly attend to their

functions, none failing to be respectful, temperate, earnest, scrupulously reverential, loyal, and trustworthy, and never being deficient in the execution of their duties'.[40] These duties were performed so serenely that it even seemed as if there were no government at all, just as things had been in antiquity. This was high praise indeed from a Confucian, who seems nevertheless to have disliked the Qin.

In around ten years from 230 to 221, in a celebrated and poetic phrase of Sima Qian, King Zheng devoured his enemies as 'a silkworm devours a mulberry leaf'. He was well versed in military strategy and often adopted intrigue and stratagem in place of sheer ferocity, as Sun Tzu recommends in the opening paragraph of the third book of his *Art of War* : 'In the practical art of war, the best thing of all is to take the enemy's country whole and intact; to shatter and destroy it is not so good.'[41] But Sun also knew the huge cost of war, as he had written earlier:

> In the operations of war, where there are in the field a thousand swift chariots, as many heavy chariots, and a hundred thousand mail-clad soldiers, with provisions enough to carry them a thousand *li*, the expenditure at home and at the front, including entertainment of guests, small items such as glue and paint, and sums spent on chariots and armour, will reach the total of a thousand ounces of silver per day. Such is the cost of raising an army of 100,000 men.

Excellent strategy based on such perceptive manuals of warfare, together with harsh discipline and well-trained warriors, was the basis of Qin power, principles derived from the long tradition of the Zhou. For in essence the Qin army had been a unit of the Zhou military organization. But now the Qin added charismatic leadership to the equation, provided by the king himself and several outstanding generals.

Another significant Zhou contribution made the task of sustaining long-term control over conquered peoples easier. They had understood during the transition of power from the Shang dynasty at the turn of the millennium that they needed to legitimize their

status in order to convince traditional feudal powers to accept them as genuine rulers. So they honed a system of divinely attributed authority based on the *tian ming* or Mandate of Heaven. Whereas the Shang had claimed a quasi-religious authority, the Zhou developed what was much more a secular and political doctrine based on the tripartite division of heaven (*tian*), emperor and earth/people, in which through a complex system of rituals – perhaps most clearly imaginable in a structure like the Temple of Heaven in Beijing – an emperor regularly asserted his right to rule over the people by carrying out the necessary ceremonies to heaven. This transformation of Xia and Shang thought into a new ideology was a turning point in Chinese history: 'The Zhou conquest turned one huge region into a new land that fermented the creation of a new geopolitical region, and that region eventually groomed a culture, broadly labelled "Chinese culture"; a new nation, broadly called "Chinese"; and a new ethical-spiritual consciousness, broadly referred to as Chineseness or the Chinese character.'[42]

This made Qin Shihuang not only the First Emperor but in a sense the first man who *could have become* emperor of something called China. There was no such place before, and indeed that name in European languages is thought to derive from the dynastic name Qin.

It has been observed that 'Whereas the Shang king had been merely chief priest to the high gods, the Mandate of Heaven theory made the Zhou king Tian's executor on earth. Tian and the king were now virtually indistinguishable.'[43] This is a key fact to understand both in terms of the capital and in terms of Qin Shihuang's plan for his Mausoleum. The capital city – and hence, in the afterlife, the tomb – stood on the axis of the kingdom, which was in turn on the axis of the entire universe. In the words of Mencius, the primary duty of the person who holds the Mandate of Heaven is to 'stand in the centre of the kingdom, and tranquillize the people within the four seas'.[44]

Hence this new absolute power, together with military skills and manpower, provided the means to make the transition from the traditional multiple feudal states of early Chinese history to a new, unified and centralized bureaucratic empire which survived in one

form or another for two millennia.[45] It also elevated the existing concept of a royal mausoleum into an equally massive and unheralded structure, from the seventy-two officials buried with Duke Jing to the thousands of warriors of the terracotta army.

4

CREATION OF THE TEMPORAL EMPIRE

When, in 221, King Zheng proclaimed himself the First Emperor and effectively nominated himself ruler of the universe, his task was to transform theory into practice. From the choice of dynastic title to the vastly enlarged capital in Xianyang, from the road and communications network to the first version of an integrated defensive wall, from his administrative reforms to standardization of the language, the vision of Qin Shihuang was extraordinary.[1]

But essentially that too was a vision of what we might call internal unification, bringing together all the innovations and improvements of his ancestors into a single, well-organized and centralized system designed to create a hierarchy sustained by laws, regulations, ranks, titles and offices. This was mainly achieved by introducing administrative units such as provinces, districts and counties, which together with the registration of all citizens as *qianshou*, 'the black-haired ones', rather than as members of one of the many tribal, ethnic or state affiliations, created a unified population. The abolition of feudal titles which had been created within one of the previous states, and the use of ranks based on military success or courage, further broke down the old feudal system. Naturally the most trumpeted of reforms, the standardization of language, weights and measures as well as of dress codes, also worked in favour of abolishing traditional practices. As we have seen, much of this was not new, and a lot of the measures were implementations of and improvements to the reforms and ideas of Lord Shang. But the ruthless and determined application of all these elements under the aegis of the new empire brought about a real revolution.

However, most of these reforms were conceived – and all of them were implemented – by his great prime minister Li Si (280–208), who served in that role throughout Qin Shihuang's reign as emperor and also through that of his son and successor Qin Er Shi, until he met the brutal end which awaited most great ministers. Li Si arrived in Xianyang from his home state of Chu around 240–237 when King Zheng was still a boy, after studying – as Han Fei had – with Xunzi, and soon became close to the regent Lü Buwei. He was a forceful advocate for unification, and so impressed the young king with his reasoning that he became a valued adviser. Sima Qian records him speaking as follows to the king:

Now the feudal lords are so submissive to Qin that they are like so many provinces and districts. With the power that Qin possesses and Your Majesty's worth, it would be as easy to wipe out the feudal lords, found an imperial dynasty, and unite the whole world under one rule as it would to dust off the top of an oven! This is an opportunity that comes once in 10,000 ages. If one is lazy and fails to act quickly, the feudal lords will recover their strength and join in an alliance against Qin, and then, though one might be as worthy as the Yellow Emperor, he could never unite them![2]

Such reasoning coupled with the memory of his ancestors could hardly fail to have an immense impact on a young man still finding his way in terms of strategy. Li Si opened the mind of the young king in another celebrated episode when many at the court were urging the expulsion of officials who had been born in other states. Why is it, he asked in an acute critique of xenophobia (which also worked against him), that the king would automatically exclude a man from office solely because he is not a native of his state, and yet accept goods and products from elsewhere if they were found to be beautiful or useful? He cites as examples jade from the Kun Mountains, gold from south of the Yangtze, gems, silk, music and the 'enchanting women of Zhao'. Should they not be excluded since they are not from Qin?

Among Qin Shihuang's most important and loyal supporters, who worked beside him throughout his reign, were the brothers Meng Tian and Meng Yi, who came from a family that had long been close to the Qin.[3] In gratitude for this prolonged family service, one of the new emperor's first acts was to make Meng Tian a general, while Meng Yi soon became chief minister as his grandfather had been and was granted the rare privilege of riding together with his emperor in the imperial carriage. As Sima Qian tells it, 'Meng Tian was entrusted with the affairs on the foreign front, while Meng Yi constantly took part in the planning of internal affairs, and both enjoyed a reputation for loyalty and good faith.'[4] In fact they worked in tandem beside the emperor throughout his reign. Meng Tian was the power behind two of Qin Shihuang's greatest achievements: what is often considered to be the first version of the Great Wall, and the network of roads and canals designed to facilitate communications and troop movements.

To the west and north of the original Qin lands, from Lanzhou in the west across Shaanxi up to roughly the longitude of Xi'an and then northwards to Yulin and on to the Yellow River, a wall had already been built by Qin Shihuang's great-grandfather King Zhaoxiang in the first half of the third century. This was part of an expansion into the Ordos Desert, within the great northern loop of the Yellow River, and was intended to act as a bulwark against the Hu; it was already described by chroniclers as the Long Wall, the expression used in Chinese to refer to the Great Wall.[5] But it should not be thought of as a continuous wall; rather it was a wall system which exploited natural features such as ridges and ravines together with a series of separate walls and forts blocking river valleys, and also incorporated stretches of existing wall. As much as 40 per cent of this early wall was built on sloping terrain by the simple expedient of digging a moat on the lower side and then piling up stones and earth to stand over it.[6] Thus beacon towers could be built higher up within the wall, rather than on it. Sections of this older wall are still visible near Yulin, although the rammed-earth structures have been weathered into a more rounded shape. It has been estimated by archaeologists to have been 1,775 kilometres in length in Zhaoxiang's time.

Qin Shihuang extended this long wall, engendering stories that were still readily believed a century ago. In his book *The Great Wall* published in 1909, the American missionary and explorer William Edgar Geil cited a sequence of amusing stories then still recounted in the village of Wanyin Chien to the south-west of Yulin, and close to the wall:

In this village, untouched by civilization, ignorant of camera, where a photograph of a beautiful young lady affrighted the beholders, many interesting legends about the Wall were gathered. Qin, borne triumphantly across the empire on his horse of cloud, stamped thrice every *li*, and on each crushed spot sprang up a tower. And to this day, instead of the expression, 'do it quickly,' one hears 'do it on horseback.' Qin was a broken, bad, rotten man. The wall was erected in one day, being eighty thousand *li* long. It was ruined when one woman gave a scream, and it collapsed from the sea to Tibet. There were eighteen suns when Qin built; the men were kept working so long that grass had time to grow in the dust which lodged on their heads. The men worked so long that they fell asleep and were buried; when they awoke they were ancestors. Qin had mammoth shovels that threw up a *li* of wall at a scoop; the men were twelve feet tall and broad in proportion; nowadays men are small and could not build the Wall.[7]

The owner of the finely named Inn of Increasing Righteousness further to the west informed Geil, when the traveller stayed there, that he was sure that the men of Qin Shihuang's time were giants over ten feet tall: 'the old men say so, and I have seen the bones in the Wall, four feet long below the knee.'[8] The immensity of the imperial imagination enlarged that of each person within his realms.

The reality is grandiose enough. Sima Qian wrote that Meng Tian employed 300,000 men to build a wall 10,000 *li* (about 5,000 kilometres) in length from Lintao, Gansu Province, in the west to Liaodong, Liaoning Province, in the east. This has often been taken to mean the Great Wall of later Ming fame, but it was a simpler construct of rammed earth with rocks incorporated when available.

Moreover, it seems according to this early account only just to have gone beyond the original Qin lands in Shaanxi, although it did extend beyond the Yellow River into what is now Shanxi Province. In his account of the Han dynasty, Sima Qian provides greater detail on Qin Shihuang's wall-building:

> He seized control of all the lands south of the Yellow River and established border defences along the river, constructing forty-four walled district cities overlooking the river and manning them with convict labourers transported to the border for garrison duty. He also built the direct road from Jiuyuan to Yunyang [that is, from Inner Mongolia to Sichuan].[9] Thus he utilized the natural mountain barriers to establish the border defences, scooping out the valleys and constructing ramparts and building installations at other points where they were needed.[10]

But, as Waldron observed in his sceptical account of this early Great Wall, there is very little in the way of specific information. Sima Qian and other historians give no information about the precise route of the wall or of the military campaigns which Meng Tian carried out along it. Waldron also notes that there is no description at all of the huge amount of labour involved in 'cutting stone, hauling building blocks etc' such as the Han historian gave when he discussed the building of the mausoleum. Other ancient sources do not offer more information.

Neither do they say much about the purpose of this massive construction. Intriguingly, given the extremely superstitious nature of the emperor and his penchant for the occult, it may have been built on not much more than a whim. In her recent history of the wall, Julia Lovell makes the interesting suggestion that one motivation may derive from an oracular inscription recorded by Sima Qian which states that 'he who will destroy Qin is a Hu'.[11] This was made midway through Qin Shihuang's reign in 215. Certainly this prophecy was enough for the emperor on what sounds like an impulse to send Meng Tian north with an army of 300,000 troops to attack the Hu, and Meng was able to seize their land south of the northern bend of

the Yellow River. Yet at that time the various Hu tribes, such as the Xiongnu, presented no particular threat, so this incident is enough to give us an idea of how superstitious belief could generate momentous consequences: rarely can mere divination have brought about the deployment of such a huge and expensive force. But that is also the area in which the most important stretch of the surviving Qin wall was built. Could it have been the result of the same impulsive reaction to the oracle?

At the same time as these erratic decisions, Qin Shihuang, who understood very well the need for good communication for the efficient administration of such a large land area, embarked on a huge road-building programme. In this he was again following a Zhou tradition, for the ancient roads in this part of China – such as that between the two capitals at Xi'an and Luoyang – had been built to very high specifications. A verse in the *Book of Odes*, which the British sinologist Joseph Needham believed dates from as early as the ninth century, expresses admiration for those roads:

> Smooth as a whetstone was the road to Zhou
> And straight as shaft well fitted for the bow.
> This road the common people gladly viewed;
> The officers on it their way pursued.[12]

This also shows, as in imperial Qin times, that the roads were intended mainly for royal, imperial and official use. We may also recall the great plank road to Sichuan constructed by King Huiwen.

Instructions for the director of communications in the *Zhou li* illustrate the engineering precision and define the main traditional types of road. Interestingly, emphasis is placed on natural communication routes, and on the need for this official to study mountains, forests, lakes and rivers; if the natural route requires it, he is to cut through mountains and build bridges over rivers and lakes. There are five kinds of road: paths, wide paved paths, one-width roads, two-width roads and three-width roads – where width is taken to mean the width of a carriage or chariot. Even agricultural land (which is

divided into first, second and third class) is organized with the same precision:

> These are the general rules for organizing the countryside. Between each lot of land there is a ditch. Beside the ditch there is a pathway. After every ten lots there is a small canal with a paved path beside it. After every hundred lots there is a canal with a road beside it. After ten thousand lots there is a river or large canal, with a broad road beside it. In this way transport in the imperial kingdom is established.[13]

The dimensions of each element were also precisely fixed: a ditch was two feet wide and deep, a small canal double that, a canal double again, and then the large canal – which was five metres wide and deep. In similar vein, a pathway was broad enough for a horse or cow to pass along, a paved road for a cart, a road for a four-horsed cart, and a broad road for two such carts to pass each other.

In the cities, the roads were wider, and the master builders were instructed to build broad avenues allowing the passage of nine chariots abreast as main roads through the city, and for seven chariots around the walls. A Han dynasty author quoted by Needham wrote that Qin Shihuang 'also ordered the building of the post roads all over the Empire, east to the uttermost bounds of Qi and Yan, south to the extremities of Wu and Chu, around the lakes and rivers, and along the coasts of the sea; so that all was made accessible'.[14] These straight highways, broad and smooth to facilitate rapid transit yet sheltered by green pines lining the route, were designed for imperial travel and also for the very efficient postal service which Qin Shihuang created, and of course for rapid troop deployments; eight highways radiated outwards from Xi'an as from imperial Rome, with special central lanes reserved for imperial traffic. There were staging posts with inns, horses and other facilities spaced at regular intervals according to their size and importance varying from five to thirty kilometres and all the necessary infrastructure such as bridges to render the system efficient. Even the width of carts was fixed at 1.92 metres to facilitate passing traffic. These roads ran to Gansu in the west, to the Bohai Sea

in the east and to the South China Sea in Guangdong. All movement along them was controlled by inspection posts and tax officials.

The best-known imperial road of all was the Straight Road or Direct Road from Ganquan or Yunyang to the north-west of the capital at Xianyang to Jiuyuan in Inner Mongolia, a distance of about 1,000 kilometres. Sima Qian states that this road was laid out in a straight line in 212, by cutting through mountains and building embankments in the valleys rather like a nineteenth-century railway route.[15] It clearly had important transport and military functions, but Charles Sanft has recently shown that this too had a ritual role. He argues that the road began at Ganquan because the emperor had a palace there and it was said to be the place where the Yellow Emperor, the Huangdi from whom he derived his own imperial name, had built his *Mintang*, or 'Bright Hall', which was a 'ceremonial center and the location of other ancient sacrifices'.[16] The northern termination in the Jiuyuan area, beyond the great loop of the Yellow River, marked a strategic pass through the Yinshin Mountains which the Xiongnu used to travel between China and northern Asia. By crossing the Ordos plains, the road made a significant statement about Qin power and control, and by ending at a place where the Xiongnu gathered to perform sacrifices to their ancestors made the point with greater emphasis. As Sanft concludes, 'The Direct Road may have expanded and improved transportation in the northwestern part of the Qin realm, but more importantly, it used areas of combined ritual, cultural, and political significance to communicate Qin supremacy beyond the borders of the realm.'[17] It is a fine example of the way in which ritual framed the First Emperor's mindset, from his capping ceremony in Yong to the use of other ancient rituals in extending and maintaining his image and power in the territories he conquered.

He utilized the Straight Road and the other imperial highways for the five grand inspection tours he made of his newly created empire, as far south as Sichuan, as far east as Shandong, as far south-east as Hunan and as far north as Jehol (now Chengde); they also facilitated his travels to make sacrifice at Mount Tai (in Shandong), Mount Xianglu (in Zhejiang) and Mount Lao (on Zhifu Island, near modern

Yantai in Shandong), at each of which he erected a stele to announce his achievements and proclaim his ambitions. Here he was following well-established traditions. The *Li Ji* provides a detailed account in a book entitled 'The Royal Regulations'. It illustrates the way in which these inspections were not just about projecting an image of imperial power but also about understanding his empire:[18]

13. The son of Heaven, every five years, made a tour of Inspection through the fiefs.

14. In the second month of the year, he visited those in the East, going to the honoured mountain of Tai. There he burnt a (great) pile of wood, and announced his arrival to Heaven; and with looks directed to them, sacrificed to the hills and rivers. He gave audience to the princes; inquired out those who were 100 years old, and went to see them: ordered the Grand music-master to bring him the poems (current in the different states),[19] that he might see the manners of the people; ordered the superintendents of markets to present (lists of prices), that he might see what the people liked and disliked, and whether they were set on extravagance and loved what was bad; he ordered the superintendent of rites to examine the seasons and months, and fix the days, and to make uniform the standard tubes,* the various ceremonies, the (instruments of) music, all measures, and (the fashions of) clothes. (Whatever was wrong in these) was rectified.

* There were 12 'standard' tubes which were used first for musical scales and tuning and then as measures of length. Originally bamboo, later brass or copper.

Centuries before these rites were thus formalized, Yu the Great had 'visited the mountains and marked the trees, and determined the height of the mountains and the length of the rivers' and 'made an inspection tour to find which crops would be best to cultivate, with a view to assessing taxes'.[20] He also made the appropriate sacrifices as he travelled, just as Qin Shihuang was now to perform sacrifices to him on Mount Kuaiji. It is an irony in the life of the First Emperor that

he should die during an inspection tour not far from Yu's supposed place of death, also on an inspection tour. For he died at Shaqiu (沙丘), which means sand dune, on the terrace of a palace built by the kings of Zhao in southern Hebei.[21] It was also quite close to the emperor's own birthplace in Handan.

Once again, ancient practices and rituals informed his travels, for his first inspection tour in 220 took him westwards to the original heartland of the Qin in Gansu. There he climbed Mount Jitou, where, according to legends recounted by Sima Qian, the Yellow Emperor himself had made the same climb in antiquity.

The second tour took place in 219, when the emperor travelled east through the states of four of his conquered enemies – Hann, Wei, Qi and Chu. He ascended Mount Youyi (also known as Mount Yi), where he erected a stele composed by Li Si recording the imperial achievements. This stele is now lost, but a copy was made by a famous calligrapher of the Song dynasty in AD 993 and may be seen in the Beilin Museum in Xi'an.[22] As at the other sites and mountains which he visited on these tours, he looked out over his new domains and ritually asserted his sovereignty through sacrifice, gesture and the words inscribed on the steles in a style which emphasized and strengthened his imperial vision. He went on from Youyi to the most famous of Chinese holy mountains, Mount Tai in Shandong, where he held a ritual ceremony based on those used at Yong. Reading through the chronicles of the Shang and the Zhou in the *Book of Documents* (or *Book of History*), and in the *Bamboo Annals*, it is striking that every few pages there is a reference to some emperor or king travelling east on his inspection tour. The itineraries are not usually specified, but they nearly always mention Mount Tai as the main destination; in fact seventy-two emperors are said to have made the pilgrimage.

For in China, as Chavannes wrote in his study after two personal ascents of Mount Tai, mountains are 'divinities',[23] and this one was the most sacred of the five sacred mountains of China, which he compared in its religious significance to Mount Olympus. It was also the site of the *fengshan* ceremony dedicated to heaven and earth, so important that Sima Qian devotes an entire chapter to the

'Feng and Shan Sacrifices'. These were essential to the legitimacy and success of the Mandate of Heaven, and Sima Qian notes that one of the reasons the emperor set up a stele there was to ensure that everybody understood that he had himself made the sacrifices – which had been based on rituals used at Yong.[24] Since the details of the ritual were kept secret, we cannot know exactly which sacrifices were performed. But there are some indications of the procedure: the emperor 'erected an altar mound covered with earth of five colours, beneath which was buried a jade tablet inscribed with a secret message to the God who was to receive a sacrifice. The officials donned yellow vestments, leather caps, and the wide sashes, and then shot the sacrificial ox with arrows.'[25] This was a sacrifice to heaven, which would be followed by a *shan* sacrifice in the foothills addressed to the Earth Empress. Chavannes adds that 'Mount Tai ... presides ... over the East, which is the origin of all life. As well as the Sun, all life begins in the East.'[26]

After Mount Tai, the emperor travelled to Langye, also in Shandong, where he stayed for three months and erected a stele with an inscription which may be taken as representative (Professor Martin Kern has argued that all the inscriptions are actually variations on a theme with slight changes made according to location and specific ritual needs).[27] It begins with an eloquent summary of the emperor's achievements:

> He has regulated and standardized laws and measures,
> and the rules which serve for all people.
> He has also clarified the duties of men,
> establishing union and concord between fathers and sons.
> In his wisdom he has understood goodness and justice,
> clearly showing the right way and reason.
> He has created order in the eastern lands
> to end warfare ...
> All under heaven
> are of one mind and are united in will.[28]

It concludes with a statement of his immense power:

Wherever the steps of men reach

there is no one who does not declare himself a subject.

His glory surpasses that of the five emperors . . .[29]

During his time there, he constructed a viewing terrace and ordered the transfer of families to found a new city.[30]

He then took two significant decisions.[31] The first was instigated by a shaman called Xu Fu, who convinced the emperor that there were immortals living on three islands in the Bohai Sea and sought approval to sail in search of those islands. Qin Shihuang responded by ordering Xu Fu to gather together a large group of young girls and boys to find these immortals – an event which will be described in more detail in Chapter 5. The second, and perhaps even more significant, action in terms of the later discussion of the imperial mausoleum, occurred at Pengcheng, after the emperor had purified himself and performed ritual sacrifices. He ordered a thousand divers to search the river for a bronze cauldron from the Zhou dynasty which had been lost in antiquity, one of nine legendary cauldrons said to have been cast by Emperor Yu and hence of enormous symbolic value since it had been passed in turn to the Shang, Xia and Zhou.[32] According to legend, the nine cauldrons conferred legitimacy on a king, and this incident will serve as evidence of the importance in Qin Shihuang's mind of the cauldron vessel, or *ding*, as the pits around his mausoleum were constructed.

In 215 he set off an a tour that took him much further from the capital, to a place – perhaps a rock overlooking the sea – called Jieshi on the north-west coast of the Bohai Sea just inside Liaoning Province, a few kilometres beyond the Great Wall (near modern Suizhong), yet again suggesting his respect for the ancients in visiting a site linked with an earlier visit by Yu the Great. Once more, he constructed new buildings at the site including a palace with baths which were perhaps intended for the cleansing preparation for rituals and sacrifices.[33]

Then, on 1 November 211, he began his last inspection tour, during which he was to die. He travelled south to Yunmeng, where the bamboo strips inscribed with Qin laws were discovered forty years

ago, and performed sacrifices in the Jiuyi Mountains. After that he went to Mount Kuaiji, where once again Yu the Great had been. We may recall the prophecy made during divination rites with tortoise shells at the altar of Yu in Yong, foreseeing that the Qin would water their horses in the Yellow River. It was not therefore surprising that a man who revered the past like Qin Shihuang, who did water his horses as the tortoise shells had foretold, should make a pilgrimage to the mausoleum of Yu in Shaoxing, near Hangzhou. From Mount Kuaiji he travelled north to Langye, and made a third visit to Mount Zhifu, but soon afterwards succumbed to the disease which led to his death. Sima observes laconically: 'He followed the coastline in the hope of finding the wonderful medicine [that is, of immortality] of the three holy mountains in the middle of the sea. But he did not find it.'[34] He died on 10 September 210 at Shaqiu, several weeks' journey from his palace in Xianyang.

These inspection tours are significant for an understanding of the Mausoleum, since the peaks and rivers he visited throughout his empire over ten years mapped the universe that he wished to replicate in his burial chamber. The inscriptions emphasized that he had brought order to chaos, and warring states to peace, through his military victories, justice system and administration. It was a sophisticated cosmological, geographical and geopolitical vision of empire, creating a harmony which should continue to exist after his death.

The steles too provide an insight into his personality. The new emperor is measuring out his empire, asserting the legitimacy of his claim to power. Their tone and their content reveal his mindset, and the texts, in Kern's words, 'with their references to the Zhou tradition on the one hand and to the military success of Qin on the other, are concerned with both factors – and their political message, as the concrete textual references betray, lies in mediating the one to the other'.[35] The steles, erected on sites at the same time symbolically important and public, were a unique means of broadcasting his beliefs and ambitions.

The new paved imperial highways were essential for the inspection tours, to bear the imperial carriage and its escort in relative

comfort. Needham calculated their total length as 4,250 miles (6,700 kilometres) – other authors suggest over 8,000 kilometres – all completed in around fifteen years, compared to the main Roman road system with 'a great chain of communication' which, in Edward Gibbon's eighteenth-century estimate, 'from the north-west to the south-east point of the empire, was drawn out to the length of four thousand and eighty Roman miles' (the overall length of the Roman road system was far longer, but took centuries to complete).[36] Some stretches of Qin Shihuang's highways still exist today, and the routes of the key east–west and north–south roads are known. This transport and communication network, with its related postal service and military outposts, allowed the emperor to put his administrative reforms into practice. It also made the five great inspection tours or imperial progresses of his empire quicker and more comfortable.

The same passage of the Li Ji quoted for road building, in the form of instructions to the director of communications, defines five kinds of canal as ditches, conduits, small canals, medium canals and great canals. The greatest of all was the Zheng Guo Canal north of Xi'an. Sima Qian records the strange episode of its construction:

Another time the state of Hann, learning that the state of Qin was fond of undertaking large projects, dispatched a water engineer named Zheng Guo to go to Qin and persuade the ruler to construct a canal from a point on the Jing River west of Mt. Zhong to the pass at Hukou, and from there along the Northern Mountains east into the Luo River, a distance of over 300 li. Ostensibly the purpose of the project was to provide irrigation for the fields, though in fact Zheng Guo and the rulers of Hann hoped thereby to wear out the energies of the state of Qin so that it would not march east to attack Hann. Zheng Guo succeeded in getting the project started, but halfway through the real nature of his mission came to light. The Qin ruler was about to kill him, but Zheng Guo said, 'It is true that I came here originally with underhanded intentions. But if the canal is completed, it will profit the state of Qin as well!'[37]

What had been arid land, of little use for agriculture, became one of the most fertile areas in China – protected on all four sides, by the Yellow River and mountain passes in the east and west, by the old Great Wall and Ordos Desert in the north and by the Qinling Mountains running parallel to the River Wei south of the city. Sima Qian stated that it was as a result of this fertility that the Qin were able to conquer the other feudal states. The canal was updated and moved over the centuries from the Han onwards, and still exists today, bearing the name of its maker.

These projects, roads and canals, were important because with vast newly fertile areas it was possible for the Qin to sustain their armies with basic supplies, and thus render feasible immense tasks such as building the Great Wall and Qin Shihuang's Mausoleum. They also made other ambitious building projects feasible.

Qin Shihuang rebuilt and enlarged the capital at Xianyang in his own image. On the slopes above the city, he built replicas of the halls and palaces of the six states he had subdued which were filled with everything he had taken from them, including 'beautiful women, bells and drums'.[38] These new buildings looked down across the capital, towards the ancestral palaces built to the south of the river and in the distance to the Qinling Mountains beyond the present site of Xi'an – including Mount Li to the east where his Mausoleum was already under construction. On a clear day, when all this is visible from the terrace east of Xianyang where once an imperial palace stood, the immensity of Qin Shihuang's vision is palpable. But in addition to the landscape there were symbolic elements in his vision. Since the new palaces were seen as the embodiment of states, Mark Edward Lewis explains, 'the Qin could symbolically annex a state by destroying its original palace and rebuilding a "captive" replica in its own capital'.[39] Another historian observes that 'lurking' behind Sima Qian's remark is an awareness of the importance of maintaining the energy of the vanquished states, for in this way Qin Shihuang 'sought to focus and concentrate at his own capital the vital forces that had previously been channelled through rival capitals'.[40] As we shall see in Chapter 12 this provided a foretaste of what he would do in his Mausoleum, which was a microcosmic vision designed for his afterlife.

Between 1974 and 1982, the same period as the discovery and first excavations of the terracotta warrior site, three large imperial palaces were discovered in Xianyang. The largest was a two-storey structure facing south across the river just to the east of the present city, with the upper level about six metres higher than the lower one. It was a huge L-shaped complex stretching sixty metres east to west and forty-five metres north to south with a main hall at the centre which could be entered from the north via the covered arcade that surrounded the entire palace, and from the south-east from what is believed to have been the emperor's residence. On the lower level were quarters for bathing chambers, perhaps for female family members and imperial concubines, and other rooms whose use is unknown. There were staircases between the two levels at the east and the west sides of the building.[41] The terraces built for the palace may still be seen, as well as fragments of perimeter wall, while archaeologists have made drawings of what the palace may have looked like.

But even this was not enough to match Qin Shihuang's ambitions. Now at the height of his powers, he began the construction of a palace known as Epang to the south of the River Wei, opposite Xianyang. He believed that the old palace of the kings of Qin was not proportionate to the new population and prestige of the capital, and resolved to build a still grander one. More important, given his keen sense of mission and respect for past rulers, he noted the positions of the ancient Zhou capital at Feng and the later one at Hao – on opposite sides of the Wei tributary, the River Feng, as we have seen. 'I have heard', he said, 'that King Wen of the Zhou dynasty had his capital at Feng, and that King Wu had his capital at Hao. The area between Feng and Hao is the seat of emperors and kings.'[42] That is where he would build. Such a decision also followed his practice of occupying the land and palaces of those whose power he had supplanted, thus enhancing his legitimacy. Epang was conceived in the form of a terraced pavilion, a design which came into use during the Warring States period in place of the traditional closed compound, a proud and powerful visual statement of conquest looking out over the landscape rather than a symbol at the heart of the city.

To reach this palace from Xianyang, the emperor built what must

have been an extraordinary two-storey bridge across the River Wei. Since no representation exists, we might imagine a Chinese version of the enclosed corridor built in Florence over the Ponte Vecchio for the Medici duke Cosimo I (1519–74) by Michelangelo's friend the painter and architect Giorgio Vasari. In Florence, the objective was to link the offices, *uffizi*, now a museum, to the family residence across the River Arno – a much narrower river – in the Palazzo Pitti. In the case of the Epang Palace, the bridge was supposed to represent the corridor from the Apex Star to the Royal Chamber Star across the Milky Way. According to an ancient text, 'the Summit of the Southern Mountains was designed to be the gate of the palace'.[43] This was part of the cosmic vision which was incorporated into the tomb according to Sima Qian's description, based on the notion that Heaven was organized round the polestar, which 'radiated outward to the constellations marking the celestial equator'.[44] It sustained the concept of the macrocosm/microcosm of heaven and earth, which was incorporated in the ceiling of the burial chamber as described by Sima Qian.

Unsurprisingly, this palace remained unfinished at the emperor's death and was soon afterwards destroyed by fire during the rebellion which ended his dynasty, for like his other palaces it was a two-storey wooden structure built on terraces of rammed earth measuring some 675 by 112 metres. The upper floor was designed to accommodate 10,000 seated guests, while battle standards eleven metres high could be raised in the lower storey.[45] These numbers already sound exaggerated, but Du Mu (803–853), a well-known Tang dynasty poet, allowed himself to go further in hyperbole when he wrote in his 'Ode to Epang Palace':

In the palace,
There were more columns supporting the beams than there
 were farmers in fields,
There were more rafters attached to the ridgepoles than there
 were women around looms.
There were more nailheads than grains in a barn.[46]

Yet this was just one of 270 palaces and towers within a hundred kilometres of Xianyang which were all supposedly linked by elevated walkways so that the emperor could pass between them unobserved. The art historian Wu Hung quotes an ancient text known as the *Miao Ji* (*A Record of Temples*):

> North to Jiuzong and Ganquan, south to Changyang and Wuzuo, east to the Yellow River, and west to the intersection of the Yan and Wei Rivers, palaces and imperial villas stood side by side in this region of 800 *li*. There, trees were covered with embroidered silk and earth was painted with the imperial colors red and purple. Even a palace attendant who spent his whole life there could not comprehend the multitude of scenes.[47]

Many of these were restored or rebuilt palaces of the states he had conquered, as a perpetual reminder of his conquests to those who saw them, but there can have been few equally impressive building projects in history. It will be seen that the dimensions of the Mausoleum are perfectly consonant with such ambition.

In the midst of all this innovation and all these major works which strengthened the new empire there was one event which has always been held against Qin Shihuang, the notorious episode of the 'burning of the books'. But all is not quite as it seems. In a speech to the emperor made in 213, Li Si argued that it was wrong to study the old works of philosophy in order to find arguments which could be used to criticize their own time. But even the hypercritical Sima Qian in his account of the event specifically states that 'those in the empire who hide copies of the *Odes*, the *Documents*, or the writings of the hundred schools, should take them to the local civilian and military authorities to be burned, *except those charged with the duty of maintaining the vast knowledge they contain*' (italics added).[48] Scholars were to continue to have access to these writings since the new emperor founded an imperial academy to monitor their interpretation, the result of a policy of unification of ideas rather than one of destroying the past. In fact Han Fei had also railed against 'stupid scholars in the world [who] do not know the actual conditions of

order and chaos but chatter nonsense and chant too many hackneyed old books to disturb the government of the present age'.[49]

In other words, quotation of the classics entailed in the view of Li Si and Han Fei an appeal to an idealized past which amounted to exploiting the fallacy of authority, and could result in inciting the ordinary people to rebellion. This is why the above books were chosen, and confiscated so that only approved scholars could study them. Books on subjects such as medicine, divination, agriculture, and forestry were not confiscated. There was no systematic destruction. Actually, as in so many cases we have seen, the tradition dates back to Lord Shang. For we learn from Han Fei with a slightly different emphasis that Shang had earlier advised Duke Xiao 'to burn the *Book of Odes* and *Book of Documents* and thereby make laws and orders clear'.[50] So, if it was followed at all, this advice may have been followed only partially, and it was left to Qin Shihuang to complete the task. The edict was in any case short lived, from 213 to its repeal by the Emperor Hui in 191, and was mostly inoperative during that time. In the course of a study of the authenticity of the texts attributed to Confucius, Legge concluded that 'the calamity inflicted on the ancient Books of China by the House of Qin could not have approached to anything like a complete destruction of them'.[51] In fact, thanks to the 'great efforts' of the early Han, most of the books and chapters that were assumed to have been lost were not only salvaged but catalogued and stored safely.

Qin Shihuang himself was in fact something of a scholar. We may be certain that he knew the classics from his time spent under the tutorship of Lü Buwei as a young man, and the stele inscriptions erected on his inspection tours also make this very clear. The texts on the steles were modelled on earlier bronze inscriptions, with frequent echoes of the classics.[52] Li Si is known to have written the texts, but Qin Shihuang would have been sure to check them given their importance to his scheme. There was a well-structured message in each variant in the form of verse, with classical rhyming schemes. For example, the important inscription on Mount Tai rhymes in every third verse and has two rhyme sequences, both of six rhymes.[53] This suggests that he appreciated the rules of classical poetry as well as

the ancient rituals and inscriptions. Learned figures such as Shusun Tong, who dressed as a Confucian scholar and was renowned for his literary ability,[54] were appointed to the court with the specific task of perpetuating cultural memory in ritual and textual tradition. A large entourage of scholars and experts in ritual – as many as seventy on some occasions – accompanied the emperor on his travels. This in turn suggests that he understood perfectly well the power of words in the ancient texts (which to conceal from the populace, and which to exploit), but wished to supplant them with new forms of communication, not to destroy the traditions of the past but to absorb them and make something new which was entirely his own.

The transition from a traditional vision of rule over the 'all under heaven' to its practical implementation by military and administrative means was to occupy Qin Shihuang throughout his brief reign as emperor, yet he seems to have been driven by a deeper desire to render his person, his clan and his empire everlasting. Beautifully crafted edicts with elegant calligraphy inscribed on stone were intended to project the political message. Kern's translation of the last three lines of the Mount Kuaiji inscription emphasizes the method:

> The attending officials recite His brilliant accomplishments
> And ask to carve [the text into] stone,
> To glorify and transmit it in the superb inscription.[55]

The explicit purpose was to render those accomplishments immortal within the empire now marked out by the inspection tours.

II : MYSTERY

5

WHAT KIND OF IMMORALITY DID QIN SHIHUANG EXPECT?

One key to understanding the time and energy Qin Shihuang devoted to the creation of his Mausoleum is the ancient Chinese concept of longevity, and the next logical step of *absolute* longevity, or immortality, which became an obsession for him.

He survived assassination attempts, constantly feared conspiracies and insisted on secrecy in his movements to the extent of building walls and corridors to disguise them from public view – and to render them invisible to malign spirits. After years of military conquests and bloody massacres he had good reason to fear revenge from victims whose spirits would also continue to live after death and might lie in wait for him. His vision of a lasting dynasty was founded on personal immortality, so death was unthinkable; as a scholar of Chinese religious practices expressed it, writing of the emperor's Han successors, 'Holiness essentially meant the art of not dying.'[1] In fact we know from the biography by Sima Qian that Qin Shihuang hated even hearing conversations about death, to the point that his officials were afraid of mentioning the very word. This obsession was something of a family tradition, for traces of it appear in all the chronicles and histories from the time of King Huiwen onwards. Indeed from around 400, a couple of generations before Huiwen, it was believed that some men had managed to liberate themselves from death and had achieved perpetual life. Such beliefs were obviously attractive to kings, and later an emperor, who wished to prolong their reigns.

Attention was also paid to the preservation of corpses in their tombs. Already in the tomb of Duke Jing at Yong, the cedar beams

were carefully treated with this in mind. They were charred to ensure that no humidity entered the tomb, and knots in the wood were filled with liquid tin and covered with charcoal to ensure that no easy entrance was available for worms and scavenging animals. Signs of the charring may still be seen on the beams at Yong, as well as abundant charcoal on the ground.

In 1971, just before the discovery of the terracotta warriors, the body of an aristocratic Han lady called Xin Zhui was discovered by building workers in Changsha, in Hunan Province, at a site now known as Mawangdui which lies in the old territory of the Chu. It was found in coffins associated with the tomb of the Marquis of Dai, Li Cang (利蒼), who died in 186 – just twenty years after the demise of the Qin. Li Cang was a son of the Emperor Huidi (195–188), the second of the Han dynasty, and had been appointed chancellor to the Kingdom of Changsha seven years earlier. Xin Zhui is thought to have been his wife, and when she died in 163 her body was placed in the tomb together with that of a young man who may have been their son. Interestingly, they were placed in nested lacquered coffins – like Russian matryoshka dolls – which was a Chu burial custom and given his own Chu ancestry may suggest similar features in the tomb of Qin Shihuang himself.

Sophisticated and successful techniques were employed to preserve the body of Xin Zhui for the afterlife: 'A layer of charcoal 0.4 to 0.5 m. thick was placed outside the tomb-chamber and beyond this the crypt space was filled with at least a metre of fine white clay. The marvellous state of preservation of the contents of the tomb is attributed primarily to the use of the white clay and charcoal, which effectively kept out moisture and oxygen.'[2] Remarkably, her body was in such good condition, wrapped in twenty layers of shrouds and cloth and with internal organs and blood vessels intact, that it was possible to establish by autopsy that she had died of a heart attack shortly after eating melon seeds (she and her cosmetics and other personal belongings may be seen at the Hunan Provincial Museum). This illustrates the chemical knowledge and skills which the ancient Chinese possessed, and as Joseph Needham observed was achieved without embalming,

mummification, tanning or freezing.[3] The tomb also contained bags of medicinal and aromatic herbs, presumably placed there to maintain the state of preservation.

Other examples are given by Han Fei. As an adviser and through his writings, he is known to have had a huge influence on the thought of Qin Shihuang in the political sphere. But his writings also contain rumination about what he called the 'drug of deathlessness', or elixir of immortality. He recounts an episode from the lifetime of King Huiwen:

> Once a traveller taught the King of Yan the way to immortality. The King then sent men to learn it. Before the men sent to learn completed their study, the traveller died. Enraged thereby, the King chastized [sic] the students. Thus, the King did not know that he himself had been deceived by the traveller, but censured the students for their tardiness. Indeed, to believe in an unattainable thing and chastize innocent subjects is the calamity of thoughtlessness. Moreover, what a man cares for is nothing other than his own self. If he could not make himself immortal, how could he make the King live for ever?[4]

Han Fei is sceptical, but as Needham points out after discussing the story: 'what interests us is the fact that around 320 BC there were men prepared to teach the art of achieving material immortality, and educated patricians who were eager to listen to them. The philosopher's art doubtless included much of what we shall later describe as "physiological alchemy" with its various forms of bodily training, but it almost certainly included the ingestion of medicines.'[5] These medicines could be herb-based or mineral-chemical, or combinations of both, and were widely used.

Qin Shihuang was a member of a ruling family which as we can see in the tomb of Duke Jing sought immortality from the early days. The emperor himself certainly believed that he would be able both to live and to reign for ever, and constantly sought elixirs which would guarantee eternal life. He was willing to believe the tales of magicians and alchemists to a remarkable extent. There had existed

for many centuries legends about the three spirit mountains in the Bohai Sea where fairies who possessed the elixir of immortality were said to live. But it was difficult to reach them. Sima Qian explained in his 'Treatise on the Feng and Shan Sacrifices' that although the three mountains were close to land, once a boat arrived they would appear upside down in the water, and 'when mariners drew closer the wind would push their boat out to sea'. He cites earlier rulers among those who had sent men to sea in the past to seek the elixir.[6] The three mountains were known as Penglai, Fangzhang and Yingzhou. When the First Emperor arrived for the first time at the coast, he was greeted by a horde of magicians who told him stories about the elixir. These beliefs persisted, for the same treatise tells us that a hundred years later Emperor Wu of the Han dynasty built a lake at his Jianzhang Palace, in Xi'an, with islands with the same names that were 'imitations of what was found in the sea, the holy mountains, with tortoises and fish'.[7]

Another account of the islands occurs in a work on the mythology of islands usually attributed to a Han dynasty *fangshi* or 'master of esoterica', literally 'recipe gentleman', Dongfang Shuo: 'Formerly, in Qin Shihuang's time, when the bodies of many men unrighteously and untimely killed were lying about at Ferghana and along the roads (that led there), birds resembling crows or ravens appeared carrying this plant in their bills, and placed it on the faces of those corpses, so that they immediately sat up and were restored to life.'[8] Moreover, if this plant is eaten, it can confer longevity and even immortality. On hearing the story and being informed of the provenance of this herb of deathlessness, and learning that a single stalk is enough to raise a man from the dead, the emperor ordered samples to be brought to his court and sent Xu Fu with 500 young men and women to obtain it. They were unsuccessful. According to the scholar of Chinese medical history Paul U. Unschuld, whose account is quoted here, the interest lies in the fact that however the plant might be described, it was considered a kind of magic mushroom.

In fact, Qin Shihuang patronized the 'recipe gentlemen' as teachers of alchemy and immortality, who introduced a 'cult which promised immortal life as a transcendent being'.[9] He himself made pilgrimages

bove Mausoleum photographed by
ictor Segalen in 1914.

bove right Mausoleum photographed
y the author in 2013, two or three
undred metres to the right of
egalen's viewpoint.

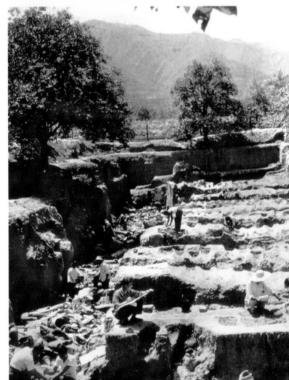

he first excavation of Pit 1 in 1974,
ooking south, with the site of
e discovery well under the large
ee on the left.

eliminary
eaning of the first
arriors, by future
useum directors,
ang Yuqin (left)
nd Yuan Zhongyi
ight).

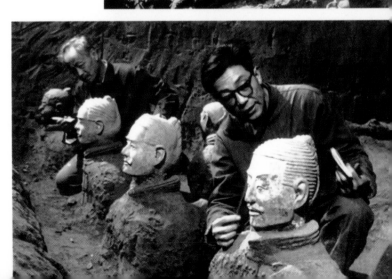

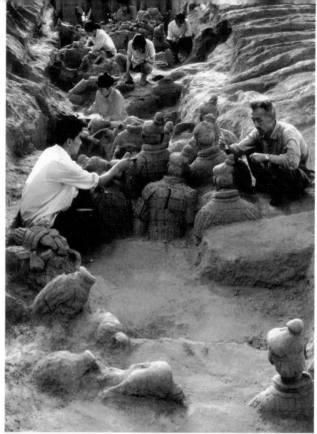

Later work at Pit 1, in 1978.

Exterior of the original museum, housing Pit 1 (photographed in January 2017).

Panoramic view of the interior of Pit 1 today.

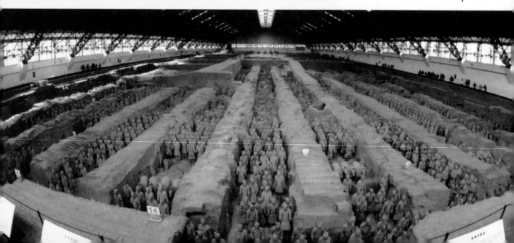

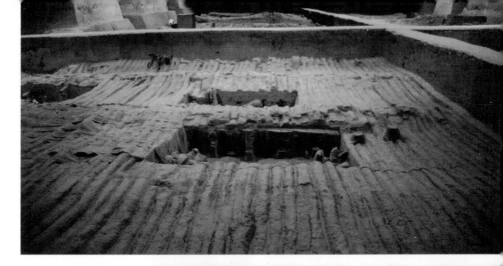

Pit 2 in March 2017, showing large areas still covered and yet to be excavated.

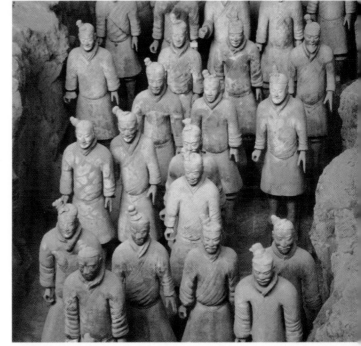

Early restored warriors in Pit 1

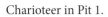

Charioteer in Pit 1.

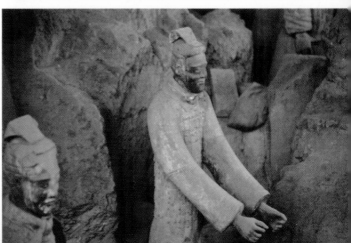

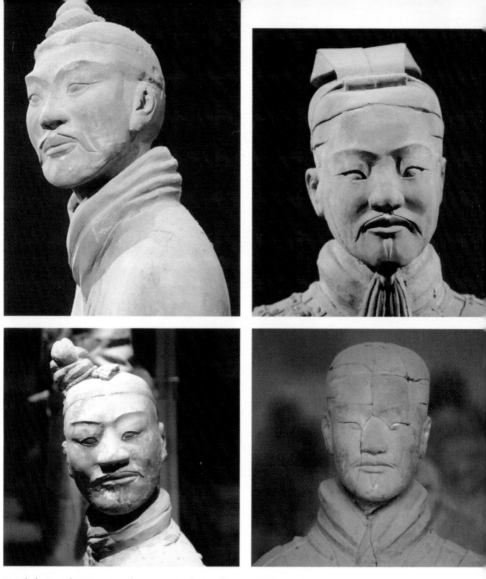

Top left & right Warrior close-ups before advanced pigment protection.

Centre left & right Warrior close-ups with some pigment protection.

Artefacts for the afterlife: a tarracotta *qun*. The *qun* seen from above.

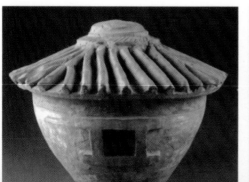 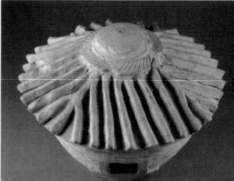

Left & above Artefacts for the afterlife: bronze vessels.

The excavated tomb of Duke Jing at his capital, Yong.

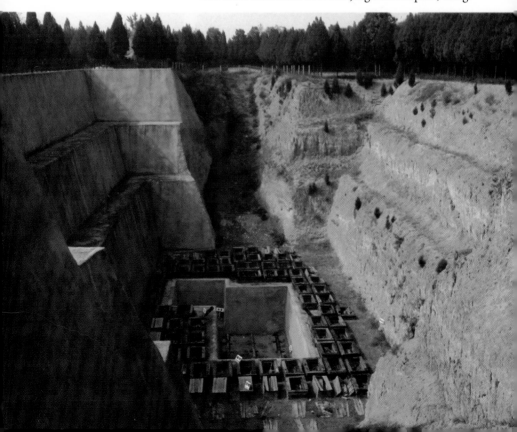

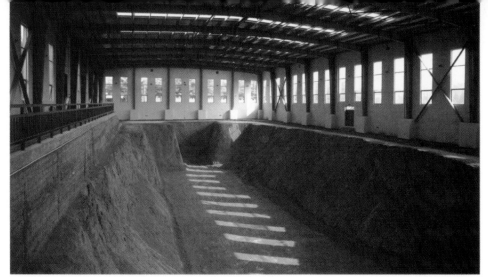

Covered pit beside the tomb at Yong, awaiting excavation.

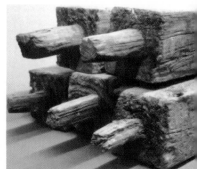

Above Cedar beams from the coffin of Duke Jing, showing knife marks.

Left Replica reception room for Duke Jing, built to scale in the museum, underground.

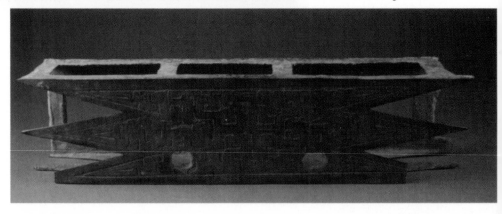

Tomb of Duke Jing, bronze junction support to strengthen the joints of cedar beams.

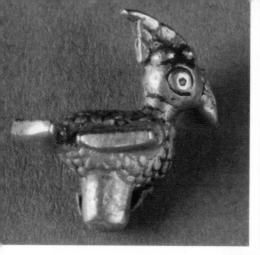

Above Miniature gold woodpecker from the tomb of Duke Jing, Yong, and (above right) viewed from above, showing the exquisite wings.

Right Miniature gold monster from the tomb of Duke Jing, Yong.

Below Tile end with deer pattern, from the tomb of Duke Jing, Yong.

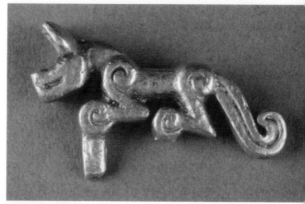

Bell from Taigong Temple with inscription about the Mandate of Heaven

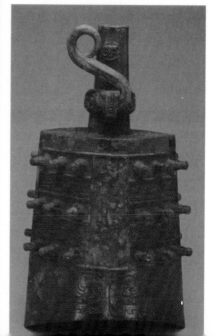

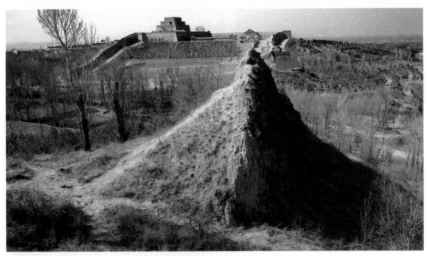

Above Eroded ancient Great Wall near Yulin, northern Shaanxi, with restored Ming tower beyond.

Below Inscription marking the site of the imperial palace at Xianyang, with palace mound behind.

Above Song dynasty copy of the inscription made by Qin Shihuang at Mount Youyi, Beilin Museum, Xi'an. *Above right* detail of calligraphy on the Youyi stele.

Qing dynasty map of the Shu Road to the Shaanxi border.

to Zhifu on three occasions, and climbed to its highest point at Mount Lao – actually only 300 metres above sea level although it feels higher. In 218 he recorded his ascent of the mountain in one of his inscriptions, which reveals in an unusual reference to the view his love of natural scenery:

> Now in the twenty-ninth year,
> the August Emperor travelled in spring
> to observe and inspect the distant regions.
> Arriving at the sea coast
> he climbed Mount Zhifu,
> and illuminated the east.
> He contemplated and studied at length
> the vast and beautiful view...[10]

The island is now joined to the mainland as a peninsula, and is only one kilometre wide by ten kilometres in length. Two shorter stone inscriptions testify to his visits: in 218 he wrote, 'Arrived at Fu, and carved the stone,' and on his final visit in 210 he wrote, 'Came to Fu, saw an enormous stone, and shot one fish.' According to this version, it was when he failed to find the elixir himself that he ordered Xu Fu to set sail in search of it.

The first step towards immortality was to inhibit bodily decay, so that the immortal would be ready to begin his wanderings over the earth or in the spirit world. Apart from the elusive and illusory recourse to magical elixirs, there were two readily obtainable materials in the natural world which it was believed could enhance preservation: jade and mercury.

The former is a stone which the Chinese still venerate as no other people on earth, already present in one of the founding myths of their culture, that of the legendary Jade Emperor or August Emperor of Jade, who was himself considered an immortal. Visually, the words 'king' and 'jade' are closely related: to the character for king (王) *wáng*, a single stroke is added to create that for jade, (玉) *yù*. Nowadays, it is thought of mainly as an ornamental rock, usually a delicate green and prized for its beauty in jewellery and as a lucky

charm, but it was then an essential element in alchemy and in the quest for immortality.

Berthold Laufer, who travelled through Shaanxi in 1909 and 1910 collecting specimens of jade for the Field Museum in Chicago, noted that in early Han times the mountains south of Xi'an were known as sources of jade, gold, silver, copper and iron. According to several sources quoted by him the best of all jade came from Lantian, which is just thirty kilometres due south of Qin Shihuang's Mausoleum.[11] So it is more than likely that the emperor was very familiar with the white and green jades of that area. According to Laufer, the city of Xi'an was still a major distribution centre for unwrought jade from western China a hundred years ago.

High-quality polished jade was often used to make axes, knives and daggers to be placed in tombs in Zhou – and hence also early Qin – times. The Yellow Emperor himself is said to have fashioned weapons from jade. But one of the reasons it was so valued in ancient times was the resonant quality which renders it ideal for making musical instruments. The reception room of Duke Jing's tomb had a wooden rack with several jade *qins* or chimes ready to be sounded, and his descendant's love of music allows us to speculate that similar jade instruments were placed in his own tomb. Then, of course, the stone is highly decorative, and was always an essential part of ritual. In a chapter with the alternative title of 'The jade-bead pendants of the royal cap', the *Li Ji* informs us that 'The son of Heaven, when sacrificing, wore (the cap) with the twelve long pendants of beads of jade hanging down from its top before and behind, and the robe embroidered with dragons.'[12] Later it states:

The son of Heaven had his pendant composed of beads of white jade, hung on dark-coloured strings; a duke or marquis, his of jade-beads of hill-azure, on vermilion strings; a Great officer, his of beads of aqua-marine, on black strings; an heir-son, his of beads of Yü jade, on variegated strings; an ordinary officer, his of beads of jade-like quartz, on orange-coloured strings.[13]

In another sign of the importance of the binomial king–jade, it adds that in the presence of the ruler even his son and heir tied up his jade pendant so that it could not be seen.

There are many cases of jade being used in an attempt to achieve immortality. One famous example came to light in 1968 when two jade-clad bodies were found in Han princely tombs near Mancheng in Hebei – those of Liu Sheng, a son of Emperor Jingdi, who died in 113, and his wife Dou Wan, who was probably the great-niece of the Dowager Empress Dou, a Daoist. Liu Sheng's so-called Gold Wire and Jade Garment was made of over 1,000 grams of gold wire with 2,498 jade plaques of various sizes. The tomb held more than 10,000 objects of gold, silver, silk, pottery and lacquerwares in a complete and luxurious underground 'palace' complete with stables and storerooms. Yet none was as striking as the jade used as a shroud.

During the Zhou dynasty, jade was also taken internally. 'When the emperor purifies himself by abstinence, the chief in charge of the jade works (*yu fu*) prepares for him the jade which he is obliged to eat,' says the *Zhou li*.[14] Jade, add the commentaries to this passage, is the essence of the purity of the male principle; the emperor partakes of it to correct or counteract the water which he drinks (as water belongs to the female principle); the emperor fasts and purifies himself, before communicating with the spirits; he must take the pure extract of jade; it is dissolved that he may eat it. And in another passage of the *Zhou li*, we read that jade is pounded so that it can be mixed with rice to be administered as food to the corpse of an emperor before burial.[15] In later Daoism, there exists the more developed belief that jade is the food of spirits and for that reason helps to guarantee immortality.[16]

There is yet another argument which links the presence of jade ornaments in real life to those in the tomb. For the *Zhou li* also provides very precise details about the six pieces of jade which should be placed in the tomb of the emperors and which represent the six cosmic deities, Heaven, Earth and the Four Quarters. There is a Holder of the Seal Tablets who controls the correct use of these tablets in all rituals and ceremonies, with specific tablets of various

shapes and sizes which can be used only by those who have received the Mandate of Heaven. When an emperor is buried, this official links the six pieces with a silk cord through holes already made in them and uses it to lower them into the tomb, with two of them representing Heaven and Earth.[17] Man is merely a small part of the cosmos and is himself created by the cosmos, so if the cosmic powers are present – in the form of the six pieces of jade – he is as much under their influence in the grave as he was in life. As Laufer observes, for the ancient Chinese 'the grave means only *a change of abode* [italics added], and if the corpse is surrounded by the images of the six cosmical gods, this signifies the continuation of his after-life existence in partnership with the gods of his former life'.[18] It is true that Qin Shihuang was not a Zhou king, but the Qin certainly assimilated the Zhou ethos and rituals in their early years and we may reasonably assume that he adopted – albeit with modifications or improvements – many of their practices.

Jade itself creates the continuity. The durability of jade signifies that there is no break between life and death, but a transition; symbolically there is neither decay nor death. That is why the early Chinese accepted the notion that a deceased emperor would continue to live among them and exercise some control and influence over them. It is also why the new emperor took so much trouble to create a suitable residence for an afterlife in which he would continue to rule. But jade also had a physical function. On display at the 2012 exhibition 'The Search for Immortality: Tomb Treasures of Han China' at the Fitzwilliam Museum in Cambridge, there was a box of what were called in the catalogue jade 'orifice plugs' used to prevent the life-force escaping from a corpse. They included plugs for every human orifice, from ears, nose and mouth to anus and vagina. Given the use of such expensive materials as gold and jade, this was clearly possible only for members of aristocratic or wealthy families.

The other readily available material, a key ingredient in ancient Chinese medicine and alchemy, was mercury. The fact that this chemical element in its mysterious form as quicksilver is the only metallic element to be found as a liquid at normal temperatures has always fascinated both ancient alchemists and modern scientists. The

mythical deity Shennong (五谷神, *wugushen*; literally 'five grains god'), the supposed inventor of both agriculture and herbal medicine, listed mercury in the *Classic of Herbal Medicine*, a treatise compiled in the early Han dynasty but attributed to him. He was also believed to hold the secret of immortality.

Early alchemists called mercury 'immortal elixir', an equivalent of the philosopher's stone. In medicine it was often used in the form of cinnabar, a sulphide of mercury, which could be found naturally in Shaanxi, although the best quality was said to come from Hunan. Cinnabar and its close relative calomel were also used by the Chinese in making pigments, cosmetics, soaps and laxatives.[19] They were used in the form of a coarse, shining powder with a reddish tinge, and it is believed that the First Emperor imbibed a medical potion including such a powder. In fact, the widespread use of arsenic and mercury in procedures designed to enhance the possibility of immortality provides support for Needham's belief – often quoted – that Qin Shihuang died of mercury poisoning. There are, however, other opinions. Duan Qingbo, for example, believes that Needham is mistaken. As an expert on the Han before he worked on the mausoleum site, he argues that the use of mercury in potions or powder form to enhance longevity came into vogue after the reign of the Han emperor Wudi, who died over a century later, and that in Qin times such medicines were made exclusively from organic materials derived from plants.[20] Thus in his view the use of mercury inside the tomb has nothing to do with the search for immortality, nor is it there to offer protection from intruders. But the theory of death by mercury poisoning is tantalizing, and the prevailing view is that after the emperor had consumed mercury in the form of a drink to achieve immortality, and employed it to create flowing quicksilver rivers, it was used directly to preserve his corpse for his tomb chamber.

Qin Shihuang's ambition was without bounds. In his mind, he was building an empire to last for 10,000 years, and he intended to be a continuous presence and point of reference for his terrestrial successors as the great presiding ancestor, supervising and controlling them from his tomb. Thus another irony of the First Emperor's life – for he died almost immediately after travelling to Zhifu Island

for the third time – is that he died relatively young compared to his ancestors, at just fifty, perhaps as the direct result of an unsuccessful quest for the elixir which he believed would guarantee personal immortality.

6

WHAT IS THE MAUSOLEUM?

Immortality in the form of global renown came over 2,000 years later as the First Emperor's creation became one of the greatest tourist venues in the world. Today, few literate people in any country would fail to identify a photograph of the lines of warriors standing in the main pit at the Mausoleum Site Museum. Yet the Terracotta Warriors site, in spite of its size, represents only a small part of the whole plan for the imperial funerary complex and indeed plays a subsidiary role in the overall layout. So what is the current state of knowledge about the entire site, and what can we see as the immediate heritage of Qin Shihuang? What exactly is his Mausoleum?

As we shall see, the Mausoleum was conceived on a scale more massive than any other monument at that stage of human history. To avoid confusion concerning the various sites and archaeological finds, in this chapter we will divide the entire Mausoleum into three main parts: the 'Terracotta Warriors', the 'Mausoleum Precinct', inside the inner wall, and the 'Area Immediately Surrounding the Mausoleum Precinct', both within the outer wall and beyond it (see Figure 3). The area beyond these three parts, the 'Total Mausoleum', has so far been little explored – in part because its full extent has only recently been understood, and in part because much of it now lies beneath villages, factories, roads and other modern infrastructure.

Terracotta Warriors

A brief review of the process of discovery will help us to set the scene, and get past the dates and dimensions. The first large-scale

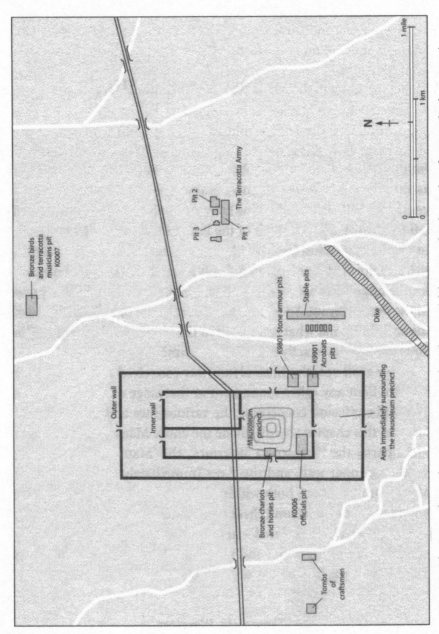

Figure 3. The Mausoleum: key sites mentioned in the text (elaboration by the author from multiple sources)

excavations in Pit 1 began almost immediately after the initial dis-
covery of warriors in the spring of 1974, and took place in three
phases: the first from July 1974 to March 1975 (comprising 965 square
metres); the second from October 1975 to January 1976 (450 square
metres); and the most important, involving 2,000 square metres,
from May 1978 to September 1981.[1] The smaller Pit 2 was discovered
during the second phase of work on Pit 1, and 170 square metres were
excavated between May 1976 and August 1977; a decade later, in 1986,
there was a new dig comprising 200 square metres. The final part
of the main early phase of work was completed by the excavation of
the 520 square metres of Pit 3, in this case the entire area, between
March and December 1977. Thus in twelve years from the original
discovery the *extent* of the terracotta army was known, and has not
changed substantially since.

Yet it should be remembered that the warriors themselves *have*
changed, in the sense of having been reconstituted and repositioned
where previously there was a chaos of terracotta fragments and body
parts. The ravages and burning thought to have been instigated after
the end of the Qin dynasty by Xiang Yu and other rebels led to exten-
sive looting very soon after the emperor's death: precious objects
were removed, most of the warriors were smashed and some of the
corridors in which they stood were set on fire either deliberately or
by chance, as shown by the presence of burned red earth and beams
reduced to charcoal. Since the entire structure was then weakened
and no longer sealed, centuries of rain, snow and summer flooding
brought heavy, sodden earth and mud into the corridors and further
damaged the warriors. The ceiling collapsed, and the figures were
toppled, pressed down into the earth and often pulverized. None
of the terracotta warriors or horses were found intact during the
twentieth-century excavations. Only painstaking extraction from the
earth piece by piece, and restoration in the laboratory, brought to
life the army we see today. More than five years passed from initial
discovery to public display.

The first museum was opened on the national holiday of 1 October
1979, with only Pit 1 on view to visitors. Other exhibition halls
followed as work on the main pits continued, that of Pit 3 being

opened in 1989, and that of Pit 2 in 1994. Later, new buildings were constructed alongside the pits to exhibit individual warriors close up in protective cabinets, together with a selection of important associated artefacts such as the imperial chariots. These new halls were opened in 1999 and in 2010, with increased facilities for visitors and features such as a special cinema with 360-degree films introducing Qin Shihuang and his warriors. A series of specialized temporary exhibitions allow the vast holdings of the Mausoleum Site Museum to be displayed, while a selection of warriors, horses and artefacts went on permanent display at the Shaanxi History Museum in Xi'an. In addition, groups of warriors and artefacts are regularly shipped overseas for temporary exhibitions in key global museums in cities such as London, Liverpool, Paris, Rome, New York, Philadelphia and Chicago, as well as lesser-known museums At the end of 2016, a new monumental entrance to the terracotta warrior site was opened on the road which runs parallel to it to the north and leads westwards to the tomb.

But what do visitors see? What are the pits, and how exactly were they made?

In preparation for the construction work, one-and-a-half kilometres east of the mausoleum precinct four large pits were dug to a similar depth of about five metres, then reinforced around the edge with rammed-earth walls and timber posts. At that stage, the site must have looked like the foundation work for a modern skyscraper with separate annexes, but with half the earth removed piled up beside the pits rather than taken away. The fourth pit was never used, presumably because the emperor's early death meant that work was unfinished. In Pit 1, by far the largest at 362 metres in length on an east–west axis and 62 metres wide (Figure 4), ten rammed-earth walls were built along its length within the pit to create eleven parallel corridors of equal width. These were then paved with clay bricks and equipped with vertical wooden posts and horizontal beams, which were first covered in reed mats and then by a layer of wet clay to seal the interiors. Lastly, the earth which had been removed was shovelled back over the pits to hide them, leaving a temporary entry ramp for access to each one. The beams used were up to twelve metres in

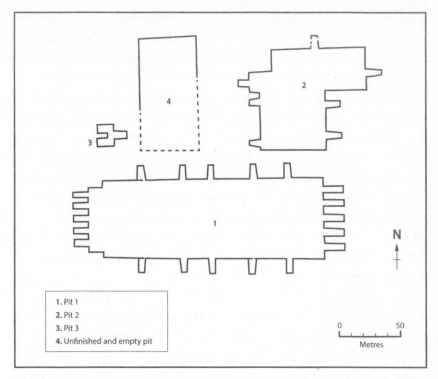

Figure 4. Plan of the warrior pits without modern accretions (after Yuan Yongyi, 2014)

length, similar to those employed at Yong. A total of around 6,000 standing terracotta warriors were placed in these eleven corridors, of which just over 2,000 have now been unearthed. They were part of an 'army' which included over 140 battle chariots with 520 horses, together with a further 150 cavalry horses, distributed between the three pits. The main body of the army, and the best-known through photographs, consists of the infantry figures standing in the parallel rows of Pit 1 and facing east (away from the tomb), together with officers in armour and four-horse carriages; they were protected by soldiers in smaller side-rows facing outwards like police around a sports stadium, and more guards at the back of the pit, facing west. There were more than fifty wooden chariots, with a single shaft and two wheels, each pulled by four terracotta horses.

Just twenty metres to the north-east of this massive pit was a

smaller one, known as Pit 2, measuring around 124 metres on the east–west axis and 98 metres north–south. It is very close to Pit 1, but structurally separate, and was initially found to have eighty-nine chariots together with over a hundred cavalry and other horses. It was divided into four parts, with communicating doors but each of them distinct, probably corresponding to their military function – one of them was certainly a cavalry unit. There were also standing and kneeling archers, absent from Pit 1. Much of the area inside this second pit is still covered by the original matting, and it has only been partially excavated. Altogether, it is estimated that the warriors in Pit 2 yet to be unearthed number around 1,400.

Pit 3 is much smaller at 28.8 metres long on the east–west axis, including a ramp entrance, and 24.7 metres north–south. It contained a single chariot with four horses, and sixty-eight warriors, but with a strikingly large number of senior officers whose presence led to its identification as a command centre. The chariot was originally painted black, and would therefore have been quite distinctive on a battlefield, and the fact that it carried a four-man team suggests that it was used by a very high-ranking officer. Pit 3 also stands little over twenty metres from Pit 1, to the north-west (Figure 4). In terms of excavation, Pit 3 is the only one to have been completed.

Over the two years from 2009 to 2011, further excavations were carried out in Pit 1. Two corridors and three sustaining walls covering an area of 200 square metres were investigated in the central part of the pit towards the north. A total of 106 newly discovered warriors were unearthed from these corridors, together with pedestals, weapons and fittings for horses and chariots. Advanced conservation techniques and knowledge of the pigments used to colour the warriors mean that these new finds are quite different to the greyish warriors thronging the corridors in the pit. The changes will be discussed in Chapter 10.[2] New work was also begun in Pit 2 in March 2015, and at the time of writing is still in progress with results as yet unannounced.

The number of warriors, horses and chariots impresses at a place where just over forty years ago there was nothing more than orchards of persimmon and pomegranate trees, the local delicacies and past

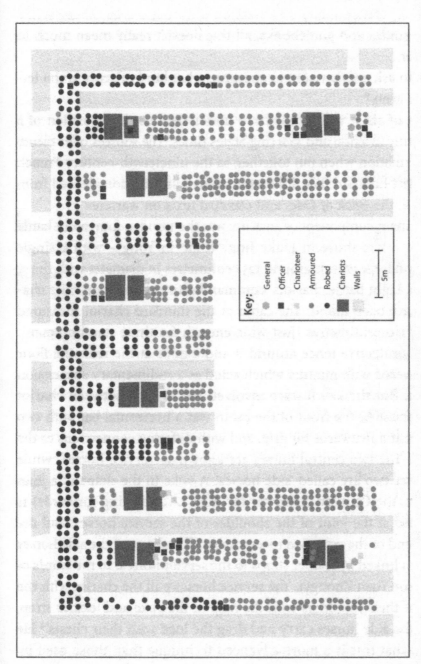

Figure 5. Distribution of the Warriors in Pit 1 (From the cooperative project between the Mausoleum Site Museum and UCL Institute of Archaeology, used with permission of the authors, Li Xiuzhen, Marcos Martinón-Torres and Andrew Bevan)

stalwarts of a mainly rural lifestyle. Since then, the local economy has been totally transformed by tourism and related industries. Yet in isolation, as the numbers of warriors, horses and chariots are reeled off by guides and guidebooks, all this doesn't really mean much to a visitor.

So, to ask another simple question, what kind of army is the terracotta army?

First of all, it will be useful to understand the composition of a 'real' army in Zhou and Warring States times. The sources offer plenty of information when put together, as the nineteenth-century French sinologist Édouard Biot did on the basis of information gleaned from the *Li Ji*, the *Book of Odes* and classical texts on warfare.[3]

The main component of an army was the wooden four-horse battle chariot – like those in Duke Jing's tomb in Yong – with a single shaft and large wheels around 125 centimetres in diameter with thirty spokes. Light battle chariots, command chariots and four-rider chariots have been found. The cabin of the standard chariot measured 140 by 110 centimetres (just wide enough for three standing men), with a protective fence around it and a door at the rear; the floor was covered with matting which acted as a rudimentary suspension system. But the key feature involved the linkage between chariot and horses. At the front of the cabin was a horizontal bar with two ends bent downwards for grip, and with differing connections to the horses. The two central horses are known as 'service horses', while the outer two are called 'side horses'. A yoke in the shape of a man (that is, the Chinese character for man, 人, pointing forwards) is mounted at the joint of the shoulder of the service horses, and the upper end of the yoke tied to a crossbar. The chests of the side horses are then linked by leather straps to the service horses. In the words of Professor Yuan Zhongyi, 'the service horses pull the chariot with the force of their shoulders with the help of the yoke and leather strap, while the side horses carry and drag the load with their chests'.[4] He argues that this is a more advanced technique than those used by contemporary chariots in the west, where neck straps were used so that horses had breathing difficulties at the gallop because the strap pressed against the trachea (see Figure 6).

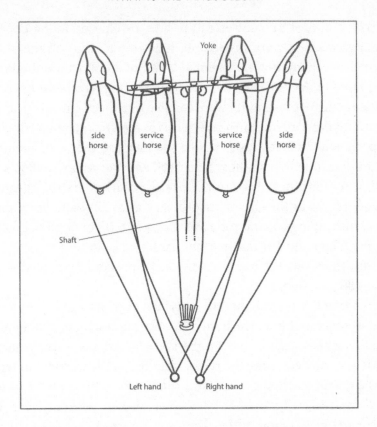

Figure 6. Sketch showing how only the two central or 'service' horses pulling a chariot are attached to the yoke (after Yuan Zhongyi, 2014)

As Biot points out, however, the term 'chariot' implied more than the simple physical vehicle and the men riding in it and is comparable to the usage of 'lance' in medieval and early Renaissance Europe, where it meant a team or military unit. He is probably thinking here of the French *lance fournie*, which was actually a battle unit consisting of a knight with a page or squire, a sergeant-at-arms and two or three accompanying archers. In France, a company of 100 lances entailed around 400 fighting men; in Italy, as contracts awarded to the *condottieri* show, the figure was 300 men. In the Qin armies, the chariot was an equivalent unit but larger: three warriors in chain armour on the chariot (the owner in the centre, his squire on the right and the driver on the left), together with twenty-five

warriors on foot in front of and beside the chariot, and a body of seventy-two lightly armoured men following it. Thus on the model of the lance, a 'chariot' represented a unit of around a hundred men (the numbers could also vary according to the terrain and specific battle tactics). These units were further organized into *shi* and *liu*, what Biot describes in European terms as a regiment and a battalion respectively, the first consisting of 2,500 men together with a duke or king (who rode in a six-horse chariot), and the second of 500 men with a senior officer, also in a six-horse chariot. Six *shi*, meaning 15,000 men, was the size of an 'ordinary army'. In battle formation, the commanding general rode in the centre, with one general on the left flank and another on the right flank.

This, then, was the real-life template. How could this be done in a funerary monument?

First of all, it is clear that the warriors, chariots and horses so far discovered roughly correspond with the proportions given above and this makes sense of the numbers and layout. Moreover, research carried out to determine the ranks and roles of the warriors in terms of the weapons they carried and the location of horses and war chariots produced a map of Pit 1 which also corresponds very well with Biot's description of the army (see Figure 5).

Each chariot is shown with three occupants, in all cases one or two charioteers plus an officer or general. There are altogether five generals, three at the head of a column and two further back. The generals at the head of the columns correspond to Zhou battlefield formation, with a central body and two flanking battalions. The presence of the 'robed' warriors ahead of and beside the main trenches is probably related to the unique function of this army, but it is interesting to note that the three columns in which a general appears with the chariot are preceded by armoured warriors and officers, exactly twelve in each case. In these columns, the chariot is followed by a troop of 108 warriors – four in a row for twenty-seven rows (this discrepancy may be explained by the fact that officers were not included in the hundred). This corresponds closely with a 'chariot' of around one hundred men in the ancient documents, a number requiring a company commander.[5]

The chariots and warriors in Pit 1 would therefore appear to represent a real army in battle formation, with the exception of the ceremonial warriors in the first three rows, and their tails which flow into the six columns not commanded by a general. The two chariots commanded by a general in the rearguard are an interesting strategic addition. Discipline in maintaining rows and files is stressed in all the military classics, although Wei Liao concedes that 'soldiers losing their squads of five and ten; chariots losing their companies and rows; unorthodox forces abandoning their generals and fleeing; the masses also running off – these are things which generals through the ages have been unable to prevent'.[6]

That they were conceived as an army in battlefield formation is supported by the presence of armour. In the case of the warriors this consisted of relief sculpture representing the leather plates or scales which were sewn together to make most suits of armour. More intric- ate armour with plates made of stone were found in the so-called Stone Armour Pit (K9801) to the east of the mausoleum between the inner and outer walls, eighty-seven sets plus one entire suit of horse armour which we will consider later. Many of the ordinary infantrymen in Pit 1 wore no armour; neither do they appear to have been equipped with helmets or shields, which would have rendered their position in the vanguard extremely dangerous should there have been a battle.* Others wore smaller pieces to protect arms and shoulders, using relatively small scales to allow almost natural move- ments of limbs. Usually, in fact, the armour was both specialized and appropriate to rank. Charioteers, for example, who drove into battle standing at the front of the chariot and thus exposing much of their bodies, wore very long armour, while members of the cavalry wore lighter and shorter armour to facilitate horsemanship and shooting from the saddle – as we saw earlier in the tactics and training of the Zhao ruler Wu Ling. The generals and other high-ranking officers wore a long armour tunic protecting the vital organs and extending in a triangular section almost to the knees. Other officers wore just breastplates or perhaps a shorter tunic-armour piece to protect the

* Illustration 69 on List of Illustrations, p.xi.

torso. The individual pieces decreased in size and decorative quality according to rank. The warriors must have been a fine sight with all the multi-coloured ribbons and buttons used to secure the plates of leather armour in place.

One of the most remarkable features of the warriors is their high-quality bronze weaponry. A total of twenty-seven bronze swords have been discovered so far, all still in their sheaths and in excellent condition. Most are between eighty and ninety centimetres long including the hilt, with the slim pointed blades ranging from sixty-four to seventy-two centimetres. The blades were as sharp and hard as medium carbon steel, with a proportion of bronze to tin of 4:1. Then there are sixteen long lances, similar in form to the bronze swords at the head but distinguished by the use of a wooden shaft nearly four metres long fixed on by means of a bronze stem behind the blade which could be forced onto the shaft. Both these weapons were made using techniques that were advanced for the time with a proportioning of bronze-tin alloy 'more scientific, reasonable, stereotyped and standardized'.[7] Most remarkably, there were over 40,000 bronze arrowheads with a triangular pyramid shape which improved flight and accuracy compared to the flat-headed shape of earlier times. There were also dagger-axes, spears and a very fine specimen of a *ji* (戟), which was a hybrid weapon combining the virtues of a spear and dagger-axe, often described as a halberd – a more modern, European weapon. The *ji*, mounted on a shaft like the long lance, was very effective used by infantry against cavalry and chariots.* There is much more to come, as may be judged by the large number of new weapons unearthed during the 2009–11 excavations in Pit 1.

Weapons using less durable materials like wood, mainly bows and crossbows, have suffered more. Naturally the wooden parts had often rotted away, although some could be restored and used to measure the size of the weapons. The Zhou had developed the bow of Scythian origins into an accurate and powerful weapon of some sophistication made of 'wood to achieve long range and horn to shoot faster, together with a silk binding and lacquer to protect against frost and dew'.[8]

* Illustration 38 on List of Illustrations, p.x.

There was a high degree of specialization, since the *Zhou li* lists eight different kinds of arrow for the traditional bow.[9] But the introduction of the crossbow was essential to the rapid success of the Qin conquests. It was said to have been invented by an archer called Chin, from the state of Chu, during the Warring States period – although he may in fact have been responsible only for the metal trigger mechanism. Noting that the traditional bow was no longer enough when all armies had well-trained archers, he had the idea of adding a stock to the bow at a right angle and creating a trigger in a box. There were various weights of crossbow, presumably heavier ones for longer range and lighter ones for rapid use, and also several different kinds of arrow for specific purposes. Certainly crossbows were more potent, had a much longer range with heavy arrows and revolutionized military warfare. But they also had limitations: they were slower to reload and fire, and could not be used from horseback – although they could be fitted to chariots. We might imagine that the twenty pages given over to the manufacture of the Scythian bow in the *Zhou li* were replicated in documents used for the crossbow in late Qin times.[10]

As might be expected, the most common finds in terms of weapons were arrowheads, usually found in bundles of a hundred which are thought to represent the full supply of a crossbowman's quiver. Detailed analysis of these was carried out under the aegis of a joint project called 'Imperial Logistics: The Making of the Terracotta Army' between the Institute of Archaeology at University College London (UCL) and the Mausoleum Site Museum (in this context abbreviated to MSM). The first phase of this project, which lasted from 2006 to 2010, included a typological study of the bronze weapons, comparative study of their dimensions, microscopic study of the alloys used and an analysis of the distribution of warriors and weapons with a view to understanding the layout of the army and the process of manufacture.[11] The arrow consisted of a bamboo or wooden shaft which fitted into a tubelike metal cylinder, the tang, onto which an arrowhead was then attached. The arrowheads themselves were found to be of remarkably consistent quality and dimensions, and to be made with sophisticated alloys: they are composed of two main parts that were cast separately and subsequently joined together: the

arrowhead itself and a tang, which together weigh approximately 15 g. The head is a solid, triangular pyramidal tip, averaging 2.7 cm in length and 1 cm in width. It has a cylindrical socket on the back, where the tang was inserted. The tangs are straight rods of metal, a few millimetres in diameter and showing variable lengths, typically ranging between 7 and 15 cm.'[12]

The heightened reality of the scene is increased by the presence of accurate and very highly detailed crossbows and other weapons. This was not just a matter of looking right, for the perfectly replicated mechanical parts of the chariots and even the officers' insignia 'seem to have been the features that ensured that the models worked like their analogues'.[13] These were accurately made models that would function in the afterlife, and would include feathers for the arrows, wooden frames and string for the crossbows, and leather and hemp for the quivers.

Chemical analysis showed surprising levels of sophistication in metallurgy, and also in manufacturing. One surprising and also controversial claim is that a very twentieth-century innovation, that of chemical chrome-plating, was used by the makers of the bronze weapons carried by the terracotta warriors. For this reason, blades were found in an excellent and unrusted state as the result of a light coating of about 10–15 microns of chromium salt oxide. Yet there is some dispute about whether this was a deliberate process. Modern Chinese specialists in metallurgy carried out experiments by mixing chrome ore with mature vinegar and saltpetre, heating the mixture to turn it into bichromate, heating again to liquidize it and then spreading the liquid on a sword surface to form grey chromic salt oxidation coatings. But more sceptical experts believe that the chromic molecules in the soil of the pits permeated into and formed the chromic salt oxidation coatings on the sword surfaces.[14]

However, other evidence does point to sophisticated knowledge, for example in the variations of the composition of alloys used in the head of the arrows and the tang. A portable X-ray fluorescent spectrometer enabled the UCL/MSM team to ascertain that arrowheads generally contained around 20 per cent of tin, which made them very hard and increased the power of penetration. In contrast,

the tang contained only 3 per cent of tin and 1 per cent of lead, while 96 per cent consisted of copper, producing a relatively soft bronze. These differences are more subtle than they might appear at first. While the bronze with a high proportion of tin had increased penetration power on hitting the target, it was also much more brittle; at the same time, the lower percentage of tin in the tang meant that it would be less likely to break when being forced onto the bamboo shaft and could also be more flexible in flight.[15]

Beyond this analysis of materials used, the team who created the map mentioned above were able to create what they call a 'snapshot' of a Qin battle formation, and implicitly therefore of Qin strategy in battle:

> For example, one can easily see how seemingly lower-status robed warriors were placed on the front line, followed by armoured warriors and the generally smaller numbers of officers or generals. Likewise, the distribution of arrowheads and crossbow triggers indicates that crossbowmen were placed primarily on the front, and along the flanks, of the battle formation, with chariots and warriors carrying other weapon types placed towards the core.[16]

These conclusions tally well with the descriptions of a real army and its organization found in the ancient texts and manuals.

The warriors themselves also seem to be closely related to reality in another important way. In his brief analysis of the size of the warriors, based on the measurements of a sample of 734 warriors provided to him, John Komlos calculated the mean height of the figures to be 177.7 centimetres, with a range from 166.0 to 187.5 centimetres. He believes that the warriors were similar to the average height of males in China at that time. Moreover, he showed that the size distribution resembles almost precisely the distributions obtained in most military institutions of the eighteenth century, indicating that the minimum height requirement of the Qin army was close to 175.95 centimetres 'because this is the point at which the sample distribution begins to deviate obviously from a normal distribution'. In fact just over 80 per cent of the warriors are at or above this minimum. He concluded

that the size of the terracotta figures could well represent the true physical stature of the Chinese infantry, and of the general male population.[17] This means that 'the terracotta statues were probably true-to-life approximations (±1 cm) of contemporary soldiers'.[18] The key word here is approximations, because as we will see below they were not actual portraits.

Since 1974, several theories and explanations concerning the purpose of this immense, complex and expensive 'army' have been advanced, as we shall see in Chapter 8. This section offers a basic description of the objects on display, and it must be said that many visitors find their first experience disorientating. The huge tourist crowds in high season, the freezing cold which persists for much of the year inside the unheated pits and the old-fashioned hangar-like appearance of Pit 1, the first building to be visited whether on a tour or on a private visit, can be underwhelming. The fact that visitors can only look down into a rather stark grey pit, especially on days when there is no sunshine to brighten it up and create interesting shadows, makes the museum quite different to those designed more recently which allow close-up views and an almost personal interaction with the exhibits inside the pits – although exemplars of some of the most interesting warriors may be seen at eye-level in the glass cabinets placed beside Pit 2.

I believe that a better understanding for visitors of the role of the warriors, and their part in the whole scheme of things, will make the three pits and the overall visit much more interesting.

Mausoleum Precinct

At first sight, the funerary mound compounds the problem. There is actually very little to see, and much of the archaeological evidence has been reburied once documented. Moreover, the excavation and ultimate display of the tomb of Qin Shihuang is for the moment a distant dream of specialists and tourists alike. Not all visitors to the three warrior pits go on to visit the mausoleum, and fewer still make a complete tour of the smaller pits around it. This is a pity because their role and story are fascinating.

Visible across the entire plain on a clear day, the funeral mound

stands as a monumental enigma against the mountains behind, often mistaken in the past as a natural hill. It may be seen as the funerary equivalent of the Epang Palace, an evolution of the terraced pavilion also intended as a visual statement of conquest and control no longer within or near the walls of the capital. A historian of ancient Chinese architecture has noted that the Warring States period witnessed the decline of the traditional lineage-temple system, in which ancestral tablets and altars were arranged in a temple or shrine to exalt the family lineage and sustain the Confucian notion of filial piety. The new elite – who we may think of as post-Zhou – began to express their status through larger and more complex tombs set within a funerary park. He writes that 'Two important manifestations of this transformation in art and architecture were the increasing grandeur of funerary structures and the development of an art tradition called *minqi* 明器 (spirit articles) made specifically for tomb furnishing.'[19] The mausoleum clearly falls within this definition. Although there is a vague description of the interior chamber in Sima Qian, nothing is known yet with absolute certainty even if ideas and hypotheses abound. For the moment we will just consider what is known.

The first historical mention of the mausoleum after the ancient descriptions came with an author in the Ming dynasty, Du Mu, who visited the site and published an article under the title 'Li Shan Ji' (骊山记) in which he provided a survey giving the dimensions of the mausoleum. The next two mentions came centuries later in the work of two foreign visitors to Xi'an.

The first was a Japanese technical or science teacher, Adachi Kiroku, who taught at the Shaanxi Higher Learning Institute, which is thought to have been on the present site of Northwestern University, founded in that period and now one of the most prestigious universities in Xi'an. He stayed in the city from 1906 to 1910 at a time when the Japanese were seen as the staunchest advocates of the modernization of Asian societies through education. Kiroku was an enthusiastic photographer, and visited most of the known historical sites in the Xi'an area during his four-year spell. Over twenty years later, in 1933, he published in Japan a book entitled *Chang'an Historical Relics*, with some 200 photographs. One of them is the oldest

known photograph of Qin Shihuang's mausoleum, taken from the east but unfortunately not very clear in the printed version.[20]

We have already mentioned the letter and report in which Victor Segalen described his experience in Lintong. He was born in 1879 in Brest, on the Atlantic coast of north-western France, where the ocean and the world it opened up to them were a natural attraction for young men; his great-uncle had been a naval doctor who visited China and must have talked about his experiences within the family, and his own father worked for the navy. Segalen himself was rejected as a regular naval officer as a result of his short-sightedness, so he embarked on a career as a medical officer. He had already spent several years in China when, on Sunday, 1 February 1914, he set off from Beijing to travel to Shaanxi with his wealthy friend and sponsor Count Augustus Gilbert de Voisins.[21] After his first sighting of the funerary mound, described in the Introduction above, he perceived it as a massive, unprecedented and never-equalled monument, comparable only to the pyramid of the Pharaoh Cheops at Giza. A few days later, in a letter to Paul de Cassagnac, a journalist friend of Gilbert de Voisins, he provided a detailed description with measurements which would be published in Cassagnac's magazine L'Autorité.[22] Historians and archaeologists in Xi'an today still consider that the photographs Segalen took that week provide valuable information about the mausoleum as it was a century ago.

Then in 1962 Wang Yu Qing of the Shaanxi Institute of Archaeology made the first professional survey. The mausoleum complex was found to comprise two walled areas: an inner walled precinct, which enclosed the funerary mound and associated buildings, and an area between the inner wall and an outer wall with official buildings and secondary tombs and pits. Professor Wang measured these walls and drew a survey map. He also discovered some pottery and remains of the outer buildings, but no excavation or scientific study took place. Since then, more accurate measurements have been made: the outer wall, forming a rectangle orientated on a north–south axis, measures 2,187 by 982 metres, while the inner wall is 1,337 by 598 metres, an area which encloses the tomb itself and directly associated buildings. In the southern part of the inner wall is the pyramid-shaped tumulus

covering the imperial tomb: today it measures 350 by 350 metres, but in ancient times is thought to have been about 470 by 470 metres (see Figure 7). The burial chamber itself lies about thirty to forty metres below the original ground level. The people and objects buried within the area of the inner wall were likely to have been essential complements to the emperor's life and work in the afterlife.

A clearer idea of the potential magnificence of the mausoleum was obtained during excavations in 1980, when bronze chariots and horses were discovered in a pit about twenty metres west of the tomb and just inside the west gate of the inner wall. Like many other later discoveries, it had been located in July two years earlier when a bore-hole mapping the area found a gold mirror, and further probes discovered bronze rust. Today, these chariots are the most spectacular exhibits in the Mausoleum Site Museum, recomposed from the thousands of broken pieces in which they were found. One is a light and open battle chariot drawn by four horses, with a charioteer in a long tunic who is wearing a sword at his left side and also has a mounted crossbow at the ready on the side of the chariot. The other is a heavier, closed chariot drawn by four similar horses. It is assumed to represent the imperial carriage, with a well-protected and covered rear compartment behind a kneeling charioteer, which would have allowed the emperor to travel privately (if not exactly incognito, since it would have been accompanied by all the pomp and pageantry accorded to his status) through his empire – in life, and then in the afterlife. The details on the harnesses and shaft linking them to the chariots behind were in both cases good enough to allow working replicas to be made.

Yet the chariots are half-size, or perfect scale models, a fact which has often created problems of interpretation. 'How', one scholar asked, 'was it possible to consider a combination of an army at life-size with a chariot for the Emperor himself at only half size?'[23] The answer to this question is that they were half-size because they were destined to be used by spirits rather than by full-sized human forms, in ceremonies or processions in which they would carry the emperor's soul. As the Li Ji explains, 'That the bones and flesh should return again to the earth is what is appointed. But the soul in its

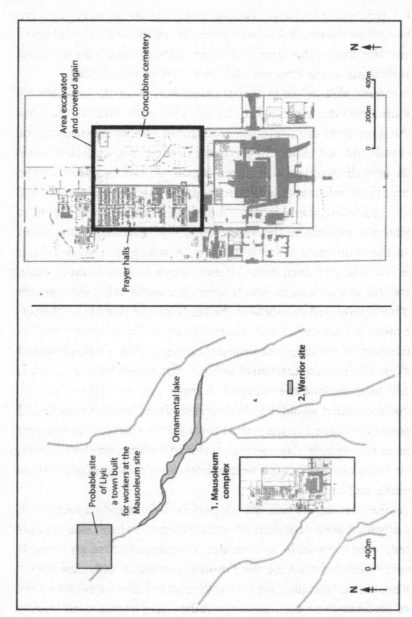

Figure 7. The area surrounding the Mausoleum (elaboration by the author based upon the original plan on the right, by Zhang Weixing in *Ritual and Order*, 2016)

energy can go everywhere...'[24] Thus the covered chariot was the 'soul carriage' or 'spirit carriage'. James Legge, who of course never saw these particular chariots, explains in a footnote that the 'left seat was that of the ruler in life, and was now left vacant for his spirit'.[25]

For this reason, they are no less elaborate than the real ones must have been. The chariots were intricate models made up of hundreds of individual pieces, then painted with designs including stylized dragons and cloud motifs – motifs which may be taken to represent the nebulous breath of the deceased. They were further decorated with about fifteen kilograms of gold and silver. These chariots faced west, and are thought to have been buried for the emperor's spirit to travel to his homelands in Xianyang, Yong and Gansu. Compared to the ideas portrayed in the *Li Ji* there is one slight anomaly, since the footnote quoted above adds that a ruler had 'five different styles of carriage, all of which might be used on occasions of state' according to the specific ceremony. We can speculate that among these 'occasions' might have been visits to perform sacrifices to the ancestors, inspection tours of the empire or just for the pleasures of sport or hunting.

Chariots required a good supply of horses. So the discovery of stable pits and horse remains was to be expected. In Jiao Village, east of the mausoleum, 101 stable pits were discovered soon after the original work began, with 37 of them being excavated in the digging season that lasted from October 1976 to January 1977. There were terracotta horses, but also real animals which had been fettered and probably buried alive. They were clearly part of the grand plan for the afterlife, since bowls for water and traces of grain and straw in basins were also found. The following year, during routine exploration of the site, a further stable pit was found near the west gate between the inner and outer walls of the mausoleum precinct.[26] Trial excavations in 1977 unearthed the bodies of three real horses, innumerable equine bones and the figures of eleven presumed grooms, court officials or stable-workers. It is estimated that three or four hundred real horses remain buried there, ranged around the courtyard or training ground which is often found in a grand stable.

The imperial afterlife also required servants. So when in 1996–7 a

tomb with buried convict-workers was discovered beyond the outer wall it could reasonably be assumed that while their life-work was no longer necessary they could be useful as a workforce in the afterlife in which they too would participate On the east side of the outer wall there were also rows of tombs of important government officials or courtiers who were presumably ready to follow the emperor as they would in real life. This suggests a further hypothesis, that on the model of the Han tomb of the Emperor Jingdi, designed just over half a century later, the unfinished plan for Qin Shihuang's mausoleum included a series of subsidiary structures around it representing the key ministries of his government – facilitating contact with their officials in the afterlife. At the Han tomb, there were nine ministries, so we might imagine a similar number for this one. None has yet been found on the scale of Jingdi's ministries, but the apparently empty space underground to the south and east of the mound might have been destined for further buildings, an unfulfilled project once again possibly due to the emperor's unexpected demise. The cluster of official buildings and stables just outside the west gate of the inner wall (see Figure 8) suggests that this was a key aspect of the design for the visits of the emperor to the west in his afterlife; for that reason, perhaps, the first constructions were focused on that south-west part of the mausoleum.

But, for now at least, the full plan and content of the mausoleum remain a mystery.

There can be no mystery as to the prominence of horses around the mausoleum. Chariots required horses, but so did pleasure for an ancient emperor. Wild animals and birds found in seventeen burial pits within the mausoleum precinct, in which individual animals often had their own coffins, were part of Qin Shihuang's private menagerie or hunting park, another key element of the imperial afterlife. Those so far excavated include the Asian barking deer (muntjac) and other species of deer. Elsewhere, in a hunting reserve to the west of the site of modern Xi'an, there were numerous lodges and palaces together with facilities for breeding tigers, wolves and moose which may have been replicated here. The location of these

pits so close to the west gate might suggest that more exotic creatures will be found in the future.

Hunting has traditionally been a favourite pastime of emperors, from the early private hunting parks of the Zhou to the annual expeditions of the Qing to their reserves in north-eastern China in modern times – as the exquisite deer carved on a tile-end from Yong illustrates, perfectly modelled so that its antlers and legs fill the circular form.* Ten stone drums with inscriptions dating from the fifth century, discovered south of Yong and thought by the American scholar who studied them and translated the inscriptions to have been made by one of the Qin dukes of that century, provide fascinating insights into their lifestyle, with a focus on hunting, horses, chariots and archery. These motifs recur in each of the poems on the stone drums, and may be exemplified by these verses from the drum known as Wu-Chü:

> Our chariots are well worked through and through;
> Our horses are thoroughly matched.
> Our chariots are perfectly in order;
> Our horses are thoroughly robust.
> The noblemen are about to go hunting,
> They are about to go hunting and about to roam.
> . . .
> The hinds and stags are frenzied;
> Their advance is ever so wild.
> We drive out the bucks;
> Their advance is marked by the thud of hoofs.
> We shoot the full-grown ones...[27]

This is early Qin culture in a nutshell, and one that would fit Qin Shihuang perfectly in the spare time of his afterlife.

In 2000, work began at Pit K0006, situated in the south-western corner and very close to the tomb mound. This proximity in itself suggests the great importance of the people or objects buried in it,

* Illustration 22 on List of Illustrations, p.ix.

and their quality. The remains of twelve terracotta figures were found, two of which were charioteers, now restored and to be seen standing in the pit, together with officials whose arms are conjoined in front of them with their hands invisible.* There was also a single chariot, and, quite differently from the chariots in the army pits, the bones of four real horses which had been buried with it. One of the terracotta figures held a ritual axe or mace (the *shu*), which is reminiscent of the ceremonial axe used during the Shang dynasty. For the axe shifted from being a basic tool to becoming a weapon and finally a symbol of power. This resembles the ceremonial practice of the Romans, who had an officer known as the *lictor* whose duty was to precede the emperor in procession, originally to protect him with sticks bound together in a *fasces*, a usage that was borrowed from the Etruscans.[28] Later, it was used in ceremonies, the *lictor* preceding the emperor – or others of high rank – holding an axe. This, and the proximity to the imperial funeral mound, led the chief archaeologist on this dig, Duan Xingbo, to deduce that this was the tomb – or afterlife office – of the minister of justice, who would therefore be ready to escort and lead the First Emperor whenever he emerged from his tomb – just like the *lictor*.[29]

Area Immediately Surrounding the Mausoleum Precinct

In the period from 1998 to 2003, significant discoveries were made when four smaller pits were excavated, two of them within the area between the inner and outer walls of the mausoleum.

The first of these was Pit K9801, where work took place from August to December 1998. This occupied a total area of 13,000 square metres, making it the largest of the so-called satellite pits around the mausoleum. But at that time only around 500 square metres were investigated. Like the large pits of the warriors, this too had been burned and also suffered breakage under a collapsed roof, but it seems that the eighty-seven complete suits of armour and forty-three helmets all made of stone which were found had been arranged there

* Illustration 72 on List of Illustrations, p.xi.

on wooden stands in readiness for use in the afterlife. There was even one complete suit of armour for a horse, the only one so far discovered. Hundreds of thin stone plates had originally been sewn together using small holes that had been drilled into each piece. A fine suit comprising 612 stone pieces and weighing altogether eighteen kilos was put on public display in 2013 after lengthy and careful restoration, together with a single reconstructed helmet. Remarkably, the individual pieces were made in several different shapes so that they would follow the contours of the human body – some square and flat, some rounded; they were also made to different standards, with more delicate pieces presumably for high-ranking offers and rougher pieces for ordinary soldiers. Since much of this pit is still to be unearthed, it is believed on the basis of material recovered so far that the total number of suits of armour may be as high as 6,000, making it a full-scale imperial armoury which may also contain further weapons.

The following year, in the summer of 1999, a trial excavation was carried out at the pit known as K9901 in the south-eastern corner of the outer wall. This too had been burned and partially destroyed, so that all eleven terracotta figures inside were shattered. During the restoration of six of them, quite different terracotta figures emerged, of a more delicate build and wearing short, toga-like garments over bare legs and torso. They were quite enigmatic, often said to have western-style bodies with more realistic and 'sculptural' shape, and they have been known since then as 'acrobats' and entertainers since some of them had their arms raised above their shoulders as if taking part in some form of gymnastic activity involving a mast or pole. They had been arranged very carefully, with strong-looking men standing behind the north wall of the pit, and thinner and more delicate figures behind the south wall. The presence of a large and heavy *ding*, weighing 212 kilos, brought another enigmatic element to this pit, while the fact that the floor had been covered in good-quality pine indicates the pit's importance. The massive three-legged bronze cooking vessel, with a characteristic interlaced design running round it, was probably part of the spoils of war of one of Qin Shihuang's actions against the Zhao.

Both K9901 and K0006, in the previous section, were to be reopened over a decade later, with results which we shall see in Chapter 12 and some surprising insights into the ritual purpose of the *ding*.

But in the midst of this mystery and serious government business, there was also entertainment for the afterlife. One of the most appealing discoveries was that thought to represent a department of musical entertainment in the government of Qin Shihuang, known as Pit K0007, about a kilometre north-east of his tomb, which was excavated from 2001 to 2003 and comprises 900 square metres. This pit, which considerably extends the land associated with the mausoleum, was built beside an artificial lake created from existing streams. The layout of the underground streams reflects that of the real ones on the land above, and the trenches are lined with planks just as canals or river embankments are still made in parks today. Forty-six life-size bronze swans, cranes and geese were uncovered along a sixty-metre stretch of river bank where the water had once been, each exquisitely cast and coloured so that they may easily be identified, some resting, some searching for food in the water, and one crane even holding what is believed to be a trout parr in its mouth. The birds vary in size and activity, just as the real birds would have done. It was an anomalous tomb. Another mystery.

When conservation experts were restoring these various aquatic birds, they noticed levels of craftsmanship and techniques which were common in the Mediterranean cultures of the time but rare in Asia. One notable example is the art of casting pieces of the final sculpture separately, then joining them together by means of brazing (like soldering but at higher temperatures, using copper and zinc) or via joints such as the mortise and tenon commonly used in woodwork. Metal supports known technically as chaplets were also employed inside the casting mould to support the slender legs of the birds and fix them to the base, where the resulting holes were covered by sheets of copper. Duan Qingbo comments that these techniques were 'rarely or never seen in bronze ware in the pre-Qin Dynasty, especially the repairing technique of embedding copper sheet', though they were in widespread use in Egyptian, Greek and Roman bronze sculpture in

the sixth and fifth centuries.[30] There was also an interesting variant in the bronze used for the birds. In China up to that time, bronze had usually been made with three metals, copper, tin and lead, and sometimes with small quantities of other metals – probably whatever happened to be at hand. Here, bronze made only of copper and tin was found for the first time, another innovation which had appeared in the Mediterranean area around 300 years earlier. Together, these features led to the inference that the bronze birds might in some way have been influenced by bronze-casting techniques prevalent in the Mediterranean.

Opposite the waterfowl in a separate trench were fifteen sitting or kneeling terracotta figures on mats with their hands in position as if holding wooden implements (long since disappeared), including one barefooted one who was assumed to be the bird-keeper. An early hypothesis based on figures in Han tombs in Yunnan was that the seated figures were weavers, perhaps weaving nets for bird-catching or fishing.[31] A more beguiling theory is that they are musicians, with their hands positioned according to the wooden instruments they would have been playing. Professor Duan believes that their identical costumes, consisting of a soft cap, a long gown, a hanging bag and long trousers, indicate that they were playing indoors and he has sought to identify the instruments by means of the position of their hands. Kneeling figures, for example, were in his view striking a drum or a bell, while others are holding the ancient equivalent of a plectrum for plucking strings.[32]

Once again, this appears to be a grander version of something that had been done in the past in miniature. A lady in a Qi tomb discovered in 1990, at Zhangqiu in Shandong, dating from around the fifth century was found with twenty-six clay figures, five musical instruments and eight birds. Ten female dancers with different costumes were dancing to music provided by two drummers and three further musicians playing bells, chime stones and a zither. The other figures, with their hands folded in front of them are thought to have been the audience. But there is one significant difference, for these figures are all slightly less than ten centimetres in height.[33]

It has been observed that sculptural detail is of a higher quality in

the tombs closest to the imperial funerary chamber,[34] which creates tantalizing expectations about the *minqi* or 'spirit articles' buried together with the emperor himself.

Also in 2003, a tomb was discovered to the north-west of the emperor's mausoleum, on a site measuring 109 by 26 metres; both its proximity to the tomb of the First Emperor and its structure suggested that it had belonged to someone of very high rank, possibly a member of the immediate family of the emperor. For these reasons it was at first assigned to the short-lived emperor Ziying. But since it is only 500 metres from the main tomb, the State Administration of Cultural Heritage in Beijing decided in 2012 not to excavate as there were too many risks, both for the objects believed to be located within the tomb and for the main tomb. In fact that attribution is now largely discredited, and the need to excavate is therefore less urgent.

Although it is hard to believe, considering his achievements and the time spent on warfare, administration, inspection tours and construction projects, Qin Shihuang died before his fiftieth birthday. What might have been if he had reigned as long as his illustrious ancestors Duke Wen and Duke Jing, fifty and forty years respectively, or his own great-grandfather Zhaoxiang, who ruled the state of Qin for fifty-five years and died at the age of seventy-five? How much more might he have done to enhance his everlasting resting place?

Be that as it may, and even though the complete design was never fully executed for want of time, the combined monumental site, comprising Terracotta Warriors, the Mausoleum Precinct and the Area Immediately Surrounding the Mausoleum Precinct, already constitutes one of the most remarkable human achievements of any epoch. Yet, as we shall see, there is much more.

7

WHO BUILT THE ARMY, AND HOW?

This idealized army was centuries in the making, at least from the conception of the tomb of Duke Jing with associated warriors and chariots in Yong to the search for everlasting glory for the Qin pursued by Lady Mi, from the practical building work initiated when Zhao Zheng became King Zheng in 246 to the acceleration in construction which followed his elevation as Qin Shihuang twenty-five years later. But the actual planning and much of the process remain a mystery, which is compounded by the fact that the historian who provides the most detailed account of the emperor and his forebears, Sima Qian, never mentions the existence of such an army. Oddly, too, no one – perhaps not even the emperor himself – apart from the workers who completed the task and were then supposedly executed, ever saw the army in its finished state until the twentieth century.

Sima Qian writes of 700,000 workers at the mausoleum site, and that is a good place to start since this number is often disputed – and taken with a pinch of salt by visitors. Actually the number is ambiguous, since Sima Qian explicitly states that some of these workers were used to build the Epang Palace and they may well have included artisans and labourers who had worked on the terracotta army, considered as part of the Mausoleum. We may assume that measures to guarantee the secrecy of the site of the funerary chamber – not least that 'all those who had worked as craftsmen or artisans to store the treasures were shut in the tomb, unable to leave'[1] – were equally applied to the army just a few hundred metres away.

Once the emperor had been lowered into his tomb and the burial chamber sealed, this workforce, in its three separate units (Epang,

mausoleum, Army), was presumably cut back to a minimum. It is likely that the people on site were fewer towards the end anyway, since the heavy digging and earth-moving had been completed and labourers were less essential. The artisans, as we shall see, usually worked off-site. The Han historian also tells us that these workers were transported from all over the empire to work on the Mausoleum when Qin Shihuang came to the imperial throne.[2] Now, again we might assume, thousands had long since returned to their homes throughout the empire; thousands more had probably died since work had begun, taking any secret knowledge with them. Yet the numbers remain huge, and many have doubted them.

The first obvious mystery is how 700,000 men and women could be mustered and put to work for such a long period. Is it plausible? And who provided the non-specialized labour? Before answering these questions directly, it will be instructive to consider an only slightly later case where the numbers of workers and the time they were employed on a task are detailed in historical records. Emperor Huidi, the second of the Han dynasty, mentioned above, constructed a new walled city which his father had planned slightly to the south-east of Xianyang, to be called Chang'an.[3] According to the Han annals, in early spring of the year 192 – less than twenty years after Qin Shihuang's burial – the emperor ordered that a workforce of 146,000 be recruited for a single month to work on the wall. These included both men and women, and the imperial edict established that they should be brought from all cities, towns and villages within a radius of around 250 kilometres of the capital city.[4] This was just for one month of intense labour. Work then paused for some months before a smaller workforce of 20,000 convicts was brought in; then two years later another temporary workforce of 145,000 people was drafted in to complete the work in the month between 13 February and 14 March 190.[5] As the modern scholar who studied the annals explains, this is presumably because it would be impossible to take so many farmworkers away from their homes during the summer months from sowing to harvest when there was much work to be done. Yet the mobilization of such vast numbers of workers for such a short time displays powers of control, logistics and organization

beyond present-day imagination. Obviously, the labour performed by 20,000 men over a period of seven months would be roughly equal to that done by 146,000 people in one month. Moreover, although the convicts were fewer they could be forced to work all year round – through the hot summers and freezing winters of the Wei valley. They could easily be recognized, and hence controlled, since 'All [convict] wall builders... had their hair and their beard removed.'⁶

Another example comes from Sima Qian's account of how his heir called up 50,000 crossbowmen to guard Xianyang in the year after the Emperor's death. It was as obvious to him as it is to us that such a large contingent required extra supplies even in a well-organized and well-supplied capital city. In addition to the soldiers, the historian mentions the need to feed 'dogs, horses, birds and other four-legged animals', some of which were themselves presumably intended for food. The problem was resolved with customary imperial logic: 'orders were given that the commanderies and prefectures should send beans, millet, hay and straw. Those who brought the food were to provide their own food, and farmers within 300 *li* of the capital were forbidden to eat the produce of their own harvest.'⁷ Such measures cannot have endeared the new emperor to his people, but absolute power could enforce them.

Considering these near-contemporary examples, the estimate of 700,000 employed over a number of years does not appear at all fanciful or impossible. It also included what may have been a large proportion of women, who performed tasks such as wood-gathering for fire and cooking. They were also an important part of the labour force in textile and lacquer factories, to the extent that textile manufacture became synonymous with 'women's work'. This included every phase and type of production from harvesting mulberry leaves, spinning, weaving and dyeing to the final sewing.⁸ In the Qin laws, one male artisan's work was usually considered equal to that of two women or five girls, but in the textile industry and especially in embroidery the ratio descended to 1:1. When Sima Qian informs us that 30,000 households were moved to work on the mausoleum at Mount Li, it could mean over 100,000 people if women and some sons or daughters also worked there. The new

town of Liyi built near the site for workers was large enough to have separate named districts such as Xi and Jiao.[9] Its exact location and size are not known, but it stood on or near to the River Wei to the north (north-north-west, to be precise) of the mausoleum area.

Such forced movements of large numbers of people were facilitated by the existence of an efficient household registration system. For each family was listed with the husband's name, wife's name, names of adult sons and daughters, names of non-adult sons and daughters, and names of other family members or servants. Here is an example of Qin date, translated by Robin D. S. Yates from texts found on bamboo strips:

Line 1: 'Nanyang householder Man Qiang, of Jing rank *bugeng*' 南隔户 人前不更蟹张;

Line 2: 'Wife called Qian' 妻曰赚;

Line 3: 'Son non-adult... of *shangzao* rank' 子小上造;

Line 4: 'Daughter non-adult Tuo' 子小女子鸵;

Line 5: 'Slave called Ju' 臣曰聚...

Thus the family of Man Qiang, on strips discovered in the ancient town of Liye, in Hunan Province.[10] Such a document would enable the entire family to be assessed for tax or ordered to move house, or for one representative member to be summoned to work on a temporary task such as the wall-building cited above. There was an equally developed apprentice system. The recently discovered Qin statutes mention a screening procedure for government-owned factories and workshops in which only the top 30 per cent of applicants were accepted, and explain that these men and women served a two-year apprenticeship before achieving full artisan status. There was a master of artisans responsible for their probation and training, during which they were expected to produce half the output of an experienced artisan. At the end of this period, they should have

been able to equal the normal production of an artisan.[11] In other words, the imperial administration system was geared to turning out the workers needed for large-scale construction projects. There was nothing haphazard or problematical about obtaining the labour force.

The bamboo strips bearing laws and regulations cited earlier also make it clear that in peacetime construction work was the main task both of convicts and of conscripted soldiers. This latter group potentially meant all men who had reached their fifteenth year, and in the early years of the new empire there could be no large-scale wars because – as we shall see – apart from the unassailable force of the Qin, tens of thousands of captured bronze weapons and arrow-heads had been melted down. The absence of a real threat, and there being no new military campaigns with the exception of those against nomads in the north, meant that there was a huge reservoir of available labour. It simply required a shift of focus and organization. In fact, there was a senior official called the controller of works who was in charge of conscripts and convicts engaged in building activities, so that the whole business of coordinating and guaranteeing the quality of their work was carefully regulated. Hulsewé's documents described in the Introduction also illustrate this: a rammed-earth wall was to be guaranteed for a year, and in the event of its collapse or deterioration not only were the conscripts who built it required to rebuild it, but the overall controller of works and the specific master in charge of the wall-building would be considered guilty of a crime.[12]

According to the survey of the penal system by Hulsewé, male convicts sentenced to hard labour were divided into five main categories: first of all the most heavily punished group known as wall-builders, then gatherers of wood for the spirits, then bond servants, then robber guards and finally watchmen.[13] The wall-building convicts could be easily recognized, as we have noted, because they had their hair and beards shaved, and the convict category was always specified as if it were an adjunct to the personal name (in this example, X), such as 'gatherer of wood for the spirits X' (工鬼薪 X).[14] When convicts were allowed to work on weapons, their names were given for the purposes of quality control. These convicts

were perceived as potential workers and artisans since on enlistment they were expressly forbidden to conceal their skills.

In all, there were seven basic levels of artisan in what Anthony Barbieri-Low calls a 'continuum of coercion', clearly in descending order: self-employed artisan, wage-labour artisan, indentured artisan, apprenticed artisan, conscripted artisan, convicted criminal artisan and slave artisan.[15] At the top of this pyramid – the self-employed – were well-paid, recognized artisans who enjoyed a certain amount of freedom of choice, who could perhaps add personal touches to their work; at the bottom were criminals and slaves who had no rights at all, could not choose when and how to work, were severely punished for the most minor infractions and could literally be considered expendable – such as the workers found in mass graves next to the mausoleum.

Hence the number 700,000 becomes *more* than plausible, especially in view of the even greater number of workers available when compared to those within the 600 *li* radius of the Emperor Hui, for according to Barbieri-Low most of the convict labourers used during the brief Qin dynasty came from Hebei, Henan, Shandong and Jiangsu.[16] But this was just the beginning. More recent scientific analysis based on the food products consumed by the mausoleum workers suggests that many of the convict labourers came from slightly further south, especially the lands of the Chu in Hubei and parts of Hunan and Anhui. Simply put, while the Zhou sites in Shaanxi show evidence of a diet based on millet, this study, based on what the authors call bio-archaeological analysis of 'ribs and long bone fragments' obtained from the graves of the convict labourers, indicates that they lived on a diet based on rice.[17] In other words, they were southerners. Putting these seven provinces together, plus Shaanxi and probably Gansu, Sichuan and Shanxi, emphasizes what a gigantic labour pool was available to the imperial administration.

But what did all these workers do? How were they organized?

We know little of the architects, engineers, bureaucrats, master-builders, inspectors and foremen who managed this workforce, although we can imagine that they were highly experienced and efficient, with such taskmasters as Lü Buwei in the early phases and

later Li Si, both named as overseers on surviving artefacts, and ultimately Qin Shihuang himself watching over them. One of the most interesting aspects is the use of a modular system parallel to that used in ancient Chinese wooden buildings, since only well-organized factories could produce such quantities of the 'components' in both cases. Using local clay, which is abundant, the figures of the warriors were built up from a strong base forming the plinth and feet. The torso was often built up with rolls of wet clay, and then the other components – arms and hands, legs, heads – added to the completed torso; next individualized features such as hair and ears were attached to the head. Wooden moulds were used, as they were for making pipes, gutters and tiles. Arms, hands and heads were produced separately and later attached to the torso using clay slip. Hands and fingers were formed in moulds and then bent into the desired position before being fired. The heads were often pressed into two moulds, and joined with a seam running up and backwards from chin to neck, though sometimes only the face was made in a mould while the back of the head was sculpted freehand from clay and added afterwards.

Existing skills were adapted in several ways, for example the expertise of artisans who fashioned gutters and pipes for imperial buildings was used to manufacture hollow arms and legs. The appearance of individual faces and expressions is also something of an illusion. Starting from a limited number of eight face shapes which could be made in advance in one of the many workshops, pieces of clay were applied – much as a make-up artist uses cosmetics and fillers – to differentiate the facial expressions and other details. The various forms of hair knot could also be added at this stage to further the illusion.

One puzzling aspect is the firing of such large objects. Kilns had already existed for centuries at the nearby Neolithic site of Banpo, yet the objects fired in them were relatively small vases, jars and other household articles. In 2006, five kilns were discovered at the Yong site, together with bricks and tiles which had been fired in them, so the process was well known to Qin artisans. Yet much larger kilns would be needed to fire statues of these dimensions, not to mention

horses. Presumably for ease of transportation such kilns would have been near the final destination, but so far none have been discovered. Support for this idea of necessary proximity comes from scientific analysis. A neutron activation analysis of the clay sources used for the manufacture of the warriors, based on around a hundred samples, led to the conclusion that the kiln sites might be located in the immediate area around the Mausoleum.[18]

Analysis of the weapons by the UCL/MSM research team also supports the idea of a modular factory system. As we have seen, arrowheads were found in the greatest number, but there were also crossbow triggers, swords, lances, spears, halberds, hooks and other weapons, some of which were found to be in such good condition that they could still be used in battle. The large number of arrowheads was carefully studied and compared, and then two hypotheses taken into consideration. If, it was thought, they had been manufactured in an assembly line with each individual or team producing a single component, the same metal composition would be found in different bundles of arrows throughout the site; if, on the other hand, a production system based on teams working in parallel was employed, there would be differences between batches of weapons delivered to various parts of the site. The final results showed 'that production was organised in multi-skilled cells that worked under centralised supervision, with well-defined models, moulds and quality-control procedures, which ensured extremely high degrees of efficiency and standardisation'.[19] This implies an extremely well-planned and well-organized production system, with workshops in various locations providing batches of weapons of easily controllable quality when and where needed. On this basis, we can speculate that overall the manufacture of the warriors and all their equipment, such as armour and headgear, was carried out in a similar manner.

There is however another intriguing possibility: that many of the weapons were not made specifically for the purpose of arming the terracotta warriors. Analysis and dating based on the regnal year inscribed on some of the longer weapons has shown that 'halberds and dagger-axes are dated from 244–237 BC, whereas lances date to 232–228 BC'.[20] This is quite some time before the emperor's death in

210, and goes back almost to his accession as King Zheng of Qin in 246. This hypothesis makes a lot of sense in terms of Qin Shihuang's premature death. If the army were not fully armed at that moment, the simplest expedient would be to raid the imperial armouries – which consequently must have been enormous and highly organized.

Nonetheless, the scope of the work was astonishing, even with so much manpower available. In 2007, Lukas Nickel calculated the volume of earth removed to create the four main warrior pits at 70,000 cubic metres, and helpfully converted this to the more comprehensible equivalent of 5,500 lorry loads,[21] although we should remember that as much as half of this could have been used for refill. Then there were the bricks, beams and posts to be transported to the site from workshops scattered across the province, for it would be easier to carry finished beams than whole trees or trunks. There was also a matter of feeding a workforce of up to 100,000 at any given moment, and perhaps greater numbers during the construction 'high season' or at times when the overseers saw the need to accelerate progress – in the weeks after news of the First Emperor's death came, for example. The logistical system can rarely have been matched until modern times, since these operations far exceeded the scale of those in ancient Egypt and Rome.

In fact one of the most modern aspects is the detailed attention paid to quality control. All work carried out by artisans for imperial workshops was scheduled by the government, all artefacts were made using strict parameters, and the weight and dimensions of tools were carefully supervised to ensure compatibility with the standards of official workshops. Fines were imposed when standards were not met. It was clear to these ancient foremen and supervisors that a series of artisans working on a single figure could not achieve the same quality as a single artisan who sees his work as a whole and thoroughly understands it. In the words of Barbieri-Low, the bureaucratic systems of responsibility were refined to 'an almost-unimaginable degree' with constant scrutiny of workshop and factory procedures: 'The law required that weights and measures be standardized and regularly checked by traveling inspectors, and that raw materials and finished products be inspected for quality and standardized

dimensions.'[22] Visitors and even guides often seem to believe that artisans inscribed their names on tiles and terracotta components as a matter of pride in their work. In fact they were compelled by law to sign their names because they were held personally responsible for the quality and durability of their work. The master of an artisan work group was required to inscribe the name of the worker, the name of his work unit and the year of manufacture.[23] The laws stipulated punishments such as flogging and fines for faults discovered up to a year after completion.

A detailed study of the production process was made by Lothar Ledderose in a landmark essay published in 1998. He explained that the figures of standing warriors were between 150 and 200 kilograms in weight and usually consisted of seven major parts: 'a plinth, the feet, the legs below the garment, the torso, the arms, the hands, and the head'.[24] Each part was crafted separately and then fitted together, much as the broken fragments are re-assembled today in the laboratories. The plinths were formed in moulds, probably wooden, which had the advantage of standardizing the production process and could be used by any worker skilled in manufacturing roof or floor tiles. Clay was kneaded, perhaps by treading as in grape-pressing, as is still done in traditional kilns in Yaotou to the north of Lintong.* The slabs which were cut out were then rolled to form large tubes which could serve for the torso and smaller ones for the limbs; other body parts were formed in moulds which were made in clay which had previously been fired. Then came the finishing, and more expert, touches.

Hands were one of the features which gave the impression of individuality, and were made separately. As we saw above, they could be made with fingers and thumbs straight or bent, either formed in advance and fitted to the palm or moulded as a whole. This was essential for the many active positions taken up by the warriors and charioteers, holding weapons or reins, for example, or stretched fingers for the archers. Once again, these parts of the hands were standardized, and could even have been produced off-site and then

* Illustration 41 on List of Illustrations, p.x.

added to pre-existing arms at the last moment. That process could have had the added virtue of protection, because the hand is often the first part to break off in any statue. The figures are quite fragile, since the thickness of the terracotta varies from five centimetres down to just one – which accounts for the destruction caused by the collapse of a heavy roof.

But the real defining characteristics which provide the illusion of individual warriors were details on the head, such as braids and topknots like that of Warrior Chu. Once the skull-shape had been formed in a mould, features such as ears, nose, beard and hair could be added, as well as significant painterly detail such as eyebrows and eyelashes, as will be seen in the more recently discovered warriors in Chapter 10.

Ledderose concluded that the use of modules was key to the differences between individual warriors. 'Only by devising a module system could their makers rationalize production to such a degree that, with the material and time available to them, they were able to meet the expectations of the emperor – the creation of a magic army that would protect his tomb for eternity.'[25] This also helps to explain the rapid creation of a large workforce, since artisans capable of producing drainage pipe, pottery or simple tiles could easily have been converted to mass production of terracotta warriors and horses. But this production necessitated kilns much larger than those which are usually found. As a noted historian of Chinese art has observed: 'The success in firing these pottery parts with so little fault, the implied dimensions of kilns, the vast requirement of clay and fuel, say much for the efficiency of the ceramic industry of the late third century BC.'[26]

The final stage in production was painting. All the figures were first primed with dark-brown lacquer, known as Qi Lacquer, the light-brown sap from the bark of the lacquer tree which is native to China and India. This sap, containing among other substances the vital ingredient urushiol, was filtered and then heated, and after cooling and storage was applied to the terracotta with a brush before being left to harden. Two layers were applied to the entire body after it had been assembled and then fired as a single piece.

One of the key problems of preserving the warriors in full colour is that the lacquer is so dependent on a stable humidity that it dries in just a few minutes after being removed from the pits, shrinking and curling upwards so that the colouring over it is cracked and breaks off in flakes. This happens as soon as the relative humidity drops below 84 per cent – which is very easy in the dry summer climate of the area. Perhaps for this reason, although Qi Lacquer had for centuries been used as a protective coating on metal, it had not been used in this way on clay.[27]

In order to overcome these difficulties, experiments were made with what is known as electron-beam polymerization. In layman's language, samples of the lacquer were consolidated by treating them with a special water-soluble solution containing hydroxyethyl methacrylate (HEMA), which penetrates pores in the glaze. They were then subjected to polymerization – or bombardment – by electrons in a particle accelerator, which converted the hydroxyethyl methacrylate into a polymer which bonds the coating together like glue. Another advantage of this method is that micro-organisms and mould were destroyed by the electron-beam radiation. The result was that 'the qi lacquer is bound to the terracotta, the fragments can be dried, [and] a natural look (not shiny) of the polychromed surface is obtained'.[28] Three years after the first experiment the original lacquer was still bound to the terracotta, which had completely dried. As we shall see in Chapter 11, the removal of polychromatic warriors from a new dig is now much more sophisticated than it was in those early years of discovery.

On this lacquer base, the Qin artists applied layers of water-soluble pigment in a surprisingly sophisticated way. Flesh tones on hands and faces were obtained by applying separate layers over the lacquer background, first of all a very thin white layer, followed by a thicker layer of pink; lacquer was again used for the darker brown necessary for hair and eyes. Some fragments have been found with pink painted over a thin layer of orange, and on at least one a mixture of red and white made with finely ground cinnabar.[29] Thus the faces would have appeared much more alive than they do now.

One aspect which provides an intriguing insight into the terracotta

army is the use of colour for clothing. For as we as modern visitors gaze down on the warriors aligned in Pit 1, it is only natural to think of them as wearing distinctive uniforms like British guardsmen or elite Chinese soldiers at some grand parade. Military elegance and pageantry are strongly associated with colourful uniforms and accessories such as plumes, both in real-life displays and in historical and movie reconstructions of medieval pageants and historic battles. Yet it seems that soldiers in the armies of Qin Shihuang were not issued with uniforms at all, and evidence suggests that the colours used in their clothing were varied and highly individual, presumably according to what they happened to possess and how much money they had available for purchasing clothes suitable for travel and war. Weapons and armour *were* supplied to soldiers, but they were expected to provide their own clothing – so the colours and materials used were a reflection of contemporary taste and fashion, usually involving bright primary colours but also many tints and shades. This may be seen in the various tints of red, blue, green, yellow and white found on the terracotta warrior bodies. Trousers and tunics were also often different colours, with extra colours used for collars and similar sartorial details. The few figures discovered with colour almost intact confirm this, as do other tantalizing clues. For example, one of the bamboo strips from Yunmeng cited above contains an instruction from a soldier to his mother to look for 'low-priced silks or cottons which can be used to sew shirts and jackets'.[30] So we may imagine some strange combinations of colour, perhaps even patchwork, with soldiers showing off the materials which their mothers had obtained in local markets. More remarkably, the use of colour cannot be used to distinguish between infantry and cavalry or between low-ranking officers and important generals, although there were some differences in the style of clothing.[31]

Organic pigments such as cinnabar for the production of reds, azurite for blue, and malachite for green, were widely used, as was the artificially made colour known as Han or Chinese purple. The pigments on the warriors were identified by polarized light microscopy (PLM), X-ray diffraction (XRD) and X-ray fluorescence (XRF). They were applied in fairly thick layers of 0.01 to 0.8 millimetres,

and surviving signs of brushstrokes often indicate the confidence of the painter when the pigments are applied with a single stroke. They are often used to denote texture, or for following the line of draperies, and also in a sophisticated representation of features such as eyebrows and hair partings.[32]

It remains to imagine a visit to the underground army just after the imperial burial, walking down the entry ramp and along one of the corridors rather than gazing down from a walkway in sunlight. In the flickering flames of torches, the solemn larger-than-life pink-and-white-faced warriors on their pedestals, adorned by variegated and always brightly coloured clothes, must have made an impressive but also disturbing sight in the narrow corridor as they appeared one after the other to a supervisor or quality inspector walking past them.

8

WHAT WERE THE WARRIORS FOR?

Oddly enough, the answer to this is not completely clear. There are several inconsistencies and anomalies yet to be resolved and explained. The main ones may be summarized in the following questions: Why do the officers in Pit 1 not carry weapons? Why is it that many of the horses are real while all the human figures are made of clay? Are the warriors generic types or intended to be seen as individual portraits? Why was it necessary to create the illusion of individual appearances? Are the warriors in fact soldiers at all? What is the purpose of stone armour which would be impossible to wear? In the context of this book, we may also ask what recent discoveries have made the presence and function of the warriors better understood.

An answer to the first question, concerning the absence of weapons, shows that many of the apparent inconsistencies may be explained by an examination of Qin military practices. The most likely answer is surprising, and illustrates how the completely different mindset of a third-century army can mislead us. It has always been difficult to quantify success in the field, while courage is intangible and often depends on the perspective of the observer. The Qin obsession with numbers and measurement led them to devise a means of evaluating success for an officer, and thus provide an objective basis for promotion: this was to count the number of enemy heads obtained by men directly under the officer's command during a battle. Rank-and-file soldiers were rewarded on a similar basis, and gained promotion by presenting severed heads to an officer as evidence. Since the officer's own promotion partly

depended on the number of enemy killed by his troops, he himself, presumably to avoid cheating, was forbidden to behead enemies. As Robin D. S. Yates explained in the volume accompanying the British Museum exhibition of terracotta warriors in 2007, 'since their responsibility was to manage the troops under their command, they were not supposed to cut off heads themselves, which explains why the officers in the First Emperor's terracotta army are represented without weapons'.[1] As so often, an apparent anomaly is explained by a careful reading of contemporary texts.

The second question, on the contrast between clay figures and real horses, also finds its answer in a now incomprehensible mindset. As we have seen, there was a long-standing tradition, which for the Qin seems to have begun in Yong, of sacrificing concubines and court officials to 'follow' a ruler into his tomb. The number of sacrificial victims of various ranks increased from the 66 buried with Duke Wu in 678 to the 186 buried with Duke Jing in 537. These human victims were always accompanied by a larger number of horses, in the case of Duke Jing around 200 – yet to be excavated. An even greater number were buried with his homonymous contemporary, Duke Jing of the rival state of Qi, at its capital Linzi (now part of Zibo, in Shandong Province in the east). The two never met, but the Qi duke did send an emissary to his Qin counterpart in 539, two years before the latter's death, and later travelled to Qin in person to meet his son.[2] Two hundred and fifty horse skeletons have already been unearthed in sacrificial pits around *his* tomb, but it is believed that the total number of horses buried may be 600. Appalling though this may seem to a modern reader, Sima Qian tells us that the duke loved to collect horses and dogs and to display them.[3] It would seem only normal to him that these prized animals should be buried with him, to be admired and ridden in the afterlife.

Yet there seems to have been a growing awareness that such practices represented an extravagant waste of manpower (and good horses) when sculpted or moulded human figures could serve the purpose just as well. The Dutch scholar of Chinese religion J. J. M. de Groot noted however that there was some ambiguity: 'attention must be called to the fact that the character 殉, which is used in

the ancient writings to denote burying human victims with the dead, has in the *Shu king* [the classic Book of Documents, now known as *Shujing*] also the meaning of "to desire, to seek".' Is this a mere etymological accident, he asks, or 'does it confirm the belief that in ancient China to be buried with the dead was sought after as a favour?'[4] This puts an unexpected spin on the matter, which was perhaps not quite as horrific in prospect as we imagine. Total confidence in the existence of an afterlife, in which rank and wealth will still be guaranteed by loyalty to a monarch, would make it seem absurd to choose *not* to 'follow' him into death. It was simply not worth the risk of staying alive for a little longer and then being cast aside for eternity.

Be that as it may, in 384 the practice of sacrificing court officials and workmen with their master as a part of burial rites was banned by Duke Xian. Although it is unlikely that the duke – not to be confused with his eighth-century homonym in Yong – was particularly humane, he may have recognized the waste of administrative talent and loyal courtiers. There were also scholarly arguments in favour of abolition, even though as a matter of fact the number of human sacrifices under the Qin was 'notably lower' than the average in other states within the cultural sphere of the Zhou.

One example of criticism of the practice comes from a commentary on the *Li Ji*, given here in the translation of James Legge:

Confucius said, 'In dealing with the dead, if we treat them as if they were entirely dead, that would show want of affection and should not be done; or, if we treat them as if they were entirely alive, that would show a want of wisdom and should not be done. On this account the vessels of bamboo (used in burials of the dead) are not fit for actual use; those of earthenware cannot be used to wash in; those of wood are incapable of being carved; the lutes are strung, but not evenly; the bells and musical stones are there but they have no stands. They are called vessels to the eyes of fancy; that is, [the dead] are thus treated as if they were spiritual intelligences.'[5]

Confucius, who lived from 551 to 479, was himself a contemporary of the two Duke Jings. But his 'small and weak'[6] home state of Lu, whose capital was Qufu, at that time bordered Qi to the south, and Duke Jing of Qi actively opposed the reforms that Confucius sought to introduce and even invaded Lu – though he had earlier welcomed the sage to his court. He was clearly a man of tradition, like his Qin counterpart – whose realms Confucius never visited on his later peregrinations through northern China.

However, this concept of the dead as 'spiritual intelligences' was integral to third-century thought, as Eugene Wang has observed, and will help us to understand the thought of Qin Shihuang as he planned his funerary chamber:

Life and death, in the third century BCE, were defined largely with regard to the condition of breath. Human existence was understood as part of a cosmos made up of all-permeating 'breath', or *qi*. Everything in the universe was conceived in terms of *qi*. Concentration of breath meant life; dispersion spelt death. Existence after death was understood as an amorphous state, a nebulous mass of scattered breaths that tended to fly around aimlessly.[7]

Yet it still meant the loss of life in the ordinary sense of the word. A mournful and moving poem known as the 'Yellow Birds', or 'Huang Niao', in the *Book of Odes* – also associated with Confucius – may have had some influence on the changing of attitudes about ritual suicide. It was written to commemorate the funerary rites of Duke Mu of Qin in 621, when, we will recall, three senior ministers who were members of a prominent family were ordered to die with him, probably by ritual suicide. They were called Yanxi, Zhonghang and Zhenhu. The lament for their deaths bears a hint in the refrain of the famous lament for times past of the French poet Jacques Villon. The poem is given in full here, since it is an important document in the story of human sacrifice under the Qin. The translation is that of James Legge, with the names of the three officials modified to pinyin to correspond with those used above:

1. They flit about, the yellow birds,
And rest upon the jujubes find.
Who buried were in duke Mu's grave,
Alive to awful death consigned?

'Mong brothers three, who met that fate,
'Twas sad the first, Yanxi, to see.
He stood alone, a hundred men
Could show no other such as he.
When to the yawning grave he came,
Terror unnerved and shook his frame.

Why thus destroy our noblest men,
To thee we cry, O azure Heaven!
To save Yanxi from death, we would
A hundred lives have freely given.

2. They flit about, the yellow birds,
And on the mulberry trees rest find.
Who buried were in duke Mu's grave,
Alive to awful death consigned?

'Mong brothers three, who met that fate,
'Twas sad the next, Zhonghang, to see.
When on him pressed a hundred men,
 A match for all of them was he.
When to the yawning grave he came,
Terror unnerved and shook his frame.

Why thus destroy our noblest men,
To thee we cry, O azure Heaven!
To save Zhonghang from death we would
A hundred lives have freely given.

3. They flit about, the yellow birds,
And rest upon the thorn trees find.

Who buried were in duke Mu's grave,
Alive to awful death consigned?

'Mong brothers three, who met that fate,
'Twas sad the third, Zhenhu, to see.
A hundred men in desperate fight
Successfully withstand could he.
When to the yawning grave he came,
Terror unnerved and shook his frame.

Why thus destroy our noblest men,
To thee we cry, O azure Heaven!
To save Zhenhu from death we would
A hundred lives have freely given.[8]

In his more recent and elegant version, Ezra Pound has each of them shaking at 'the grave's brink'.[9] The fame of this poem and its powerful explicit criticism of the Qin may have been a key factor in the banning of this specific book by Li Si and Qin Shihuang. To imperial eyes, it would have been seen to defile the memory of a great ancestor.

In fact the practice of human sacrifice and voluntary suicide did not end absolutely with the order of Duke Xian in 384. Qin Shihuang himself in 210, or at least his executors and administrators, still arranged for a large number of concubines – perhaps in their hundreds – and dozens of workers to be buried with him. The former, some of whom may still lie in the unexcavated tomb, died for the emperor's future pleasure; the latter as a result of his obsession with secrecy.

But most of the figures in the army and other mausoleum pits were made of clay and then fired, so we need to ask two questions: how did it come about that clay substitutes would be good enough, and what is the function of the differentiation of the thousands of figures – especially in Pit 1 – if they are not individual portraits? A well-known analysis by Ladislav Kesner starts from the assumption that the figures 'were commissioned and created as surrogate beings,

substitutes in the sense of compensating for the absence of real people, who, for various moral as well as economic reasons, could not have been actually buried with their master'.[10] This is generally held to be the reason why they were made as realistic as possible. In fact, as Kesner notes, the details of hairstyles, costumes, armour and such accessories as belts, boots and collar closures point to a deliberate attempt at creating verisimilitude, as does the posture of kneeling figures. The presence of colour, real weapons and chariots heightens this effect. At the same time, however, the effect is offset by the stiffness and distorted proportions of the figures, and by what Kesner describes as a 'marionettelike artificiality' in that the bodies are defined by the tunics and armour they wear rather than by anatomical features like joints and muscles.

In simple terms, we could argue that they are not realistic at all, although this is very much the perception of a twenty-first-century European rather than that of the First Emperor himself and the artisans (artists?) who made the warriors. For it is difficult to imagine how the ancient Chinese would *see* portraits without the tradition of Vasari, Berenson, Clark and Berger which informs us in comparing, say, Raphael with Rembrandt. The Swedish art historian Osvald Sirén wrote of Han dynasty portrait painters that rather than attempting likeness they worked in a symbolic way, so that the paintings became 'more or less imaginative works of art whose importance depended on their power to evoke certain characters, actions or events'.[11] In other words, their importance did not depend on realistic likeness. In similar vein, the fourth–century AD painter Gu Kaizhi stated unequivocally that he aimed for expression rather than likeness in his portraits.[12] Such a statement could be employed as a tool for the analysis of the figure of Warrior Chu.

To return to the warriors, there are two questions which now require an answer: if the figures are not portraits, what are they, and what were they supposed to represent?

As we saw in the brief quotations above from Sirén and Gu, the portraits represented types rather than individuals and we may assume that 2,000 years ago personal identity was irrelevant in the grand imperial scheme. When we speak of a million soldiers, or

tens of thousands of men beheaded after a military defeat, they can never be considered as individuals. They are just combatants and heads. As Kesner explains, 'each figure in the terracotta army acquires its status and significance only within the framework of the whole and insofar as it contributes to the function of that whole'.[13] That function is the only measure, to which everything else is ruthlessly subordinated: the details, the weapons, the hairstyles, the facial expressions tweaked with an extra strip of clay, all provide a gloss of personality and individuality to what remains a generic type such as an archer, a charioteer or a general. The success of the imperial army in the afterlife needed the illusion of reality, of these military roles, based on an illusion of individuality. To adapt Gu Kaizhi's words, the warriors in Pit 1, in particular, are perfect expressions of the role of a million soldiers in the Qin scheme of conquest. Hence, also, the massive numbers. It makes little sense to think of them as portraits, or as real historical figures.

It is usually the case in ancient burials that there is no reference at all to the personal identity of sacrificial victims. The example of Yanxi, Zhonghang and Zhenhu given above is rare and depends on their exalted role and family status – and a sympathetic poet. The myriad others found in tombs from the Shang to the Han remain anonymous skeletons with no personal attributes or even trinkets. They are there simply to represent in numbers the power and prestige of their duke, or king, or emperor. In the case of the terracotta warriors, they may look realistic to a certain extent, but their function overrules any need for personality or individuality. They should closely resemble real figures, to sustain the illusion, but their role is far more important than their putative existence as individuals. This overriding importance of role and function is equally true in terms of workers and concubines sacrificed, even though they had once been real people, as it is of terracotta models.

From the point of view of common sense, too, it is hard to believe that Qin Shihuang would have cared much about the features of the individuals who made up his army. They were disposable for the purposes of his own ambition, necessary for his protection. Their value was based on what they could do, or what they could be used

for. In this sense, one of the conclusions which Kesner reached is absolutely convincing:

> Their individual personalities were fully encased in their roles. What mattered within the confines of the underground realm were those aspects that made each soldier a constitutive component of the whole – his function, as it was embodied in position, gesture, and the requisite attributes. And this is exactly what is depicted in each figure.

But there was another important point that Kesner does not make, that the army assembled over several decades from distant parts of the future empire was – to use a modern expression – a multi-ethnic force. The faces, expressions and styles of headgear unite the people of the central plain north of the River Wei with others from Chu in the south-east, Zhao and Yan in the north-east, the Shu and Ba of Sichuan in the south and the nomads in Gansu and further west. Unified China stands in front of us in Pit 1. There was no need for realistic portraits, only for figures that could be assumed to fulfil their roles in the emperor's afterlife – which possessed the power to evoke, to return to Sirén's words.

We still tend automatically to think of them as members of an army intended to defend the immortal emperor in his tomb from attacks from the east – whence real-life enemies might have come, as they did in the case of Xiang Yu and Liu Bang. The word 'warrior' has become synonymous with the site and the museum; few guides or popular books use any other expression. Yet there have been other theories and suggestions which make more sense in the light of the above considerations, focusing on the *roles* of the figures.

For example, Professor Liu Jiusheng, formerly of Shaanxi Normal University in Xi'an, has argued that the 'army' was in fact an army of servants and bodyguards rather than warriors. After studying this army for many years, he became convinced that the function of the terracotta figures was quite different, approaching the matter from the perspective of ancient rituals. The notion of defence implied potential enemies, while in Qin Shihuang's vision of an eternal empire ruled

over by him, and by his descendants under his own supervision, there could logically be no enemies. So the army was not placed there to guard against attacks by real enemies, and indeed the presumed burning and looting by Xiang Yu and other rebels was not prevented by its presence. The role of the terracotta figures was underground, and in the afterlife. On this view they may be imagined as guards or courtiers intended to be used in rituals and ceremonies – rather like a noble form of cardboard cut-out figures.

Liu adduces several key points: that the warriors are not wearing helmets but what he describes as *quefei* hats (却非冠), a kind of formal headwear worn by palace guards as prescribed in the classic later history known as the *Book of Han*; that the warriors in Pit 1 are clearly divided into charioteers, cavalry and infantry each with independent commanders and tasks concerning ceremonial procedures; and that the figures in Pit 3 are guards-in-waiting without a staff officer present. They are all gentlemen of the imperial court.[14] On this reading, the layout in rows is simply the disposition of guards and courtiers for a grandiose imperial ceremony, such as that arranged for the coffin of Qin Shihuang arriving at his final resting place, or ceremonies in the afterlife in which the emperor would participate. These were, Liu believes, people of high social status such as imperial court officials, servants – themselves often noble, rather like the aristocratic girls in Rome who became Vestal Virgins – and bodyguards, again like royal equerries. Ordinary men and women could never have been placed so close to such a grand figure as Qin Shihuang.

In particular, Liu argues that thirty of the sixty-eight warrior figures in Pit 3 are provided with bronze weapons known as *shu*. The *shu* was a short ritual mace head, cylindrical in form, used by guards of honour. During the Spring and Autumn and later Warring States periods, crossbows, daggers, halberds and spears were the main weapons employed by the infantry, while the *shu* was then used for ceremonial purposes. He states that according to historical records soldiers armed with the *shu* performed guard duties at the palace, greeting and bidding farewell to guests. Thus the 'warriors' in Pit 3, who are in fact quite distinct from the main army in Pit 1, with their

quefei, were in his view on ceremonial duties as guards of honour.[15] They stood facing each other, as in a ritual, rather than facing towards possible enemies in the east; these weapons were issued to a general or commander to confer the authority to issue commands and to order executions. A mural painting from the seventh century AD, now restored and on view at the Shaanxi History Museum, shows guards of honour in similar formation standing at the eastern end of the access ramp to the tomb of the sixth son of Emperor Gaozu of the Tang dynasty, Li Xian (654–684), known posthumously as Prince Zhanghuai. The more obviously ceremonial roles of the figures in the smaller pits around the mausoleum would appear to support this theory.

These hypotheses of Professor Liu, which are not generally accepted by the archaeologists, do have merits, because considering the terracotta figures from another perspective helps us to resolve several commonly perceived problems and inconsistencies. First of all, if we consider once again the matter of why many of the senior officers bear no weapons, with this hypothesis the problem is resolved immediately, as they don't need them; secondly, if the warriors were to be equipped with helmets, there would obviously not be such a wide variation in their hairstyles, especially the attractive and ornamental topknots. From the latter point of view alone, they would seem to be dressed more for a ceremony than for battle. It is hard to imagine our Warrior Chu fussing about his hair as he marched into battle across the windswept plains of the lands of the Zhao.

One other important point which fits with Liu's hypothesis is that whoever these men were, they did not need to be alive in the afterlife. Indeed, according to the great British sinologist and scholar of texts of this period Angus Graham, consciousness and knowledge – or awareness – were never important for the ancient Chinese as they might be for a western Christian. This is brought out by a witty anecdote that he recounts from an ancient source concerning Lady Mi, the Dowager Queen Xuan. On her deathbed she ordered that her lover should be buried alive with her, but was dissuaded as follows:

'Do you think that the dead have knowledge?'

'They do not,' said the Queen.

'If Your Majesty's divine intelligence plainly knows that the dead lack knowledge, why uselessly bury the man you loved in life beside an unknowing corpse? But if the dead do have knowledge, his late Majesty's wrath has been mounting for a long time.'[16]

It sounds a convincing argument. In fact a good likeness was enough anyway. Jessica Rawson has observed that the Chinese 'seem to have developed a complex intellectual position that assumed that if an image was convincing, that is, if it had the correct features, then these features gave the image the powers of the thing or person depicted'.[17] If they were nearly identical, there was no difference between the real thing and the image of it.

A provincial king who had literally fought his way to an empire would have assigned immense importance to his military entourage. Advanced military strategies expounded by the many manuals of war written in the Warring States period were accompanied by technical advances in weaponry. Traditional weapons were improved by the use of good-quality alloys. But the most significant innovation was the introduction of the crossbow, which if it was to be used successfully required strong and well-trained men such as we see in the terracotta army. Mark Edward Lewis quotes a contemporary assertion that a single elite soldier of the Hann with his crossbow and a sharp sword could equal a hundred men. He also cites crack troops of the Wei, who would presumably have their counterparts in the Qin army, men who were trained to wear heavy armour and to carry three days' worth of provisions and a large crossbow with fifty bronze-headed arrows, with halberds on their backs and heavy swords at their sides. Like their equivalents in modern special forces, they were expected to speed-march long distances with these loads, up to a hundred *li* in a day.[18] Is it not likely that Qin Shihuang would train a similar force?

At first sight, another apparent mystery concerns the stone armour discovered near the mausoleum, which could hardly have been worn

in a battle in real life because of its weight and also because the individual components would easily shatter if struck by a metal blade. Yet it seems much more likely that stone armour was designed to guard against evil spirits as much as against real enemies or even grave-robbers, since stone was a recognized defence tool against spirits. James Lin cites an exhortation found on a bamboo slip from Hubei among those mentioned earlier: 'The ghosts often call people out of their homes and toward where the ghosts reside. Ignore the ghost's entreaty, throw a white stone at it, and it will stop.'[19] Thus white stone was considered particularly efficacious. Lin also emphasizes that decomposition of the corpse was believed to be caused by evil spirits rather than by any natural process. On this view, the mausoleum was designed to thwart such spirits, which entailed the use of abundant jade and the special powers of stone armour. The less important ceremonial figures in the main pits had to look good in ceremony rather than function as a deterrent against spirits. Such a powerful man had much less to fear from terrestrial enemies.

As is now clear, there are several fascinating theories, hypotheses, arguments and counter-arguments concerning the purpose of the terracotta warriors. The lack of ancient writings on the then unknown 'army', and the total absence of contemporary documents, suggests that no definitive answer is likely without some exceptional new discovery. An aura of mystery will persist. But, as we will see in later chapters, the improved understanding of the wider scheme of the Mausoleum which has emerged from fresh interpretations of the smaller pits around the imperial tomb tends to indicate a predominantly ritual function.

WHAT IS IN THE MAUSOLEUM?

The title of this chapter presupposes an answer to the apparently much simpler question, what in the mind of kings and emperors of that era was a mausoleum? This in turn entails other questions, such as what should it look like, what were its functions and where should it be built? But, above all, what would be placed or built inside it?

The answer to all these questions ultimately derives from the fact that the imperial mausoleum was first and foremost to be conceived as a *home*. An afterlife required the existence of a structure where it could take place, a duplicate of the world of the living. The particular items interred with the dead changed with dynasties and the passage of time, but the belief in an afterlife which was very much like earthly existence meant that the dead would need their favourite objects, as well as things of value, in the other world. This may be seen in the tombs of non-imperial generals and aristocrats unearthed throughout China in recent years.

It has been observed that the Chinese 'have from at least the third century BC, and probably much earlier, shown a willingness to combine pictures, models and objects from life in tombs, with the effect of duplicating the settings of life above ground'.[1] An interesting instance may be seen in the *Zhuangzi*, composed in the second half of the fourth century, when, in refusing the accoutrements of a grandiose tomb for himself, Master Zhuang provided by reverse logic an insight into what an important or wealthy personage *would* have in his tomb: 'When Zhuangzi was about to die, his disciples signified their wish to give him a grand burial. "I shall have heaven

and earth", said he, "for my coffin and its shell; the sun and moon for my two round symbols of jade; the stars and constellations for my pearls and jewels; and all things assisting as the mourners. Will not the provisions for my burial be complete? What could you add to them?"[2] Jade, pearls, jewels and mourners (in the sense of government officials and concubines) were obviously the quintessential funerary possessions. The planners of such an important monument as that of the First Emperor would clearly draw on burial customs of the ancient emperors, and also develop new traditions for the succeeding generations of Qin emperors. It would have been a priority from the moment he became king. Indeed, it is specified in the *Li Ji* that when 'a ruler succeeds to his state, he makes his coffin, and thereafter varnishes it once a year, keeping it deposited away'.[3] This is not to say that King Zheng did precisely that, but that even as a youth he would have been fully aware of the importance of rites and ceremonies concerning the long-term preparation for death. The Mausoleum itself was conceived as an everlasting replica of the actual state of Qin Shihuang's empire and capital. According to the *Annals* of Lü Buwei, 'The towers and courtyards that are erected, the chambers and halls that are constructed, and the "guest stairway" that is fashioned make the burial site resemble a city'.[4] This from the spiritual guide of the young King Zheng.

Contemporary usage informs us that such a massive tomb with so many ornaments and utensils was quite normal. The *Annals* of Lü Buwei further assert that the larger the state and the richer the family, the more elaborate the burials:

> Such burials now include pearls put in the mouths of corpses, jade suits that cover their bodies like fish scales, silk cords and bamboo documents, jewels and trinkets, bells, tripods, winepots, coolers, carriages and horses, robes and coverlets, halberds and swords, all too numerous to count. Every utensil required to nurture the living is included.[5]

This could almost certainly serve as a description of the contents of the emperor's mausoleum, and no one could have known them

better than his own mentor and one-time chancellor, whose name appears as overall supervisor on some of the earliest weapons found at the site. Thus we may guess that he drew up the initial plans, and through his formative teaching and copies of his *Annals* must have continued to exert influence long after his death. He had understood that ambitions grew with political power and military conquests, all of which had to be in some way represented in the mausoleum.

But one problem in assessing the mausoleum of the First Emperor, and its possible contents, is that he was in a sense the only emperor of the Qin, so no direct comparison with his ancestors or descendants is possible. The prestige of the king of one of several states was of a different magnitude to that of a single powerful ruler of 'all under heaven'. Yet his rites and ceremonies certainly represent an evolution of those from the days of Boyi and from the time of Duke Jing at Yong, and that there was a great deal of continuity in the practice of rites from Zhou to Qin, and then from Qin to Han, is generally accepted. Martin Kern makes the point that the same ritual and textual experts would continue to work through the transition from one dynasty to another.[6] Their knowledge and experience would be vital for the new ruler, just like the knowledge and experience of modern civil servants in a political change-over. This is helpful because more evidence, both literary and archaeological, exists about the early Han burials than about earlier dynasties. So let us begin, using the Han as a reference point, with an apparently simple question which is often neither posited nor answered: what was an imperial Mausoleum?

In a recent article, one of China's leading experts on Qin and early Han burials, Jiao Nanfeng, summarized the main constituent parts of such a Mausoleum around the time of the First Emperor. The whole is comprised within a large walled enclosure the size of a small town, with at the centre a tumulus raised above an underground burial chamber enclosing the tomb, with gateways and a gate tower; distributed around the main tomb in a garden or precinct are a residential palace, a temple, tombs of the emperor's wife and/or concubines, tombs of later descendants (sons and daughters), and storage pits

outside the burial chamber. In addition, there were tombs of imperial attendants, residences for imperial officials and concubines, and further out a mausoleum town built for the many workers who would be resident through decades of building, with road and river bridges constructed where necessary. [7]

A perfect example exists at the mausoleum of the Emperor Jing (188–141), just north of Xi'an, which Professor Jiao himself excavated and which covers a total area of about twenty square kilometres. Like Qin Shihuang, the Han emperor began work on the tomb in his lifetime, around eight years before his death. But it was not completed until his second wife Empress Wang Zhi died and was buried there in 126, in a secondary tomb 450 metres to the east of that of her husband. Jing's methods, and his long-term planning for his mausoleum, were similar to those of Qin Shihuang. In 153 – at the age of thirty-six, nearly the same as the age at which the First Emperor started work on *his* tomb, thirty-eight – he changed the name of a locality called Yiyang to Yangling, meaning 'Yang tomb', and then the following spring built a bridge over the River Wei to facilitate transport to the site for people and materials. It seems from Sima Qian's account that he used two forms of labour: firstly, families who were invited to move to Yangling and received a large cash payment for doing so; and, secondly, again like his predecessor half a century earlier, convict labourers.[8]

The huge structure is located on a loess platform to the north of the River Wei. It was excavated in the 1990s, and a total of 50,000 warriors made of terracotta and originally painted and dressed in fabric were found. They are smaller than the Lintong figures, only about sixty centimetres high, and differ further in that only the body was made of terracotta while the arms were wooden and have mostly rotted away. There were also horses, chariots, weapons and utensils, numbering over 3,000. The Hanyangling Museum, opened in 2006 to house this mausoleum, was designed to avoid some of the problems of the original pits of the terracotta army, with a high-tech solution which maintains temperature and humidity. A glass-floored viewing platform has been built over ten of these pits,

so that visitors can walk above them and view the contents of the pits below.

The most interesting feature from the perspective of this book is that the whole mausoleum area is laid out as a symbolic representation of the Han capital in nearby Chang'an (modern Xi'an), with a copy of the city wall enclosing an area of copies of imperial palaces and government buildings as well as the tombs themselves.[9] Around the main burial chamber are eighty-one pits radiating outwards, representing the offices of nine ministries which have been appropriately scaled to indicate their functions, importance and relation to the empire (see Figure 9). It is therefore to some extent realistic, so that for example the administration for food and supplies has rows of pigs awaiting slaughter for the imperial table close to the chefs and their cooking facilities. Beneath, and as yet unexcavated, are three more palaces of the most important ministries. Beyond the ministry pits, still within the city walls, are two large blocks of pits of soldiers positioned to represent the structure of the Han army: the northern army, with twenty-four pits in the north-west sector, and the southern army with twenty-four pits in the south-east – representing Beijing and Nanjing respectively.[10]

Professor Jiao believes that the degree to which this mausoleum corresponds in concept and plan to that of the First Emperor is around 70 per cent.[11] Thus it gives us a good idea of the functions of the earlier exemplar – which, as his article emphasizes, is an idealized and symbolic representation rather than an attempt to imitate reality.[12] In more general terms, Duan Qingbo thinks that the entire area in which over 200 tombs have been found beyond that of the emperor and his terracotta army, and the stables full of horses to sustain them, represented the different offices of the imperial administration. More than that, they represent an entirely new and sophisticated political system devised by Qin Shihuang for the future empire; but the plan was never completed.

But there are also specific and as far as we know unique features of Qin Shihuang's tomb, in particular the use of mercury to represent rivers. The emperor went even further in asserting his central position in the historical narrative and in the cosmos. As he built and

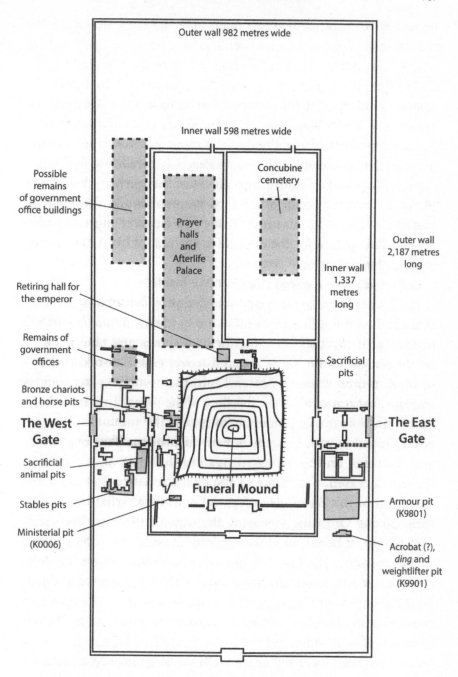

Figure 8. The mausoleum (elaboration by the author from multiple sources)

named his palaces, he mapped them onto the stars, which were at that time thought to be the dwellings of a supreme deity and his officials. He designated a palace built south of the Wei River as the 'Polar Temple', as Kern notes, 'to represent the celestial pole, the cosmic counterpart to his own position on earth. The Wei itself was seen as the Milky Way, with other buildings and palaces regarded as the equivalents of astral bodies.'[13] If the structures in and around his capital at Xianyang could be envisaged as paralleling the stars – the dwellings and administrative offices of the spirits – then in the physical world the power of the First Emperor would also replicate that of the spirits. In this same context the emperor must also have regarded his palace for the afterlife as the seat of his future power, equally aligned with the cosmos.

But what was the burial chamber like inside?

Here, the early Qin tomb of Duke Jing provides an insight, since at the museum built nearby a mock-up in identical dimensions has been created together with interior furnishings and objects based on the real structure, some actual discoveries and also knowledge of other tombs. Visitors descend into the 'tomb' via steps and a corridor which resembles the dwelling of the living. This, it has been observed, is part of a tendency 'to regard the tomb as a "microcosm"' together with typically homely furnishings like pots, vessels and figurines, and therefore in treating the tomb 'as a residence for the deceased'.[14] It is one of the characteristics that mark the evolution of the Zhou idea of burial and the afterlife into a new form during Qin rule, preparing the way for the First Emperor's own design. It begins in Duke Jing's tomb with four rooms joined by the corridor. The first one is a reception room where the duke could meet and entertain his guests in the afterlife. On the left, hanging on a wooden frame is a series of jade *qins*, the favourite musical instrument of emperors devoted to music as his future descendant was, either for the duke himself to play or for musicians who 'lived' near by. There are some large bronze vessels, for holding or preparing food, and space for guests to sit and talk.*

* Illustration 19 on List of Illustrations, p.ix.

Although we no longer know them, each of these ritual vessels had a specific function – rather as we have special pots and pans for different foodstuffs today, from a copper polenta saucepan to a rarefied object like an asparagus pot which might confuse future archaeologists. Nothing was random, and everything was made of the most expensive materials in order to honour the deceased. This tomb, like that of the future emperor, was pure theatre, an elaborate show to illustrate to the deceased the piety and ancestral worship of the living, for the dead were conceived of as acting in the present 'and the sense of their presence was given concrete form by the use of impersonators who took their places at the ritual feasts and sacrifices of a clan'.[15] The bigger the better, but intense spirituality lies behind what superficially appears to be a show of military or political strength.

The painted and lacquered wooden screen with images of birds feels authentic and reflects the love of nature – and indeed the swans – of Qin Shihuang. Music, dance and birds. Behind the screen is the coffin room, here hung with a silk canopy, rather as a medieval cloth baldachin was used as an altar canopy. This is the permanent abode of the duke.

On the other side of the coffin room is a chamber thought to have been the duke's bedroom or sitting room, a private space where he could spend time by himself or perhaps with one of his concubines. These three rooms are in a sequence, but in a sense the most interesting room is a smaller fourth one which leads off the bedroom and is not on the same axis as the other three. A tiny doorway gives onto a personal museum or collection room, in which pieces of jewellery, fine ceramics and objects in gold were arranged in display cases so that the duke could walk in by himself and enjoy his favourite pieces. In modern terms, this was a private den which could be accessed only from the ducal bedroom. Once again the Shang offer a precedent, for in the tomb of Queen Fu Hao in their capital at Anyang, mentioned above, there were ancient jades which she is thought to have acquired as antiques and must have regarded as a personal collection prepared for the afterlife. The whole four-roomed tomb of Duke Jing is the equivalent in size of a modern apartment,

not as enormous as the real palaces above but adequate; it might be said to represent the innermost and secret living quarters of the emperor in life (the personal living space of kings and emperors is often surprising small, as in the Forbidden City in Beijing). It illustrates Xunzi's observation that 'one uses objects of the living to adorn the dead and sends them to their grave in a fashion that resembles the way they lived'.[16] Ancestral sacrifice was a key element of Zhou life, with both religious and social functions. Martin Kern describes its function as follows:

> It created the space where the ancestral spirits could mingle with the living, receiving sacrifices from their descendants and conferring their blessings on them in return. The living were not separated from their forebears, and the dead were not gone. The spirits, thought to be dwelling 'on high' (shang 下) or in Heaven (tian 天), would in regular intervals descend to the sacrificial offerings, each time renewing their presence as the source of dynastic life and power.[17]

As we have seen, the historical and emotional attachment of the First Emperor to Yong was always powerful, and the rites used in the ceremonies on his inspection tours were derived from these ancient Zhou rites practised at Yong.[18]

Further information may be gleaned from the tomb built by the First Emperor earlier for his own grandmother. Once again, discovery was a matter of serendipity, when in the spring of 2004 earth-moving equipment began work on a site purchased by the Xi'an University of Finance and Economics, south-west of the city and facing the Qinling Mountains. Anomalies led to bore-holes being drilled as a result of a law which now makes such testing obligatory on construction sites, and samples of earth at depth suggested there were a tomb-like structure, corridors and other buildings underground. The assumption was that this was a burial dating to the period of the Western Zhou, so Zhang Tian'en, then director of the Shang and Zhou Research Department of the Shaanxi Archaeology Institute, was called in. As in the case of the terracotta warriors, a team was put

together very quickly, in a matter of three or four days. Thus began a dig that lasted for three-and-a-half years, which ended in October 2007 and as yet has not been fully published.[19]

There were immediate contradictions, and the reasoning process of Professor Zhang and his team enables us to understand more clearly the methods used. It was at once recognized as a very large tomb complex, with a wall enclosing the mausoleum measuring 550 metres by 310. The presence of four entry ramps with a total length of 135 metres (north, south, east, west) indicated a tomb of imperial status, since dukes and kings were allowed only two ramps – as in the case of Duke Jing at Yong, the early Qin norm being east and west ramps. This was a puzzle, as the sites of the Zhou imperial mausoleums were known to researchers and the presence of one particular feature, the mausoleum precinct around the central tomb, was usually associated with the Qin. Pottery fragments dating from the Warring States period indicated however a date between the end of that period and the early Han.

But when digging began, pieces of Qin-style ceramics emerged bearing the reign marks of the last Zhou emperor, usually known as King Nan of Zhou, who reigned for fifty-nine years from 314 to 256. Professor Zhang believes that these represent the spoils of war from battles with the other Warring States as the Qin achieved hegemony. So who could be important enough to enjoy imperial burial status and have the tomb enriched with Qin war booty? The only other tombs with four entry ramps were those of the First Emperor himself and his son the Second Emperor. As so often in this story, it was Sima Qian who provided the answer. For on the sixteenth day of the fifth month of the year 240 we read in the *Records* that the Queen Dowager Xia died.[20] So this was the birth mother of King Zhuanxiang, known as Xia Taiho, or Xia Ji – meaning concubine, or 'small wife' – and the second wife of King Zhaowen, who had died ten years earlier. She was a powerful presence at court, like the earlier Queen Dowager Xuan, and exercised considerable influence on activities at the court in general and on her grandson King Zheng in particular. The dimensions now make sense, and the discovery of carriages designed for six horses, which was again an imperial

privilege, offered further proof of the rank of the person entombed there. The tomb within the walled garden, or 'garden of auspicious omens' was 140 metres long, 113 metres wide and 15 metres deep, with the tomb chamber itself measuring around 100 square metres and following the traditional form 亞. There were thirteen mass graves in the mausoleum area, and the remains of several large buildings. Although the tomb had been looted, archaeologists found over a thousand objects including coffin nails, and bronze, silver and gold ornaments; inside the chamber were a silver bronze belt hook, silver handles and iron knives, pearls and jade objects. There was a gallery containing horses and other animals, and in a nearby pit to the east two six-horse wooden carriages with what the archaeologists describe as the 'son of heaven six specification', one of which was 1.75 metres long, 1.55 metres wide, and bore traces of the original colouring. The quality of the jade objects, the bronzeware and silverware found with the carriages, and pearls, glassware and lacquerware of very high specification show that the tomb's occupant enjoyed imperial status. There were also engraved pots, and fragments of text concerning palaces, government offices, the calendar, place names and the names of craftsmen.[21]

The extraordinary wealth of these finds and the dimension of the tomb convinced the archaeologists that the tomb was indeed that of Qin Shihuang's real grandmother. Whereas the first wife of King Zhaowen was interred with her husband in Xianyang, the Queen Dowager Xia chose her own site south of the River Wei so that she could look east towards her grandson's tomb, and west to that of her husband.[22] It was on a hill overlooking a small tributary of the Wei, the River Shen, with a fine view across the valley to the imposing wall of the Qinling Mountains. Once again, Zheng's intense family loyalty meant that he alone would supervise the construction of the mausoleum of his grandmother.

It is therefore believed that this tomb was begun in the seventh year of King Zheng's reign, 240, under the guidance of the young king. Unfortunately few of the precious contents survive because the burial chamber was systematically looted and then burned by troops of the rebellious Xiang Yu in a fury of destruction. Sandalwood

timber from the coffin and other structures was used to shore up shafts to protect the robbers, as if they were working in a mine. In spite of this devastation, as we have seen, the number and quality of surviving objects provided sufficient clues. Moreover, the tomb still provides interesting insights. The number of ramps and the size of the entire mausoleum area would suggest that the young King Zheng considered it appropriate for a lady of imperial rank, and may even suggest the dimensions he then had in mind for his own mausoleum already under construction. Then in 221, when he assumed the title of emperor, we know that he immediately began to scale up the work-in-progess at Mount Li. But the Dowager's tomb offers an idea of what might have existed at that time. At the other end of the spectrum, the mausoleum of Emperor Jing a few years later was scaled up from the First Emperor's tomb, with the 30 per cent (Jiao Nanfeng's estimate above) added by the Han to the earlier Qin example.

Now the excavations for this tomb have been filled in, and the site stands as an untidy copse, incongruous amid the landscaped grounds of the still-growing university, a hundred metres west of the main library. Beyond it, pushing right up to the site, a large new teaching building was under construction in early 2017, with the shadows of giant cranes traversing the site of the tomb. No sign marks the plot.

Let us now consider what is known about the burial chamber of the First Emperor himself. As we have seen, it was certainly a much larger structure than that of the Queen Dowager Xia. A combination of archaeological surveys and modern scientific analysis has been able to define the location and shape of the underground structures. Thus we can be fairly sure that the plan of the palace's main area is rectangular in shape, and that the cross-section shape of the underground palace's excavated area is like an inverted truncated pyramid. It has also been shown that there is a multiple-step soil structure underneath the tomb mound (see Figure 10). As suggested earlier, this means that the tomb of Duke Jing at Yong is indeed a possible model, or at the very least that Qin Shihuang's tomb was designed in the conventional Zhou–Qin mode. One important difference is that in this case the underground vault was lined with brick to a height

Figure 9. Plan of the Mausoleum of the Emperor Jingdi (ruled 156–141 BC) at Hanyangling, showing surrounding pits with ministries and offices radiating outwards from the central funerary mound. This concept was largely derived from the Mausoleum of Qin Shihuang, and was built just north of Xi'an.

of four metres, measuring 460 by 390 metres on a north–south axis and east–west axis respectively. As in Yong, the tomb faces east, with passages leading off to both east and west, and once again the Han evolution of this concept at the Emperor Jingdi's with the ministries arranged around it is highly suggestive.

The chamber itself, which lies thirty to forty metres below the original ground level, measures about eighty metres on its main east–west axis and fifty metres north–south, and is fifteen metres in height. Remarkably, it was designed to be watertight, once again

attesting to the high level of expertise of engineers and architects. In 2000, archaeologists discovered a sophisticated drainage system comprising a U-shaped channel measuring 778 metres in the east and 186 metres in the west. This was used to stop water entering the deep site of the tomb as it was being built, and was filled with rammed earth to create a dam which prevented underground water seeping in after its completion. Tests carried out using surface nuclear magnetic resonance to measure underground water flow have shown that even today there is no water in the underground palace area. Two thousand years later, the tomb chamber seems to be free of flooding, and the drainage system functions perfectly.[23]

This is interesting from a technical and engineering point of view, yet it was much more than a simple matter of keeping the tomb dry. It was a key element of the rituals which were vital to ancient Chinese life and afterlife. At the moment of death, the body of the deceased returns to the earth whence it came, which is one reason why the dukes and kings of ancient China were buried in such deep pits – to be closer to, literally entombed inside, the earth. Water is of course present in the earth, and will eventually lead to rebirth. This is especially significant because the source of life according to the *Canon of Internal Medicine*,[24] attributed to the Yellow Emperor himself, 'is determined by the arrival of the heavenly *kouei* which is considered to be an emanation of the heavenly principle, corresponding to the North East, which is water'.[25] Yet the pit in which the tomb is placed should not reach the water table beneath, for doing so would be an act of hubris even for such a powerful emperor. The tomb should be as deep as possible to introduce the deceased person to the earth – the land of the dead – but it would be sacrilege to open the earth too deeply. That is why, Marcel Granet explained, Qin Shihuang made workers dig down only as far as the water level.[26] As if to confirm Granet's explanation, Lü Buwei also stressed the inadvisability of a burial which is too deep since it 'may reach springs of water'. Inundations of the tomb by springs, he stated very clearly, should be avoided at all costs.[27]

Now the reason for such a sophisticated drainage system is clear, to ensure that the tomb is deep in the earth without touching water – or

being touched by water. It is also worth noting that the emperor provided a similar drainage system for his grandmother's tomb, and may even have benefited from that work to perfect his own system.[28] It was absolutely essential and is integral to the concept of the mausoleum and the empire. Since the ancient system of Five Phases (wood, fire, earth, metal and water), based on the structure of the cosmos and the seasons, associated water with the number six and with the colour black, these too assumed a new importance in the empire. Black became the official colour of clothes, flags and standards; official hats were to have six plumes, paces for calculating distance were to be counted as six feet, and a carriage was to be drawn by six horses. Sima Qian tells us that the emperor even changed the name of the Yellow River to Powerful Water to show that the era of water had begun.[29]

The mausoleum was, in Granet's striking phrase which sums it all up, at the same time 'the land of the dead and the reservoir of life'.[30] The American scholar Grant Hardy goes a bit further with an amusing simile that emphasizes the serious nature of the enterprise:

> Taking the symbol as the thing itself, the First Emperor's mausoleum seems like an elaborate, subterranean miniature golf course, over which only a madman would want to reign, but as a ritual representation of all China, where model and modelled are joined by cosmological correspondences, the whole tomb operates as a spiritual device. Control of the model offers control of the whole.[31]

Another positive aspect of the mausoleum is that its immense size means that it has been immune to some of the problems common among ancient tombs in China. The pragmatic *Annals* of Lü Buwei also suggest a reason for the obsession with disguising and hiding it: 'From antiquity until now [around 240], there has never been an imperishable state. Since there are no imperishable states, there are no unrobbable tombs.' The *Annals* even anticipate Sima Qian's account of disguising the mausoleum by planting trees: 'Burial mounds of

the present day are as tall as mountains, and the trees planted on them are like forests.'[32]

One other important aspect derives from the fact that the purpose of such a massive and complex mausoleum was to guarantee that the emperor's influence over his earthly world would endure, since his spirit would continue to live in its new home. It was a culmination of his life and success, and was intended to endure for millennia just like his empire, constructed as a working model of the universe. There were two senses in which it was a working model, according to Professor Hardy: 'It included mechanical machinery for circulating mercury (which stood for the waters of the empire), but it also was intended to work *for* the First Emperor. Because his spirit would not be satisfied with ruling over a toy China in an underground chamber, the model was intended to influence the outside world as well as represent it.'[33] Clearly, destruction of the tomb by an enemy or future rival would destroy that power and influence, rendering the tomb useless.

In this case, even tomb-robbers, ancient and modern, have been unable to cause much damage, with evidence of such activity found only on a small scale and not on the actual site of the tomb. A low level of radon gas has been taken by scientists to suggest that cracks in the main structure have not 'advanced above the tomb chamber and that the main body of the tomb chamber has not collapsed'.[34] High levels of mercury present around the tomb have been taken as evidence that the palace as described by Sima Qian – the representation of the cosmos – remains intact. Yet at the same time 'scattered ashes, fired earth, broken bricks, and tile fragments were found within the tomb complex area, suggesting that any above-ground buildings in the tomb complex area were burned at the end of the Qin dynasty'.[35]

There is much to be done.

III: LATEST DISCOVERIES

THE LATEST DISCOVERIES

10

LATEST DISCOVERIES AND RESEARCH

Just over thirty years after the original discovery of Pit 1, new work was carried out from the summer of 2009 to 2011 with the excavation of 200 square metres in the two northernmost corridors about halfway along their length (that is to say, on the right as a visitor enters). The uncovered sections have been left open, so that they are visible from the walkway around the pit.

A total of 107 new warriors and eight horses were unearthed from these corridors, together with the remains of two four-horse chariots, pedestals for the warriors, weapons, and fittings for horses and chariots – an indication of how much more there is to be found in the as yet untouched parts of the corridors. The first new warriors emerged in May 2010. Among the most exciting discoveries was an officer whose painted figure was almost intact, and a head which exemplifies the techniques described above for creating flesh tones by applying separate layers over the lacquer background, a white layer followed by a thicker layer of pink.

Most of the new figures are between 175 and 185 centimetres in height, with bodies which suggest young men with broad shoulders, full foreheads and large feet. The heads are around 28 centimetres in height, and the faces 19.5 centimetres high and 20.5 centimetres wide, having been attached to the torso before firing. The quality of paintwork is exceptional, with white as mentioned above, brown irises, some red just above the eyebrows, and one astonishing case of very finely painted black eyelashes only 0.02 centimetres wide – applied with a single brush-hair. There are variations in the thickness of lips and in skin colour as if to differentiate them, as they were

varied by the main colours used for clothing: cinnabar red, pink, green, grey-green, emerald green, a light purple like lilac and sky-blue; reds and greens predominate.[1] Intriguingly, some of the pieces were found to be so similar in style that they appear to be the work of a single artisan. An account of the new techniques and restoration process applied to one of these painted figures is given below. The resulting figures are even more realistic than their counterparts unearthed when conservation was much less successful, and augur well for future digs.

But now that so much digging has been done, and so much material unearthed, broader historical and literary research has become vital in the attempt to make sense of the finds. In recent years a whole new field has opened up, forcing even traditional archaeologists to reconsider their earlier conclusions.

One of the most fascinating questions regarding the terracotta warriors concerns where the knowledge and inspiration for these lifelike figures came from, since there was no sculptural tradition in China beyond some miniature statues a few centimetres in height found in earlier tombs, and of course the reliefs on bronzes, which however have little bearing on these human figures. For, as Segalen wrote in his early study of ancient sculpture, the oldest known statues in the European sense of the word came with the Han.[2] So what was the source for the figures created for the First Emperor? How was it possible to achieve a sudden increase in the size of terracotta figures, from those between ten and twenty centimetres in height found in other tombs to those nearly two metres tall in Pit 1, and how, Professor Duan asks on a more technical level, was it possible to move from low-heat firing of small objects to firing life-size figures at 950–1000 degrees centigrade?[3] Where did the expertise come from?

An attractive theory which has gained currency in recent years is that concerning possible contact with and influence by Greek sculpture, advocated most strongly by Lukas Nickel in an often cited academic article published in 2013. He begins from the premise that there must have been outside influence to create something so radically new and accomplished: 'The emphasis on the realistic appearance of the warriors as well as the sheer scale to which the medium

was used place the terracotta warriors outside the local tradition and require us to consider an outside stimulus for their creation.'[4] Professor Nickel locates a possible stimulus in Greek sculpture. At first sight, this might seem far-fetched, but there were powerful Hellenistic influences in countries very near to China and within its trade and warfare orbit. Indeed I remember very well, during a visit to the National Museum of Afghanistan in Kabul in 1978, being struck by the Greek coins and obviously Greek features in Buddhist sculptures there. Alexander the Great not only travelled to Afghanistan, then part of Bactria, but married a Bactrian princess called Roxane after defeating her father Oxyartes at Balkh – now just a raised site of broken walls and rubble in the north of the country. He was said to have fallen in love at first sight with Roxane, who was described by his followers as 'the loveliest woman in Asia' after the young wife of Darius III, the Persian Emperor.[5] It is likely that the first real contact between China and Greek culture came with the Greco-Bactrian kingdom which began around 250 with King Diodotus I of Bactria, and that this exchange took place over the next two decades through Xinjiang and Gansu along what would later be known as the southern Silk Road, which passes south of the Tarim Basin.

The impact of Alexander on Central Asia was immense, and even after he had died the soldiers of his conquering armies stayed on in the new colonies he had created in Bactria and other eastern states. There were enduring Greek elements in the culture of these colonies, and inevitably many mixed marriages like that of Alexander himself which spread the Greek influence through what is today known as soft power. Since these Greco-Bactrians were the key cultural and military power in Bactria and Sogdiana through the lifetime of Qin Shihuang, it is important to understand how much contact there may have been. Alexander himself had taken artists such as his personal sculptor Lysippos with him on other expeditions, and certainly Greek artists from Bactria worked in India and may have influenced local craftsmen.[6] But there is no direct evidence available for China.

According to Apollodorus the Amphipolitan, a general who fought with Alexander, the Bactrians 'extended their empire even as far as

the Seres and the Phryni',[7] the word 'Seres' being used for China and the Phryni most likely associated with what is today called Xinjiang. In the opposite direction, nickel was introduced into Bactria from China during the reign of King Euthydemus, an exact contemporary of Qin Shihuang (he ruled from roughly 230 to 200). A historian of Bactria wrote as follows: 'Frequent as must have been the caravans from Kabul to Bactria, others doubtless arrived from the distant Seres of the north-east, for the then novel commodity of silk was in great demand in the luxurious towns of the new and cosmopolitan Hellenic age...'[8] This was before the Han sent the envoy Zhang Qian to the west and inaugurated the Silk Road. Conversely, the impact of Greek culture in Bactria was powerful and enduring, much more than a temporary military campaign. One city in particular, excavated by French archaeologists in the 1960s, was described by Nancy Hatch Dupree and colleagues in their *Illustrated Guide* to the Kabul museum written shortly after its discovery, as 'the easternmost genuine Greek city in Asia'.[9]

There seems to have been an authentic Greek element in all the cities Alexander founded in Asia. Arrian gives an example of his method:

> Alexander himself now spent twenty days in building the wall of the city which he proposed to found, and arranged to settle there any of the Greek mercenaries and any of the neighbouring tribesmen who had as volunteers shared in the settlement, with some of the Macedonians too from the camp, so many as were no longer fit for active service. He then sacrificed to the usual gods and held a cavalry and athletic contest...[10]

This particular city is known as Ai Khanoum from the name of a village near by, and is situated near the confluence of the Kokcha and Oxus rivers east of Khanabad, in the north-east of the country beyond the mountains of the Hindu Kush. Built on a typical Greek plan around 300, it comprised an upper town with a citadel, temples and a theatre, and a lower town with a palace with peristyle court-yard, homes with mosaic flooring and a gymnasium – in the Greek sense of school.

Nickel cites this city, and uses two illustrations of sculptures found there, but I believe that the torso to be found in the 1974 *Illustrated Guide* strengthens his argument because it bears closer resemblance to some of the terracotta warriors.* Commenting on another site, Dupree et al. write of a distinctive Greco-Bactrian art which developed from the third century onwards, merging Greek styles with the Bactrians' own beliefs and culture.[11]

Ai Khanoum lies south of the Pamir Mountains, which extend eastwards into China and north to Tajikistan, where other Greek sculptures have been found, while also to the north is the Ferghana Valley which in 138 was visited by Zhang Qian. As part of the later northern Silk Road originating from Xi'an, it is likely that other travellers and tribes linked Bactria and China in ancient times and that the Qin would have heard of Bactria from their nomadic neighbours such as the Yuezhi – who later conquered Bactria. As a supposition, the Greece–warrior link is plausible, but there is no real evidence. It is true that there is a new attention to detail in the representation of buckles, armour and clothes, and in the use of realistic colour tones for human skin. But it is also true that imperfections and lack of proportions – short and stiff arms, oversized heads – in many of the warriors provide a strong counter-argument, as Nickel himself admits. As far as the thousands of warriors are concerned, it seems a step too far.

Yet in the more specific case of the so-called acrobat figures in Pit K9901 the argument appears to be justifiable, as will be shown in Chapter 12. We have mentioned the gymnasium in Ai Khanoum. This was a quintessential Greek institution which through its link between the intellectual pursuits of education and the physical elements which entailed preparation for combat and war played an important role in Greek life. Two of the greatest gymnasia in Athens were the Academy, founded by Plato, and the Lyceum, where Socrates and Aristotle both taught – the latter being, among many other things, also the tutor of Alexander the Great. Competitive sports and games were at the core of this concept, which produced something akin to the modern

* Illustration 78 on List of Illustrations, p.xii.

idea of the professional athlete. Wrestling was not only a matter of 'wrestling proper', as Lucas Christopoulos puts it, but in addition 'joint locks, punching, kicking, and hitting with the palm or the fingers were incorporated into the close-combat sports for warfare, developed by the Greeks, namely boxing (*pygmachein*), wrestling (*pale*) and *pankration*',[12] which consisted of a blend of boxing and wrestling, and literally meant 'total control'. How could this not have been attractive to a perspicacious warrior-king like King Zheng?

It was Gansu, land of the origins of the Qin, which provided the link, a real crossroads between the empires of Shang and Zhou in the east, and the 'barbarian' or nomadic tribes to the west – to the extent that the Qin themselves were often considered a barbarian tribe due to their origins in that part of the world. Sima Qian wrote that in the beginning 'Qin was a small kingdom in a distant region, whose people were treated on the same footing as the Rong and Di barbarians by the ruling dynasty'.[13] In fact, until their rise to power Gansu had been dominated by the powerful nomadic Yuezhi, excellent horsemen. The Yuezhi were eventually pushed west out of what is now China by the Xiongnu, established themselves in what had been Greco-Bactria and themselves became partly Hellenized.

Excavations carried out between 2006 and 2008 at a cemetery known as Majiayuan, north of the River Wei in Gansu, dated to the late Warring States period, illustrated the way in which these cultures interacted.[14] For the artefacts discovered display a disconcerting range of provenance: chariots decorated with gold, silver and glass beads typical of the Eurasian steppes, but with lacquering like those of the Zhou; gold inlay and filigree for personal ornaments rather than jade that was characteristic of the Scythian tribes of Central Asia; decorative motifs of griffins and bird heads on the back of a tiger originating from the Pazyryk culture of Siberia and Mongolia; 'eye-beads' from Achaemenid Persia; the use of Han purple found only in China, and also bronze vases, *dings* and grey pottery jugs from the Qin state in the central plains.[15] Tiny gold ornaments resemble those found in the tomb of Duke Jing at Yong. Were the people buried at Majiayuan from the Western Rong (Xirong), from the early Qin, or from their enemies the Quan Rong? No one can be certain.

Another example concerns the Scythian-style crenellated manes, with a square tuft sticking out on the animal's crest, on some of the most important horses in the mausoleum. In a study of the Tang dynasty mausoleum of Taizong, Zhou Xiuqin considers the introduction of crenellated manes into Chinese art, and observes that they appeared briefly in the third century at Qin Shihuang's mausoleum where the tufted mane is found on the eight bronze horses associated with the two imperial chariots: 'All eight are adorned with a single square tuft on their manes, the same as those on the Scytho-Samarthian gold and bronze plaques.'[16]

For Gansu was truly a cultural melting-pot, located in the area where the Qin first rose to prominence. There can be little doubt that there were powerful cross-cultural influences, or that knowledge of Alexander and his feats reached their lands.

We have seen how the Xiongnu were also a constant threat to the Qin for centuries, with lands that were based on what is today Inner Mongolia, but expanded to cover most of northern China and extending to modern Kazakhstan and Kyrgyzstan in the west. The celebrated Han envoy Zhang Qian just a few decades after the fall of the Qin was captured and held hostage by the Xiongnu for ten years before he could continue his journey to the west. It was the Xiongnu who pushed the Yuezhi tribe out of their traditional lands in western China into Bactria.

The Qin kingdom was constantly in contact with what were known as the 'Western armies',[17] the Xirong (西戎), with one in particular known as the Lirong (骊戎), the 'black-horse armies'. As Li (骊) means 'black horse', it was a general denomination for the nomadic steppe tribes riding the tall black horses from Central Asia. King Yong, last of the Western Zhou dynasty (781–771), was killed by the black-horse armies at the foot of Mount Li, or Black Horse Mountain, Lishan (骊山), where the Lirong had settled (and where the First Emperor built his Mausoleum).[18] A century later, we find a lord of the Rong complaining about exclusion from a meeting summoned by Duke Xiang of the small state of Song, in Henan, in terms which show that they had long been associated with the Qin:

From that time to the present, in all the expeditions of Qin we Rong have taken part, one after the other, as they occurred, following its leaders, without ever daring to keep ourselves apart from them. And now when the troops of your officers have indeed committed some errors which are separating the States from you, you try to throw the blame on us. Our drink, our food, our clothes are all different from those in the Flowery States; we do not interchange silks or other articles of introduction with their courts; their language and ours do not admit of intercourse between us and them: – what evil is it possible for us to have done?[19]

These were what we might call 'the people between', who created one of the earliest cultural-exchange corridors. For there was a state of constant flux in Central Asia during the century before Qin unification, with Macedonians, Greeks, Persians, Scythians, Parthians, Sogdians and eastern nomads such as the Yuezhi and Rong meeting, fighting and interacting on all levels. If Sima Qian is right, then Qin customs were close to those of the Rong and it is certainly true, as we have seen, that the first step towards power was based on the prowess of a horse-breeding ancestor.

Another pertinent piece of evidence concerns a legendary story of twelve gigantic bronze statues, and returns again to the origins of the Qin in Gansu. As so often, the story begins with Sima Qian, who reports briefly and rather enigmatically that all the weapons of defeated armies in the empire were collected and brought to Xianyang, where they were melted down to make bells, bell stands and 'twelve metal men' to be set up in the courtyard of the palace.[20] These metal men provide one of strangest stories in the history of the Qin, one that is often overlooked. For they were in effect bronze statues each standing around ten to sixteen metres in height – according to different sources – and weighing as much as thirty tons each. They were placed at the entrance of the imperial palace and must have made an impressive sight, especially because these giants stood on pedestals between four and six metres high. This was Qin strength writ large, or as Nickel puts it, 'For the first time in Chinese history

we find records of public sculpture with a distinctly political function.'[21] Indeed, while many other Qin creations were destroyed or ignored by the Han, these statues were used in the same way at the Epang Palace in Xi'an and survived intact for 400 years. Later all of them suffered the same fate as the weapons which had been melted down to create them.

The really intriguing questions, posed by Nickel and Christopoulos in detailed scholarly articles, are where did the idea for these giant figures come from, and who was able to provide the technical skills to cast them? If, as they both suppose, there is a direct link with Greek sculptural tradition, could that also have influenced the making of the terracotta warriors?

The twelve statues were copies of giant figures in Lintao (in what is today Min County, 岷), in Gansu at the western extreme of the new empire, and were dressed as what were described as Di barbarians (that is, foreigners). They represented something unprecedented in Chinese art, and the very site on which they stood suggests contact with unknown artists at the very least from western China. Christopoulos goes further: 'To sculpt and erect twelve statues of ten meters in height representing "Di barbarians" in bronze and gold requires an art and a technique that could not have been simply transported by Hellenized Scythians on horses. I do not see another alternative at that time than that of Greek sculptors casting the twelve "barbaric" chryselephantine statues.'[22] He further argues that the Great Wall in the west of the empire was built to halt the advance of these Di barbarians, who were in fact Scythian horsemen and may have been led or sent by a Greco-Bactrian king.

Intriguingly, in another context Martin Kern hinted that the use of stone as a material for sculptures and for inscriptions may have been introduced from regions to the west of Zhou territory. In a subtle note he manages to speculate without speculating: 'without any concrete evidence we unfortunately have to refrain from speculation that the practice of inscribing stones may have been introduced from a western culture to the pre-imperial state of Qin, even though that would explain why we know of no pre-imperial stone monuments in the eastern region of the Zhou world.'[23] This is a remarkable comment

by such a meticulous scholar, made a few years before the articles we have been discussing were written.

Two pieces of evidence have been deployed to explain these statues, one by each of the above authors. Noting that the number twelve is of no particular importance in Chinese culture, Christopoulos is reminded of 'the twelve Olympian gods venerated by the Greeks of Bactria' and adds that in Gansu Province 'a Hellenistic golden plate has been unearthed representing the twelve gods together with Dionysos (or Alexander-Dionysos) sitting on a panther surrounded by grapes and having a Bactrian inscription on the back'.[24] The label in the Gansu Provincial Museum in Lanzhou gives a later date, but the Bactrian on the reverse side (*uasapo'k*, *uasapo* or *uapobso*) is a convincing argument in favour of this hypothesis.[*] This gilded silver plate (not solid gold) is thirty-one centimetres in diameter, and was found in Beitan, Jingyuan, which is just north of the traditional Qin lands – and Majiayuan.

Following Christopoulos's lead, Nickel quotes a slightly later Sicilian-Greek historian, Diodorus Siculus, who recounts how Alexander the Great marked the eastern limits of his military campaign by erecting twelve giant altars representing the twelve major deities of the Greeks known from their residence on Mount Olympus as the Olympians, together with giant huts and beds. The idea, in the words of Diodorus, was 'to make a camp of heroic proportions and then leave to the natives evidence of men of huge stature, displaying the strength of giants'.[25] In Arrian's version, the description of the same episode could as easily apply to Qin Shihuang as to Alexander:

Then he divided the army into twelve parts and ordered an altar to be set up for each part, in height like to the greatest towers, and in breadth greater even than towers would be, as thank-offerings to the gods who had brought him so far victorious, and as memorials of his labours. And when the altars were made

* Illustration 79 on List of Illustrations, p.xii.

ready, he sacrificed upon them, according to custom, and held a contest of athletics and cavalry exercises.[26]

From what we know of Qin Shihuang from his military campaigns, his building activities and his inscriptions, both of these ideas would have had strong appeal to his grandiose imagination should he have learned of them. Twelve giant bronze statues would have been irresistible. While most records indicate that the statues were placed outside the imperial palace in Xianyang, the scholar of Chinese art Wu Hung believes that they were placed 'standing along the imperial way' which led to the palace as a signal that no further wars were necessary – hence the melting down of weapons to make them. He sees the twelve men as 'six *pairs* of figures that, one may imagine, represented the *six* defeated kingdoms'.[27] In that sense, they prefigure the robust stone figures along the Spirit Way of the Tang emperor Taizong, at Zhaoling north of Xi'an, where a series of statues of envoys from tribute-paying countries represents the status of the Tang, or the much later ones at the Ming tombs near Beijing, where exotic animals such as the elephants serve as a metaphor for the extent of Ming domination.

One rational explanation for their exaggerated size, offered by Duan Qingbo, is that the 'Qin people were so astonished to see people from a different race, that they exaggerated the news' and the height of these strange western people increased in the telling.[28] That the statues existed is beyond doubt in spite of discrepancies in accounts of their height, since Duan and other scholars cite several later references to them. In particular, ten of them were melted down at the end of the Eastern Han to mint coins by the general Dong Zhuo, who in AD 190 forced the last Han emperor and his court to return to Xi'an after burning their capital at Luoyang. No one knows what happened to the other two, but it is likely that their value as metal for coinage led to future emperors or rebels following suit and melting them down.

The Yale art historian Richard M. Barnhart writes that 'the presence in China for the first time of realistically modelled life-sized statues in the third century BCE instantly connects China culturally

and artistically to the Hellenistic and Persian worlds lying far to the west – no matter how little we yet know about the actual process of connection.[29] Their presence seems however to be linked to the people known as Scythians, who in Qin Shihuang's lifetime operated across an area stretching from Dunhuang in what is now China, traditionally the gate to the west, as far as Transoxiana. In their easternmost extension they were very much neighbours of the Qin in Gansu, who through them would have seen and heard of the peoples and arts of Persia and Greece.

Alexander spent two years, from 329 to 327, on the campaigns which led to his conquest of Bactria and Sogdiana. These were the years in which King Huiwen of Qin (ruled 338–311) was engaged in the expansionary policy that led to the conquest of Sichuan, and followed the period in which Lord Shang had created the legal and administrative base that facilitated ultimate control over the neighbouring states (356–338). It is unlikely that no news of Alexander's presence filtered through the intermediate nomadic tribes to Gansu, and to the outposts of Qin power in the western regions of China. The exploits and legends of his campaigns were too spectacular not to be discussed in the desert caravanserai and towns on the route which later became the Silk Road. The earliest known direct contacts between the Kingdom of Bactria and the Qin lands are thought to date to the next century, around 220, when Greek culture had an enduring influence exceeding that of Alexander's lifetime. This was the moment Strabo referred to when he wrote of the Bactrians extending their empire to China, and just as news of Alexander would have filtered eastwards so would news of the momentous event of 221 have filtered westwards from Qin Shihuang's new empire to Bactria. At that time, Ai Khanoum was at its zenith, and it would be the most likely period for the Greek artefacts so far discovered to find their way to Xinjiang and Gansu.

Barnhart goes further in finding evidence of western influence in the monumental architecture of the third century. As he writes, after observing that he has never seen a feasible explanation of where the idea of using a pyramid form in China came from, *any* pyramid whether in the Louvre or in China ultimately derives from Egyptian

culture: 'Chinese histories on the period indicate no knowledge of Egypt in ancient China, yet the pyramid over Qin Shihuangdi's tomb tells us that such knowledge indeed existed.'[30]

In fact, it was not the first pyramid-like structure in China, for others were built slightly earlier, for example at the never completed royal tomb complex of King Cuo of Zhongshan in north-western Hebei, which dates from a century earlier. But those too were built just a few years after the famous Mausoleum at Halicarnassus – now Bodrum in Turkey – which was already regarded as one of the Seven Wonders of the World in the fourth century. King Mausolus, who reigned from 377 to 353 (and whose name gave us the word 'mausoleum'), was both a satrap of Achaemenid Persia and an admirer of Greek art. Professor Barnhart notes that elements long associated with Mediterranean, Aegean and Iranian cultures such as pyramids, realistic sculptures of armed soldiers and wild animals carved in stone appear in several tomb structures of the time in China like the tombs of Hu Qubing and Qin Shihuang.[31] The basic design model of the latter was the step pyramid. But is this just a coincidence? It may well be, but let us imagine a man like the young King Zheng visiting the Qin lands in Gansu, or as the First Emperor making his pilgrimage to Lintao, and hearing a traveller's tale of something impressive enough to be called the Seventh Wonder of the World. Such a grandiose statement would certainly have fired his curiosity, and prompted an effort to obtain more information – just as he would have done about Alexander (see Figure 10).

Nowadays the mausoleum of Qin Shihuang is sometimes referred to as the Eighth Wonder of the World, but the chronology of the eight is overlooked in favour of size or local pride. As Barnhart again points out, this mausoleum is the last in a sequence that begins with the Great Pyramid at Giza in 2580 and follows the most easterly of them, the Mausoleum at Halicarnassus (350), by just over a century. No real evidence exists, but again it is hard to imagine reports of the latter not filtering through at the very least as campfire gossip and quite possibly as sketches or outlines by Greek or Greco-Bactrian artists as close to the Qin lands as Dunhuang.

Some evidence of interaction does exist, as in the golden bowl in

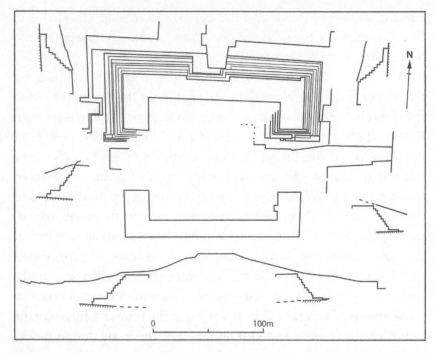

Figure 10. Sketches showing the pyramidal structure beneath the ground (after Zhang Weixing, *Ritual and Order*, 2016)

Gansu mentioned above, and in the first known pictorial frieze in China on a lacquer box in a Chu tomb at Baoshan which dates from just a decade after Alexander's arrival in Bactria (just as Chu silk and bronze mirrors were found in Scythian tombs in Siberia).[32] For Alexander and the thousands of court officials, soldiers and artists who travelled with him are the most likely candidates for a direct impact: on their way east they saw with their own eyes the pyramids in Egypt, the Mausoleum at Halicarnassus and another of the Seven Wonders, the Hanging Gardens of Babylon; they also visited the magnificent tombs of the Achaemenid kings at Persepolis. Some news of these wonders must have filtered through to the Qin – and to a man who would have wished to outdo all of them.

Attempts have been made to prove a direct connection between Greece and Lintong with DNA evidence, but no conclusive evidence has been found. In the spring of 2003, a mass grave was discovered

500 metres from the pits containing the terracotta warriors. There were 121 male corpses of heavy-set men aged from fifteen to forty with strong bones, indicating that they were likely to have been manual workers at the mausoleum site. Three notably different skulls were found, with high cheekbones and deep eye-sockets. Samples of DNA were taken from these skulls.[33] In an interview with *Archaeology*, a journal published by the Archaeological Institute of America, a sinologist from the University of Pennsylvania, Victor Mair, summarized the conclusions in these terms:

Of the 121 shattered skeletons, 15 were tested, but so far only one of them appears to have a west Eurasian genetic profile. It is said that his genetic features mark him as belonging to T-genodeme, which unmistakably belongs to a western haplotype. Specifically, Chinese geneticists say that this links him with people living to the west of the Pamirs: the Parsi (Persians) in India and Pakistan, the Kurds in Turkmenistan, and the Persians in Iran.[34]

The problem is that the category of Greek sculptors is an infinitesimal subset of European DNA, which covers all of Europe and an area as far east as the Ural Mountains and Iran. More real evidence or future archaeological discovery would be necessary to make the thesis totally convincing.

We can never know whether this single figure was an artist, and it actually seems unlikely. A profound scholar of Hellenistic influence in Bactria remarked more than a hundred years ago that in a new country 'every European was needed as a fighter or a governor', and that there was little time for art, science and literature.[35] Certainly however commercial activities antedate the Silk Road, and its putative 'discoverer' Zhang Qian seems himself to have been surprised on arrival in Bactria to see that the people already possessed cloth from Sichuan.[36] The nomadic and semi-nomadic peoples who inhabited the area between Persia and China frequently traded, just as they would do in later centuries. But evidence of cultural interaction is scant. There is much archaeological and linguistic work to be done, for which few scholars are qualified. In a different context, Berthold

Laufer, an early twentieth-century German-trained orientalist who knew all the relevant languages (including Chinese, Persian, Sanskrit, Mongolian and Tibetan), wrote that the ancient Persians 'were the great mediators between the West and the East, conveying the heritage of Hellenistic ideas to central and eastern Asia and transmitting valuable plants and goods of China to the Mediterranean area'.[37] How many can claim knowledge of all those languages now, in addition to the key Central Asian commercial languages like Sogdian?

The ideas of Barnhart, Nickel and Christopoulos are exciting and valuable, and will stimulate others to future research. Some contact certainly existed between the worlds of Alexander the Great and Qin Shihuang, at first sight so distant and disparate, and some degree of Greek or Greco-Bactrian influence is plausible. Nickel concludes:

> It is conceivable that nomadic peoples such as the Xirong, Xiongnu (匈奴) or Yuezhi (月氏 or 月支), whose territories were bordered by Bactria, Sogdiana and Qin China, carried east reports of Hellenistic statuary, which factored in the creation of the sculptures. It is equally possible that Chinese traders who crossed the Pamir brought back knowledge of Greek art.[38]

But to go further, as a BBC documentary did in late 2016,[39] and suggest that an individual Greek sculptor was actually working in Lintong is a step too far.

The strongest visual evidence for western influence may be found in the so-called acrobat figures in Pit K9901. For these figures are distinctly different from the terracotta warriors in style, with a command of anatomy quite unique in the Chinese context. Whoever made them understood the workings of the human body, the bulging muscle on the arms when exerting strength, flank muscle and ribs shown when lifting weights, and prominent vertebrae along the back. Certainly, it is easy to be swayed in favour of a European contact when standing in front of these anomalous acrobats and weightlifters.

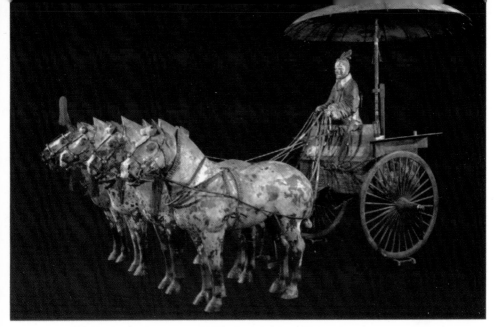

Half-sized imperial war chariot for the afterlife.

Half-sized personal travelling chariot for the afterlife of the Emperor.

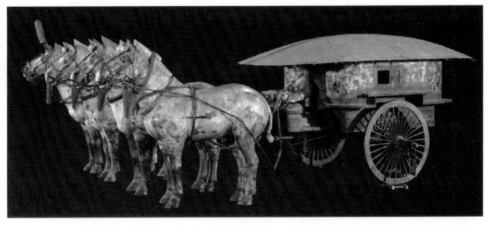

Front and side views of restored armour.

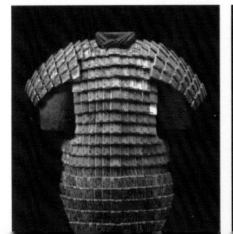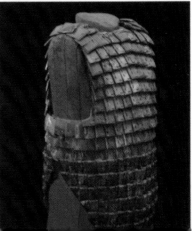

Far left Acrobat or wrestler discovered in 1999.

Left Wrestler or weightlifter discovered in Pit K9901 in 1999.

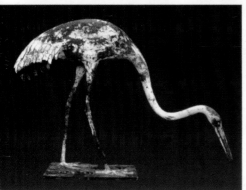

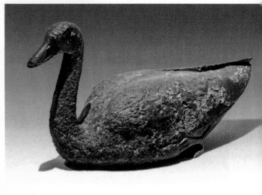

Above left Bronze crane discovered in Pit K0007 in 2003.

Above Bronze duck discovered in Pit K0007 in 2003.

Seated musician discovered in water-bird tomb, K0007 in 2003.

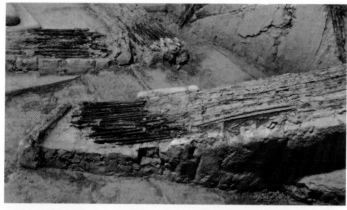

Bundles of quivers of crossbow arrowheads as found, with decayed wooden shafts.

Bronze shu from Pit 2.

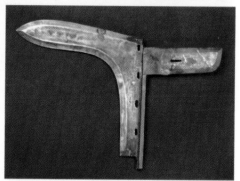

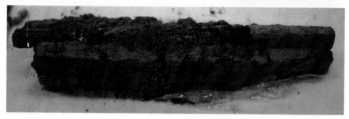

Above Halberd, combining an axe and hook; highly effective against mounted warriors when fixed on a long wooden pole.

Restoration of bronze spearhead with decayed wooden handle.

Makers' marks:

(*left*) The top two characters indicate it was made in the capital, Xianyang.

(*above*) The place of manufacture is given as Gong; the palace workshop and the artisan's name is Yang.

Kneading clay by foot
at Yaotou Kiln, Chengcheng,
north-east Shaanxi,
12 January 2017.

Chariot horses from Pit 1,
in Shaanxi History
Museum, Xi'an.

Below Animal sculpture at
the tomb of Han General
Hu Qubing.

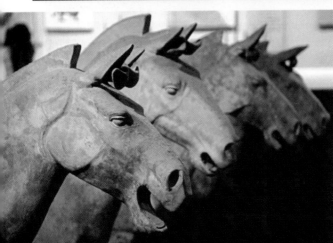

Left Horse standing over a Xiongnu warrior's
head, at the tomb of the Han General Hu Qubing.

Hairstyles.

Funeral mound of
Emperor Jingdi of Han.

Half-size wooden warriors
in the mausoleum of
Emperor Jingdi of Han.

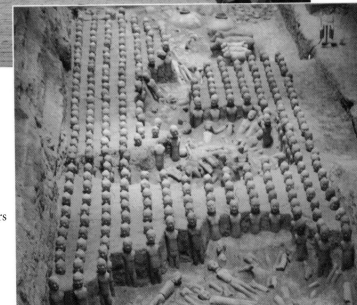

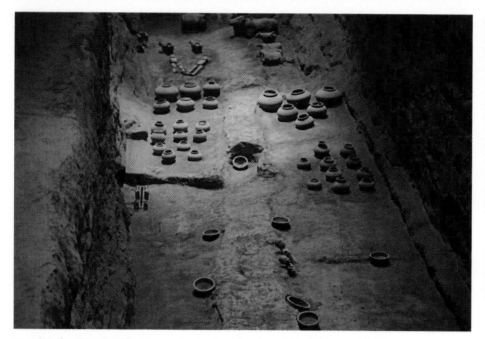

Supplies for the afterlife: sheep, pigs and cooking vessels at the mausoleum of Emperor Jingdi of Han.

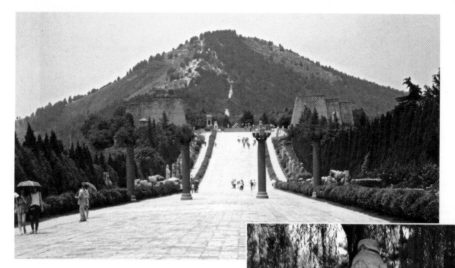

Monumental figures along the Spirit Way of the tomb of Emperor Gaozu of the Tang dynasty, Zhaoling, Shaanxi.

Monumental figure at the Spirit Way of the Ming Tombs, Beijing.

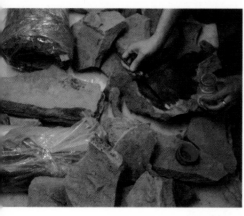

Cleaning and reassembling warrior parts in the lab.

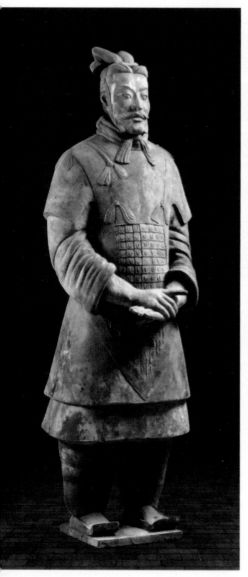
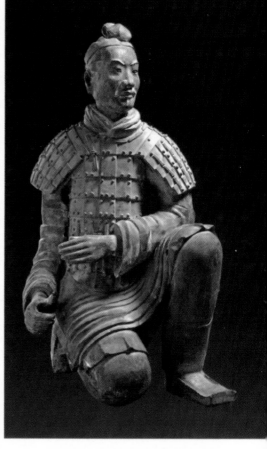

Above Kneeling warrior in armour.

Left General in longer armour suit.

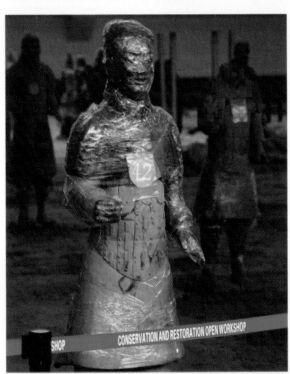

Warrior wrapped in plastic film to conserve humidity and avoid lacquer loss.

Below Figures made with original materials and with the same pigments as the ancient Chinese used, created by Catharina Blansdorff and her team in Munich: (left) a general and (right) an archer.

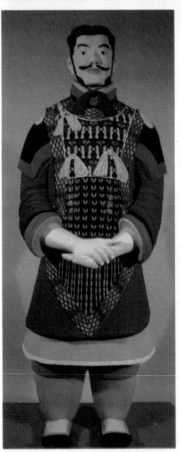

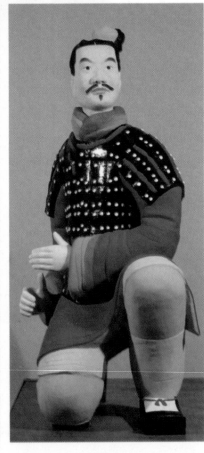

11

NEW TECHNIQUES FOR STUDY, RESTORATION AND CONSERVATION

Recent technological and scientific work on finds from the Mausoleum site has focused on four major areas: the manufacturing systems of weapons, metallurgy, the use and protection of colour on the terracotta figures, and problems of conservation related to humidity and atmospheric pollutants.

Some of the most interesting work concerns the predominance of the crossbow, which by the time of Qin Shihuang seems to have become the weapon of choice as a result of its effectiveness on the battlefield. It was used in huge numbers. As already noted, Sima Qian tells us that the Second Emperor was able to summon 50,000 crossbowmen from around the empire to protect Xianyang after his father's death. This entailed vast workshops, for the crossbow was a complex weapon which required not only the production of bronze arrowheads, tangs and triggers, but also bamboo and feathers to complete the arrows, wood for the frame, linen string, and leather and hemp to make the quiver – each of which, we saw earlier, usually contained a hundred arrows. In the case of the Second Emperor, the crossbows were manufactured for combat and needed the greatest possible quality and accuracy.

The need for precision and high-grade materials was paramount. The trigger assembly could easily be disassembled for cleaning and quickly reassembled. Then it could just be dropped into its slot in the wooden bow and used immediately. Needham quotes an ancient source which emphasizes this with a vivid Chinese comparison: 'If the mechanism of a crossbow trigger is out of alignment by no more than the size of a rice-grain, it will not work.'[1] In fact the crossbow

mechanisms found with the terracotta warriors are as precise as any modern weapon, in particular the triggers. In similar vein, there was a Han expression 'as round as a crossbow bullet' referring to the planet earth, attesting to the perceived perfection of the man-made article.[2]

But why was such quality required of those to be buried with Qin Shihuang and unlikely to be deployed in real warfare? For one of the most surprising factors is that such focus on quality and details, allowing for accurate flight and effective penetration on impact, was used to produce large numbers of arrows which were never intended for battle. As the UCL/MSM team suggest, it is probable that weapon-makers consciously chose to add more tin to the melting crucibles to ensure optimum performance, with compromises that 'include a likely higher cost for the time employed for the arrowheads as well as the extra organizational effort required to create specific alloys depending on the weapon or weapon part being cast'.[3] The weapons were made of extremely high-grade alloys of tin and bronze which would be hard enough to allow their use with lethal effect on the battlefield: they are not merely decorations to be used in a tomb.

Elsewhere, the same team found a parallel system in operation with the manufacture of crossbow triggers, and in conclusion go much further in suggesting that 'it is fair to say that the organisation of production in Pit 1 offers a view in microcosm of wider patterns of close political and economic control in the Qin Empire'.[4] In other terms, the immense bureaucratic and military apparatus created by Qin Shihuang was unable – or unwilling – to conceive of the afterlife as in any way different to the present life. Perfection, organization and control were essential aspects of duty, and the emperor would always be the emperor whether alive or dead.

For this reason, organization has been the main focus of Phase 2 of the UCL/MSM project, which began in 2011. Based on the marking practices, with characters stamped or incised on warriors and weapons to indicate their maker and/or provenance, research was carried out with the aim of acquiring a deeper understanding of the organizations of artisans and overall logistics involved. Two hundred

and eighty-three of the initial group of just over a thousand warriors unearthed in Pit 1 were found to have either single or multiple characters indicating personal names, place names and numbers stamped or incised before the figures were fired in a kiln. Three marks were also found on horses. Many of these marks include the character *gong*, or palace (宮), which is believed to refer to a large imperial factory, while others specifically mention the capital at Xianyang; this, the researchers suggests, means two large factories.[5]

Another category of similar marks on bronze weapons suggests the existence of a large separate factory for metal-working. These provide fascinating insights into the long-term production process and planning. For chiselled inscriptions on dagger-axes and halberds also provide the regnal year in which production took place, those on seven halberds giving a range from 244 to 237 as well as referring in all but one case to the overall supervisor of the entire process, none other than King Zheng's mentor and chancellor Lü Buwei. It is striking that the earliest date, 244, was just two years after the young king had acceded to the Qin throne, and that the latter date, 237, was just two years before Lü Buwei's downfall and death. The inscriptions on the spines of sixteen lances, on the other hand, all bear dates from 231–227, during the chancellorship of Li Si.[6] While the UCL/MSM team are cautious and suggest that many of the weapons could have been taken to the site later from imperial arsenals where they had been stored (although they argue that the arrowheads were produced especially for the warrior site), it should also be remembered that the pristine state in which they were found means that they had never been used in battle. It sounds unrealistic to suggest that weapons could lie unused for decades when such huge campaigns and battles were the order of the day. Whatever their origin, however, this documentary evidence of dating shows that the weapons in Pit 1 derive from a remarkably long period, thirty-four years from the earliest dated halberd to the death of Qin Shihuang. This in itself represents a notable feat of organization and logistics.

One of the unexpected benefits of Phase 1 of the UCL/MSM project, designed to find patterns in the military layout of Pit 1,

was that the results produced important insights into the logistics of transportation and placement of the weapons in the pit. Thus Phase 2, planned for the period 2011–16 but in fact still ongoing, was designed to seek similar patterns in the production of the warriors themselves. The most interesting current work involves 3D modelling of the terracotta warriors and study of the different kinds of clay and their provenance, with a view to improving understanding of the logistics of construction of the entire Mausoleum.

Fairly straightforward technology now allows detailed 3D images to be made from overlapping photographs taken with ordinary digital cameras and processed on a standard computer using the appropriate software – akin to the process of creating panoramic shots from multiple images. The research team go so far as to emphasize that the comparison of warriors' ears discussed below was made from shots taken with a standard DSLR camera in ordinary lighting without the use of a tripod. The two major elements are known as structure-from-motion and multiview-stereo (SfM and MVS). From a purely technical point of view, there is nothing revolutionary in this since software capable of such processing, such as MeshLab, is available for free downloading. In this case, rather than on a single plane, photographs may be taken from different perspectives and angles around an object such as a terracotta head and used to produce a 3D map or even print a copy with a 3D printer. What *is* new is the use of similar software to build a library of warriors or warrior parts – such as body shapes, ears or other physical features in order to study their provenance and develop detailed comparisons. The question of the ears is especially interesting since both forensic scientists and art historians have used differentiation between ears as a key factor in identifying bodies or artists. Moreover, 'The terracotta warriors' ears were made from the same loess-rich, pale clays as the rest of the figures' bodies and were probably hand-finished at a fairly late stage in their manufacture... [with] visible differences in the way they were rendered on different warriors.'[7] These differences may be used to identify clusters, individual artisans or even a studio style in the way in which a critic like Bernard Berenson identified an artist's style in a painting from similar features a century ago, thus

radically changing theories of provenance. Yet they might also be deployed in argument to show that there was every intention of creating individual human figures.

A second area of research in Phase 2 concerns the clay used for making the terracotta warriors. Sophisticated techniques such as the analysis of trace elements and lead isotopes allow researchers to distinguish between clays found in various parts of the pit, and comparison with samples from the area around the mausoleum which are being studied in the laboratory at the Museum site should facilitate the identification of areas in which the components were made. In other words, it will soon be possible to ascertain whether the warriors were all made in a single area, a few significant areas or multiple areas – just as analysis of metals enabled the identification of specific batches. In time, this may lead to the discovery of the remains of workshops or kilns which would provide much more information.

In terms of colour, much greater care is now taken during new excavations, with a series of professional conservation principles to act as a guideline. These include authenticity, minimum intervention, retreatability (allowing replacement later by new and improved materials), long-term stability, compatibility of conservation materials, and practicability in terms of cost, simplicity and environmental friendliness.

Recent scientific investigations into colour which included a terracotta warrior with a purple under-robe have shown that distinctive barium copper silicate pigments were developed by the Qin, in particular two colours known as Chinese or Han purple and Chinese or Han blue – the former first appearing during the Spring and Autumn period and the latter during the Warring States period. A polarized light microscopy technique was employed to analyse these colours in twenty-two samples taken from sites from Gansu to Shaanxi and on to Shandong.[8] This showed a trajectory of usage which 'follows precisely the route of the Qin state and imperial development' eastwards from Gansu.[9] These pigments are no longer found after the third century, so they may be considered distinctly Qin colours for application on ceramic wares.

Perhaps the best way to review the recent research is to outline

the work done on a single figure which was uncovered in July 2010, during the latest dig in Pit 1 which lasted from 2009 to 2011. It provides an excellent example of the way in which a more detailed understanding of colour, and more advanced techniques, enable the warriors to be preserved better than in the 1970s and 1980s with a greater focus on – and understanding of – the local environment and conservation problems at the time of excavation.[10] In fact techniques and methods vary from warrior to warrior according to their state of repair and how much colour is seen to be still present. No two figures are alike in this sense.

The figure in question, of a standing charioteer, was found broken into thirty-seven pieces but with residual traces of good-quality colour.* The first step was to preserve the colour by using a calligraphy brush to moisten the paint gently with deionized water so that it did not peel off from the lacquer base. This was possible on the arms and back of the warrior, and on the chest armour, after which paint on the upper arms, the chest and the back was further consolidated by impregnation after moistening by being covered with degreased cotton wool that had been soaked and prepared with a special chemical solution in deionized water. Finally, the body parts were wrapped in multiple layers of ordinary kitchen film. One particular problem was the exposed soil still adhering to the fragments, since its moist state could facilitate the growth of mould. This entailed lengthy and very careful cleaning to remove as much as possible in situ.

At that stage, the warrior fragments could be removed to the polychrome conservation laboratory for humidification, so that the paint layers could be further consolidated, and the remaining traces of soil on the surface painstakingly removed using bamboo sticks moistened with the deionized water solution. Other harder accretions, such as salt precipitates of calcium, barium and magnesium were removed equally carefully with a scalpel or chisel after being softened by another specific solution.

Now the fragments could be pieced together to reassemble the

* Illustration 60 on List of Illustrations, p.xi.

warrior as we see it today. This is also a slow and meticulous process, with special care taken to ensure with the application of a primer layer before gluing that the pieces could be separated later if necessary. For this reason, minimal possible damage is vital. To protect the areas around and outside the joins, the limbs were wrapped with plastic film so that only the surfaces to be glued were exposed. After cleaning the exposed parts, and carefully avoiding stains on the paint and other parts of the figure, a solution comprising modified epoxy resin and polyamide resin in a ratio of 3:2 was applied. Once the pieces had been joined, cotton straps were applied to hold the pieces in place. The restorers are reluctant to replace missing pieces, but occasionally use resins, pottery powder, glass bubbles, quartz powder, gypsum and fine sand when it is planned to put the figure on display or send it to exhibitions. One room of the lab is constantly experimenting with different types of clay and resins to find the ideal mix.

Using these techniques, polychrome statues, and of course metal objects, may easily be removed from the earth and stored in ideal conditions, but immovable relics pose a much more difficult problem. Major enemies such as changes in temperature, bad air quality and increased humidity can be destructive. Once a site is opened to the atmosphere, it is necessary to understand several processes such as the effects of humidity both in the air and in the ground, proximity to the water table, and air quality as well as its temperature. The levels of humidity also bring with them exacerbating factors such as fungal infections even in the exposure to apparently innocuous simple, bare earth. Problems that have inflicted huge damage on artefacts in the west, such as the cave paintings in Lascaux, were not understood in China when the terracotta site was first opened up in the 1970s. Even today, it is impossible to replicate outdoors the close control possible in major museums with the use of specialized viewing rooms and display cabinets, a major difficulty in a country with many newly discovered open-air archaeological sites. More recent museums, such as the Hanyangling Museum, where up-to-date techniques in lighting and ventilation were used, and where the excavated pits were covered in glass so that visitors can look down on the exhibits

apparently without interfering with the enclosed atmosphere, were one solution to the problem. But even there the preservation has not been as good as had been expected, so that statues have suffered cracks and erosion over the years. One problem, revealed in the restoration of the charioteer outlined above, is that twenty-four-hour surveillance is required once new polychrome warriors are unearthed due to environmental changes on a daily level – diurnal temperature changes, external pollution and visitor numbers, for example. Hence, among other reasons, the reluctance to begin work on – or even near – Qin Shihuang's tomb until these phenomena are much better understood and conservation guaranteed beyond reasonable doubt.

In the last few years, ongoing research has studied conservation problems within the main pits of the Mausoleum Site Museum, where warrior bodies, colour, stone armour and the earth itself all suffer problems due to the environment. One recent focus has been on methods of controlling and maintaining humidity and temperature even in open pits. But beyond these obvious parameters it is also necessary to measure gaseous pollutants such as sulphur dioxide, nitrogen dioxide, nitrogen oxides and ozone, as well as controlling airflow in a difficult environment such as a large pit which is subject to the influence of outside weather and atmospheric conditions and the almost continuous presence of large numbers of visitors. In the specific case of Pit 1, for example, high levels of sulphur dioxide were attributed to emissions from a nearby thermal power plant.[11] It is a profound irony that pollutants from the development of industries and transport needs due to the very presence of the terracotta warriors, and essential to the increased wealth of the area, can also represent a threat to them. In fact the primitive environment of the main pit was described as 'completely destroyed' in the research quoted above. No such environment can ever be simultaneously 100 per cent isolated and fully open to the public.

While it will be easier to create air-curtaining systems for future digs in order to maintain the primitive environment and minimize damage to the relics found – especially those which cannot be moved, at least not quickly – sites such as Pit 1 will necessarily remain as they are with a large open space above the warriors. One possible

solution is that the pits already excavated could be reintegrated into smaller, independent spaces by using an air-curtain system: 'The small space would be composed of an air filtering module and an air curtain system; the former is designed to provide the filtered air which is conditioned with appropriate temperature and humidity as demanded, while the air curtain sheer is devised to diverge the air pollutants and heat from penetrating into the pits.'[12] (See Figure 11.) The success of such a strategy could be measured by studying the efficiency of isolation. In this way the individual pits, or in this case corridors, could be separated from the vast area of air under the roof which is subject to exterior conditions. Discussions are also currently being held about installing a much more environmentally efficient roof than that which was built according to the museum design criteria of forty years ago.

This research emphasizes problems which may have been overlooked at that time, but today constitute a powerful argument against opening the imperial tumulus and burial chamber of Qin Shihuang. Even if the fears of some archaeologists that the burial chamber has in any case been looted, or has collapsed due to centuries of erosion above ground, are realized, it would take a political and cultural decision of some courage to order the opening of the tomb. Technology does not yet provide an answer, for the introduction of robots or cameras would require the breaking of seals which may exist, thereby allowing humidity and polluted air to enter the chamber and wreak havoc as they have in the excavated pits. Indeed, if the chamber has been sealed and never reopened the effects are likely to be even more devastating.

It would seem that the only way to guarantee the protection of the body or bodies, of precious artefacts that were buried with the emperor, of the colours that were used and of the representation of the cosmos with its rivers of mercury which may still be intact is to leave everything in its place under the enigmatic pyramid which rises above the plain. On being questioned about the possibility of the tomb being opened, most archaeologists and historians resort to a phrase such as 'not in my lifetime', or assert, as Yuan Zhongyi did to the author, that archaeologists are 'self-disciplined, and never speak without facts'. Yet even he, on the basis that soundings have

Figure 11. Air curtain system for the preservation of historical relics (after Zhaolin Gu et al., 'Primitive Environment Control', 2013)

led to the belief that the tomb has not been robbed, is convinced that 'something truly astonishing' will be found when that day arrives.[13]

For the moment at least, we must be satisfied by further discoveries and research concerning the Terracotta Army and the wider area of the Mausoleum.

12

RECENT EXCAVATIONS AND CURRENT STUDIES

Some of the most interesting recent results have emerged as a result of returning to previously excavated sites – although it must be said that 'recent' is a strangely elongated adjective in the world of the archaeologist, where the process from the dig to the final publication of results can take years, following painstaking removal of artefacts, their restoration and then careful analysis and research.

In December 2012, after two years of digging, a large complex of buildings – without warriors or other human figures – was identified within the inner wall of the mausoleum and just north of the tomb of Qin Shihuang. They have variously been described as an imperial palace and as a series of prayer halls. Covering a total area of 690 by 250 metres, these underground rooms represent the largest single structure so far discovered in the mausoleum area and certainly fulfilled a ritual and ceremonial function (see Figure 7). It was believed that the deceased emperor would leave his tomb on special occasions, emerging from his sleeping chamber to change his clothes, and then use a series of other rooms, shrines and altars for ritual preparations. For example, four times a year, at the formal beginning of each of the seasons, he would emerge for celebratory banquets with his court. At such times, these prayer halls and chambers would be peopled with his 'deceased' court officials, ministers and intimate family members.[1] The sequence of halls and chambers has since been filled in again, but its position and outline are indicated by signs embedded in the paving stones above at the main viewing point for the tumulus.

In 2013, a further complex of 105 tombs was discovered in a slightly smaller area parallel to the prayer halls, separated from them by the pathway leading into the mausoleum from the north gate (see Figure 8). They were relatively simple tombs containing little more than bare bones and a small number of trinkets and a few more precious items like pearls. It is likely that at the time of the emperor's death this area was empty – perhaps destined for other functions in his long-term plan. Most of the corpses buried here were female. In fact one tomb, numbered M17, contained the bones of about twenty women around thirty years old, with artefacts of gold and silver, copper, iron, pottery and jade, together with shellfish, bones, lacquer and silk used for ornaments. There were also some bones of cattle, sheep, pigs and poultry.[2] Unlike the other large graveyards, however, there are neither horses nor warriors buried here, and the absence of children's corpses is also striking. These factors have led archaeologists to conclude that these are the corpses of the concubines of the First Emperor, who were ritually sacrificed after his death and placed here by his son, the Second Emperor. This area too has been filled in since the dig took place.

In the summer of 2014, a group of fifty tombs was discovered about five kilometres north of the mausoleum, in a site measuring approximately 1,200 by 300 metres. Some of these graves may date from a later period, but forty-five of them contained coffins with the twisted legs which characterized non-aristocratic Qin burials (this meant that they could be buried in large vertical terracotta vases, such as have been found in Yong). Around 300 items of pottery were unearthed together with the coffins. The notable distance from the mausoleum area suggests that these burials were not directly linked to the monumental layout of the imperial burial. The archaeologist responsible, Sun Weigang of the Shaanxi Provincial Institute of Archaeology, suggests intriguingly that they may have been artisans or workers engaged in the manufacture of the terracotta warriors. In fact these graves are not far from the presumed site of the township of Liyi built in 231 for the families which Sima Qian tells us were moved to the area to work on the mausoleum project.

But much recent work has produced more doubts than certainties,

especially in the case of excavations of Pits K9901 and K0006 located to the south of the mausoleum proper.

Pit K9901, generally referred to as the acrobats tomb, was as we have seen first excavated during a six-month campaign in 1999 – as its designation shows. But fresh ideas have emerged following a second campaign undertaken by the director of archaeology at the Mausoleum Site Museum, Zhang Weixing, from 2011 to 2013, with the final results as yet unpublished. The acrobat hypothesis is less convincing than before. In 2012, twenty-nine further terracotta figures were unearthed, most of them much larger and stronger than the slender figures that led to the original acrobat hypothesis. In fact they look much more like weightlifters, with immense arms and strong biceps. In particular there is one massive seated figure at the time of writing in the process of reconstruction and restoration in the laboratory at the pit. He looks as if he is resting, with his right shoulder back as if shifting his body, and his left hand splayed palm down on his upper thigh. He is one of the most extraordinary and enigmatic figures yet discovered, with feet which in modern European measurements would be size 54; his body is around seven feet tall without the head, and has biceps worthy of a serious body-builder. He, like some of the other figures, is clearly a strong man engaged in physical activity not usually associated with acrobats. These discoveries have not been published yet, and the laboratory is not accessible to the public, but clearly something different to the massed warriors in the other pits is being revealed.[3] No official photographs are available, but he may be seen in the typical visitor-record shot shown on the jacket. The precise function of this imposing character remains unclear, as is that of a dozen or so other figures also currently being restored.

In a separate area of the same pit, several lead and stone weights have been found, the lead ones weighing around thirty kilos each.[*] Once again, their function is unknown, although it is possible that they were used for training purposes. Christopoulos notes that athletes used such heavy weights for power training 'and also smaller round weights to strengthen their fingers'.[4] The evidence

[*] Illustration 67 on List of Illustrations, p.xi

of weight-training also provides a new context for the mysterious bronze *ding* – which we may recall weighs 212 kilos. For there is an old Qin tradition regarding a similar bronze vessel. In 307, the twenty-three-year-old King Wu, who had acceded to the Qin throne aged nineteen, made a visit to Luoyang. The young warrior-king was proud of his physical strength, enjoyed sports and had an eccentric predilection for appointing well-known strong men to official positions in his government. It is easy to see how such a man could be tempted or provoked by a challenge to lift what sounds like a fine bronze cauldron, red in colour and decorated with dragons, to show off his weightlifting skills. He succeeded, but managed to break his kneecaps as he held the weight above him; it must have been a severe and painful injury, for later it led to his death.[5] He died childless, so the throne passed to his brother Zhaoxiang, great-grandfather of the First Emperor. Exercises such as cauldron-lifting remained popular throughout Qin times and were often used as a metaphor for strength: to illustrate the strength of the rebel Xiang Yu, for example, Sima Qian describes him as strong enough to lift a *ding*.[6]

All the newly discovered figures currently being restored have those strong calves and biceps of the weightlifter or wrestler. Certainly they would need the lead weights for training, perhaps as preparation for a ceremony based on King Wu's earlier feat. These military sports were important throughout Qin history, and during the First Emperor's reign became 'institutionalized for the foot soldier's warfare training'.[7] As late as 209, in the first year of his reign, the Second Emperor, Hu Hai, built the Palace of Linguang, meaning 'Forest Light', in Ganquan, which became famous for its wrestling displays.[8] Christopoulos comments:

> Although there was no evidence of a prior culture depicting naked human forms in sculpture at the Qin court, these statues show strong individuals like wrestlers or acrobats wearing only loincloths. The details in the body lines and the 'heroic' representation of some of them remind us of Hellenistic influences, but with a Chinese conception of strength, e.g., large, strong men with big bellies.[9]

Expressed this way, the influence becomes plausible.

But there is more to it than this and the mystery centres on the bronze *ding*, or cauldron, which was closely associated with ritual and ceremony and is often found in ancient Chinese tombs – such as that of Duke Jing at Yong discussed above. The art historian Eugene Wang of Harvard notes that these putative acrobats have very solemn facial expressions, and that while acrobatic scenes were festive in character and included music, in this case no musicians have been found – unlike the birds and musicians found together both in Duke Jing's tomb and here in Pit K0007. Professor Wang observes: 'We thus find ourselves mired in a conundrum: the bare-torso exhibitionism evokes light-hearted acrobatics; the gravity of the mood suggests some staged stately ritual, presumably keyed to the funerary context. So, the pit presents acrobatics without levity, and a death ritual with some lightheartedness.'[10] During the Warring States period, the *ding* – presumably as an extremely expensive and rarefied object when engraved – had become closely associated with rank, so that specific numbers of them were assigned to ritual activities and burials, nine to an emperor or king for example. But its status went beyond its physical aspect. Qin Shihuang had himself gone to considerable trouble in his search for the lost cauldron of the Zhou, as we will recall from the events as Pengcheng on his first inspection tour. That in itself would suggest that he thought of the Zhou cauldrons as an essential part of the cosmos he wished to replicate in his mausoleum, for their ritual and mythical value.

Following a detailed artistic discussion of the *ding* and associated ritual in the early Han, with abundant illustrations from objects found in tombs of that time, Wang reaches some intriguing conclusions regarding the acrobats and weightlifters, and above all the *ding*. Elsewhere, he refers to the *ding* as the 'crucible that refines the nebulous breaths into quintessential forms of permanence'.[11] But here he argues that this episode represents a moment in the seasonal cycle of Chinese belief, and could be a feature which makes sense of many of the mysteries of the Mausoleum as a whole – including the terracotta warriors. Based on examples from Han burials, he asserts that the acrobatic 'show' in fact represents a ritual observance of the

autumn phase of the seasonal cycle, 'the basic framework for the ebb and flow of "breath" or vital energy, the stuff that makes both the body and the cosmos'.[12] Parallel to this, the scene with the wild birds in K0007 represents a ceremony which through the migratory birds heralds spring and the seasonal renewal. Wang points out that it is *not* a hunting scene, since the objective is to capture rather than kill – as shown by a silk cord attached to the arrow used, the idea being to shoot across the bird's flight path to trap and entangle it without the arrow making contact: 'The goose-shooting is therefore a special kind of hunting, with heavy symbolic overtones.'[13] He also quotes the 'Monthly Almanac' given in Chapter 1 of the *Annals* of Lü Buwei, on a ceremony regarding 'Establishing Spring', when 'the Son of Heaven personally leads the Three Dukes, the Nine Ministers, the feudal lords, and the grand officers in welcoming spring at the eastern suburban altar' (in fact, we might add that a few lines earlier the *Annals* refer to the east wind melting the ice and to the 'migrating geese' who head north at this time – and presumably return in the spring).[14] This is evidence of the ethos and beliefs regarding the season in the late third century as expressed in the name of a courtier.

This detailed argument, with over twenty pages of examples and illustrations from ancient artefacts, leads to an interesting conclusion:

> The K9901 (the cauldron-raising) and K0007 (goose-shooting) point to a large conceptual plan premised on the mapping of seasonal cycles as the reassuring mechanism for imagined postmortem revivification or regeneration. If so, it is very likely that the east-facing terracotta army a mile away from the tomb mound goes out to fulfill the ceremonial function of 'welcoming spring' at the east suburb...
>
> The so-called 'spirit carriage,' painted white, on the west side of the tomb mound is accordingly part of the ritual observance of the autumn phase. West, white, and autumn are all transposable and exchangeable concepts in the third-century BCE habit of thinking.[15]

Thus the master-plan of the Mausoleum, to use a modern phrase, was designed to replicate cosmic patterns through the cycle of seasons, and guarantee the fate of the emperor in the afterlife by maintaining and celebrating them. This entails a much more sophisticated model of which the terracotta army is just one part, while up to now it has generally been considered by visitors and tour guides as an autonomous entity.

Moreover, this fascinating theory clearly reinforces the controversial arguments of Liu Jiusheng. Wang too notes that the warriors in Pit 1 have neither helmets nor shields, and adds the curious fact that while advanced weapons of the late third century also in the possession of the Qin were made of iron and even steel, all the 40,000 weapons and weapon parts discovered are made of bronze. Thus he also assigns to the 'warriors' a ceremonial role more appropriate to guards than to soldiers.

Further enigmas concern Pit K0006, which was originally excavated between 2000 and 2003, and is often referred to as the 'officials tomb' or some such term. Here, too, recent work has provided fresh evidence and suggests new theories. In 2012 further excavations were carried out at the eastern end of the long, narrow existing pit, beyond the chariot found in 2000 and perhaps outside a gate or door separating the two parts. The total length of the excavated area was 48.2 metres, varying in width from 2.7 to 11.8 metres, making an area of 144 square metres (with the whole area around amounting to 410 square metres). The remains of horse skeletons were cleaned and counted, showing that twenty-four more real horses had been buried there in a separate pit in addition to the six already found with the chariot – which stood ready for use facing the base of a ramp leading up to ground level towards the west.[16] This creates in the minds of the archaeologists a mismatch: why should there be twelve male figures, of which four are charioteers, a total of thirty horses (all real), and only a single chariot? Was the earlier hypothesis that this was the tomb of a minister of justice correct, or is there some other explanation? The rank of the incumbent, as a minister, is sufficient to explain the six horses buried while harnessed to the chariot, but what of the other twenty-four? And if the figure with the ceremonial

axe is the minister himself, who are the other seven non-charioteers? At present, there is no real solution to this problem, since it does not fit the hypothesis of the seasonal cycle but is clearly linked to the functions of government in the afterlife, as its position within the inner wall and close to the imperial tomb and the west gate attests. One possibility is that the horses in the rear part of the pit, to the east, are simply components of an important official's stable. It is hard to believe that such a personage would not have back-up animals when multiple duties were required.

Be that as it may, these examples give an idea of how much more work there is to be done. Ironically, each new dig seems to throw up fresh questions as well as partially answering the old ones. At least in part, the difficulties may be attributed to the fact that Qin Shihuang died relatively young so that his funerary complex was never completed. As usual in making any assertion about the Mausoleum, even the simplest conclusion raises new difficulties. For in the turmoil following his death, the warrior pits and some of the other associated pits were certainly ransacked by Xiang Yu's rebel army, and perhaps by others, but we can never know exactly what they destroyed and what they may have taken away. Worse still, due to the death of the emperor occurring so far from Xianyang and during a hot coastal early autumn at a time when maintaining the condition of a corpse was itself a serious problem, there are some who believe that the body was never brought back and therefore never interred.

Mysteries persist. The greatest of all concerns the contents of the burial chamber of Qin Shihuang, for, if it is still untouched as many believe, surely that would herald discoveries to rival and even exceed those of Tutankhamun's almost intact tomb when it was opened in 1922.

Another key problem regarding the opening of the tomb concerns the presence of mercury, mentioned at the end of Chapter 9. Sima Qian emphasized the use of the flowing metal in creating the emperor's personal model of the world: 'The hundred rivers, the Yangtze River and the Yellow River, and the vast sea were made with mercury, using machines which made them flow and meet.'[17] Modern scientific studies would appear to confirm the presence of a high

level of mercury in the soil. Research conducted in the 1980s found an area at the centre of the funerary mound, about 12,000 square metres in all, which had an unusually high level. The archaeologist then in charge, Professor Duan, concluded that 'In this area the mercury concentration varied between 70 and 1,500 ppb [parts per billion], averaging 250 ppb. In the rest of the tomb concentration was less than 70 ppb. Outside the mound mercury concentration varied between 5 and 65 ppb, averaging 30 ppb. These numbers show that the high level of mercury found in the centre of the tomb mound is not natural.'[18] (See Figure 12.)

Further tests in 2003 confirmed these results. The most fascinating observation by Professor Duan is that the distribution of mercury within the tomb mound corresponds on an ideal map imagined over the burial chamber to that of the real rivers it is supposed to represent: very little in the north-west, and a heavy concentration in the north-east and south. The highest level shown in a schematic reproduction of the results in 1981 in fact corresponds with an area presumably representing the Yellow River, and other areas of high intensity correspond with the position of the Han and Yangtze rivers. We know that mercury was used for medicinal purposes by alchemists and other royal nobles, and have seen that Qin Shihuang himself used it as part of his search for immortality. But nothing yet known matches these levels. So it seems that Sima Qian's description may be taken at face value, although some archaeologists are sceptical. Professor Martinón-Torres of UCL, for example, believes that the apparently abnormal mercury levels may derive from the cinnabar which was ground to make the red or scarlet paint likely to be abundant in funerary furnishings and other art work in the tomb, and which is the base ore for producing liquid mercury.[19]

The studies we have mentioned on Greco-Bactrian influence offer another tempting idea concerning the contents of the tomb. Christopoulos believes that personal artefacts linked with wrestling and other martial sports will be found in the burial chamber. In a footnote, he adds:

Figure 12. Mercury levels and the Mausoleum site showing a peak at the burial chamber (after Duan Qingbo)

As unrealistic as the alternative seems, I do not see any rational possibility of transmitting a realistic Hellenized art style into Qin dynasty China other than by explicitly teaching it. The same reasoning applies to the existence of the twelve chryselephantine statues of Lintao. Greek sculptors at the time frequently offered their services to kings as far as Parthia and Bactria. If the Greco-Bactrians were based in Khotan, Loulan or Lintao, then they could have offered their services to the Qin Emperor as well.[20]

He believes that evidence will be found when Qin Shihuang's tomb is unsealed. Certainly the opening of the burial chamber, filmed live or – more likely – recorded in detail, would be one of the great cultural events of the century, overwhelming even the original discovery of the terracotta warriors. It also seems likely that it will offer unimaginable riches and artefacts, since Qin Shihuang was anything but an ordinary man and seems to have possessed infinite curiosity. If the contents were to surpass those of the existing pits, equalling or excelling in quantity and quality those of Sima Qian's description and the examples provided by near-contemporary Han

tombs, that would be no exaggeration. We might anticipate objects reflecting the emperor's refined tastes and need to impress, such as musical instruments, rare editions of the Chinese classics and a personal cabinet of porcelain, jade and precious stones like that of his ancestor Duke Jing. But what will the 'replicas of palaces and government buildings, and wonderful utensils, jewels and rare objects' recorded by Sima Qian actually look like? The exquisite bronze chariots hint at the quality of his private possessions and a level of workmanship and design likely to surpass all the other artefacts unearthed in ancient tombs – and in the minor pits around his own mausoleum.

Other events are more imminent, such as the opening of the new pit of the ducal tomb at Yong, anticipated in 2018. The main tomb, one of over twenty in the area, was discovered in 1976, but in 2003 archaeologists located a pit containing his personal 'army' just a few paces away from the tomb. Soundings and comparisons with similar but smaller tombs suggest that there are fifty chariots with 200 horses sacrificed for the burial together with at least fifty charioteers and probably more soldiers. Since the norm for light chariots, as for the sixty-four found in Pit 2 of the terracotta warrior site, was for a driver wearing armour on his hands and arms together with a charioteer on each side, this could mean as many as 150 human bodies. In other words, Qin Shihuang was following family tradition on a larger scale and with terracotta figures rather than real ones. The Yong 'army' rests undisturbed six metres below the bottom of the pit, and dates from around 530. The pit was dug down to a level just six metres above the chariots, and early in 2016 a steel and glass roof was built over it to protect the imminent excavation work.*

It seems certain to offer some surprises, but can we guess what the chariots will be like? Literary evidence offers an answer. An early poem in the *Book of Odes*, in which an unnamed Qin lady laments the absence of her lord who has gone to fight the tribes in the west, provides a fine description of his chariot as she imagines him driving into battle. It is given here in full, in the translation of James Legge:

*Illustration 16 on List of Illustrations, p.ix.

Before my mind's eye stands my lord's short chariot,
In which he dares the risks of savage war: –
Its pole, whose end turns upward, marring round,
And in five places shines, with leather bound;
The slip rings and the side straps; the masked place,
Where gilt rings to the front unite the trace;
The mat of tiger's skin; the naves so long;
The steeds, with left legs white, and piebalds, strong.
Such my lord's car! He rises in my mind,
Lovely and bland, like jade of richest kind;
Yet there he lives, in his log hut apart: –
The very thought confuses all my heart.

The driver with the six reins guides along
The horses, with their shining coats, and strong –
One inside dappled, one bay with black mane;
Black-mouthed and bay, and black, the outer twain.
Shields, dragon-figured, rise up side by side,
Shelter in front 'gainst missiles to provide.
Gilt buckles with the carriage front connect
The inner reins by which the insides are checkt.
I see my lord, thus in his carriage borne,
With his mild form the frontier towns adorn.
What time can be for his return assigned?
Ah me! his figure ever fills my mind!

With measured steps move the mail-covered team.
The trident spears, with gilded shaft-ends gleam.
The feather-figured shield, of beauty rare,
He holds before him, all his foes to dare.
The bow-case, made of tiger's skin, and bright
With metal plates, lies ready for the fight.
It holds two bows which bamboo frames secure,
And keep unhurt, to send the arrows sure.
To him thus busy all my thoughts are borne,
Both when I rest at night and rise at morn.

He, my good lord, is tranquil and serene,
His virtuous fame more prized, the more he's seen.[21]

This gives an accurate description of the Qin chariots already excavated in Gansu. The upward-pointing pole rings true; the horses are magnificent. The mention of tiger skin used for a mat and for the bow-case, and the shields on the side of the chariot, lead us to hope that remnants of these accessories may be found.

Yet it also provokes a new question: what might those of Qin Shihuang buried in his mausoleum look like, not the half-size ceremonial chariots but his war chariots? For each new discovery brings with it new questions, and each interpretation creates fresh mysteries.

13

WHY DID THE QIN FAIL?

Absolute longevity was not to be, either for the dynasty or for the emperor, who died on 10 September 210. Meng Tian, the key aide in his imperial schemes, was imprisoned and forced to commit suicide by poison soon afterwards; the emperor's long-time chancellor Li Si was executed two years later. The new empire was effectively doomed from that moment.

The blatant cynicism of court officials immediately led them to shift the succession from a young man who might well have made a good second emperor, given time to enter into the role and with full political support, to another son who could be more easily manipulated. The real heir, Qin Shihuang's eldest son Fusu, had been sent to the northern frontier in what amounted to exile, ostensibly to supervise Meng Tian, after arguing with his father – a sign that *he* may have been strong enough to counter the ministers. His second son, Huhai, had travelled on the inspection tour with his father and was present at his death, as were the minister Li Si and the powerful chief eunuch Zhao Gao, who had been valuable to Qin Shihuang as a result of his expertise in law and the suppression of rivals, rather like his distant predecessor Lord Shang. Now Li Si and Zhao Gao, certainly acting with a view to retaining and perhaps increasing their power at court, conspired to avoid having Fusu as their ruler by forging an imperial decree with Huhai's connivance which ordered Fusu to commit suicide. Perhaps unable to believe that three such men could commit such a forgery in the name of his father, Fusu complied. Such were the extremes of filial loyalty!

Certainly Huhai had not anticipated his new role. He assumed

the reins of power with the name Qin Er Shi, literally 'Qin Two Emperor' and more usually called the Second Emperor as his father had determined future emperors should be known according to their number in what he imagined to be an infinite sequence. But his character was quite different to that of his father, and presumably also to that of Fusu. He seems to have been a dissolute young man of twenty-one with few obvious virtues apart from being the son of an emperor. Moreover, the situation in which he ruled was complicated by riots and rebellions throughout the empire, fomented both by peasant leaders and by members of powerful rival families driven by motives of revenge.

Since Qin Shihuang expected to live a long life – or at the very least refused to contemplate the possibility of his death – he presumably gave little thought to preparing his sons to succeed him (this was by no means unusual, as we read that the earlier Duke Jing of Qi always refused to contemplate any discussion of his succession, even as an old man after more than half a century of rule).[1] Added to that, there may have been a certain reticence in expressing his vision. In a chapter entitled 'The Tao of the Sovereign', Han Fei reported a saying which Qin Shihuang certainly knew: 'The ruler must not reveal his wants. For, if he reveals his wants, the ministers will polish their manners accordingly. The ruler must not reveal his views. For, if he reveals his views, the ministers will display their hues differently.'[2] Two paragraphs later, this becomes a philosophy of leadership: 'Tao exists in invisibility; its function, in unintelligibility.' In the event of an unexpected death, this could clearly be a handicap for an heir and his ministers. In fact, as we have already suggested, it is likely that the mausoleum and terracotta army had not been completed because his death was untimely. Apart from the three pits which contained warriors, chariots and horses there was also a fourth pit which was found to be empty when excavated. Sometimes this is attributed to the fact that work on the tomb stopped during the uprisings following the emperor's death, but it might simply be the case that work stopped because he had died, and was never to be completed. Be that as it may, a pampered young man with little knowledge of government or warfare – and no experience of either – suddenly

found himself becoming emperor in 210. He may even have been unaware of the detailed plans of his father's Mausoleum project.

Perhaps Qin Er Shi tried his best to live up to his responsibilities. He ordered the completion of the Epang Palace in honour of his father, but was said to have starved the people of the countryside surrounding his capital in order to pay for the 50,000 crossbowmen that he recruited for his own protection, as described above. Local warlords, brigands and potential enemies soon occupied land and cities within his empire as he left the affairs of state to his conniving eunuch tutor and indulged his pleasures in the palace of Xianyang while the empire disintegrated. Sima Qian (with Han bias, we must presume) portrays an arrogant young man as saying: 'They honour me by assigning ten thousand chariots, but in reality I do not have them. I wish to be equipped with 1,000 chariots and to be followed by a procession of 10,000 chariots, so that the title given to me is no longer an empty title.'[3] Such megalomaniac dreams persisted, while, as he acknowledged, his empire was increasingly infested with brigands. He continued in relative isolation for three years until he was forced by his eunuch 'adviser' to commit suicide – just as Fusu had done. The 'everlasting empire' so long dreamed of by the Qin fizzled away.

But the work on the Epang Palace and the process of completing the mausoleum provide examples of how the workers engaged on imperial projects could be reassigned when necessary, for Sima Qian observes almost as a footnote that 'work there was abandoned so that workmen could be transferred to provide earth for the tumulus at Mount Li'.[4] Now, seven or eight months after the First Emperor's death, that task was finished.

Qin Er Shi had even tried to emulate his father by making an inspection tour of the empire in the spring following his death, together with Li Si. In performing sacrifices, in Charles Sanft's words, 'his expressed purpose was to avoid looking weak before the people of the realm in comparison to his father, who had so sedulously communicated with the population'.[5] He travelled to Jieshi, and visited the steles at Mount Tai and Mount Kuaiji, ordering that a few words should be added to each of his father's inscriptions to show

clearly that they had been erected by him. He was concerned that 'in the distant future, it could seem that they were made not by the First Emperor but by one of my successors, and this will not serve to praise the merits and perfect virtue [of Qin Shihuang]'.[6] He too certainly did not lack the requisite filial loyalty.

But he effectively ceded real power to the eunuch administrator Zhao Gao, and to his adviser Li Si. Once again, Han Fei foresaw such a situation in his chapter on the forty-seven 'portents of ruin': 'If the royal seed is short-lived, new sovereigns succeed to each other continuously, babies become rulers, and chief vassals have all the ruling authority to themselves...'[7] Although Li Si initially served as chancellor and thus guaranteed some continuity of government, he was soon to be executed; Zhao effectively ruled the ruler.

This eunuch was a man who had once presented Qin Er Shi with a deer and pretended it was a horse. Rightly, the emperor derided him, but as a result Zhao Gao asked all those around the whether it was a deer or a horse: some agreed that it was a horse, and those who denied it were executed on the spot. Thus he demonstrated his absolute tyranny over the young emperor, who was too young and inexperienced to oppose such a wily and ruthless adversary. Now Zhao managed through similar guile and further murders to place Er Shi's nephew Ziying, the son of Fusu (although some believe he was another son of the First Emperor), on the declining throne for forty-six days under his own tutelage before the Qin were forced to surrender their power to the founder of the next dynasty, Liu Bang. A few weeks later, the city and palace of Xianyang were destroyed. All surviving members of the Qin imperial family were beheaded; Zhao Gao himself was torn apart by chariots – as Lord Shang had been. Dynastic prestige dissipated. Until the excavation of the terracotta army there was little tangible evidence of the immense power of the Qin.

That power ended with the death of the entire clan, and the devastation of their capital by fires that are said to have raged for months – which is more plausible than it might sound because most of the hundreds of palaces and other buildings were built of wood on rammed-earth foundations. It is a fascinating and bloody tale to end

the story of the family, charged with intense rivalry, terror, ambition and violence. Six centuries of careful planning were laid waste; 10,000 proclaimed years of dynastic power reduced to sixteen.

But, leaving aside Sima Qian's potentially deliberate bias, there are other possible reasons for the rapid collapse of the new empire. A very strong argument has been made that the fall was due to economic overreach which derived from Qin Shihuang's huge building projects – walls, dams, hundreds of palaces and fortresses, the Mausoleum itself – and the desire to create and control a vast bureaucracy capable of governing such an empire. Although as King Zheng he had ruled for twenty-six years (eight of them as a child, and many in a constant state of war), with his elevation to emperor and access to the entire economy and workforce now controlled by the Qin, there was an incredible acceleration in his building activities. In just ten years he built 6,800 kilometres of road, around 2,800 kilometres of Great Wall, two major canals, palaces and buildings for the 120,000 noble families who were moved to Xianyang after their own states had been conquered, as many as 700 palaces and temples for himself (including Epang, one of the largest ever envisaged anywhere in the world, though never completed), terraces and palaces during his inspection tours and large mausoleums for his grandmother and for himself. One recent and detailed calculation of the total manpower necessary, including court officials and servants, arrives at an estimated labour force of about two million, with unfathomable but certainly enormous costs in terms of provisions, transport and housing in addition to salaries. This means that on current estimates of the population of the empire, around 15–30 per cent of the total active workforce was engaged on public projects. As the author of these calculations, Gideon Shelach, observes: 'This is a very high proportion of the workforce to have been taken out of the production of food and basic resources, and in itself must have placed the people who were left behind to produce food and basic resources under great pressure.'[8] Certainly there were other causes of the collapse, as we shall now see, but this must have been a major factor both in economic terms and in creating resentment against the new dynasty.

For the Han and subsequent dynasties, the story of the Qin and their rapid demise after Qin Shihuang's death was summed up in a famous essay by the contemporary scholar and poet Jia Yi, who was born in 201 in Luoyang, and later moved to Xi'an where he became tutor to the Emperor Wen's favourite son. The essay was entitled 'Disquisition Finding Fault with Qin' (Guò Qín Lùn, 過秦論), and was included in full by Sima Qian in his *Records* as the conclusion of his biography of the First Emperor.[9] Jia Yi begins by praising the emperor's achievements from the moment he assumed the throne as King Zhen, the way in which he had completed the work of his ancestors by absorbing the two Zhou dynasties and destroying the lords of the rival Warring States, and also repulsing the Xiongnu and building the Great Wall. He 'imposed his law in the six directions, scourged the empire with his whip, and his prestige shook the four seas'.[10]

But at the same time, Jia Yi wrote, the First Emperor was greedy and selfish, trusting his own wisdom without heeding the advice of his court officials; above all, he never understood the thoughts of the ordinary people. He ran his court in an autocratic manner unlike those of earlier kings, and while the tactics, deceits and use of brute force of a long military campaign served their ends, in the new context of a unified empire they were not the right tools for guaranteeing peace and stability.[11] This lack of willingness to listen to those around him meant that he compounded his errors; his son, when he became the Second Emperor, continued in the same way and his personal cruelty made matters even worse. First Emperor, Second Emperor and the last member of the dynasty lost the straight way because they were blinded by their arrogance and never understood the situation around them. In short, they deserved to fail.[12] Towards the end, the critic observes, there were within the court officials and ministers who understood the imminent demise and could have navigated a route away from the disaster. But they were afraid to speak out, fearing execution if their words were not well received. This meant that the old relationships had been overturned because of the emperor's strength, for in the *Li Ji* it is said that 'In serving his ruler, (a minister) should remonstrate with him openly and strongly (about his faults),

and make no concealment (of them); should in every possible way wait on and nourish him, but according to definite rules.'13 This was obviously forgotten, although we may imagine such strong political figures as Lord Shang and Li Si abiding by this recommendation in earlier times. So even when the rebellion against the dynasty was in full swing, court officials never reported it to their ruler. Is that not deplorable, Jia Yi asks rhetorically?14

For some time after the First Emperor's death, the memory of his military prowess and political power helped to maintain the aura of his empire. But such was the inherent weakness of his successors that an uneducated man like Chen She, born in a hut in rural poverty far from the centre of power, managed to challenge the mighty Qin with a ragtag force of peasants armed with short sticks as weapons and carrying their battle standards on longer sticks. In a picturesque turn of phrase which brings the Pied Piper of Hamelin to mind, Jia Yi writes that 'the whole world gathered around him like a cloud and answered him like an echo, loading provisions onto their shoulders and following him like a shadow'.15 The Second Emperor could in fact have resolved the problems, he argues, since everybody was expecting him to take charge in a positive way. In a powerful paragraph which merits quotation in full, he excoriates the new emperor with a rhetorical flourish:

If Er Shi had conducted himself as an ordinary king and had delegated loyal and wise men to the task, if the subjects and the sovereign had the same feelings and had taken pity on the misfortune of the world by repairing the faults of the former emperor when he was still dressed in white [that is, in mourning], if he had divided his territory and distributed it to his people so as to give fiefdoms to the descendants of the most deserving among his subjects, if he had founded new states and set up princes to honour the empire, if he had emptied the prisons, pardoned the condemned, abolished slavery and allowed people to return to their villages, if he had distributed the contents of the granaries and funds to save the abandoned and miserable, and those in extreme poverty, if had he cut taxes and corvée labour to help

people in distress, if he had softened the laws and moderated punishments in order to safeguard the future, if he had allowed the inhabitants of the empire to begin again, each tending to his own well-being through integrity and good conduct, satisfying the wishes of the multitude of the people, and presiding over the empire with authority and virtue, then all the people would have gathered around him. Then, within the [four] seas, everyone would have been content, and satisfied with their lot.[16]

But unfortunately it was not to be.

Instead of such an honourable resolution, nobles and soldiers alike were overburdened with taxes and duties to finance the imperial ambitions. Moreover, Jia Yi says that no one felt safe from severe punishment, and that the roads were crowded with condemned men. That was the reason, in his view, why the rebel leader Chen Sheng, even though he held neither high rank nor title, 'only needed to raise his arms in [the county of] Dazexiang for the entire empire to respond with an echo, because everyone felt in danger'.[17] The reference here is to the Dazexiang Uprising led by Chen Sheng in the autumn of 209, which began when he and his childhood friend Wu Gang were leading 900 peasant conscripts northwards to Yuyang. They were behind schedule due to heavy rains, Dazexiang being in an area prone to flooding since it sits on a plain in Anhui Province crossed by dozens of tributaries of the Yangtze. Fearing certain execution in the event of late arrival, they incited their peasant companions to rebel against the Qin. This uprising is considered to be the beginning of the rebellion which brought Liu Bang (the future Han emperor Gaozu) and his clan to power. In spite of Jia Yi's obvious bias towards the Han, it is hard not to agree with him that this was the real turning point in the fall of the Qin. Chen himself was assassinated by one of his own guards early in 208.

Two main forces emerged from this and the other rebellions, that of Xiang Yu and that of Liu Bang.

Xiang Yu is portrayed as a ruthless and psychopathic warlord from Chu territory in Jiangsu Province, strong and courageous in battle as well as having the scholarly background of the scion of

an aristocratic family. He was said to have witnessed the passage of Qin Shihuang on one of his inspection tours as a young man and to have asserted even then that he could have taken the emperor's place.[18] He became involved in plans for a separate rebellion of the Chu and as a result of personal prowess, in battles and intrigues too numerous to discuss here, made himself into the 'Supreme King of Western Chu', with his capital at Pengcheng.[19] It was Xiang Yu who killed the last Qin emperor, Ziying, put the residents of Xianyang to the sword and set fire to the imperial palaces.[20] It is also believed that he was responsible for the fires which brought the roof down on the terracotta warriors and instigated looting at the mausoleum. For a short while he effectively ruled over half the ex-Qin lands, but lost out to his rival Liu Bang at the Battle of Gaixia in 202, at a site near Suzhou in Anhui Province.[21]

Liu Bang was also born in Jiangsu, in the north-western town of Feng in the county of Pei. Sima Qian recounts several miraculous stories and omens concerning the young man, but what seems certain is that he was an exceptional warrior and a shrewd politician whose personal qualities compensated for the lack of a noble background. Later, as Governor of Pei, he became one of the main leaders of the rebellion which eventually overthrew the Qin. When Xiang Yu made himself Supreme King, he divided the empire into nine kingdoms and marquisates with new titles given to the key generals, assigning to the Governor of Pei the lands of the Han, Ba and Shu peoples at a safe distance in south-western Shaanxi near the border with Sichuan. That was how he became known as the King of Han, from the river, even though he spent little more than four months in the capital of his new kingdom at Hanzhong. For the restless and ambitious king soon returned east to fight for what he believed to be his destiny against the forces of Xiang Yu. Three years later, after defeating Xiang at the Battle of Gaixia, he assumed the title of Supreme Emperor with the reign name Gaozu, thereby creating the new Han dynasty. He established his capital first at Luoyang, and then at the Qin capital of Xianyang, where he took up residence at the newly completed Palace of Lasting Joy. Xiang Yu committed suicide after the defeat, still only thirty years old.

It is interesting that both Xiang Yu and Liu Bang came from Jiangsu, in what had been the kingdom of the Chu, the only rival power that might have produced a king strong enough to become emperor in place of the Qin. In spite of all the explanations, it might just be that the Chu were too distant and culturally distinct to accept Qin dominion. For the Great Wall which the emperor built to defend his realm from external armies was redundant when faced with the resentment and rebellion of recently conquered subjects *within* the Wall.

Qin Shihuang – once again following the traditions of his ancestors – had believed profoundly in the importance of wall-building, because in Jia Yi's words 'he himself believed in his heart that, thanks to his strength within the passes and to a thousand *li* of strong walls, his descendants would exercise imperial power for ten thousand generations'.[22] Yet his version of walls and war had become old-fashioned with successful unification. A population within the walls traumatized by fear of punishment could never sustain such a dream, which in the end lasted less than 10,000 hours. Some historians argue that the Qin simply did not keep up with the times. The sinologist Mark Edward Lewis, for example, in his perceptive study of the Qin and Han, argues that 'Despite its proclamations of making a new start in a world utterly transformed, the Qin carried forward the fundamental institutions of the Warring States era, seeking to rule a unified realm with the techniques they had used to conquer it. The Qin's grandiose visions of transformation failed to confront the extensive changes that the end of permanent warfare had brought about.'[23] The empire Qin Shihuang had created, and the title of emperor, were indeed innovations, but he himself did not live long enough to force his ambitions through. There were many in the empire, from the old aristocracy of the conquered Warring States to disgruntled imperial officials, who may just have desired a return to the previous status quo – to 'the good old days'.[24]

Some later authors attributed the demise to the emperor himself. Du Mu, for example, wrote what may be taken as a summary of the general opinion during the Tang dynasty, and a succinct version of Jia Yi's essay:

It was not the rebels, but the Emperor of Qin himself who
killed his entire family.

...

If Qin could have loved its people,
Then the Qin dynasty could have lasted not only three but
thousands of generations.[25]

Without his ruthlessness and determination, and those of such offi-
cials as Lord Shang and Li Si, the emperor could not have created
so much in such a short time. Yet too much revolved around the
personality of a single figure. One modern scholar has observed that
the Qin effectively created an *ideology of the emperor* rather than an
ideology of the empire, that he and his courtiers did not understand
the need for an imperial ideology to sustain the person.[26] In this,
the Han were wiser. When Qin Shiguang died rather suddenly and
unexpectedly, his project unravelled even though much good was
left behind.

In fact, the immediate heritage of the Qin was the continuation
and enhancement of his undoubted achievements by the Han
dynasty, which in its various guises lasted from the end of the Qin
in 206 to the abdication of the last emperor of the Eastern Han
over 400 years later. Documents concerning the organization of
the state were immensely helpful to Liu Bang. Qin Shihuang was
careful to collect and protect documents of all kinds which could
be useful for the smooth administration of his kingdom and help
create the missing ideology of an empire. Among these was a map
engraved on wood which had come into his possession during an
assassination attempt – according to Chavannes the most ancient
map known in China. When Liu Bang, soon to become the first
emperor of the Han dynasty, took possession of this map it gave him
an immense advantage, because through it he could understand the
strategic importance of specific areas, and also learn the number
of homes and people in his new kingdom. Through these maps,
Chavannes observes, the vital geographical strategy of Qin Shihuang
was revealed to his successor.[27]

The Han continued and developed the imperial ideology, and

employed to full effect the administrative and political tools acci-
dentally bequeathed to them. In some ways, the Han were the real
unifiers of China, with a more lasting impact, which is why books
on art, architecture and political history of the period tend to speak
of Qin–Han as a continuum. In the more laconic and sycophantic
summary of Sima Qian, 'Qin failed in goodness and the great leaders
rose to vex it.'[28] Yet this observation fits into a recognized pattern
in Chinese history, as Sima Qian would have been well aware.
K. C. Chang has shown how King Zhou (帝辛), the last ruler of the
Shang dynasty, was overthrown by the Zhou (周朝, names unrelated
in Chinese) 'when he incurred hatred for his despotic actions'.[29] The
founder of a new dynasty achieved merit in the eyes of his people
by overthrowing the old – just as Gaozu did in overthrowing the
Qin. Chang comments that 'political dynasties fell because the king
misbehaved and no longer deserved to rule'.[30] The Han historian
could have used the same words to describe King Wu, first of the
Zhou dynasty, and an earlier Jia Yi could also have found similar
faults in the later Shang kings.

For nearly a millennium the Qin had gradually risen to promin-
ence, and for 600 years had been dukes and then kings of an
independent territory in expansion – since Qin Zhuang had become
the first duke in 822 and built his capital at Quanqiu. They effectively
overthrew the Zhou, and created a new polity known as an empire
and the new figure of an emperor, which has been described as the
single most important contribution Qin Zhuang made to posterity.[31]
Naturally that generated resentment among his former fellow kings,
and his successors. In a succinct coinage, Lothar von Falkenhausen
has argued that the fall may have been due to what he describes as
'gigantomania' which had characterized them from the earliest times,
that 'arguably Qin had overextended itself by reaching beyond the
limits of the Zhou culture sphere that it had been its original aim to
rule'.[32] Looked at another way, the personality and obvious charisma
of the First Emperor meant that he himself did *not* overextend since
he was powerful enough to create and sustain the new empire and
embark on all his building projects. Xunzi wrote that the main task of
the true monarch was to 'cause the whole world, without exception,

to join him obediently and to follow him' in his thoughts and actions. Writing before the rebellion of Chen Sheng, he stated that 'If the world is not unified, and the feudal lords desire to rebel, then the man who holds the title is not a king appointed by Heaven.'[33] The problem was that the Second and Third Emperors were unable to assert themselves with charisma equal to that of their father, and were not in these terms kings 'appointed by Heaven'. Their subjects knew this.

Qin Shihuang was a hard act to follow, because his personality and what Yuri Pines has called in a recent book the 'Messianic' qualities and fervour of his imperial project required a truly extraordinary mind: 'The Qin's exceptional position in Chinese history derives neither from its culture nor from its institutions but from the very peculiar mindset of its leaders, most notably the First Emperor, who claimed to end history and demanded the literal realization of his theoretical omnipotence.'[34] Charles Sanft quotes an edict probably issued by the great Emperor Wu of Han to his son and heir around the year 74, suggesting that he find suitable advisers and treat the common people well. After a reign of fifty-four years, Wu was as aware as anyone of the difficulties inherent in following a powerful emperor and used the son of Qin Shihuang as an warning. The edict asserts that 'Huhai destroyed himself, ruined his reputation, and cut off his line.'[35]

In a sense, then, rather than a symbol of imperial success the Mausoleum and its Terracotta Army stand as a testament to hubris.

Magnificent, awe-inspiring, yet ultimately tragic.

EPILOGUE: FUTURE PROSPECTS

The accumulation of knowledge about the Mausoleum and the Terracotta Warriors will continue for many decades with evidence acquired from future excavations at the enlarged site and possible discoveries elsewhere, such as further bronze inscriptions or hoards of bamboo strips. New scientific techniques may yield fruitful and surprising results. But for the moment the very latest research allows us to bring our story to an end with a series of intriguing and original hypotheses.

The landscape of Xianyang and the plains beneath Mount Li must have been populated for decades by hundreds of artisan workshops of every kind, and temporary lodgings for workers such as those in the dormitory villages erected around modern building sites in China. As we have seen, one of the studies by the UCL/MSM team points out that the need to add elements such as scale armour, hair and facial features by hand to the bodies and moulded heads suggests that, from a logistical point of view, these processes would have been carried out in a cluster of workshops close to the pit where the finished product was to be placed.[1] Perhaps these workshops were systematically destroyed after the imperial burial just as some workmen were killed, to disguise the location of the site, or perhaps they were such simple structures that they just disintegrated with time. Useful tools and equipment may have been removed when work on the Mausoleum presumably stopped after the emperor's burial – and certainly after the end of the dynasty. This would have been a fairly simple bureaucratic task since all government tools were strictly controlled and branded; indeed, the Qin statutes indicate that the Overseer Responsible for Tools would be fined 'one shield' if

they were found not be branded.[2] We know that the Han scavenged and tomb-robbed in the vicinity. Any workshops that did survive, or any other buildings at all, would have been further destroyed by the purloining of useful building material by local people – as has happened with the Great Wall.

That poses the question of transport. How were raw materials, finished statues and other heavy objects such as wooden beams transported to their final destination? One of the most fascinating possible solutions to this conundrum is now being tested with a series of bore-holes which are being drilled as this book is being written in search of a road leading northwards from the site to the River Wei, just over five kilometres away as the crow flies.[3] This is exciting because river transport, for example of timber from forests in the west of the province and other building supplies, would be the most rapid and efficient. Traces of such a road, or of a now silted-up fluvial port, would open up a further significant field of research for the coming years, and confirm a hypothesis which fits perfectly into the studies of manufacturing processes and logistics for the Mausoleum.

In the event that such an access road existed, on the model of the imperial highways, with two-way traffic possible for chariots and large carts for transport of heavy items, any government factory or private workshop would clearly have sought a worksite as close to it as possible to simplify the transport of locally made or locally assembled products, in addition to materials brought from elsewhere. It is not insignificant that the probable site of the town of Liyi built to accommodate workers lies just 500 metres west of the shortest possible route from the mausoleum to the river (see Figure 7). The discovery of the precise route would facilitate the creation of a map of the manufacturing process by modern researchers, and suggest areas to be investigated in search of ancient workshops.

The ambitions of Qin Shihuang were of a new order, and we need to reimagine the whole to understand these details, to go beyond the overwhelming spectacle of the Army and Mausoleum to picture the broader context. For in this hypothesis the emperor sought to encapsulate both the story of his ancestors and his own prowess in a

single geographical location, as no one had attempted before. Until this immense tradition-respecting but also rule-breaking personality arrived, royal and imperial tombs were usually situated within the walls of a city, or at least within sight of the walls. We need to ask a simple question which is not often asked: why was the Mausoleum built on this particular site?

The history of the Zhou dynasty and the parallel rise of the Qin are deeply associated with this part of the valley of the River Wei in which the ancient Zhou capital at Fenghao, the major Qin capitals of Yueyang and Xianyang, and the Han capital of Chang'an are all situated. Mount Li, which as part of the Qinling Mountains bounds the valley to the south, in Grant Hardy's phrase 'represented both the beginning and the culmination of Qin's involvement with Chinese civilization'.[4] On the plains below, in 771 an important battle took place in which King You of Zhou died at the hands of 'western barbarians' known as the Quan Rong (or 'dog barbarians'), who had been enlisted by his father-in-law the Marquis of Shen to attack the capital when it seemed his grandson would be disinherited.[5] The exact site was at the foot of the mountains twelve kilometres to the west of the terracotta army, and about ten from the mausoleum, beneath a still-existing 'fire tower' or in Chinese 'burning place' (*feng huotai*, 烽火台) built to send signals to troops within a distance of around fifty kilometres on a clear night. The tower may be seen from the hot springs of Huaqing, which are on the tourist trail following the warriors and mausoleum.

King You's death in battle marked the beginning of the Qin ascendancy and was therefore an emotionally important moment in the story of the First Emperor's family. It also lends symbolic importance to the entire plain for twelve kilometres east and west of the mausoleum site.[6] The Zhou turned to the Qin for support and protection in a moment of crisis, requesting that Duke Xiang escort the dead king's son and heir Ping to his new capital in the east, Luoyang. In his chapter on the Zhou, Sima Qian specifically states that this was to 'remove themselves from the incursions of the Quan Rong'.[7] Zhou's western lands were formally assigned to the Qin, who began their rise to broader power from this plain. For now, in Sima

Qian's words in the 'Basic Annals of Qin', Duke Xiang had his own realm, which comprised the western part of the Zhou 'empire'. King Ping of Zhou said: 'The Rong have acted against all reason, invading and ravaging my lands of Qi and Feng. The Qin have attacked and repulsed the Rong, and shall have these lands.'[8] The duke marked this key moment by observing the correct rituals in sacrificing three red foals, three yellow oxen and three rams at a sacred altar in Gansu.

We should recall at this point the importance of divination and sacrifice for establishing or confirming the choice of site for a city or temple, and assume that some form of divination took place here when King Zheng assumed the throne of Qin and began to consider his burial place. As Donald Harper has noted, divination 'exemplifies the interface between magico-religious and naturalistic thinking in early China'. We have already seen within the mausoleum as described by Sima Qian that the First Emperor had fully accepted Warring States beliefs that, again in Harper's words, 'astral bodies were the celestial manifestations of divine entities'.[9] There was to be a magico-religious purpose to his mausoleum, emphasizing the virtues and merits of his ancestors. We know that Qin Shihuang valued maps and the power of physical geography. He gathered all existing maps together when he established his capital in Xianyang, in order to comprehend his new empire. Joseph Needham makes the intriguing observation that the fact that the rivers of mercury in his burial chamber ran in channels may imply the existence of a *relief map*. Wooden maps were also used, and Needham refers to a Han general two centuries later who used rice to model mountains and valleys and explain his strategies to his emperor.

Above what we may now see as a relief map was a reproduction of the cosmos. Ancient Chinese astronomy was based on the pole and the Pole Star, which corresponded to the position of the emperor on the earth. In the words of Confucius, 'He who exercises government by means of his virtue, may be compared to the north pole star, which keeps its place and all the stars turn towards it.'[10] Around this pole were the twenty-eight lunar mansions (宿 *xiu*), representing a graduated scale on which the movements of the moon could be measured. This number is thought to have represented in

turn a compromise between the full lunar cycle of 29.53 days and the sidereal month of 27.33 days (the time it takes for the moon to return to the same place among the stars);[11] the *xiu* are further divided into four equatorial palaces. Each of the mansions contains a group of stars, from a minimum of two to a maximum of twenty-two, and each is linked to a special meaning. To take one example, No. 5, 心 *xin*, Antares or Scorpio, has three stars and its meaning relates to the heart; it receives the visit of the sun in autumn, and is also associated with the spring. Eight of these *xiu* appear in the poems of the *Book of Odes*.[12] This system, dating from Shang times, is far too complex to be explained in detail here, but this brief review is enough to comprehend why the emperor wished to recreate the cosmic map on the ceiling of his burial chamber, and how his microcosm related to the greater macrocosm. A much later representation from Dunhuang, now in the British Museum, gives some idea of what may have been depicted on the ceiling.* In Needham's words, 'One has to think of them as segments of the celestial sphere (like segments of an orange) bounded by hour-cycles and named from constellations which provided determinative stars... and from which the number of degrees in each *xiu* could be counted.'[13]

Imperial ideas about the universe began with the North Pole, or more precisely from its closest visible manifestation, the Pole Star. Starting from that fixed point, the mapping of his territory was clearly one of the first priorities of the new emperor, who devoted an inordinate amount of time to his inspection tours. At a rough count the five tours absorbed between 25 and 30 per cent of his time as emperor, the final one alone lasting from 1 November 211 to his death the following September; Kern calculated the linear distance covered in 219–218 as having been over 5,000 kilometres, which he considered 'a bit too strenuous' even for Qin Shihuang,[14] while the actual distance travelled must have been much more. All this, and the thirteen recorded trips to Yong, to map out his empire. The work was continued in microcosm on the ceiling and on the relief map of the tomb chamber, but what about the land around the mausoleum

* Illustration 80 on List of Illustrations, p.xii.

and beyond? Surely a man so focused on lines, divination, maps and layout had strong ideas about how the Mausoleum area fitted within his macrocosmic scheme, especially given its historical importance for the Qin?

Now we have the first point on our new map: the model of the empire and cosmos under the north–south line of the Pole Star. Let us take the observations and detailed mapping of Zhang Weixing, and note with him – as the diviners would have done – that the centre alignment of the mausoleum on its north–south axis is perfectly coordinated to the south with the peak known as Wang Feng (望峰), one of many small peaks of Mount Li, which sits above what appears from below – from the south gate of the inner wall of the mausoleum – to resemble a huge armchair.*

We now have a north–south line with the centre of the mausoleum perfectly placed, and we know from further research that the area encompassed by the site is based on lines radiating from the centre of the mausoleum in the four directions of the compass for a distance of 3.75 kilometres, which when formed into a square makes the often quoted total area of 56.25 square kilometres. Now the main entrance to the mausoleum precinct is from the west, and as we have seen the warriors are located to its east and themselves face east. But the chariots awaiting the deceased emperor are on the west side of the mausoleum, facing west. So where would the emperor wish to go?

The answer is surprisingly obvious, although few seem to have noticed. For an extension westwards of the east–west axis brings us to the heart of the Qin imperial capital, Xianyang, and even more interestingly to the area containing the ancestral tombs of the great King Huiwen, who founded the capital, and his son King Wu (the same Wu, intriguingly, who died after lifting a bronze *ding* and whom Qin Shihuang probably admired for that feat), as well as the imperial palace of Yongmen Gong. Then, based on the research of Professor Zhang, although he does not take the final step,[15] comes the most astonishing hypothesis of all. Qin Shihuang not only mapped but

* Illustration 74 on List of Illustrations, p.xii.

literally *replicated* the entire history and power of his family past and his own empire in the plan for his Mausoleum, a tour de force of myth-making, symbolism, imperial power and *feng shui*.

Yet this raises the question, in an era and country when the lack of precision in maps was about as distant from the modern tradition of cartography as is possible, of what the emperor considered to be a map. Topographical detail was often distorted because the intention of the map was not to portray the terrain involved, but 'to transmit more a certain spatial idea or viewpoint than geographical facts', and to create a schematic representation such as is implied in dividing the empire into nine provinces and five zones.[16] This is a carefully structured world of symmetry and harmonious organization imposed on a rugged landscape, so that for example the emperor and in this case his mausoleum are placed in the central box of a diagram with nine equal squares – like one face of Rubik's cube. This is reflected in the ideal image of a hall deriving from the *Zhou li* and known as the *ming tang*.

It was much more than a matter of mapping a microcosm; rather it was a matter of creating one. Let us summarize by creating our own 'spatial idea' based on the facts we possess, as may be seen in Figure 13.

All geographical positioning, whether in such a simple structure or in a cartographic representation, requires two coordinates. The north–south axis in this case is easily understood, since the Wang Feng peak is an idea place to start, and because the north–south axis is fundamental to all ritual, imperial power and sacrifice. In fact, if this north axis is prolonged, it will reach the area of the penultimate Qin capital at Yueyang, which was mentioned earlier. It is true that the walled city as excavated lies slightly to the east of this line, but the tomb of the first Han emperor's father, named by his son the Grand Supreme Emperor, who died in the Palace of Yueyang in 196,[17] does lie on the axis, and the tomb of Duke Xiao of Qin, who resided in Yueyang before moving the capital west to Xianyang, is also found in the same area. That leaves a choice to be made for the east–west axis, and once again the tangible presence of the Qin capital at Xianyang allows us to see the reasoning behind the choice of the

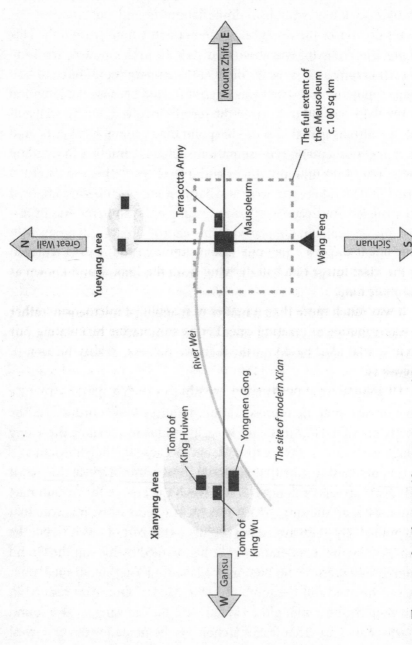

Figure 13. The geography of empire (diagram not to scale)

then young King Zhen. It also fits with the traditional axis of Qin tombs, east–west, as seen at Yong. Thus the prospect of excavation of the west gate is exciting.

To the south was Wang Feng, and to the north and west two areas sacred to Qin Shihuang's memory and the recent history of the Qin. There could be no other site for the positioning of his body at the exact centre of the mausoleum mound than the one he chose. It was absolutely ineluctable.

Thus the west gate, and a possible entrance road from the west, together with a bridge over the River Wei, assume immense importance. The imperial funeral procession could begin in the heart of Qin Xianyang, near the tombs of the emperor's recent ancestors – especially Huiwen, the first king of Qin, and proceed towards the site selected on the basis of the *feng shui* of mountain and water. The procession would enter the mausoleum through the west gate. The excavations of 2017–18 will be fascinating, because they hint at something even greater. The entire complex is already huge, but Professor Zhang believes that it was planned to be even larger. Rather than *only* fifty-six square kilometres, he believes the real dimensions include the entire area from the River Wei up to Mount Li, which means a total area of at least seventy square kilometres and perhaps a hundred square kilometres. His photograph taken looking north from the peak of Wang Feng provides an idea of the area stretching down to the River Wei, now much built over by villages and small factories.*

But the lines we have traced need not stop at Xianyang, since they incorporate the mountains and rivers of the imperial inspection tours. Further west on the line of the River Wei is Yong, and then Lintao in Gansu; further east, again tracing the route of the Wei and later the Yellow River which follows the same line, were the conquered lands of Qin Shihuang's rivals and the sea which marked his eastern border at Mount Zhifu – and which seems to have fascinated this man of the plains and steppes. In other words, the Mausoleum repeats the 'cosmo-magical' significance of a city, whence power

* Illustration 73 on List of Illustrations, p.xii.

generated at the axis mundi flowed out through its gates towards the cardinal points of the compass. Just as, in Paul Wheatley's words (Chapter 2), the size of the gates at Yong and other cities exceeded the dimensions necessary for their mundane task of providing access and guaranteeing defence, so too does the Mausoleum exceed the need to provide an adequate tomb for an emperor. It is conceived as a series of nestled microcosms and macrocosms which incorporate the 'all under heaven' of Qin Shihuang's vision. Gansu, Yong, Yueyang, Xianyang and Mount Li itself were the ancestral anchors which held the vast structure in place and conveyed its meaning. Thus the map of the skies on the ceiling, the rivers and mountains of what might be a relief map, assumed even greater significance. Power generated at the heart of the Mausoleum flowed out to control the empire, in the mind of the emperor for all future time.

If this hypothesis turns out to be anywhere near correct, then nothing in the entire world from ancient times to the present could compare with the audacity it implies.

Such vast ambition is consonant with everything we know about the First Emperor, and anticipates the schemes of future Chinese emperors. The mausoleum of the Emperor Taizong of the Tang dynasty, at Zhaoling just eighty kilometres north of Lintong, comprises the imperial tomb dug into a real mountain with nearly 200 satellite tombs around it covering a total area of more than 200 square kilometres. Although it was planned 800 years later, anyone who stands at the highest point just over 1,000 metres above sea level, looking down on the satellite tomb sites and across at mountain ranges stretching into the distance in every direction, will obtain an insight into the grandiosity of imperial vision – something which Qin Shihuang certainly did not lack. The choice of his own site indicates this; a hundred square kilometres confirm it.

The archaeologists I have spoken to believe that the alignments discussed above occurred 'by chance', that there was no such scheme in the First Emperor's mind. This is obviously a cautious, professional approach; yet they do not dismiss the idea out of hand. A close reading of the ancient texts, of the *Zhou li*, the *Annals* of Lu Büwei, the sacrifices, the continuous quest for the ideal capital, the thinking

behind the inspection tours, the description of the tomb by Sima Qian, all point to a complex man so imbued with a sense of the past and driven by his cosmological, geological and geographical notions that such a scheme rings true. He devoted his life to the Mausoleum as a base of everlasting power. Let's put it the other way round: should evidence emerge that there had been such a plan – a bamboo text or an inscription on a bronze vessel – no one would be surprised because all the facts would fit the reverse logic. Thus I believe that an imperial scheme is more than plausible, and that there was a broader ambition in an extraordinary mind which simply did not perceive the world as others did, and do. It's worth remembering that little more than half a century ago any rational expert would have scoffed at the notion of an unrecorded, buried army of up to 8,000 sculpted and painted terracotta warriors standing in battle formation or ceremonial order close to the imperial tomb.

On this view, the work carried out thus far is just the beginning and there is much more to be discovered. Perhaps, even more important, it is fascinating to imagine everything from a different perspective, with a little provocation. Let's try.

From the perspective of archaeologists, visitors and most of the books about the warrior–mausoleum complex (including this one), the story begins in 1974 with the chance discovery of terracotta figures and weapons from Pit 1. From that moment, digs and research have been carried out with the objective of *explaining* the presence of the warriors. Other pits were found, tombs were located near the mausoleum, ever increasing numbers of artefacts were unearthed and studied; the job required scientific collaboration which brought international research institutes into the picture. Newspaper editors are excited when beautiful bronze birds are found, visitors gasp when they see the imperial chariots and reconstructed warriors in full colour. Overseas exhibitions stun their audiences. Digs continue, reports are published and knowledge slowly accumulates. But the fundamental objective in the minds of most of the researchers is still *explaining* the raison d'être of the thousands of warriors. As journalistic cliché has it, the who, what, when, where and why.

Qin Shihuang did not need explanations, and from his perspective matters were wholly different. At the beginning of the project, in 247, he had just become King Zheng of Qin, and following the custom referred to above in the *Li Ji*, that when 'a ruler succeeds to his state, he makes his coffin', the young king immediately began – in consultation with the prime minister and regent, Lü Buwei, and his mother the Queen Dowager – to consider his eventual royal burial. Following ancient practices and rituals, he set out to locate the ideal site by means of divination, perhaps using the traditional tortoise shells. He looked back at the successes of his ancestors, visited Fenghao and Yueyang, travelled to offer sacrifice at the ancestral hall in Yong and studied the terrain of the Wei valley with astrologers, geographers, historians, map-makers and master-builders. It all began with the death of King You of Zhou, as he was intensely aware. He asked the astrologers how the site of Yueyang had been chosen, went to visit the still-extant old city and understood the geomantic reasons behind it when he saw the peak of Wang Feng one clear winter day. Half the task was completed. He rode south towards the mountain, and, after ordering diviners to trace the underground water sources and surface streams, chose the most auspicious site. Then, after studying the line of latitude which passed through the new capital and the garden precinct of the tomb of King Huiwen and King Wu, he of the cauldron, he understood that there could be no other place for his tomb. That was the key choice which conditioned all decisions in the future.

Next he conferred with Lü Buwei and the astrologers, and commissioned a group of literati and sages to study the *Rites* and Qin *Annals* and suggest appropriate plans as he had watched Lü Buwei do as a child. A profound scholar himself as he grew older, these discussions sometimes lasted for days at a time, changing as he grew into maturity and the role of king. It was to be a magnificent tomb equalling those of his ancestors without seeking to belittle them. He gained valuable practical experience preparing the mausoleum and attending the ceremony for his grandmother's burial when he was just nineteen years old in 240, and listened with interest to tales of the exotic western king whose armies had encroached on his own

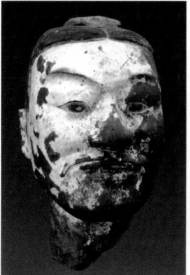

Above Coloured garment.

Left Coloured head from 2009–2001 excavations in Pit 1.

Below Coloured arm from 2009–2011 excavation in Pit 1.

The eye of a warrior from Pit 1, clearly showing painted eyebrow above and delicate black brushstrokes as eyelashes below.

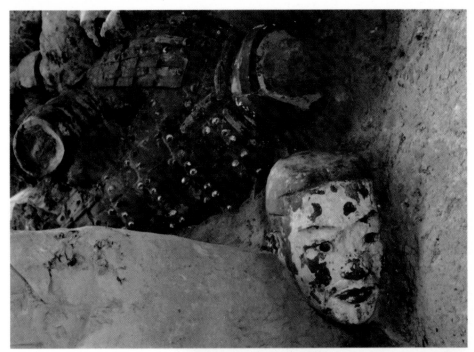

Warriors unearthed with
good colour conservation.

Head emerging from the soil
with traces of white and pink
pigment in good condition.

Restoration work on a spear and crossbow in the lab.

The funeral mound seen from the north, with the palace and prayer structures re-buried under the paving stones.

The enterance to Pit 9901.

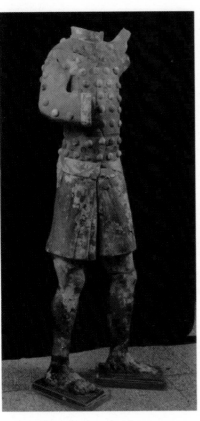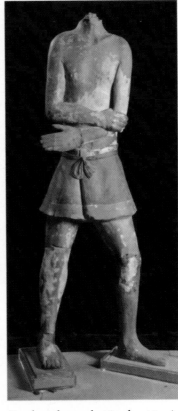

Wrestler/acrobat in armour. Greek-style acrobat in short tunic (front and side view).

Lead weights for training, with five blocks clearly visible in the top right-hand corner.

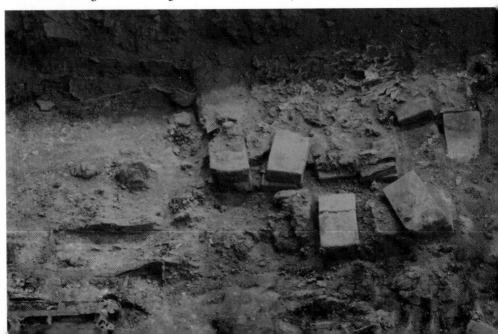

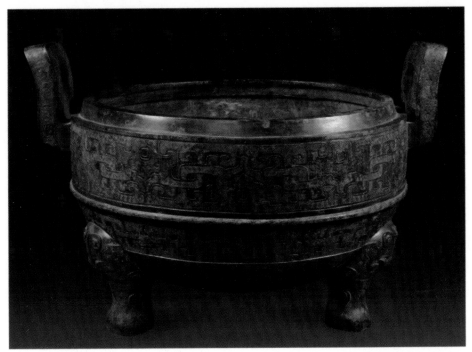

Ding from Pit K9901.

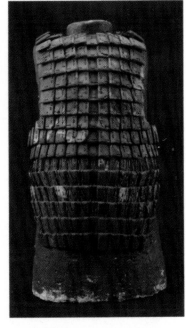

Reassembled armour
from Pit 9801.

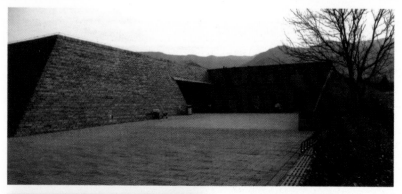

The entrance to Pit K0006.

Ritual mace head
from Pit K0006.

Charioteers in Pit K0006, with horse
skeletons in the pit beyond them.

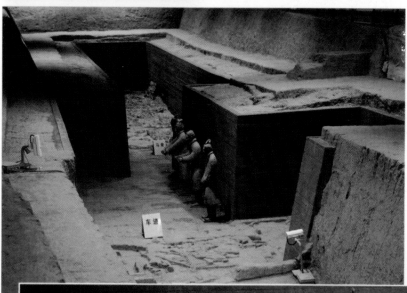

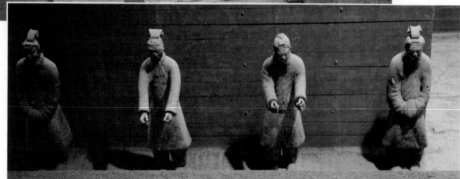

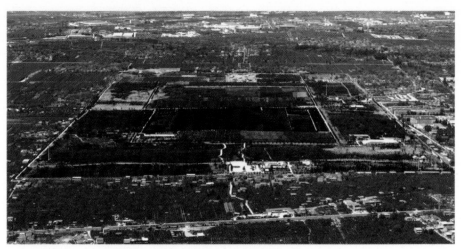

Looking down on the Mausoleum from Wang Feng peak.

Wang Feng peak on a misty morning, looking due south from the axis of the funerary mound and showing the natural 'armchair'.

Rack of replica *qins* (chimes) for musical entertainment, Duke Jing's tomb.

Original *qin* (chime), from the Shaanxi History Museum.

Above left Surviving wall of the South Gate of the inner precinct.

Above right Marble torso of a Greek man from Ai Khanoum, possibly the master of the gymnasium.

Dionysos and the twelve Olympian gods on a Hellenistic gilt plate found in Gansu Province.

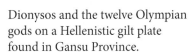

The Dunhuang star map of 700 AD.

lands. The process of planning, digging and building continued for the next twenty years, with regular visits and consultations whenever he returned to Xianyang after military campaigns and inspection tours.

Then, in 220, he became emperor. The inscriptions he left on the steles set up in the east tell us how conscious he was of this new status. After years of travel and battle, he now had to rethink the plans for his mausoleum. The vision was magnified. Once again he consulted the literati and sages, for the tomb of an emperor created new requirements, accompanied by access to almost infinite resources of materials and manpower. He studied the classics again, and discussed the matter this time with his new chancellor Li Si. He decided to build a full panoply of ministries around his tomb. The area of the plan was expanded, and it was decided that a secret army should be made of terracotta figures and added to the scheme to sustain his new power in the afterlife. Under this fresh impetus, thousands more families were transferred and new factories set up by artisans who had been working on the Xianyang and Epang palaces. On his inspection tours, as he performed and increased his knowledge of the ancient rites and sacrifices, new inspirations came – as in the case of the search for the lost cauldron . He requested regular reports on progress at the site, and visited every year in each of the four seasons, gradually expanding it to stretch from the River Wei to the foot of Mount Li. He micromanaged more than before, often studying and discussing the plans far into the night, removing something here, adding something there. He ordered Meng Tian to construct, again in secret, another short imperial 'straight road', in this case arrow-straight, from the palace in Xianyang to the burial site. This and the underground army were not to be mentioned in the dynastic *Annals*. Then, unfortunately, as the plans were finalized and work accelerated, he died in the east before they could be fully implemented.

The First Emperor thus left behind one of the greatest unfinished projects in history, which, in the light of this new hypothetical perspective, appears in a quite different light.

*

Let us bring the story to an end by imagining the funeral ceremony of the First Emperor on the basis of what we know and what we can deduce from the ancient writings on ritual and ceremony that he himself scrutinized. How big would it have been? Who would have participated? In what would it consist? In a conversation I had with Zhang Weixing beside the tumulus, he suggested that there were three possible sub-hypotheses: firstly, that there was just a quick ceremony, since Qin Shihuang had died in early September when the daytime temperature in northern China ranges from 25 to 30 degrees centigrade and bodily decay would have been rapid, so a ceremony might even have taken place far from the mausoleum; secondly, that there might have been a fairly small ceremony at the mausoleum, without pomp and pageantry, because the Second Emperor had come to power under suspicious circumstances and would not wish to antagonize the populace; and, thirdly, that following the ancestral traditions and Zhou rites there was a magnificent ceremony to demonstrate both the Second Emperor's respect for his father and the importance of his own new role. It seems to me that the third hypothesis is most likely, given the immense significance of ritual in ruling families and the significance of trumpeting the power of the Qin dynasty. Surely court officials would have feared diminishing in any way the honour and respect due to an emperor who they believed would live for ever, and whom they might meet in the afterlife?

Procedures and tasks for an imperial funeral in the period leading up to Qin success can be gleaned from studying the roles and duties of various court officials as laid out in the *Zhou li* – although there is no single specific section on funerals. But we can be certain that rites, rituals and ceremonies were at the core of the imperial court, and of all ancient Chinese life. Indeed it is striking how in relatively recent times – just a century ago – the funerals of ordinary people still imitated these ancient ceremonies in part, for example the placing of a coin in the mouth of the deceased in the ancestral hall, the use of a paper tablet or pouch to preserve the soul, and the playing of music as the coffin was lowered into the grave.[18] Since Qin Shihuang was always meticulous in his observation of ancestral ritual, and it

is likely that his premature death meant that no new rituals had yet been devised, the members of his court would have turned to age-old protocols. The rites and duration of mourning, for example, were in the Zhou dynasty carefully regulated, and we can imagine something similar here. In the *Li Ji* we read: 'When the son of Heaven died, three days afterwards, the officers of prayer were the first to assume mourning. In five days the heads of official departments did so; in seven days both males and females throughout the royal domain; and in three months all in the kingdom.'[19] An untimely death weeks of travel away may have influenced the scheduling of these events, but the rituals would have been substantially the same.

The first task was the ceremony of the preparation of the body, which took place in an antechamber of the Hall of the Ancestors. When the carriage arrived at the imperial palace from the east, the emperor's body was placed on a formal bed, known as the parade bed. The Under-Secretary for Sacred Ceremonies supervised this stage of the procedure. Now, the corpse was carefully washed under his supervision with ceremonial wine made from black millet in what was known as the 'small burial' ceremony. Next, the Under-Secretary led specially appointed senior officers and members of the imperial family into the hall for the 'great burial' ceremony, during which the emperor was dressed in his funerary attire. Following this ceremony the Under-Secretary affixed on the main gate, erected by the emperor's ancestor Duke Xiao in 349, a notice announcing the correct robes and headgear to be worn by those present during the mourning.[20]

At this stage, the Concierge of the Imperial Palace positioned torches outside the palace gate; in the case of an emperor this was to be 100 torches placed on the ground and kept alight throughout the period of the funeral and subsequent mourning.[21] Now the Under-Secretary made a formal obeisance and request to the princely heir to seal the vaults containing the terracotta warriors. He sent a small detachment of elite officers and senior court officials to carry out this task, and to arrange for the remaining workers to be killed and buried in a separate common grave.

At the court in Xianyang, officials had been hyperactive since the

corpse of the emperor arrived from the east. Astrologers had read the auguries and fixed the most auspicious time for the sepulture; rites had been performed in all the temples of the city and environs. The Director of Silk had elected the finest silks from the imperial stores and provided the tailors with rolls of material. This included silk thread for sewing, silk for padding, and blue and red silk for embroidering the funeral robes of the emperor.[22] Once the emperor was fully robed, the Head of the Jade Store, who had begun his work by preparing the specified jade for the imperial robes and the imperial belt, together with the pearls which were also used, continued the procedures. He applied jade plates to the imperial robe and belt, and then added three very special finely engraved pieces. These were the pillow block to support the emperor's neck in his coffin, a seven-angled spatula to support the jaws and teeth and therefore maintain the imposing form of the imperial head. Finally a smaller piece of engraved jade was placed in the emperor's mouth.[23]

All this was accompanied by music that the Grand Director of Music had prepared, after he had carefully assigned the players and their instruments to the appropriate places. These were the finest players of *qin* and flutes in the empire, making solemn music against a quiet background of bronze bells and distant drumbeats.

The Administrator of the Interior had the duty to ensure that the ladies of the court were dressed appropriately in the robes used for the occasion, and assigned them the correct position in the procession. Now his assistants led the empress through the ceremony, ensuring that all was done in the proper way, with the ladies of the court followed by Nine Ladies of the Second Degree. Behind them, eunuchs led the concubines and ladies of the household.[24]

When the Chooser of Colours had taken the robes and headgear of the deceased emperor to the Hall of Ancestors, where they must remain, and had summoned the imperial soul thence, the funeral cortège was ready to depart for the mausoleum.[25] At dawn on the appointed day, the draped coffin was placed in a carriage larger than but similar to the covered half-sized model found in his mausoleum, and the carriage was led by the Grand Director of the Multitudes out of the imperial palace through the east gate along a new highway

prepared by Meng Tian which had been brushed and scented over-
night. Elegant six-horse bronze carriages bearing the emperor's sons
and the empress, together with high officials, followed at walking
pace. The total imperial cavalcade was formed by eighty-one smaller
carriages. Crowds watched silently as they passed, overseen by the
assistants of the Grand Director of the Multitudes, whose task was to
lead the multitude of the six interior districts. A thousand cavalry and
grand noblemen of the court rode along the south bank of the river
to receive the procession when it crossed the bridge over the Wei:
the imperial carriage with the emperor's coffin, the empress and the
princes, high officials and gentlemen of the court, ladies, concubines
and senior members of the household, officials of the government of
the capital and governors of all the cities in the empire. They drove
through the west gate into the mausoleum precinct.

In front of the entrance to the unfinished tomb a large marquee
with yellow awnings had been prepared by the Master of the Marquee,
who had chosen the style and colour of the marquee and erected
it the day before. The awnings flapped in the early-winter breeze
of a fine sunny morning; as the procession halted, only birdsong
could be heard – and the distant hoof-falls of those still on their
way. Beneath a canopy with three thicknesses of the best silk stood
an elaborately carved dais appropriate for an emperor.[26] When the
coffin had been gently lowered onto the dais, the Under-Secretary for
Sacred Ceremonies entered the scene again. Together with specially
appointed senior officers and court astrologers he carried out a
formal inspection of the burial chamber. He presented the articles
which were to be placed in the tomb, and immediately burst into
tears for the deceased as he began to recite auguries for the correct
placing of the coffin.[27]

The final preparations were made. The Controller of Aromatic
Plants, who was responsible for the vessels used for libations, now
prepared the correct vases for the ceremony of interment. The princes
and great officers of the empire were ranged according to rank and
name for hours of ritual wailing. They drank libations of ceremonial
wine to their deceased emperor as a last farewell while ceremonial
music was played under the direction of the Master of Music.[28] Later,

in a long but moving funeral elegy heard in total silence, the Grand Historian recited the great deeds of the deceased emperor, from his coronation as King Zheng of Qin to his unification of the empire. Soft, bass bells and *qins* performed a dirge when he had finished.[29]

The imperial coffin was then lowered into the tomb as more solemn music was played, once again with bells, drums, flutes and *qins*. When it was laid to rest, the Grand Director of Music together with the Master of Organs and Pipes formally presented to the emperor the instruments which had been used, and placed them in a reception room of the tomb near to the coffin so that they were ready for use in the afterlife.[30] The Under-Secretary for Sacred Ceremonies then supervised the final operations.

No one was allowed to watch as the tomb was sealed. When a deep roll of drums sounded to indicate that the process had been completed, the main procession turned and moved westwards towards the capital; ideally, the imperial guard marched east around the funerary mound to take up station in the rows we see in Pits 1, 2 and 3. A small number of workers remained to complete the task of covering the open part of the mausoleum, after which they were themselves interred under the supervision of the Under-Secretary for Sacred Ceremonies who now stood alone with a few members of his staff. A thousand shaven-headed convict labourers began to break up the road, and a hundred carts loaded with trees to plant over it were driven up to the mausoleum from the river where they had been landed from barges towed downstream from Yong.

The occasion was sombre, but it must also have been magnificent amid those mountains. The discovery of the road would be the perfect preliminary to opening up the mausoleum that was sealed the last time it was used over 2,000 years ago.

NOTES

1 This is one key point regarding the Mausoleum on which translators and interpretations diverge. Burton Watson has 'They dug down to the third layer of underground springs' (*Qin Dynasty*, p. 63), while Nienhauser has 'They dug through three [strata] of springs' (*The Grand Scribe's Records*, vol. I, p. 155). Chavannes first translated the same phrase as 'on creusa le sol jusqu'à l'eau' ('they dug down to the water level'), but later corrected himself in a note in which he quotes the Dutch sinologist Jan Jakob Maria de Groot in his *Religious System of China* (1910) as translating the phrase as 'they excavated the ground underneath three wells of groundwater' and in another place as 'they dug up three wells of groundwater'. He then cites an ancient text, a Commentary on the *Hou Hanshu*, 後漢書, to explain that the original Chinese expression 'three springs' actually means just 'deep' since 'three is the smallest number which expresses a complete set' (Chavannes, *Les Mémoires historiques*, vol. II, p. 66, and note 418 on p. 292). This might sound trivial, but it makes an important difference to the explanation of the mausoleum in Chapter 9 below; to a non-reader of classical Chinese it just seems to make more sense.

2 Translated by the author from the French of Édouard Chavannes, *Les Mémoires historiques*, vol. II, p. 66. Most references to Sima Qian on the Qin dynasty and some on the Han dynasty will be from this edition, giving only the volume number and page number in this form: Sima Qian, II, p. 66; where another edition is used, it will be specified. The role of court astrologer seems to have combined various functions in Han times, which is why Sima Qian is variously described as astrologer, scribe and historian. He inherited the post from his father, Sima Tan.

3 Segalen had been a keen photographer since his youth, and had a darkroom in the attic of his family home in Brest as early as the 1890s. In

a letter to his father from his school in Rennes written on 13 March 1896 he mentions the darkroom ('mon laboratoire de la mansarde'), and adds that he looks forward to continuing his photographic experiences in the coming holiday. Segalen, *Correspondance I*, p. 65.

4 Segalen, 'Premier Exposé', p. 971.

5 Letter written to Yvonne Segalen, 16 February 1914 (in Segalen, *Correspondance II*, p. 310).

6 The article was entitled 'A Group of Funerary Warrior Statues of Qin Times Found at the Tomb of Qin Shihuang' and published in an internal supplement of the official newspaper *People's Daily* ('Case Reviews', No. 2396).

7 This account is based on a long conversation with Yuan Zhongyi at his home on 26 April 2017.

8 The translation of a short, illustrated book – just 150 pages of less dense text – was published in the US by a small firm in New Jersey mainly specializing in Chinese books (Yuan, *China's Terracotta Army*).

9 See the summary in Pines et al., *Birth of an Empire*, pp. 9–10.

CHAPTER 1: WARRIOR CHU

1 This photo was taken by the author in the Shaanxi History Museum in Xi'an, which permits to the public closer access than is possible in the Mausoleum Site Museum itself.

2 This was the year in which Qin Shihuang's father Zhuangxiang became king of Qin; his personal name was Zichu, since his adoptive mother was of Chu origin.

3 Modern Xinzheng, near the present-day provincial capital Zhengzhou.

CHAPTER 2: THE ANCESTORS OF QIN SHIHUANG

1 The year 1045 is used in Loewe and Shaughnessy's *Cambridge History of Ancient China*; 1046 was established by the China-based Xia-Shang-Zhou Chronology Project, published in 2000, and is used in China as the standard date. Other dates have also been suggested, but given the slight difference here the period is clear. There are more dramatic differences in the dates of individual rulers.

2 Numbers vary according to author, but there is no doubt that the number of 'states', often no larger than a city with its surrounding land or a valley,

dropped from several thousand at the beginning of the Shang dynasty to a handful at the end of the Warring States – the seven named here plus others outside the ex-Shang/Zhou lands. K. C. Chang cites a well-known seventeenth-century Chinese source which gives 1,800 at the beginning of the Zhou, 1,200 when the Zhou moved east in 771 and just over 100 at the end of the Spring and Autumn period in 481. Of the last number, 'only fourteen were considered major states' (Chang, *Art, Myth, and Ritual*, p. 27). Some examples of the 'minor' states will appear below, for example Xiao in Anhui Province and Xian in Hubei Province, together with Ba and Shu in present-day Sichuan.

3 This was the Changping in the extreme south-east of Shanxi Province, part of modern Gaoping, not the better-known one to the north-west of Beijing.

4 Sima Qian, I, p. 10.

5 Zhao, 'New Explorations of Early Qin Culture', p. 53.

6 Sima Qian, II, p. 6.

7 Zhao, 'New Explorations of Early Qin Culture', p. 63.

8 This is based on the research by Xiu Weimin, historian and former director of the Mausoleum Site Museum, in a short but dense book which remains a key text on the successive Qin capitals, 秦俑· 秦文化丛书 秦都城研究 (*Study on Terracotta Warriors*).

9 In ancient China there were five ranks of nobility, given in the *Li Ji* (*Book of Rites*) and traditionally translated in descending order as duke, marquis, earl, count and baron. Nowadays these old-fashioned titles are sometimes not used, and in the most recent scholarly overview of Qin studies the editors argue that since the titles in pre-imperial times were fluid they will use only 'lord', or *gong*, except for rulers who deliberately adopted the rank of 'king', or *wang* (Pines et al., *Birth of an Empire*, p. xi). As so many texts, museums and exhibition catalogues use 'duke' and 'king', this book will follow that practice. I think it's also useful to distinguish between ducal rulers and well-known names like Lord Shang, who was not a ruler. As Edwin Pulleyblank has explained in a scholarly article, this was not a feudal enfeoffment as might have been the case in medieval Europe since the Zhou political organization was patrimonial rather than feudal. It did not entail a contract with mutual obligations like that between a lord and his vassal, but was a more straightforward 'delegation by the Zhou king of

responsibility for defending the Zhou patrimony' (Pulleybank, 'Ji 姬 and Jiang 姜', p. 7).

10 Eric Teichmann, *Travels of a Consular Officer in North-West China*, Cambridge: Cambridge University Press, 1921, p. 47.

11 Xu, *Study on Terracotta Warriors*, pp. 64–5.

12 Tian, 'A Study of the Layout of the Yongchen Capital Site of the Qin State', p. 64.

13 According to the *Zhou li*, there were two levels of animal sacrifice: cows/oxen for those of the first level, and goats or sheep for the second level. Note to Biot, *Le Tcheou-Li*, Part I, Book II, p. 30.

14 Sima Qian, I, p. 27.

15 Ibid., II, pp. 9–10.

16 Ibid., V, p. 107 (Chapter XLVII, 'Biography of Confucius').

17 Slightly edited for simplicity from Wheatley, *The Pivot of the Four Quarters*, pp. 459–60.

18 Xu, *Study on Terracotta Warriors*, p. 71, and in conversation.

19 Tian, 'A Study of the Layout of the Yongchen Capital Site of the Qin State', p. 63.

20 Wheatley, *The Pivot of the Four Quarters*, p. 435.

21 Keightley, 'The Shang: China's First Historical Dynasty', pp. 266–8.

22 She was one of about sixty wives of King Wu Ding and died around 1250. Her tomb was discovered intact in 1976 in his capital city of Yin, now part of Anyang in the north-west of Henan Province.

23 Duke Wu (Chavannes uses the form 'le duc Ou'), in Sima Qian, II, p. 9; Duke Mu, in Sima Qian, II, p. 19.

24 Legge, *The She King*, Part IV, Book I, v, p. 359.

25 The interview was provided by You Fuxiang, deputy research librarian of archaeology. It was published in Chinese on the official social media account of the National Museum of China, at http://mp.weixin.qq.com/s/ TMqlb1WMSQ8r7LabTYgNZw.

26 Biot, *Le Tcheou-Li*, Part I, Book XXI, pp. 20–6.

27 These details were communicated to the author in person by the director of the museum, Jing Hongwei, during visits to the Yong site.

28 Personal communication.

29 Sima Qian, II, p. 38. Here Chavannes translates the formal headware as 'chapeau viril'; elsewhere he calls it the 'bonnet viril' (for example, Sima

Qian, II, p. 27 and V, p. 12). Burton Watson calls it 'the cap of manhood' (*Qin Dynasty*, p. 37). Nienhauser translates the phrase as 'the king was capped and put on a sword' (*The Grand Scribe's Records*, vol. I, p. 130).

30 Hardy, 'Capping Ritual', p. 75.

31 There was an equivalent 'pinning' ceremony for girls. Although less is known about it, this entailed pinning an adult's hairpin on the girl's head just as the male ceremony involved the placing of a cap, or adult headdress, on the head of the initiate.

32 Legge, *The Lî Kî*, XI–XLVI, Book XL, p. 427.

33 Sima Qian, II, p. 24.

34 Information from the website of the Institute of Archaeology, Chinese Academy of Social Sciences, 2 November 2015: http://www.kaogu.cn/en/News/New_discoveries/2015/1102/51873.html.

35 *Xinhua*, 17 January 2017.

36 Wu, 'The Art and Architecture of the Warring States Period', p. 673.

37 In the original: 'cela prouve assez clairement qu'à leurs yeux le personnage poétique appelé empereur était à Lo-yang; mais que l'autorité se trouvait avec Hiao-kong à Hien-yang'. Tschepe, *Histoire du Royaume de Ts'in*, p. 123. This provides a good example of the changes in transliteration.

38 Duyvendak, *The Book of Lord Shang*, Paragraph 3, p. 185.

39 Ibid., p. 207.

40 Liao, *Han Feizi*, Chapter VII, 'The Two Handles'; Marquis Zhao ruled from 362 to 333. The *Hanfeizi* (formerly transliterated as Han Fei Tzu) in Liao's good and very readable translation can be read online in a bilingual version at http://www2.iath.virginia.edu:8080/exist/cocoon/xwomen/texts/hanfei/tpage/tocc/bilingual. Pages are not numbered, but many of the chapters consist of a single page.

41 Ibid.

42 Hulsewé, *Remnants of Ch'in Law*, A 7, p. 26.

43 Ibid., D 53, p. 6. It's interesting to note that Hulsewé was the product of a great and direct line of Dutch sinologists, since he had studied at Leiden with Duyvendak, who had himself studied there with de Groot (before moving to the Collège de France and advanced studies with Chavannes).

44 Ibid., D 53, p. 138.

45 Ibid., D 83, p. 146.

46 Lewis, *The Early Chinese Empires*, p. 49.

47 Duyvendak, *The Book of Lord Shang*, pp. 17–19. I use this translation of Sima Qian's biography of Lord Shang, which Duyvendak gave in full in his introduction to *The Book*, as his notes are very full and useful. I have just amended Ch'in to Qin.

48 Legge, *Mencius*, Book I, 'King Hwuy of Leang', Part I, VI, 2, p. 12 (in pinyin, this name becomes King Hui; Leang/Liang was an alternative name for the state of Wei under King Hui).

CHAPTER 3: FROM PROVINCIAL KINGS TO UNIVERSAL EMPEROR

1 Torday, *Mounted Archers*, p. 27.

2 Di Cosmo, *Ancient China and its Enemies*, p. 129.

3 Watson, *Han Dynasty II*, pp. 129–62.

4 Lattimore, 'Origins of the Great Wall of China', p. 108.

5 Sage, *Ancient Sichuan*, pp. 107–15.

6 Ibid., pp. 108–10; Sage uses the phrase 'Stone Cattle Road'.

7 Wiens, 'The Shu Tao', p. 585.

8 Waley used the archaic spelling 'Szechwan Road'. Waley, *The Poet Li Po, AD 701–762*, East and West, 1919, p. 20.

9 Blakely, 'The Geography of Chu', p. 18.

10 Sage, *Ancient Sichuan*, p. 115.

11 *Hua yang guo zhi*, cited in Sage, ibid., p. 127. Now of course Chengdu is much larger than Xianyang, and even Xi'an.

12 Knoblock, *Xunzi*, vol. II, 'On Strengthening the State', p. 246.

13 Sima Qian, III, p. 17.

14 Bonsall, 'Records', vol. III, Ch'in 1, §1 (p. 14). This work, in Chinese the *Zhan Guo Ce* (戰國策), may be read in English in an unpublished version by the Methodist missionary Bramwell Seaton Bonsall (c.1890–1960), who after fifteen years of work and study in China returned home in 1926 and obtained a doctorate from the University of London for the translation. He also made a complete, but unpublished, translation of the great Chinese novel *A Dream of Red Mansions* which reads very well.

15 Chen, 兵马俑真相 标准书 (*The Truth of the Terracotta Warriors*).

16 Quoted from Crump, *Legends of the Warring States*, p. 115.

17 Rang is now known as Dengxian, in the extreme south-west of Henan; Tao is now Dingtao in the south-west of Shandong, close to the border with Henan.

18 Now called Xindeng.

19 Watson, *Qin Dynasty*, p. 119.

20 Sima Qian, II, p. 31.

21 There were rumours that both had been poisoned by Lü Buwei to pave the way for Zheng's accession to the throne.

22 For clarity and consistency, the names of states and places in this paragraph have been changed to the modern pinyin form. We have seen the conquest of the Shu, in Sichuan. Ba (Pa in Bonsall) was a smaller ancient state in the east of Sichuan, in the Chongqing area, and came under Qin control after the conquest of the Shu in 316 BC.

23 I believe the phrase 'badgers of Hu' refers to horse-traders, in the sense of 'itinerant licensed dealers' pestering their clients (for badger the OED gives: 'sb. cadger, hawker or hustler' and 'v. 2., to beat down in price'; the date given for usage of the latter is 1875, not far distant from Bonsall's birth). The Tai were also a nomadic people who traded in horses; they lived near modern Datong in the north of Shanxi Province.

24 The Wu Mountains (Mt Wu in Bonsall) straddle the Wu Gorge, one of the famous Three Gorges on the Yangtze River – on the southern border of Sichuan; Qianzhong (Chien-chung in Bonsall) was the name of an area south-west of Chongqing near the point at which the modern provinces of Sichuan, Hubei and Guizhou meet.

25 Xiao and Xian (Hsiao and Hsien in Bonsall) were minor states in Anhui and Hubei provinces respectively.

26 Bonsall, 'Records', vol. III, Ch'in 1, §1 (p. 14).

27 Ibid.

28 Crump, *Legends of the Warring States*, p. 51.

29 Knoblock and Riegel, *Annals of Lü Buwei*, 12/5.4, p. 270.

30 The suffix 'zi' (子) is an honorific meaning 'master', hence Xunzi, Master Xun, Han Feizi, Master Han Fei, and also in Chinese Kongzi, Master Kong, which was Latinized as Confucius in early translations, as was the name Mengzi as Mencius; in the past this suffix was rendered 'tzu', hence Sun Tzu, Master Sun, whose name in pinyin is Sunzi.

31 Now a small town south-east of modern Luohe, close to the major road from Zhengzhou to Wuhan that follows an ancient route into the heart of Chu territory in Hunan where the River Han joins the Yangtze. Shangcai

was previously the seat of a small independent state called Cai which was overthrown by the Chu in 447.

32 Watson, *Qin Dynasty*, p. 179; the chapter from which this is quoted, No. 87, 'The Biography of Li Si', was not translated by Chavannes.

33 Bonsall, 'Records', vol. III, Ch'in V, §5, p. 54.

34 Bodde, *Statesman, Patriot*, p. 68. In his well-known *Ancient History of China*, p. 327, Friedrich Hirth wrote that 'If among the intimates of the court of Ts'in there had been the merest shadow of a doubt as to his paternity, the young king would certainly not have been imprudent enough to invent for his prime minister just this title [i.e. Chung-fu, 'Second Father'], nor would Lü Pu-weï have had any interest in inducing him to bestow it.'

35 Knoblock and Riegel, *Annals of Lü Buwei*, Introduction, p. 11.

36 Cervera Jiménez, 'Qin Shihuang', p. 538.

37 Knoblock and Riegel, *Annals of Lü Buwei*, 3/1.4, pp. 96–7.

38 Sima Qian, II, p. 40. Chavannes uses 'oiseau de proie' and 'chacal'; Burton Watson uses 'hawk' and 'jackal' (*Qin Dynasty*, pp. 38–9); Crump, in his introduction to *Wei Liao-tzu*, uses 'vulture' and 'jackal' (*Legends of the Warring States*, p. 231). All these variants render the idea of his personality effectively.

39 Crump, *Legends of the Warring States*, p. 210.

40 Knoblock, *Xunzi*, vol. II, pp. 246–7.

41 Giles, *Sun Tzu*, Book III, 'Attack by Stratagem', §1, p. 17.

42 Chang, *The Rise of the Chinese Empire*, p. 38.

43 Eno, *The Confucian Creation of Heaven*, p. 23.

44 Legge, *Mencius*, 'Jin Xi', Part II, XXI, 2, p. 335.

45 This relationship between heaven and man is visually manifest in the word for king, or ruler: *wáng*. Three simple steps provide an insight into Chinese culture: first, the character for *wáng* consists of three horizontal lines representing heaven, man and earth, connected by a single vertical stroke to signify the person who forms the link downwards from heaven to earth: 王; secondly, the character for jade, *yù*, is the same as that for king with a single stroke added to differentiate it from *wáng*: 玉, which also explains the significance of jade in the Chinese mind (as is explained in Chapter 5); thirdly, the simplified character for country, *guó* (as in Zhōngguó), consists of a box meaning boundary or land, with the character for jade – representing the king or ruler – inside the box: 国. Thus

the political theory of kingship is encapsulated in the written script, and is integral to language and culture as in no other civilization. It is also integral to the name the Chinese use today for their country, Zhōngguó, a later adaptation of the Zhōng-yuan, or Central Plain (where 'zhōng' means 'centre' or 'middle'), of the Zhou lands. Thus the centrality and the link to heaven inform the name: 中国, traditionally translated as 'Middle Kingdom'. It could therefore be clumsily, but more appropriately, translated as 'the central civilizational area which is ruled by a king mandated by Heaven'. The realm of this king was *tianxia*, the 'all under heaven', or in other words the universe.

CHAPTER 4: CREATION OF THE TEMPORAL EMPIRE

1 To enhance his own status and announce his superiority to other kings, Qin Shihuang took the word *huáng* ('August Ones'), which was used to describe the legendary *san huáng* ('Three August Ones') said to have ruled at the dawn of Chinese history: Fuxi, Shennong and Huangdi. Each of these mythical figures played an important role in ancient Chinese culture: Fuxi was said to have taught his subjects to hunt, fish and tend animals; Shennong is said to have invented agricultural tools and to have discovered the medicinal properties of many plants; Huangdi was the Yellow Emperor. He then added to *huáng* the word *di* ('God-kings') from the equally legendary Wudì ('Five Emperors' or 'Five God-kings'). Thus he cleverly amalgamated both sources of ancient Chinese culture to enhance the legitimacy of his rule, combining 'Three August Ones' (三皇) and 'Five Emperors' (五帝) by taking the second character of each phrase to create the single title Huángdì (皇帝), which has always been translated into English as 'emperor'.

2 Watson, *Qin Dynasty*, 'The Biography of Li Si', p. 180.

3 Their grandfather Meng Ao became the chief minister to the emperor's grandfather King Zhaoxiang, and a general to his successor King Zhuan-xiang – contributing famous victories in the wars of subjugation of the Warring States. Their own father Meng Wu was also a general in the royal army, who two years before Qin Shihuang made himself emperor led it against the Chu and not only defeated them but captured their king.

4 Watson, *Qin Dynasty*, 'The Biography of Meng Tian', p. 208.

5 Di Cosmo, *Ancient China and its Enemies*, p. 142.

6 Ibid., pp. 145–6.

7 Geil, *The Great Wall*, p. 118. I have substituted 'Qin' for the 'Chin' used by Geil.

8 Ibid., p. 121.

9 This was also known as the 'Straight Road', on a route that can still be followed north from Xi'an through Tongchuan and Yan'an as Road G65W.

10 Watson, *Han Dynasty II*, p. 133.

11 Lovell, *The Great Wall*, p. 53.

12 Legge, *The She King*, Part II, Book V, ix, p. 243. I've changed Legge's 'Chow' to the pinyin 'Zhou'.

13 Biot, *Le Tcheou-Li*, Part I, Book XV, pp. 341–2.

14 Translation from Needham, Wang and Lu, *Science and Civilisation*, vol. IV, Part III, p. 28; the Warring States mentioned have been modified to their pinyin forms.

15 Sima Qian, II, p. 58.

16 Sanft, *Communication and Cooperation*, p. 114.

17 Ibid., p. 121.

18 Legge, *The Lî Kî*, I–X, Book III, 13–14, pp. 216–18.

19 Legge adds in a footnote that 'poems' here includes songs and ballads, hence also popular music (ibid., p. 216).

20 See Sima Qian, I, 'Basic Annals of the Xia', pp. 27–31. This is based on an account in the *Zhou Li*. Chavannes observes in his notes that in Legge's version 'cutting down the trees makes more sense' to a European, but does not amend his translation as 'et fit de marques sur les arbres' since he takes it to mean marking the route. See ibid., p. 125 n. 114.

21 This palace was also the place of death of King Wuling of Zhao, mentioned above for his innovations in cavalry warfare.

22 According to Chavannes, seven reproductions were made, of which this is the best one (Chavannes, 'Les Inscriptions des Ts'in', p. 486).

23 Chavannes, *Le T'ai Chan*, p. 3.

24 Sima Qian, III, p. 225.

25 Lewis, 'The *Feng* and *Shan* Sacrifices', p. 50.

26 'Le T'ai chan est le Pic de l'Est; il préside, en cette qualité, à l'Orient, c'est-à-dire à l'origine de toute vie. De même que le soleil, ainsi toute existence commence du côté de l'Est.' Chavannes, *Le T'ai Chan*, p. 12.

27 Kern, *The Stele Inscriptions*, p. 119.

28 Sima Qian, II, p. 48.

29 Ibid., p. 50.

30 Sanft, *Communication and Cooperation*, p. 80.

31 Recounted in Sima Qian, II, pp. 51–2.

32 Sima Qian tells this story in the 'Feng and Shan Sacrifice' chapter (III, p. 245).

33 Sanft, *Communication and Cooperation*, p. 82.

34 Sima Qian, III, p. 227.

35 Kern, *The Stele Inscriptions*, p. 109.

36 Edward Gibbon, *The History of the Decline and Fall of the Roman Empire*, ed. J. B. Bury, London: Methuen, vol. I, 1897, p. 50. Bury notes that 4,080 Roman miles were equivalent to 3,740 English miles.

37 Watson, *Han Dynasty II*, p. 54.

38 Sima Qian, II, p. 46.

39 Lewis, *Early Chinese Empires*, p. 89.

40 Wheatley, *The Pivot of the Four Quarters*, p. 464.

41 Description based on that of the architectural historian Liu Xujie in Steinhardt, *Chinese Architecture*, p. 39.

42 Sima Qian, II, pp. 58–9.

43 Quoted by Steinhardt, *Chinese Architecture*, p. 40.

44 Harper, 'Warring States Natural Philosophy and Occult Thought', p. 831.

45 Sima Qian, II, p. 59.

46 Translation online at http://www.lcwangpress.com/essays/e-pang-palace.html.

47 Wu, *Monumentality*, p. 108.

48 Sima Qian, II, p. 58.

49 Liao, *Han Feizi*, Chapter XIV, 'Ministers Apt to Betray, Molest, or Murder the Ruler'.

50 Ibid., Chapter XIII. The translator notes that this episode does not appear in other documents, such as Sima Qian's *Records*.

51 Legge, *Chinese Classics*, vol. I, p. 10 (I've substituted Qin for Ts'in).

52 Kern, *The Stele Inscriptions*, p. 15.

53 Ibid., p. 17 n. 18.

54 Sima Qian wrote a short biography of Shusun Tong, translated in Watson, *Han Dynasty I*, pp. 240–6; Kern provides further information in *The Stele Inscriptions*, pp. 184–7.

55 Kern, *The Stele Inscriptions*, p. 49.

CHAPTER 5: WHAT KIND OF IMMORTALITY
DID QIN SHIHUANG EXPECT?

1 Granet, *La pensée chinoise*, p. 419 ('La Sainteté, pour les Néo-taoïstes, c'est essentiellement l'art de ne point mourir').

2 Buck, 'Three Han Dynasty Tombs', p. 34.

3 Needham et al, *Science and Civilisation*, vol. V, Part III, p. 304.

4 Liao, *Han Feizi*, Chapter XXXII, 'The Outer Congeries of Sayings'.

5 Needham and Lu, *Science and Civilisation*, vol. V, Part II, p. 95.

6 King Wei and King Xuan of Qi (ruled 378–343 and 342–324), and King Zhao of Yan (311–279); Sima Qian, III, p. 227.

7 Sima Qian, III, p. 258.

8 Unschuld, *Medicine in China*, pp. 122–3.

9 Harper, 'Warring States Natural Philosophy and Occult Thought', p. 827.

10 Sima Qian, II, pp. 53–4.

11 Laufer, *Jade*, p. 24.

12 Legge, *The Lî Kî*, XI–XLVI, Book XI, I.1. p. 1.

13 Ibid., Section III, p. 19.

14 Biot, *Le Tcheou-Li*, Part I, Book VI, p. 125.

15 Ibid., Book XX, p. 492.

16 De Groot, *The Religious System of China*, vol. I, Book 1, pp. 271–3; vol. II, Book 1, p. 395.

17 Biot, *Le Tcheou-Li*, Part. I, Book XX, pp. 483–90.

18 Laufer, *Jade*, p. 122.

19 'Mercury (Hg) occurs as the pure elemental substance (e.g., liquid mercury), as inorganic mercury in ores such as cinnabar (HgS, mercuric sulfide) and calomel (Hg_2 Cl_2, mercurous chloride), and additionally in compounds such as mercuric chloride ($HgCl_2$) and mercuric acetate.' From Masur, 'A Review of the Use of Mercury in Historic and Current Ritualistic and Spiritual Practices', p. 314.

20 Personal communication, 23 February 2017.

CHAPTER 6: WHAT IS THE MAUSOLEUM?

1 The excavation dates given here and throughout this volume are based on conversations with the current director of archaeology at the Terracotta

Army Museum, Professor Zhang Weixing, and the chronological tables in his 2016 book 礼仪与秩序 (*Ritual and Order*), pp. 23-7.

2 Preliminary results were published in *Wenwu Cultural Relics* in 2015 (Xu et al., 'The Excavation of the Terracotta Army Pit No. 1'); the detailed report was published in early 2017 (Xu and Shen, *Qin Shihuang Terracotta Excavation Report: Pit 1, Third Excavation 2009-2011*). See Chapter 10 below for more details.

3 Biot, 'Sur les mœurs des anciens Chinois', pp. 335-6.

4 Yuan, *Terracotta Warriors: Archaeological Discoveries and Research*, pp. 92-100; Yuan, *China's Terracotta Army*, p. 30.

5 In Sawyer, *The Seven Military Classics*, p. 251.

6 In ibid., p. 245.

7 Yuan, *China's Terracotta Army*, p. 81.

8 Biot, *Zhou Li*, Part II, Book XLIV, p. 580.

9 Ibid., Book XXXII, pp. 241-2.

10 According to the military expert on crossbows Ralph Payne-Gallwey, the repeating crossbow was still used by the Chinese in the 1894-5 war with Japan (*The Book of the Crossbow*, p. 273).

11 See the website at http://www.ucl.ac.uk/terracotta-army/logistics/weapons.

12 Martinón-Torres et al., 'Making Weapons', p. 70.

13 Rawson, 'The Power of Images', p. 149.

14 See Yuan, *China's Terracotta Army*, pp. 80-1; Professor Martinón-Torres at UCL, who has worked on the analysis of the metals used, is sceptical (private communication).

15 Martinón-Torres et al., 'Forty Thousand Arms', p. 549.

16 Martinón-Torres et al., 'Making Weapons', pp. 6-8.

17 Komlos, 'The Size of the Chinese Terracotta Warriors', p. 1.

18 Ibid., p. 2.

19 Wu, 'The Art and Architecture of the Warring States Period', p. 652.

20 The photo may be found on p. 75 of the Chinese edition.

21 The count wrote an excellent parallel account of their journey: Gilbert de Voisins, *Écrit en Chine*, Paris: Floury, 1913.

22 Letter written on 20 February 1914, in Segalen, *Correspondance II*, pp. 318-20; published in *L'Autorité* on 16 June 1914.

23 For example, by Jessica Rawson, in 'The Power of Images', p. 132.

24 Legge, *The Lî Kî*, I–X, 3.13. p. 193.

25 Ibid., p. 97.

26 Yuan, *China's Terracotta Army*, pp. 108–14.

27 Mattos, *The Stone Drums of Ch'in*, pp. 165–6; the drums are now in the Palace Museum, Beijing.

28 Strabo tells us that 'fasces, axes, trumpets, sacrifical rites, divination, and all music used by the Romans' were transferred to Rome from Etruria (Jones, *Geography*, vol. II, p. 339 (Book V, 2.2)). In the twentieth century the *fasces* became the symbol of and provided the very word fascism.

29 Personal communication, 22 February 2017.

30 Duan, 'The Cultural Interaction', Part I, p. 14.

31 Yuan, *China's Terracotta Army*, pp. 118–19.

32 Duan, 'Entertainment for the Afterlife', pp. 200–1.

33 Wu, 'The Art and Architecture of the Warring States Period', p. 734.

34 Zhang Weixing made this point strongly in a personal communication.

CHAPTER 7: WHO BUILT THE ARMY, AND HOW?

1 Sima Qian, II, p. 67.

2 Ibid., p. 66.

3 This city was situated in what is now the north-west of the present urban area of Xi'an. Studies and archaeological surveys over the past few decades have revealed the layout and many details, and sections of the city walls and the foundations of the main gates may be seen. It is now a protected heritage site, with a small but interesting museum of Han artefacts unearthed there.

4 This was a traditional method of recruitment. The *Zhou li* already explains how many people could be recruited per family: 'Dans les terrains de première qualité, une famille se compose de sept individus (mâles et femelles), sur lesquels trois sont en état de servir l'État ou corvéables. Dans les terres de qualité moyenne, une famille se compose de six individus, et sur deux familles, cinq individus sont en état de servir l'État ou corvéables. Dans les terres de qualité inférieure, une famille se compose de cinq individus, et, par famille, deux individus sont capables de servir l'État ou corvéables.' District officers were responsible for leading the conscripted men to their superior officer. Biot, *Le Tcheou-Li*, Part I, Book X, pp. 223 and 233.

5 Barbieri-Low, *Artisans in Early Imperial China*, pp. 221–2.

6 Hulsewé, *Remnants of Ch'in Law*, p. 15.

7 Sima Qian, II, p. 70.

8 Hinsch, *Women in Early Imperial China*, p. 69.

9 Sun, '"Xi", "Liyi" and "Lishan Yuan"', p. 68.

10 Quoted in Yates, 'Soldiers, Scribes and Women', p. 359.

11 Barbieri-Low, *Artisans in Early Imperial China*, p. 72.

12 Hulsewé, *Remnants of Ch'in Law*, A 64, p. 63.

13 Ibid., pp. 14–18.

14 Barbieri-Low, *Artisans in Early Imperial China*, p. 223.

15 Ibid., pp. 212–13.

16 Ibid., p. 241.

17 Ma, 'Tracing the Locality of Prisoners and Workers'. This article was published online under the Creative Commons licence in June 2016, and does not provide page numbers. It may be found at https://www.ncbi.nlm.nih.gov/pmc/articles/PMC4890548/#

18 Gao et al., 'Neutron Activation Analysis', p. 70.

19 Martinón-Torres et al., 'Making Weapons', p. 74.

20 Martinón-Torres et al., 'Forty Thousand Arms', p. 552.

21 Nickel, 'The Terracotta Army', pp. 161–4.

22 Barbieri-Low, *Artisans in Early Imperial China*, p. 75.

23 Li and Branner, *Writing & Literacy*, p. 373.

24 Ledderose, *Ten Thousand Things*, p. 70.

25 Ibid., p. 73.

26 Watson, *The Arts of China to AD 900*, p. 87.

27 Emmerling, 'Aims and Results,' p. 17.

28 Rogner, 'New Methods,' pp. 46–7.

29 Thieme, 'Paint Layers and Pigments,' p. 53.

30 Quoted in ibid., p. 52.

31 Yuan Zhongyi, 'The Costume Colours of Qin Terracotta Warriors', in Wu et al., *The Polychromy of Antique Sculptures*, pp. 13–15.

32 The technical information here was provided in conversations with Xia Yin, vice-director of the Conservation and Restoration Department of the Mausoleum Site Museum, who has spent two decades working on colour – as well as other conservation problems.

CHAPTER 8: WHAT WERE THE WARRIORS FOR?

1 Yates, 'The Rise of Qin', pp. 34–5.

2 Sima Qian, IV, pp. 38–9 (in Chapter XXXII, 'Duke Tai of Qin'). The tomb and already excavated horses may be seen at the site museum in Zibo.

3 Ibid., p. 39.

4 De Groot, *The Religious System of China*, vol. II, Book I, p. 723.

5 Legge, *The Lî Kî*, Book II, Part III, 3, p. 14.

6 Sima Qian, V, p. 107 (in Chapter XLVII, 'Biography of Confucius').

7 Wang, 'What Happened to the First Emperor's Afterlife Spirit?', in Lui Yang (ed.), China's First Emperor, pp. 210–27.

8 Legge, *The She King*, Part I, Book XI, vl, pp. 162–3.

9 Ezra Pound, *Shih-ching: The Classic Anthology Defined by Confucius*, Cambridge, Mass.: Harvard University Press, 1954, p. 63.

10 Kesner, 'Likeness of No One', p. 116.

11 Osvald Sirén, *The Chinese on the Art of Painting: Texts by the Painter-Critics, from the Han to the Ch'ing Dynasties*, New York: Dover, 2005, p. 9.

12 See Laurence Binyon, *Painting in the Far East*, London: Edward Arnold, 1913, p. 46.

13 Kesner, 'Likeness of No One', p. 129.

14 Liu, *Qin Shi Huang's Mausoleum*, p. 156.

15 Ibid., p. 190; he gives Yuan Zhongyi's 2002 work as a reference, citing p. 236.

16 Graham, *Disputers*, pp. 16–17.

17 Rawson, 'The Power of Images', p. 126.

18 Lewis, 'Warring States Political History', p. 621.

19 Lin, 'Armour for the Afterlife', p. 189.

CHAPTER 9: WHAT IS IN THE MAUSOLEUM?

1 Rawson, 'The Power of Images', p. 132.

2 Legge, *The Writings of Chuang Tzu*, Part III, Book XXXII, 14, p. 212.

3 Legge, *The Lî Kî*, I–X, Book II, Section 1, 3.31, pp. 156–7.

4 Knoblock and Riegel, *Annals of Lü Buwei*, 10/3.1, p. 230.

5 Ibid., 10/2.4, p. 228.

6 Kern, *The Stele Inscriptions*, Preface, p. vii.

7 Jiao, 'Shape Factor Analysis', p. 73.

8 See Watson, *Han Dynasty I*, p. 313.

9 Jiao, 'Construction Concept', p. 80.

10 Ibid., p. 79.

11 This figure was suggested during a private conversation.

12 Jiao, 'Construction Concept', p. 83.

13 Kern, *The Stele Inscriptions*, p. 105.

14 Poo, 'Religion and Religious Life', pp. 192 and 194.

15 Hardy, *Worlds of Bronze and Bamboo*, p. 5.

16 Knoblock, *Xunzi*, vol. I, p. 112.

17 Kern, 'Bronze Inscriptions', p. 153.

18 Sanft, *Communication and Cooperation*, p. 80; Bujard, *Le Sacrifice au Ciel*, pp. 135–8.

19 This account is based on conversations with the lead archaeologist, Zhang Tian'en of the Shaanxi Archaeology Institute, and a report and his short article in Chinese published in 2008. The full report is in preparation.

20 Sima Qian, II, p. 38.

21 Zhang, 'New Archeological Acquisitions', pp. 111–12.

22 Watson, *Qin Dynasty*, 'The Biography of Lü Buwei', p. 164.

23 Ibid., p. 206.

24 Most scholars now believe that the text of this book is from the following century, i.e. that it is a Han compilation. But many of the concepts contained in it were much older; the fact that Sima Qian describes Qin Shihuang's use of the Five Virtues would seem to confirm this.

25 Granet, 'La vie et la mort', pp. 12–13.

26 Ibid., p. 20 (see also note 2 above).

27 Knoblock and Riegel, *Annals of Lü Buwei*, 10/2.3, p. 228.

28 Zhang, 'New Archeological Acquisitions', p. 111.

29 Sima Qian, II, pp. 45. Chavannes gives 'l'eau efficace'.

30 In the original: 'pays des morts et réservoir de vie'. Granet, 'La vie et la mort', p. 22.

31 Hardy, *Worlds of Bronze and Bamboo*, p. 49.

32 Knoblock and Riegel, *Annals of Lü Buwei*, 10/3.1, p. 230.

33 Hardy, *Worlds of Bronze and Bamboo*, p. 182.

34 Appendix, 'Scientific Studies', in Portal, *The First Emperor*, p. 207.

35 Ibid.

CHAPTER 10: LATEST DISCOVERIES AND RESEARCH

1 Xu et al., 'Excavation of the Terracotta Army Pit No. 1', p. 7.

2 Segalen, *Les Origines de la statuaire de Chine*, p. 15; *Œuvres Complètes*, p. 869.

3 Duan, 'The Cultural Interaction', Part I, p. 9.

4 Nickel, 'The First Emperor', p. 420.

5 Arrian, *Anabasis of Alexander*, vol. I, Book IV, 19, p. 403.

6 Rawlinson, *Bactria*, Appendix III, p. 158.

7 Jones, *Geography*, v (Book XI, 11.1).

8 Rawlinson, *Bactria*, p. 74.

9 Nancy Hatch Dupree, Louis Dupree and A. A. Motamedi, *The National Museum of Afghanistan: An Illustrated Guide*, Kabul: The Afghan Tourist Organization, 1974, p. 7.

10 Arrian, *Anabasis of Alexander*, vol. I, Book IV, 3, p. 345.

11 Dupree et al., *The National Museum of Afghanistan*, p. 5.

12 Christopoulos, 'Greek Combat Sports', p. 432.

13 Sima Qian, III, p. 17.

14 Zhao, 'New Explorations of Early Qin Culture', pp. 54–7.

15 Wang, 'On the Issues Relevant to the Majiayuan Cemetery', pp. 61–2.

16 Zhou, 'The Mausoleum of Emperor Tang Taizong', pp. 161–3.

17 Legge refers to them as the 'hordes of the west' and uses the romanization 'Jung' for 'rong' (*Classics*, vol. V, Part 1, 'Prolegomena', 3.6. p. 123).

18 Christopoulos, 'Hellenes and Romans in Ancient China', p. 5.

19 Legge, *Classics*, vol. V, Part II, Duke Seang [i.e. Xiang], Year XIV, p. 464.

20 Sima Qian, II, p. 46.

21 Nickel, 'The First Emperor', p. 437.

22 Christopoulos,'Hellenes and Romans in Ancient China', p. 12.

23 Kern, *The Stele Inscriptions*, p. 52 n. 11.

24 Christopoulos, 'Hellenes and Romans in Ancient China', p. 11.

25 Quoted from Nickel, 'The First Emperor', p. 441.

26 Arrian, *Anabasis of Alexander*, vol. I, Book 29, 1, p. 97.

27 Wu, *Monumentality*, p. 110.

28 Duan, 'The Cultural Interaction', Part III, p. 12.

29 Barnhart, 'Alexander in China?', p. 331.

30 Ibid., p. 335.

31 Ibid., p. 338.

32 Ibid., p. 340.

33 Duan, 'The Cultural Interaction', Part I, p. 10.

34 The interview is dated 2006; http://archive.archaeology.org/online/interviews/mair.html.

35 W. W. Tarn, 'Notes on Hellenism in Bactria and India', *Journal of Hellenic Studies*, 22 (1902), p. 292.

36 Watson, *Han Dynasty II*, pp. 235–6.

37 Laufer, 'Sino-Iranica: Chinese Contributions to the History of Civilization in Ancient Iran', p. 185.

38 Nickel, 'The First Emperor', p. 442.

39 *The Greatest Tomb on Earth*, broadcast on 16 October 2016. Promotional material picked up by many daily newspapers included the phrase 'Ancient Greeks may have built China's famous Terracotta Army'.

CHAPTER 11: NEW TECHNIQUES FOR STUDY, RESTORATION AND CONSERVATION

1 Needham et al., *Science and Civilisation*, vol. V, Part VI, p. 140.

2 Needham and Wang, *Science and Civilisation*, vol. III, p. 499.

3 Martinón-Torres et al., 'Forty Thousand Arms', p. 549.

4 Xiuzhen et al., 'Crossbows and Imperial Craft Organisation', p. 138.

5 Xiuzhen et al., 'Marking Practices', pp. 170–2.

6 Ibid., p. 178.

7 Bevan et al., 'Computer Vision', p. 252.

8 Yin et al., 'Development of Chinese Barium Copper Silicate Pigments', pp. 500–1. The equipment used for this analysis was provided by Janssen Pharmaceutical NV, from Belgium, whose Xi'an joint-venture company sponsored one of the research labs at the site, opened in 2001.

9 Ibid., p. 508.

10 The account in the next three paragraphs is based on a scientific paper published in 2014 in the specialized journal *Studies in Conservation* (Lan et al., 'Conservation of a Polychrome Terracotta Warrior').

11 Zhaolin et al., 'Primitive Environment Control', p. 1505.

12 Ibid., p. 1508.

13 Personal communication.

CHAPTER 12: RECENT EXCAVATIONS AND CURRENT STUDIES

1 These comments are based on the contents of an article by Professor Duan which has been accepted by a leading Chinese archaeological journal and will appear in 2018.

2 Zhang, *Ritual and Order*, p. 284.

3 According to Professor Zhang Weixing, responsible for the new work in this pit, there should be a brief journal article published in 2018, to be followed later by an internal report. (Personal communication; my camera and phone had to be deposited at the entrance to the lab.)

4 Christopoulos, 'Greek Combat Sports', p. 452.

5 Sima Qian, II, p. 29; ibid., V, p. 27.

6 Ibid., II, p. 91.

7 Christopoulos, 'Hellenes and Romans in Ancient China', p. 28. He gives the source as the *Wenxian tongkao* (文献通考) or 'Comprehensive Examination of Literature', which was published in 1317 using a variety of ancient texts.

8 Christopoulos, 'Hellenes and Romans in Ancient China', pp. 9–10.

9 Ibid., p. 14.

10 Wang, 'Afterlife Entertainment', p. 61.

11 Wang, 'What Happened to the First Emperor's Afterlife Spirit?', p. 42.

12 Wang, 'Afterlife Entertainment', p. 85.

13 Ibid., p. 87.

14 Knoblock and Riegel, *Annals of Lü Buwei*, p. 6.

15 Wang, 'Afterlife Entertainment', p. 90.

16 Zhang, *Ritual and Order*, pp. 260 and 276; there is a sketch of the pit on p. 261.

17 Sima Qian, II, p. 66.

18 Duan, 'Scientific Studies of the High Level of Mercury', p. 204.

19 Private communication, UCL, 4 April 2017.

20 Christopoulos, 'Hellenes and Romans in Ancient China', p. 30 n. 53.

21 Legge, *The She King*, Part I, Book XI, iv, p. 159.

CHAPTER 13: WHY DID THE QIN FAIL?

1 Sima Qian, IV, p. 40.

2 Liao, *Han Feizi*, Chapter V, 'The Tao of the Sovereign'.

3 Sima Qian, II, p. 72.

4 Ibid., p. 70.

5 Sanft, *Communication and Cooperation*, p. 84.

6 Sima Qian, II, p. 68.

7 Liao, *Han Feizi*, Chapter XV, 'Portents of Ruin', Article 29.

8 Shelach, 'Collapse or Transformation?', p. 131.

9 Sima Qian II, pp. 72–84.

10 Ibid., p. 79.

11 Ibid., p. 82.

12 Ibid., p. 78.

13 Legge, *The Lî Kî*, I–IX, Book II, 1.2. p.121

14 Sima Qian, II, p. 79.

15 Ibid., p. 81.

16 Ibid., pp. 83–4.

17 Ibid., p. 84. Chavannes gives Dazexiang (大泽乡) as Ta-tsé, and Burton Watson as Daze (which is easy to pronounce incorrectly in English; in this case the two French syllables render the name better). This was a county to the south-west of Suzhou in Anhui Province – *not* the more famous Suzhou in neighbouring Jiangsu Province.

18 Ibid., p. 90.

19 Ibid., p. 109; Watson translates this title as 'Dictator King of Western Chu' (*Han Dynasty II*, p. 35).

20 Sima Qian, II, p. 106.

21 See Chapter 7 note 14 above.

22 Sima Qian, II, p. 81.

23 Lewis, 'Warring States Political History', p. 53.

24 See the discussion about this in Dull, 'Anti-Qin Rebels', pp. 316–17.

25 See http://www.lcwangpress.com/essays/e-pang-palace.html.

26 Dull, 'The Legitimation of the Ch'in', p. 5.

27 Chavannes, 'Les deux plus anciens spécimens de la cartographie chinoise', pp. 237–8.

28 Watson, *Han Dynasty II*, p. 18.

29 Chang, *Art, Myth, and Ritual*, p. 34.

30 Ibid., p. 35.

31 Pines, *Envisioning Eternal Empire*, p. 109.

32 In Pines et al., *Birth of an Empire*, Introduction to Part I, p. 49.

33 Knoblock, *Xunzi*, vol. II, pp. 107–8.

34 Pines et al., *Birth of an Empire*, p. 279.

35 Sanft, *Communication and Cooperation*, p. 147.

EPILOGUE: FUTURE PROSPECTS

1 Xiuzhen et al., 'Marking Practices', p. 174.

2 Hulsewé, *Remnants of Ch'in Law*, p. 82.

3 Personal communication by Shen Maosheng, vice-director of archaeology, in January 2017.

4 Hardy, *Worlds of Bronze and Bamboo*, p. 183.

5 Sima Qian, I, pp. 72–3. Shaughnessy calls this story 'obviously fictionalized but doubtless based on a core of historical fact' (Shaughnessy, 'Western Zhou History', p. 350 n. 144).

6 The area is clearly mapped in the colour plates at the end of Zhang, *Ritual and Order*, in particular Plate 8 (no page number).

7 Sima Qian, I, p. 73.

8 Ibid., II, p. 7.

9 Harper, 'Warring States Natural Philosophy and Occult Thought', p. 817.

10 Legge, *Confucian Analects*, Book II, Chapter 1, p. 9.

11 The calendar at this time was in fact very accurate, because already by the seventh century seven intercalations were made every nineteen years to eliminate the missing days (Endymion Wilkinson, *Chinese History: A Manual*, Cambridge, Mass.: Harvard University Press, 2000, p. 171).

12 This brief account is based on the detailed tables and explanations provided by Needham and Wang in their study of astronomy (*Science and Civilisation*, vol. III, pp. 229–42).

13 Ibid., p. 231.

14 Kern, *The Stele Inscriptions*, p. 107 n. 112.

15 Zhang, *Ritual and Order*, pp. 375–6.

16 Dorofeeva-Lichtmann, 'Conception of Terrestrial Organization', pp. 61–2.

17 Watson, *Han Dynasty I*, p. 80.

18 See for example the description of the ceremonies by the Jesuit scholar Henry Doré, *Researches into Chinese Superstitions*, trans. M. Kennelly, Shanghai: T'usewes Printing Press, 1914, vol. I, pp. 47–62.

19 Legge, *The Lî Kî*, I–IX, Book II, 3.16, p. 194.

20 Biot, *Le Tcheou-Li*, Part I, Book XIX, p. 451.

21 Ibid., Book VII, p. 153.

22 Ibid., p. 162.

23 Ibid., Book VI, pp. 123–4.

24 Ibid., Book VII, p. 145.

25 Ibid., p. 170.

26 Ibid., Book VI, p. 120.

27 Ibid., Book XIX, p. 452.

28 Ibid., Part II, Book XX, p. 467.

29 Ibid., Book XXIII, p. 51.

30 Ibid., Book XXII, p. 40, and Book XXIII, pp. 61–2.

BIBLIOGRAPHY

Arrian, *Anabasis of Alexander*, trans. E. Iliff Robson, 2 vols, London: William Heinemann, 1954

Ball, Philip, 'Flowing Rivers of Mercury', *Chemistry World*, 7 January 2015, https://www.chemistryworld.com/feature/flowing-rivers-of-mercury/8122.article

Barbieri-Low, Anthony J., *Artisans in Early Imperial China*, Seattle: University of Washington Press, 2007

Barnhart, Richard M., 'Alexander in China? Questions for Chinese Archaeology', in Yang, *New Perspectives on China's Past*, vol. I, pp. 329–43

Bevan, Andrew; Cao, Wei; Li, Xiuzhen; Ma, Shengtao; Martinón-Torres, Marcos; Green, Susan; Rehren, Thilo; Xia, Yin; Zhao, Kun; and Zhao, Zhen, 'Computer Vision, Archaeological Classification and China's Terracotta Warriors', *Journal of Archaeological Science*, 49:1 (2014), pp. 249–54

Biot, Édouard, 'Sur les mœurs des anciens Chinois, d'après le *Chi-king*', *Journal Asiatique*, série 4, 2 (1843), pp. 345–56 and 430–47

—— (trans.), *Le Tcheou-Li ou Rites des Tcheou*, Paris: L'Imprimerie Nationale, 1851

Bishop, Heber R., *Investigations and Studies in Jade*, Rahway, NJ: The Mershon Company Press, 1902

Blakely, Barry B., 'The Geography of Chu', in Cook and Major, *Defining Chu*, pp. 9–20

Blänsdorf, Catharina; Emmerling, Erwin; and Petzet, Michael (eds), *The Terracotta Army of the First Chinese Emperor Qin Shihuang*, Munich: Bayerisches Landesamt für Denkmalpflege, 2001

——, *Studien zur Farbfassung von Figuren der Terrakottaarmee und*

aus anderen Beigabengruben der Grabanlage des Ersten Chinesischen Kaisers Qin Shihuang, Munich: Siegl, 2015

Boardman, J., *The Diffusion of Classical Art in Antiquity*, London: Thames & Hudson, 1994

Bodde, Derk, *China's First Unifier: A Study of the Ch'in Dynasty as Seen in the Life of Li Ssu*, Leiden: E. J. Brill, 1938

——, *Statesman, Patriot, and General in Ancient China; Three Shih Chi Biographies of the Ch'in Dynasty (255–206 B.C.)*, New Haven, Conn.: American Oriental Society, 1940

——, 'The State and Empire of Ch'in', in Denis Twitchett and Michael Loewe (eds), *The Cambridge History of China*, vol. I, Cambridge: Cambridge University Press, 1986, pp. 20–102

——, 'The Idea of Social Class in Han and Pre-Han China', in W. L. Idema and E. Zürcher (eds), *Thought and Law in Qin and Han China*, Leiden: E. J. Brill, 1990, pp. 26–41

Bonsall, Bramwell Seaton, 'Records of the Warring States: Zhan Guo Ce', unpublished typescript of translation, late 1920s, available online at Hong Kong University Library. (http://lib.hku.hk/bonsall/)

Buck, David D., 'Three Han Dynasty Tombs at Ma-Wang-Tui', *World Archaeology*, 7:1 (June 1975), pp. 30–45

Bujard, Marianne, *Le Sacrifice au Ciel dans la Chine ancienne: théorie et pratique sous les Hans occidentaux*, Paris: École Française d'Extrême-Orient, 2000

Bujard, Marianne and Pirazzoli-T'Serstevens, Michèle, *Les Dynasties Qin et Han: histoire générale de la Chine (221 av. J.-C.–220 apr. J.-C.)*, Paris: Les Belles Lettres, 2017

Burman, Edward, *Xi'an through European Eyes: A Cultural History in the Year of the Horse*, Xi'an: Shaanxi People's Press, 2016

Cervera Jiménez, José Antonio, 'Qin Shihuang: La historia como discurso ideológico', *Estudios de Asia y África*, 44:3 (2009), pp. 527–58

Chang, Chun-shu, *The Rise of the Chinese Empire*, vol. I: *Nation, State & Imperialism in Early China ca. 1600 B.C.–A.D. 8*, Ann Arbor: University of Michigan Press, 2007

Chang, Kwang-chih, *The Archaeology of Ancient China*, New Haven: Yale University Press, 1968.

——, *Art, Myth, and Ritual: The Path to Political Authority in Ancient China*, Cambridge, Mass.: Harvard University Press, 1983

Chang, Yong and Li, Tong, 'Application of Mercury Survey Technique over the Mausoleum of Emperor Qin Shi Huang', *Journal of Geochemical Exploration*, 23:1 (January 1985), pp. 61–9

Chavannes, Édouard, 'Les Inscriptions des Ts'in', *Journal Asiatique*, série 9, 1 (1893), pp. 473–521

——, *Les Mémoires historiques de Se-ma Ts'ien traduits et annotés*, 5 vols, Paris: Adrien Maisonneuve, 1895–1905

——, *Introduction aux mémoires historiques de Se-ma Ts'ien*, vol. I, Paris: Ernest Leroux, 1895

——, 'Les Deux Plus Anciens Spécimens de la cartographie chinoise', *Bulletin de l'École Française d'Extrême-Orient*, 3 (1903), pp. 214–47

——, *Le T'ai Chan: essai de monographie d'un culte chinois* (Annales du Musée Guimet), Paris: Ernest Leroux, 1910

Chen Jingyuan, 兵马俑真相 标准书 (*The Truth of the Terracotta Warriors and Horses: Challenges to the Third Excavation of the Terracotta Warriors*, in Chinese), Beijing: Yi Wu Guang, 2009

Chia, I., 'The Faults of Ch'in', in de Bary and Bloom, *Sources of Chinese Tradition*, pp. 228–31

Christopoulos, Lucas, 'Hellenes and Romans in Ancient China (240 BC–1398 AD)', *Sino-Platonic Papers*, Number 230, August 2012, http://www.sino-platonic.org/complete/spp230_hellenes_romans_in_china.pdf

——, 'Greek Combat Sports and their Transmission to Central and East Asia', *Classical World*, 106:3 (2013), pp. 431–59

Ciarla, Roberto, *The Eternal Army: The Terracotta Soldiers of the First Chinese Emperor*, Maidstone: Vercelli, 2005

Cook, Constance A. and Major, John S. (eds), *Defining Chu: Image and Reality in Ancient China*, Honolulu: University of Hawai'i Press, 1999

Couvreur, S., *Li Ki ou Mémoires sur les bienséances et les cérémonies: texte chinois avec une double traduction en français et en Latin*, 2 vols, Ho Kien Fou [Hejian, Hebei]: Imprimerie de la Mission Catholique, 1913

Creel, Herrlee G., *The Origins of Statecraft in China*, vol. I: *The Western Chou Empire*, Chicago: University of Chicago Press, 1970

Crump, J. I., *Legends of the Warring States: Persuasions, Romances and Stories from Chan-kuo Ts'e, Selected, Translated, and Edited*, Ann Arbor: Centre for Chinese Studies, University of Michigan, 1998

de Bary, William Theodore and Bloom, Irene (eds), *Sources of Chinese Tradition*, vol. I, revised edn, New York: Columbia University Press, 1999

de Groot, J. J. M., *The Religious System of China: Its Ancient Forms, Evolution, History and Present Aspect. Manners, Customs and Social Institutions Connected Therewith*, 6 vols, Leyden: E. J. Brill, 1892–1910

Di Cosmo, Nicola, *Ancient China and its Enemies: The Rise of Nomadic Power in East Asian History*, Cambridge: Cambridge University Press, 2002

——, *Military Culture in Imperial China*, Cambridge, Mass.: Harvard University Press, 2009

Dorofeeva-Lichtmann, Vera V., 'Conception of Terrestrial Organization in the Shan Hai Jing', *Bulletin de l'École Française d'Extrême-Orient*, 82 (1995), pp. 57–110

Duan, Qingbo, 'Entertainment for the Afterlife', in Portal, *The First Emperor*, pp. 192–203

——, 'Scientific Studies of the High Level of Mercury in Qin Shihuangdi's Tomb', in Portal, *The First Emperor*, pp. 204–7

——, 秦始皇陵园考古研究 (*Archaeology Studies on the Cemetery of Emperor Qin Shi Huang*, in Chinese), Beijing: Peking University Press, 2010

——, 'The Cultural Interaction between East and West: From the Perspective of the Archaeological Findings of the Mausoleum of Qin Shi Huang', *Journal of Northwest University* (Philosophy and Social Sciences Edition), Part I, 45:1 (January 2015), pp. 8–15; Part II, 45:2 (March 2015), pp. 8–14; Part III, 45:3 (May 2015), pp. 8–13

Dull, Jack L., 'The Legitimation of the Ch'in', in *Conference on the Legitimation of Chinese Regimes Sponsored by the Committee on the Study of Chinese Civilization of the A.C.L.S.*, Monterey, California, 15–24 June 1975

——, 'Anti-Qin Rebels: No Peasant Leaders Here', *Modern China*, 9:3 (July 1983), pp. 285–318

Duyvendak, J. J. L., *The Book of Lord Shang: A Classic of the Chinese School of Law*, trans. from the Chinese, with Introduction and Notes, London: Arthur Probsthain, 1928

Emmerling, Erwin, 'Aims and Results of the Chinese–German Project for the Preservation of the Terracotta Army', in Wu et al., *The Polychromy of Antique Sculptures*, pp. 16–18

Eno, Robert, *The Confucian Creation of Heaven: Philosophy and the Defense of Ritual Mastery*, New York: State University of New York Press, 1990

Falkenhausen, Lothar von, *Chinese Society in the Age of Confucius (1000–250 BC): The Archaeological Evidence*, Los Angeles: Cotsen Institute of Archaeology, University of California, 2006

——, 'Culte des ancêtres et système funéraire à Qin à l'époque pré-impériale', in *Les Soldats de l'Éternité*, pp. 33–45

Fields, Lanny B., 'The Ch'in Dynasty: Legalism and Confucianism', *Journal of Asian History*, 23:1 (1989), pp. 1–25

Gao, Zhengyao, et al., 'Neutron Activation Analysis of Sources of Raw Material of Emperor Qin Shi Huang's Terracotta Warriors and Soldiers', *Science in China Series G: Physics, Mechanics & Astronomy*, 46:1 (February 2003), pp. 62–70

Geil, William Edgar, *The Great Wall of China*, New York: Sturgis & Walton, 1909

Giles, Herbert A. (trans.), *Chang Tzu: Mystic, Moralist, and Social Reformer*, London: Bernard Quaritch, 1889

Giles, Lionel (trans.), *Sun Tzu on the Art of War*: London: Luzac, 1910

Graham, A. C., *Disputers of the Tao: Philosophical Argument in Ancient China*, Chicago and La Salle, Ill.: Open Court, 1989

Granet, Marcel, 'La vie et la mort: croyances et doctrines de l'antiquité chinoise', *L'Annuaire de l'École Pratique des Hautes Études, Section des sciences religieuses*, 33:29 (1919), pp. 1–22

——, *La civilisation chinoise*, Paris: La Renaissance du Livre, 1929

——, *La pensée chinoise*, Paris: La Renaissance du Livre, 1934

Han Fei Tzu, *Basic Writings*, trans. Burton Watson, New York: Columbia University Press, 1964

Hardy, Grant, 'The Reconstruction of Ritual: Capping in Ancient China',
 Journal of Ritual Studies, 2:7 (1993), pp. 69–90

——, *Worlds of Bronze and Bamboo: Sima Qian's Conquest of History*,
 New York: Columbia University Press, 1999

Harper, Donald, 'Warring States, Ch'in, and Han Periods', *Journal of
 Asian Studies*, 54:1 (1995), pp. 152–60

——, 'Warring States Natural Philosophy and Occult Thought', in
 Loewe and Shaughnessy, *The Cambridge History of Ancient China*,
 pp. 813–84

Hinsch, Bret, *Women in Early Imperial China*, Lanham, Md.: Rowman &
 Littlefield, 2002

Hirth, Friedrich, *The Ancient History of China to the End of the Chóu
 Dynasty*, New York: Columbia University Press, 1908

Hulsewé, A. F. P., *Remnants of Ch'in Law: An Annotated Translation
 of the Ch'in Legal and Administrative Rules of the 3rd Century B.C.
 Discovered in Yûn-meng Prefecture, Hupei Province, in 1975* (*Sinica
 Leidensia*, vol. XVII), Leiden: E. J. Brill, 1985

Jiao, Nanfeng, '试论西汉帝陵的建设理念' ('On the Construction
 Concept of Western Han Dynasty Mausoleums'), *Archaeology*, 2007,
 pp. 78–87

——, '西汉帝陵形制要素的分析与推定' ('Shape Factor Analysis and
 Inference of Western Han Dynasty Mausoleums'), *Archaeology and
 Heritage*, 2013, pp. 72–81

Jones, Horace Leonard (trans.), *The Geography of Strabo*, 8 vols, London:
 William Heinemann, 1954

Keightley, David N., 'The Quest for Eternity in Ancient China: The
 Dead, their Gifts, their Names', in G. Kuwayama (ed.), *Ancient
 Mortuary Traditions of China: Papers on Chinese Ceramic Funerary
 Sculptures*, Los Angeles: Los Angeles County Museum of Art, 1991

——, 'The Shang: China's First Historical Dynasty', in Loewe and
 Shaughnessy, *The Cambridge History of Ancient China*, pp. 232–91

—— (ed.), *The Origins of Chinese Civilization*, Berkeley: University of
 California, Center for Chinese Studies, 2000

Kern, Martin, *The Stele Inscriptions of Qin Shihuang: Text and Ritual in
 Early Chinese Imperial Representation*, New Haven: American Oriental
 Society, 2000

——, *Text and Ritual in Early China*, Seattle: University of Washington Press, 2005

——, 'Bronze Inscriptions, the *Shijing* and the *Shangshu*: The Evolution of the Ancestral Sacrifice during the Western Zhou', in John Lagerway and Marc Kalinoski (eds), *Early Chinese Religion, Part One: Shang through Han (1250 BC–220 AD)*, Leiden: E. J. Brill, 2009, pp. 143–200

Kesner, Ladislav, 'Likeness of No One: (Re)presenting the First Emperor's Army', *Art Bulletin*, 77:1 (March 1995), pp. 115–52.

Kiroku, Adachi, 長安史跡の研究 (*A Study of Historical Sites in Chang'an*, in Japanese), Tokyo: Tōyō Bunko, 1933; 长安史迹研究 (in Chinese), 三秦出版社, 2003

Knoblock, John, *Xunzi: A Translation and Study of the Complete Works*: vol. I: *Books 1–6*, Stanford: Stanford University Press, 1988

——, *Xunzi: A Translation and Study of the Complete Works*: vol. II, *Books 7–16*, Stanford: Stanford University Press, 1990

Knoblock, John and Riegel, Jeffrey, *The Annals of Lü Buwei: A Complete Translation and Study*, Stanford: Stanford University Press, 2000

Komlos, John, 'The Size of the Chinese Terracotta Warriors', *Antiquity*, 77 (June 2003), http://antiquity.ac.uk/projgall/komlos296/

Kuwayama, George (ed.), *The Great Bronze Age of China: A Symposium*, Seattle: University of Washington Press, 1983

Lan Desheng; Wang Dongfeng; Zhou Tie; and Xia Yin, 'Conservation of a Polychrome Terracotta Warrior of the Qin Dynasty: Newly Excavated from Vault 1 in Xi'an, Shaanxi, China', *Studies in Conservation*, 59 (2014), pp. S70–S80

Lattimore, Owen, 'Origins of the Great Wall of China: A Frontier Concept in Theory and Practice', in *Studies in Frontier History: Collected Papers 1928–1958*, London: Oxford University Press, 1962

Laufer, Berthold, *Jade: A Study in Chinese Archæology & Religion* (Anthropological Series, vol. X), Chicago: Field Museum of Natural History, 1912

——, *Chinese Clay Figures, Part I: Prolegomena on the History of Defensive Armor* (Anthropological Series, vol. XIII, no. 2), Chicago: Field Museum of Natural History, 1914

——, 'Sino-Iranica: Chinese Contributions to the History of Civilization in Ancient Iran, with Special Reference to the History of Cultivated Plants and Products' (Anthropological Series, vol. XV, no. 3), Chicago: Field Museum of Natural History, 1919, pp. 185–630

Ledderose, Lothar, *Ten Thousand Things: Module and Mass Production in Chinese Art* (The A.W. Mellon Lectures in the Fine Arts, Bollingen Series, XXXV, 46), Princeton, NJ: Princeton University Press, 1998

Legge, James (trans.), *Chinese Classics*, vol. I: *Confucian Analects, The Great Learning, and The Doctrine of the Mean*, London: Trübner, 1861

—— (trans.), *Chinese Classics*, vol. II: *The Works of Mencius*, London: Trübner, 1861

—— (trans.), *Chinese Classics*, vol. V, Part I: *Dukes Yin, Hwan, Chwang, Min, He, Wan, Seuen and Ch'ing*, and the Prologomena, London: Trübner, 1872

—— (trans.), *The She King, or Book of Ancient Poetry*, London: Trübner, 1876

—— (trans.), *The Sacred Books of China: The Texts of Confucius, Part III, The Lî Kî*, I–X, Oxford: Clarendon Press, 1885

—— (trans.), *The Sacred Books of China: The Texts of Confucius, Part IV, The Lî Kî*, XI–XLVI, Oxford: Clarendon Press, 1885

—— (trans.), *The Writings of Chuang Tzu*, in F. Max Müller (ed.), *The Sacred Books of the East*, vol. XL, Oxford: Clarendon Press, 1891

Lewis, Mark Edward, 'Warring States Political History', in Loewe and Shaughnessy, *The Cambridge History of Ancient China*, pp. 587–649

——, 'The *Feng* and *Shan* Sacrifices of Emperor Wu of the Han', in McDermott, *State and Court Ritual in China*, pp. 50–80

——, *The Early Chinese Empires: Qin and Han*, Cambridge, Mass.: Harvard University Press, 2007

Li, Feng, *Landscape and Power in Early China: The Crisis and Fall of the Western Zhou, 1045–771 BC*, Cambridge: Cambridge University Press, 2006

Li, Feng and Branner, David Prager (eds), *Writing & Literacy in Early China: Studies from the Columbia Early China Seminar*, Seattle and London: University of Washington Press, 2011

Li, X. J.; Bevan, A. H; Martinón-Torres, M.; Rehren, T.; Cao, W.; Xia, Y.; and Zhao, K., 'Crossbows and Imperial Craft Organisation: The Bronze Triggers of China's Terracotta Army', *Antiquity: A Quarterly Review of Archaeology*, 88:339 (2014), pp. 126–40

Li, X. J.; Martinón-Torres, M.; Meeks, N. D.; Xia, Y.; and K. Zhao, 'Inscriptions, Filing, Grinding and Polishing Marks on the Bronze Weapons from the Qin Terracotta Army in China', *Journal of Archaeological Science*, 38 (2011), pp. 492–501

Li, Yu-ning (ed.), *The First Emperor of China*, White Plains, NY: International Arts and Sciences Press, 1975

Liang, Yun and Tian, Yaqi, 'The Tomb Occupants and Layout of the Mausoleums of the Dukes of the Qin State in Yongchen', *Archeology and Cultural Relics*, April 2015, pp. 15–19 (in Chinese)

Liao, W. K., *The Complete Works of Han Fei Tzu*, London: Arthur Probsthain, 1939

Lin, James, 'Armour for the Afterlife,' in Portal, *The First Emperor*, pp. 181–9

Liu, Jiusheng, 秦始皇帝陵与中国古代文明 / 刘九生著 (*Qin Shi Huang's Mausoleum and Ancient Chinese Civilization*, in Chinese), Beijing: Ke Xue Chu, 2014

Liu, Yang (ed.), *China's First Emperor, the Terracotta Army and the Qin Culture*, Minneapolis: Minneapolis Institute of Arts, 2012

—— (ed.), *Beyond the First Emperor's Mausoleum: New Perspectives on Qin Art*, Seattle: University of Washington Press, 2015

Loewe, Michael, *Ways to Paradise: The Chinese Quest for Immortality*, London: Allen & Unwin, 1979

——, *The Government of the Qin and Han Empires:* 221 BCE–220 CE, Indianapolis: Hackett, 2006

Loewe, Michael and Shaughnessy, Edward L. (eds), *The Cambridge History of Ancient China: From the Origins of Civilization to* 221 B.C., Cambridge: Cambridge University Press, 1999

Lovell, Julia, *The Great Wall: China against the World* 1000 BC–AD 2000, London: Atlantic Books, 2006

Ma, Ying, et al., 'Tracing the Locality of Prisoners and Workers at the Mausoleum of Qin Shi Huang: First Emperor of China (259–210 BC)', *Scientific Reports*, 6 (2016)

Mair, Victor H. (ed.), *Contact and Exchange in the Ancient World*, Honolulu: University of Hawaii Press, 2006

Man, John, *The Terracotta Army: China's First Emperor and the Birth of a Nation*, London: Bantam Press, 2007

Martinón-Torres, Marcos, et al., 'Making Weapons for the Terracotta Army', *Archaeology International*, 13 (2011), p. 70

——, 'Forty Thousand Arms for a Single Emperor: From Chemical Data to the Labor Organization behind the Bronze Arrows of the Terracotta Army', *Journal of Archaeological Method and Theory*, 21:3 (September 2014), p. 549

Masur, L. Charles, 'A Review of the Use of Mercury in Historic and Current Ritualistic and Spiritual Practices', *Alternative Medicine Review*, 16:4 (2011), pp. 14–20

Mattos, Gilbert L., *The Stone Drums of Ch'in*, Nettetal: Steyler, 1988

Needham, Joseph and Lu, Gwei-Djen, *Science and Civilisation in China*, vol. V: *Chemistry and Chemical Technology, Part II: Spagyrical Discovery and Invention: Magisteries of Gold and Immortality*, Cambridge: Cambridge University Press, 1974

Needham, Joseph, Ho, Ping-Yu and Lu, Gwei-djen, *Science and Civilisation in China*, vol. V: *Chemistry and Chemical Technology, Part III: Spagyrical Discovery and Invention: Historical Survey, from Cinnabar Elixirs to Synthetic Insulin*, Cambridge: CUP, 1976

Needham, Joseph and Lu, Gwei-Djen, *Science and Civilisation in China*, Vol. 5: *Chemistry and Chemical Technology, Part V: Spagyrical Discovery and Invention: Physiological Alchemy*, Cambridge: CUP, 1983

Needham, Joseph and Wang, Ling, *Science and Civilisation in China*, vol. II: *History of Scientific Thought*, Cambridge: Cambridge University Press, 1956

Needham, Joseph and Wang, Ling, *Science and Civilisation in China*, vol. III: *Mathematics and the Sciences of the Heavens and the Earth*, Cambridge: Cambridge University Press, 1972

Needham, Joseph, Wang, Ling and Lu, Gwei-Djen, *Science and Civilisation in China*, vol. IV: *Physics and Physical Technology, Part III: Civil Engineering and Nautics*, Cambridge: Cambridge University Press, 1971

Needham, Joseph, Yates, Robin D., Gawlikowski, Krzysztof, McEwen,

Edward; and Wang, Ling, *Science and Civilisation in China*, vol. V: *Chemistry and Chemical Technology, Part VI: Military Technology: Missiles and Sieges*, Cambridge: Cambridge University Press, 1994

Nickel, Lukas, 'The Terracotta Army', in Portal, *The First Emperor*, pp. 159–79

——, 'The First Emperor and Sculpture in China', *Bulletin of the School of Oriental and African Studies*, 76:3 (October 2013), pp. 413–47

Nienhauser, William H., Jr (ed.), *The Grand Scribe's Records*, vol. I: *The Basic Annals of Pre-Han China by Ssu-ma Ch'ien*, Bloomington and Indianapolis: Indiana University Press, 1994

——, *The Grand Scribe's Records*, vol. II: *The Basic Annals of Han China by Ssu-ma Ch'ien*, Bloomington and Indianapolis: Indiana University Press, 2002

Nylan, Michael and Loewe, Michael, *China's Early Empires: A Re-appraisal*, Cambridge: Cambridge University Press, 2010

Olberding, Amy and Ivanhoe, Philip J. (eds), *Mortality in Traditional Chinese Thought*, Albany: State University of New York Press, 2012

Payne-Gallwey, Ralph, *The Book of the Crossbow*, London: Longmans, Green, 1903

Pines, Yuri, 'L'Idéologie de Qin: créer l'empire', in *Les Soldats de l'Éternité*, pp. 171–81

——, *Envisioning Eternal Empire: Chinese Political Thought of the Warring States Era*, Honolulu: University of Hawaii Press, 2009

Pines, Yuri, von Falkenhausen, Lothar, Shelach, Gideon and Yates, Robin D. S. (eds), *Birth of an Empire: The State of Qin Revisited*, Berkeley: University of California Press, 2014

Poo, Mu-chou, 'Religion and Religious Life of the Qin', in Pines et al., *Birth of an Empire*, pp. 187–205

Portal, Jane (ed., with the assistance of Hiromi Kinoshita), *The First Emperor: China's Terracotta Army*, Cambridge, Mass.: Harvard University Press, 2007

Prusek, Jaroslav, *Chinese Statelets and the Northern Barbarians in the Period 1400–300 BC*, New York: Humanities Press, 1971

Puett, Michael J., *To Become a God: Cosmology, Sacrifice and Self-Divinization in Early China*, Cambridge, Mass.: Harvard University Press, 2002

Pulleybank, Edwin G., 'Ji 姬 and Jiang 姜: The Role of Exogamic Clans in the Organization of the Zhou Polity', *Early China*, 25 (2000), pp. 1–27

Rawlinson, H. G., *Bactria: The History of a Forgotten Empire*, London: Probsthain, 1912

Rawson, Jessica, *Mysteries of Ancient China: New Discoveries from the Early Dynasties*, New York: G. Braziller, 1996

——, 'The Power of Images: The Model Universe of the First Emperor and its Legacy', *Historical Research*, 75:188 (May 2002), pp. 123–54

——, 'The First Emperor's Tomb: The Afterlife Universe', in Portal, *The First Emperor*, pp. 114–45

Rogner, 'New Methods to Characterise and to Consolidate the Polychrome Qi-lacquer of the Terracotta Army', in Wu et al., *The Polychromy of Antique Sculptures*, pp. 46–51

Sage, Steven F., *Ancient Sichuan and the Unification of China*, Albany: State University of New York Press, 1992

Sanft, Charles, 'Progress and Publicity in Early China: Qin Shihuang, Ritual, and Common Knowledge', *Journal of Ritual Studies*, 22:1 (2008), pp. 21–43

——, *Communication and Cooperation in Early Imperial China: Publicizing the Qin Dynasty*, Albany: State University of New York Press, 2014

Sawyer, Ralph D., with Mei-chün Sawyer, *The Seven Military Classics of Ancient China, Translation and Commentary*, Boulder, Col: Westview Press, 1993

Segalen, Victor, 'Premier Exposé des résultats archéologiques, in *Œuvres Complètes: Cycle Chinois*, pp. 915–81

——*Œuvres Complètes: Cycle Chinois; Cycle Archéologique et Sinologique*, Paris: Robert Laffont, 1999

——, *Les Origines de la statuaire de Chine*, Paris: Minos, La Différence, 2003

——, *Correspondance I: 1893–1912*, Paris: Arthème Fayard, 2004

——, *Correspondance II: 1912–1919*, Paris: Arthème Fayard, 2004

Selby, Thomas G., *Chinese Archery*, Hong Kong: Hong Kong University Press, 2000

Shaughnessy, Edward L., 'Western Zhou History', in Loewe and
 Shaughnessy, *The Cambridge History of Ancient China*, pp. 292–351
Shelach, Gideon, 'Collapse or Transformation? Anthropological and
 Archaeological Perspectives on the Fall of Qin', in Pines et al., *Birth of
 an Empire*, 2014, pp. 113–38
Sivin, Nathan, *Chinese Alchemy: Preliminary Studies*, Cambridge, Mass.:
 Harvard University Press, 1968
——, 'The Theoretical Background of Elixir Alchemy', in Joseph
 Needham, *Science and Civilisation in China*, vol. V: *Chemistry and
 Chemical Technology, Part IV: Spagyrical Discovery and Invention:
 Apparatus, Theories and Gifts*, Cambridge: Cambridge University
 Press, 1980
——, *Medicine, Philosophy and Religion in Ancient China: Researches and
 Reflections*, Aldershot: Variorum, 1995
Les Soldats de l'Éternité: l'armée de Xi'an (catalogue of exhibition held 15
 April–14 September 2008), Pinacothèque de Paris, 2008
Steele, John (trans.), *The I-Li or Book of Etiquette and Ceremonial*, 2 vols,
 London: Arthur Probsthain, 1917
Steinhardt, Nancy S. (ed.), *Chinese Architecture*, New Haven and
 London: Yale University Press, 2002
Sun, Li (ed.), 秦始皇帝陵园考古报告 (*Report on Archaeology of
 the Tomb of Qin Shihuang 2009–2010*, in Chinese), Beijing: China
 Scientific Research Institute, 2012
Sun, Weigang, '"Xi", "Liyi" and "Lishan Yuan": The Function of Liyi for
 the Qin Shi Huang Mausoleum', *Archaeology and Cultural Relics*, 4
 (2009), pp. 67–71
Thieme, Cristina, 'Paint Layers and Pigments on the Terracotta Army', in
 Wu et al., *The Polychromy of Antique Sculptures*, pp. 52–7
Tian, Yaqi, '秦都雍城布局研究' ('A Study of the Layout of the Yongchen
 Capital Site of the Qin State', in Chinese), *Archaeology and Cultural
 Relics*, May 2013, pp. 63–71
Torday, Laszlo, *Mounted Archers: The Beginning of Central Asian History*,
 Edinburgh: Durham Academic Press, 1997
Tschepe, Albert, *Histoire du Royaume de Ts'in (777–207 av. J.-C.)*,
 Shanghai: Imprimerie de la Mission Catholique, 1909
Twitchett, Denis and Fairbank, John K. (eds), 'The Ch'in and Han

Empires, 221 B.C.–A.D. 220', in Denis Twitchett and Michael Loewe (eds), *The Cambridge History of China*, vol. I, Cambridge: Cambridge University Press, 1986

Unschuld, Paul U., *Medicine in China: A History of Ideas*, Berkeley: University of California Press, 1978

——, *Huang Di nei jing su wen: An Annotated Translation of Huang Di's Inner Classic - Basic Questions*, vol. I, Berkeley: University of California Press, 2011

Waldron, Arthur, *The Great Wall of China: From History to Myth*, Cambridge: Cambridge University Press, 1990

Wang, Eugene Y., 'Ascend to Heaven or Stay in the Tomb?', in Olberding and Ivanhoe, *Mortality in Traditional Chinese Thought*, pp. 37–84

——, 'What Happened to the First Emperor's Afterlife Spirit?', in Liu Yang (ed), *China's First Emperor*, pp. 210–27

——, 'Afterlife Entertainment: The First Emperor's Tomb', in Liu Yang, *Beyond the First Emperor's Mausoleum*, pp. 59–95

Wang, Hui, 'On the Issues Relevant to the Majiayuan Cemetery in Zhangjiachuan County', *Chinese Archaeology*, 11 (2011), pp. 60–4

Watson, Burton (trans.), *Records of the Grand Historian: Qin Dynasty, by Sima Qian*, New York: Columbia University Press, 1993

——, *Records of the Grand Historian: Han Dynasty I, by Sima Qian*, revised edn, New York: Columbia University Press, 1993

——, *Records of the Grand Historian: Han Dynasty II, by Sima Qian*, revised edn, New York: Columbia University Press, 1993

Watson, William, *The Arts of China to AD 900* (Pelican History of Art), New Haven and London: Yale University Press, 1995

Wheatley, Paul, *The Pivot of the Four Quarters: A Preliminary Enquiry into the Origins and Character of the Ancient Chinese City*, Edinburgh: Edinburgh University Press, 1971

Wiens, Harold J., 'The Shu Tao or Road to Szechwan', *Geographical Review*, 39:4 (October 1949), pp. 584–604

Wu, Hung, *Monumentality in Early Chinese Art and Architecture*, Stanford: Stanford University Press, 1995

——, 'The Art and Architecture of the Warring States Period', in Loewe and Shaughnessy, *The Cambridge History of Ancient China*, pp. 651–744

Wu, Yongqi; Zhang, Tinghao; Petzet, Michael; Emmerling, Erwin; and Blänsdorf, Catharina (eds), *The Polychromy of Antique Sculptures and the Terracotta Army of the First Chinese Emperor: Studies on Materials, Painting Techniques and Conservation*, Paris: ICOMOS, 2001

Xiuzhen, Janice Li; Bevan, Andrew; Martinón-Torres, Marcos; Rehren, Thilo; Cao, Wei; Xia, Yin and Zhao, Kun, 'Crossbows and Imperial Craft Organisation: The Bronze Triggers of China's Terracotta Army', *Antiquity*, 88 (2014), pp. 126–40

Xiuzhen Li; Bevan, Andrew; Martinón-Torres, Marcos; Xia, Yin; and Zhao, Kun, 'Marking Practices and the Making of the Qin Terracotta Army', *Journal of Anthropological Archaeology*, 42 (June 2016), pp. 169–83

Xu, Pingfang, 'The Archeology of the Great Wall and Han Dynasties', *Journal of East Asian Archeology*, 3:1–2 (2001), pp. 259–81

Xu, Weihong et al., '秦始皇帝陵博物院兵马俑坑考古队: 秦始皇帝陵一号兵马俑陪葬坑 2009–2011年发掘简报' ('The Excavation of the Terracotta Army Pit No. 1 of Emperor Qin Shihuang's Mausoleum in 2009–2011', in Chinese), *Wenwu Cultural Relics*, 9 (2015), pp. 4–38

Xu, Weihong and Shen, Maosheng, 秦始皇帝陵一号兵马俑陪葬坑 发掘报告（2009–2011年）秦始皇帝陵博物院 (*Qin Shihuang Terracotta Excavation Report: Pit 1, Third Excavation 2009–2011*, in Chinese), Beijing: Cultural Relics Press, 2017

Xu, Weimin, 秦俑·秦文化丛书 秦都城研究 (*Study on Terracotta Warriors: The Qin Capitals*, in Chinese), Xi'an: Shaanxi Normal University Press, 2000

——, *Emperor Qin and his Terracotta Warriors*, Shanghai: Better Link Press, 2006

Xu, Weimin and Yong, Jichun (eds), 早期秦文化研究 (*Early Qin Culture Studies*, in Chinese), Xi'an: Qin Press, 2006

Yang, Xiaoneng (ed.), *New Perspectives on China's Past: Chinese Archaeology in the Twentieth Century*, New Haven and London: Yale University Press, 2004

Yates, Robin D. S., 'The Rise of Qin and the Military Conquest of the Warring States', in Portal, *The First Emperor*, pp. 31–57

——, 'Soldiers, Scribes and Women: Literacy among the Lower Orders

in Early China', in Li and Branner, *Writing & Literacy in Early China*, pp. 339–69

Yin, Xia; Ma, Qinglin; Zhang, Zhiguo; Liu, Zhendong; Feng, Jian; Shao, Anding; Wang, Weifeng; and Fu, Qianli, 'Development of Chinese Barium Copper Silicate Pigments during the Qin Empire Based on Raman and Polarized Light Microscopy Studies', *Journal of Archaeological Science*, 49 (2014), pp. 500–9

Yuan, Zhongyi, 秦始皇陵的考古发现与研究 (*The Mausoleum of Qin Shihuang: Archaeological Discoveries and Research*, in Chinese), Xi'an: Shaanxi People's Press, 2002

——, *China's Terracotta Army and the First Emperor's Mausoleum: The Art and Culture of Qin Shihuang's Underground Palace*, Paramus, NJ: Homa & Sekey Books, 2011

——, 秦兵马俑的考古发现与研究 (*Terracotta Warriors: Archaeological Discoveries and Research*, in Chinese), Beijing: Relics Bureau Publishing House, 2014

Yueyang Excavation Team, IA, CASS, '秦汉栎阳城遗址的勘探和试掘中' ('Trial Excavations of Yueyang City Site of the Qin and Han Dynasties', in Chinese), *Acta Archaeologica Sinica*, 3 (1983), pp. 353–89

Zhang, Boduan; Liu, Yiming; and Cleary, Thomas F., *Understanding Reality: A Taoist Alchemical Classic*, Honolulu: University of Hawaii Press, 1987

Zhang, Tian'en, '陕西长安神禾塬战国秦陵园遗址田野考古新收获' ('New Archeological Acquisitions at the "God Wo Yuan" Qin Mausoleum Ruins of Chang'an in Shaanxi Province', in Chinese), *Kaogu Yu Wenyu*, 5 (2008), pp. 111–12

Zhang, Weixing, 礼仪与秩序: 秦始皇帝陵研究 (*Ritual and Order: Research on the Mausoleum of the First Qin Emperor*, in Chinese), Beijing: Science Publishing, 2016

Zhao, Huacheng, 'New Explorations of Early Qin Culture', in Pines et al., *Birth of an Empire*, pp. 53–70

Zhaolin Gu; Luo, Xilian; Meng, Xiangzhao; Wang, Zanshe; Ma, Tao; Yu, Chuck; Rong, Bo; Li, Ku; Li, Wenwu; and Tan, Ying, 'Primitive Environment Control for Preservation of Pit Relics in Archeology Museums of China', *Environmental Science and Technology*, 47 (2013), pp. 1504–9

Zhou, Xiuqin, 'The Mausoleum of Emperor Tang Taizong', *Sino-Platonic Papers*, No. 187, April 2012, http://www.sino-platonic.org/complete/spp187_taizong_emperor.pdf

ACKNOWLEDGEMENTS

First of all, I should like to express my gratitude to the president and senior staff of the Shaanxi Provincial Cultural Relics Bureau, which oversees all museums and archaeological sites in the province, including what is now known as the Emperor Qin Shihuang's Mausoleum Site Museum (hereafter Mausoleum Site Museum), and the magnificent Shaanxi History Museum in Xi'an: Zhao Rong, president; Luo Wen Li, deputy director-general; Zhang Tong, director, Promotion & Cooperation Department; and Liu Yongzheng, deputy director of the same department; and at the Mausoleum Site Museum, Hou Ningbin, the Director. In practical terms, Liu Jun, vice-director, provided assiduous support in arranging interviews and access to archaeological sites, while the Museum's official photographer over the past thirty years, Zhang Tian Zhu, assisted in providing some very up-to-date pictures.

Professor Zhang Weixing, director of archaeology at the Mausoleum Site Museum, was the most enthusiastic supporter in long discussions about the old – and new – mysteries, and on several visits to the main sites round the mausoleum; his most recent book on the subject, *Ritual and Order*, published in Chinese in late 2016, has many stimulating and original ideas which we discussed together. Professor Shen Maosheng, vice-director of archaeology, also shared long conversations, and provided a copy of *his* book on the latest excavations of Pit 1, published in 2017. Zu Xue Wen, director of the Research Office, and Zhou Tie, chief engineer in charge of scientific research, were also unfailingly helpful, while Xia Yin, vice-director of the Conservation and Restoration Department, provided materials and information about the latest research, in particular concerning his own specialized area of pigment research. Former director of

archaeology Duan Qingbo, now a professor at Northwest University in Xi'an, provided copies of his articles in translation and an absolute openness to discussing new ideas and hypotheses. His enthusiasm for all things connected with Qin Shihuang is stimulating in itself. So too is that of Professor Yuan Zhongyi, an earlier director of archaeology, even after more than forty years' hard work on the terracotta warriors; his personal reminiscences and seminal publications were vital sources. In fact, the experts named in this paragraph have each dedicated decades of work to the warriors and the mausoleum, and laid the basis of our current understanding through their research and publications.

Leading archaeologists of the Shaanxi Provincial Institute of Archaeology were also generous with their time and documentation, in particular the Han expert and director Jiao Nanfeng, responsible for excavating the Han tomb complex of the Emperor Jingdi (and who in 2017 was a visiting professor at the Harvard-Yenching Institute), and the Qin expert Professor Zhang Tian'en, who excavated the tomb of Qin Shihuang's grandmother. I should also like to thank another former director of the Mausoleum Site Museum, Professor Xu Weimin, author of a seminal work on the early Qin capitals and also now at Northwest University, for his enthusiasm and for his kindness in providing copies of his books which are now very hard to find. Jing Hongwei, director of the Baoji Pre-Qin Mausoleum Museum in Fengxiang (formerly Yong), shared the expert knowledge gained from working for ten years at that site, and was an infinitely patient guide during my visits.

Professor Lukas Nickel, of the Department of Art History at the University of Vienna, kindly provided me with a copy of his 2013 article on 'The First Emperor and Sculpture in China'. Professor Marcos Martinón-Torres of the Institute of Archaeology at University College London provided a conversational account of the project he has coordinated since 2006, 'Imperial Logistics: The Making of the Terracotta Army', and some fascinating photographs. Dr Catharina Blänsdorf of the University of Munich provided photographs of her important work in analysing ancient colour pigments and then creating model warriors to test her hypotheses. Other specialists who

offered assistance in a friendly and constructive spirit include Professor Grant Hardy of the University of North Carolina at Asheville and Professor Eugene Wang of the Department of the History of Art and Architecture at Harvard.

Special thanks are also due to Father Jim Caime, SJ, director of the Beijing Center for Chinese Studies – a quiet haven in the middle of the city – for permission to use and borrow from the Center's excellent Anton Library of 30,000 books in English about China, including many rare and scholarly items, and also to Dr Amanda Berry, director of research until February 2017, and the librarian Heather Mowbray.

I would like to thank Susannah Lear for her critical comments and suggestions on the original proposal for *Terracotta Warriors*.

I should also like to thank my agent, Michael Alcock, and publisher, Alan Samson, at Weidenfeld & Nicolson for their immediate enthusiasm for this book, and my editor, Lucinda McNeile, the designer, Helen Ewing, for the figures and photo layout, and the copy-editor, Peter James, who each helped to improve it.

Last but not least, I would like to thank my friend and business partner in Xi'an, Wang Youqun, known in English as Wilson, for his support from the first hint of this book and his constant facilitation of meetings and logistical assistance.

INDEX

Mount Zhifu, 211
Mount Zhong, 57
Mu, Duke of Qin, 17, 122–4
muntjac deer, 98
music, 17–18, 102–3, 138, 218–20

Nan, King of Zhou, 141
Napoleon Bonaparte, 5
Needham, Joseph, 49–50, 57, 68–9,
 75, 167, 206–7
Nickel, Lukas, 113, 152–3, 155,
 158–60, 166
nickel, introduced into China, 154

Ordos Desert, 4, 46, 51, 58
oxen, measurement of, 25
Oxus, River, 154

Palace of Lasting Joy, 198
Pamir Mountains, 155, 166
Pazyryk culture, 156
Pengcheng, 55, 181, 198
Penglai, 70
Persepolis, tombs of Achaemenid
 kings, 164
Phryni, 154
Pines, Yuri, 202
Ping, King of Zhou, 206
Pingyang, 6, 13–14, 22
Plato, 155
Pole Star, 206–8
Ponte Vecchio (Florence), 60
postal service, 50
Pound, Ezra, 124
punishments, 24–5, 109–10, 114
pyramids, 94, 162–3

qi ('breath'), 122
Qi state, 4, 9, 53, 120, 122, 206
 Zhangqiu tomb, 103
Qian, 15
qianshou ('black-haired ones'), 44
Qin Er Shi (Second Emperor), 45,
 141, 180, 190–3, 196–7, 202, 216
Qin Shihuang (First Emperor),
 xxiv, 3–4, 6–8, 22, 26–7, 29
 appearance, 40
 birth and rise to power, 35–44
 and 'burning of the books', 61–3,
 124
 capping ceremony, 20–2, 51,
 224–5
 death at Shaqiu, 53, 55–6
 funeral ceremony, 216–20
 and grandmother's tomb, 141–3,
 214
 and human sacrifice, 124
 and imperial succession, 191
 inspection tours, 51–6, 63
 and jade, 71–4
 'Messianic' qualities, 202
 name, 10
 obsession with immortality,
 67–76
 and palace building, 58–61, 138,
 194, 215
 premature death, 75–6, 104, 113,
 184, 191, 200, 217
 and search for immortals, 55
 suspected mercury poisoning,
 75–6
 vision of lasting dynasty, 63, 67
 and wall-building, 46–9, 199